THE LAST **FOLK HERO**

A TRUE STORY OF RACE AND ART, POWER AND PROFIT

ANDREW DIETZ

ELLIS LANE PRESS

ELLIS LANE PRESS

Published by Ellis Lane Press
An imprint of Ellis Lane I, LLC.

Ellis Lane Press
3221 West Andrews Drive
Atlanta, GA 30305
www.ellislanepress.com

Library of Congress Control Number: 2005909779

ISBN: 0977196801

Cover design by Mike Melia and Karly Young of Melia Design Group
Book design by Jill Dible
Author photo by Joel Silverman
Distributed by Independent Publishers Group

For my wonderful family
For the artists

ALONE IN THE JUNGLE

IT WAS SUNDAY NIGHT. A NOVEMBER WIND FOUGHT PAST THE WOODEN studio walls and pushed through the tin roof. A tiny space heater battled back the chill while a one-thousand-watt industrial lamp, throwing off as much warmth as light, provided reinforcement. Thornton Dial moved too fast, generated too much body heat to notice. Dial had the lean frame of a featherweight fighter, and at sixty-five years old he still moved like one. His gnarled hands swiped and jabbed paint across the enormous canvas with commensurate power. Dial stepped back to consider what he had made. As he rested his brush on a can of Sherwin-Williams white, the overhead door rattled open. Little Buck, Dial's firstborn son, called his father into the main house. The show was about to start.

Dial walked through an iridescent glow that illuminated the front yard, and he followed the light to its origin. He looked past large glass panes to see the master bedroom. His wife, Clara Mae, sat back against the headboard of their king-size bed, supported by a tower of pillows and buttressed by fidgeting grandchildren. Dial's daughter Mattie, his sons Richard and Dan, and their extended families sat around the room, in chairs, on the floor. They passed a bowl of popcorn, returned from last-minute trips to the bathroom, and

anxiously studied the ticking *60 Minutes* stopwatch that lit up the big-screen TV.

Eight months earlier, Morley Safer and a crew from *60 Minutes* visited Bessemer, Alabama, to film Thornton Dial and his art. Mr. Safer was doing a good story, his producers said. He didn't always do good stories, but this time he would. This time Safer would showcase Dial's story: an uneducated, out-of-work African American from the Pipe Shop ghetto of Bessemer, who catapulted from obscurity to fame through the world of fine art. The story would be seen around the country in ten million homes.

Before: Dial spent thirty years off and on at the Pullman, a box-car factory that shuttered and severed Dial's employment in 1980. Now: two major New York museums were simultaneously exhibiting his work. The exhibitions were one-man shows, no less. Just Dial. Before: he made little more than twenty thousand dollars a year. Now: he reportedly earned more than ten times that amount. Folks around Bessemer figured he was a millionaire. Dial moved his family from the tiny brick bungalow that he built with his bare hands to a twenty-acre compound in an upper-middle-class white neighborhood. Before: you could virtually roll off of a busy Pipe Shop thoroughfare and tumble right through Dial's front door. Now: one approached the Dial family enclave through a gate that opened onto a winding driveway that climbed up to a sprawling clapboard and stone house overlooking a stocked pond out back, a swimming pool on one side, and an open field for outdoor sculpture on the other. Plus, it had plenty of wandering room for poultry and cows. When Dial was younger, he raised cows on vacant lots throughout the Pipe Shop ghetto and split the proceeds with the landowners. "If the money ain't got to go nowhere, if you put it in cows then you still got the money," Dial reckoned.

Thornton Dial stepped across the yard to his family, to the show. In the darkness nearby a heifer shuffled cautiously, pondering the figure of a mule that lay motionless on the grass. Crafted from decaying

metal drums and scrap, the lifelike sculpture rested with front legs outstretched. A rusting companion grazed alongside.

––––––––––

Thirty minutes east down Interstate 20, fringing the Birmingham International Airport, Lonnie Holley's yard was famous for its sculpture menagerie, though some called the place a junkyard and others claimed it the most fabulous yard art environment they had ever seen. One thing was definite: it was impossible to distinguish Holley's home from the fortifications of recycled scrap that were piled, twisted, shaped into figures, and strewn across his yard.

Holley floored his jalopy. It bumped along the dirt drive, kicking up a cloud of rubbish as he braked to a stop. He had spent the day with a Sunday school full of preteens working a stash of sandstone. Holley carved. The kids carved. The kids jabbered nonstop, and so did he. He loved the noise. Holley showed the youth how to scrape away the surface, to dig into the flesh of stone and discover something beautiful. He spewed stories that came like spirit voices streaming endlessly from his mouth, but he had lost track of the hours and now he was late. Hoping to make up whatever time he could, Holley sprinted through his ramshackle cave and into the bedroom.

A Delta 727 that thundered from the nearby runway rocked Holley's home, and he twisted up his Sony television's volume control. Lonnie Holley—the artist who introduced Thornton Dial to the art world—sat alone, cross-legged atop a rumpled mattress watching a small television mounted on a whirring VCR. He was taping that night's *60 Minutes*. He wanted to hear his own words emitting from the screen, and he wanted the power to play them back at will. Perhaps he would send the tape to collectors or curators. It would be something to add to his collection of clippings and promotional material. *Publicity got to be good*, he told himself. *Everybody need advertising to make things happen.*

———————

Bill Arnett was certain that life as he knew it would be over within the hour. He tried to shake the thought, but it wouldn't go away. He wandered the SoHo streets that late November evening obsessing, "My life is over, my goddamn life is over." He shuffled along the sidewalk, shaking his head. Strands of slick black hair tumbled loose and fell over his glasses. He let them hang.

He convinced himself that this was the last day he could walk the streets respectably, that this was the end of it, forever. Then, just as readily, he convinced himself otherwise. He was fifty-three years old. He had survived bad things before. He'd had two heart attacks, and that hadn't stopped him. He was just coming off the triumph of his career. Days earlier he launched a critically acclaimed double exhibition for his star artist, Thornton Dial, at New York City's Museum of American Folk Art and the New Museum for Contemporary Art. The reviews were A-plus, right?

But the words of Arnett's Deep Throat on the High Museum board of directors haunted him: "Be very, very careful. Ned Rifkin is boasting to board members at the High that Morley Safer and *60 Minutes* are going to cut your throat."

"What can they do to me?" he responded then.

"You're not going to like what *60 Minutes* has in store for you," Rifkin told him more recently. That's when he figured for sure he was fucked.

Bill schlepped back to the bar but couldn't bring himself to watch the show.

"My goddamn life is over," he said out loud to no one.

HEADING FOR THE HIGHER-PAYING JOBS

MATTIE BELL LAY HALF-NAKED IN THE LATE SUMMER HEAT, KNEES UP, spread. Her head swung back and forth. Her sweat-drenched face twisted in a blend of pain, joy, and disorientation. Holes in the roof of her cabin revealed a vivid blue Alabama sky, and a square opening cut in one wall showed the surrounding cornfield. Thirteen years old, she held a screaming newborn to her breast. Mattie Bell's mother, Martha Jane Dial Bell, was nearby. Martha Jane would take care of the infant boy as she still took care of her own daughter, Mattie. The baby would take his grandmother's family name: Dial.

Thornton Dial kicked out of his teenage mother's womb in Emelle, Alabama, in 1928, just a year before the Crash of 1929 kicked off the Great Depression that devastated America. But, to the Negroes of Emelle, the Depression didn't make a lick of difference: "same old, same old," just a little worse. Emelle was situated at the center of Sumter County in western Alabama, and Sumter County was situated at the center of the Black Belt region of the South.

Thick with slave labor, Sumter County became the heart of Alabama's cotton economy prior to the Civil War. Cotton livelihoods died with the war's end, and during Reconstruction Sumter morphed into the poster child for sharecropper poverty. Not long after, it

changed shape again, this time into an incubator for profound white-on-black anger. So much interracial violence took place in Sumter County during the decade after the Civil War that the federal government sent its Seventh Cavalry into Sumter to stem the unrest. The deadly atmosphere remained, and through the early 1900s more blacks were lynched in Sumter County than any other place in Alabama, leading one Alabama governor to label the area "Bloody Sumter."

Hope embraced the region in 1912, as the Alabama, Tennessee & Northern Railway Company pushed to complete its passage through western Alabama. Where the railroad went, prosperity was sure to follow. Officials from the AT&N pressed white Sumter landowner Joseph Dial to donate land for the right-of-way of their rail line. In exchange, they agreed to name a new town after Dial's daughters, Emma and Ella. That town was Emelle. Better times for Sumter did not mean more tolerance toward blacks even deep into the twentieth century, as evidenced by the 1954 conviction of two white brothers from a prominent Sumter family who were found guilty of buying Negro prisoners from Alabama and Mississippi prisons and holding them "in involuntary servitude by acts of force and violence." The twentieth-century slaveholders were named Fred and Oscar Dial, the distant white relations of Thornton Dial.

Thornton Dial wasn't Mattie Bell's only child. After Thornton, Mattie Bell bore three more children: Arthur, Richard, and Mary Etta—though not all to the same man. The burden of an expanding household was too much for Mattie, and she believed that she needed a man to help her full-time. She found that man in Dan Pratt: an Emelle sharecropper with an impulsive streak and little patience for children. He married Mattie when Thornton Dial was still a toddler, but he made it clear that he didn't want her children in his house.

Dial's grandmamma Martha Jane *did* want them. She took the children and raised them on the twelve dollars a week that she earned from cooking in white people's homes. As soon as he built a touch of boyhood strength, young Dial plowed fields, drove mules around hay presses, and picked cotton to help pay down the family's sharecrop-

ping debt. Dial's brother Arthur recalls, "After the fields got harvested, we used to go behind the men plowing in the field and pick up whatever was left—sweet potatoes, corn, peanuts, or whatever—and carry them home to eat."

If money bought freedom, the Dials could never afford it. Growing up, Thornton Dial wore patched clothes, and to him a nickel piece of candy cost a fortune. But his heroes were not rich men. Dial's heroes were his Uncle Buddy Jake, Frank Dial, and Pete Dial—farmers, men who worked hard, men who made something from nothing.

Young Dial also made something from nothing. From dirt and sticks and castaway objects he made his own world. "I would hook up a matchbox to two hoppergrasses, tie threads around their neck. I wanted to have my own mules and wagon. Called it 'the green horses.' You know a hoppergrass kind of favor a horse," Dial remembers. As a child sitting in a sand pile outside his Emelle home, Thornton Dial drew stories in the dirt. He sketched whole villages in the earth: cars and roads, trains and rails. He built little houses populated with people crafted from cornhusks, rolled them out with tin cans or a bottle, and started over again. "I was drawing and making stuff about everything I would see," says Dial.

When Thornton Dial was eleven, his grandmamma Martha Jane died suddenly, leaving him and his siblings orphaned. On the day of her funeral, Dial knelt under the old shade tree outside of the church, still in his Sunday best, and scratched the ground with a broken branch. He didn't know that Sarah Dial Lockett, his maternal great-aunt and a woman with a bosom as big as her heart, watched him from the doorway of the chapel. At the end of that day, Dial and his siblings went to live with his mother's sister, Lillian Bell. But his Aunt Sarah had determined that she would bring the boys to her as soon as she could arrange it. Two years later, Thornton and Arthur Dial boarded a train in the Sumter County fields bound for her home in industrial Bessemer.

Bessemer, Alabama, was two hours northeast of Emelle but only twenty minutes west of Birmingham. By 1941, when Thornton Dial

arrived, Bessemer had become nearly as big as a city. The town had sprung not a century earlier from the brazen ambition of its founding father, Henry Fairchild Debardeleben, a bona fide robber baron who built his fortune reconstructing post–Civil War Birmingham through mining and iron production. Birmingham earned the moniker "the Pittsburgh of the South," and Debardeleben was crowned "King of the Southern Iron World." Debardeleben's realm fell into jeopardy, however, when iron gave way to steel as the industrial material of choice; so the metals monarch decided to create a new kingdom. Debardeleben paid one hundred thousand dollars for nearly four thousand acres of land southwest of Birmingham near the Red Mountain iron seam. There, he erected an iron and steel powerhouse from the rich Alabama earth. The area had all of the natural resources that Debardeleben needed for production: ores, coke, limestone, and water in abundance. The broad Valley Creek carried millions of gallons of water a day through Debardeleben's land. Debardeleben named his domain for the British scientist who revolutionized steel production: Bessemer.

Within two years of its founding, four thousand people lived in Bessemer, but it still trailed Birmingham by twenty-one thousand residents. To keep pace with its sister city and to match that city's "Magic City" moniker, Bessemer needed its own nickname. "Marvel City" was the one that stuck. Debardeleben's money, vision, and bravado, coupled with Alabama's use of "convict leasing," attracted a flood of big business. In the late 1800s and early twentieth century, businessmen like Debardeleben could "buy" mostly black prisoners from the State of Alabama for as little as six dollars per body per month. And for crimes such as gambling, adultery, disturbing white women, and even charges "not given," thousands of men were imprisoned and then leased to industry, becoming the State of Alabama's largest source of funding. One *Wall Street Journal* article reports that in addition to inconceivable toil, laborers were "subjected to squalid living conditions, poor medical treatment, scant food and frequent floggings, thousands died."

In Bessemer, industry smokestacks scattered the landscape, vertical cigars belching gray clouds into the southern sky. Debardeleben owned many of them himself. The Bessemer Iron and Steel Company, Debardeleben Coal and Iron Company, and Little Bell Furnace were all his. Bessemer Rolling Mill, Krebs Manufacturing, and the Marvel City Brick Company were just a few of the others that came to town, riding the wave of "cheap" labor and steel mill success.

Among the operations, at least one smokestack would give rise to its own Bessemer neighborhood with a nickname all its own. In 1889, the Howard-Harrison Iron Company opened in Bessemer to forge water and wastewater pipes. Ten years later it consolidated with eleven other plants from around the country to form United States Cast Iron Pipe and Foundry, a company that generated 75 percent of the iron pipe production in the United States. Inside the Bessemer facility, foundry minions torched iron at twenty-seven hundred degrees Fahrenheit and poured molten metal into enormous tubular casts. "U.S. Pipe dominated our neighborhood, which was bounded by the plant at Nineteenth Street on the north, Twelfth Street on the south, Seventeenth Avenue on the east, and Twenty-second Avenue on the West," wrote Deborah McDowell in her 1997 memoir named for the Bessemer enclave, *Leaving Pipe Shop*. But outside of the walls of the foundry, in the streets, the yards, the houses of Pipe Shop it was the people, not the pipes, who were in control. "It was a very close-knit, warm, cohesive neighborhood," says McDowell. "In the face of the most abject conditions they managed to devise incredible expressions of creativity. They took care of gardens; swept yards in intricate designs—planted flowers, my mother was a dress maker, my own love of writing originated in love of language which I learned in the church listening to the preacher's poetry," McDowell explains. The foundry workers and their families who constituted the Pipe Shop community were like many who throughout human history, McDowell says, "found ways to be creative despite unfathomable conditions." It was in this place that Thornton and Arthur Dial

arrived when they stepped off the train from Emelle. It was in this place, in the unwelcoming shadows of the U.S. Pipe and Steel foundry, where their Aunt Sarah welcomed them with open arms.

Debardeleben knew the value of railroads, especially in the late 1800s. For his Bessemer kingdom to thrive, he knew that railroads would be its lifeline: Alabama Great Southern, the Louisville and Nashville, the Bessemer and Huntsville, Georgia Central, the Kansas City and Memphis, the Georgia Pacific, the Woodward Iron, the Bessemer to Tuscaloosa, and the Bessemer Belt Line Railroad cut paths at various times through the town. The endless stream of engines and boxcars carried raw materials in and finished product out from the likes of Debardeleben Furnaces; a double row of beehive coke ovens two and a half blocks long where laborers worked twenty-four hours a day. In 1893, however, long before Thornton and Arthur Dial took their train ride to Bessemer, the price of iron dropped precipitously, and the United States fell into a deep economic downturn. Debardeleben's fortune crashed with the markets. In the ensuing years, Debardeleben and Bessemer both struggled to regain their financial balance, until the recession of 1907 fatally crippled the effort. Debardeleben died in 1910, and with his loss it was clear that the city of Bessemer must further diversify.

The Pullman-Standard Company thought so, too. In 1929, they bought what was left of Debardeleben Furnaces. They tore down the crumbling blast furnaces, wiped away the incapacitated beehive ovens, and bulldozed the remnant slag piles scattered among the decrepit tract of land. In their place, Pullman erected an enormous freight-car plant that measured one-third of a mile in length and over a million square feet of space. From 1929 through the early 1980s, the Bessemer factory issued a steady flow of freight cars: nearly one every fifteen minutes for fifty years. It cranked out one hundred thousand cars by 1951, and it had produced two hundred thousand by 1970.

The number of boxcars was only rivaled by the number of people who lived around the plant. "There were a plethora of ghettoized black

homes down by the boxcar factory," says Dr. Walter Branch, who served as principal of Bessemer's Colored High School, Jackson Solomon Abrams High School, and later as Bessemer's director of education. Branch continues, "A lot of women who made money engaging in illicit sex with loose factory workers would know exactly when payday was. They hung out along the fence by the plant waiting for the men to empty out. Bootleggers would be out there, and loan sharks would be waiting to collect. Pullman people lived hard and worked hard."

The gargantuan Pullman facility was referred to simply as "the Pullman," and on and off for thirty years, it was where Thornton Dial would leave the relative comforts of his Pipe Shop neighborhood to toil.

Even before he was old enough to work at the Pullman, Thornton Dial's new life in Pipe Shop revolved around three things: family, labor, and invention. His Aunt Sarah enrolled him in school, but at thirteen years old Thornton had only enough education to qualify for Bessemer's third-grade class—a horrible embarrassment for a boy entering his teens. So he spent most of his time drawing. Dial says, "I was drawing pictures of Tarzan and cowboys and stuff like that I learned from the boys that went to the picture shows. I always had the idea to draw. Put time at something like that you get better at it. I put in more time with drawing than I did with my lessons. Instead of being in my books I was into the drawing, and Professor King, the principal over the school, gave us so many ass-whippings. Back then, shoot, they whip you till you pee in your pants. So I quit school and went to work at the icehouse. It was more safe."

Dial spent the next ten years drawing and working an endless stream of odd jobs: hauling ice, pouring cement, melting iron, loading bricks, fitting pipes, painting houses, and helping out at the Bessemer Waterworks. "Everything that could be did I done did it," he says, and he did it mostly under the watchful narrowed eyes of his white supervisors.

All the while, Dial struggled to maintain a paradoxical balance of obsequiousness and courage. When he was sixteen, Dial and a cousin

were bailing cotton near Bessemer. Typically punctual, Dial arrived late one day.

"Where you been, boy?" the burly overseer interrogated when he saw him.

"Well . . . I don't know . . . ," Dial replied, not feeling up to offering excuses.

"You'll keep your ass there 'til you tell me, or I'll whup your ass," the overseer threatened and brandished a stick used for stirring clothes.

Dial stared back, considered his options. He could win a fight with the overseer but not the resulting war. The same man had beaten his cousin for running from a threat. So Dial stood his ground.

"Go ahead," Dial said flatly, staring at the man with fierce resolve. "Whup my ass." Eyes locked—Dial's and the big man's. The overseer turned and walked away kicking dirt and cussing as he went. "He never bothered me after that," Dial remembers sixty years later. "I was too good a man and a worker. I was a man at that age."

Potential employers thought Dial was at least man enough to work under the dimmest of circumstances. Dial worked at the Jones Foundry, casting and forging iron into widgets and gears for industrial applications he would never see. The Foundry blast furnaces were samples of hell: a smoking blend of raging inferno and molten metal. "I been in there," says Dial. "I been in the fire."

Dial worked at the Jones Foundry with his half-brother, Arthur, and while there he became consumed with another kind of fire. Speaking of his future wife, Clara Mae, Dial says, "I was working at the Foundry where you pour iron at, and I saw her time after time. She was real young. I come past her house every day eating, laughing, and talking with my friends and my brother Arthur." At the time, Dial was sixteen and Clara eleven, but they developed a special friendship. "I used to go down there a lot," Dial remembers, smiling. "We used to play a lot of checkers and dominoes and knocking balls with brooms and things down at her house." But over time, it was Clara's cousin George that sparked the romance. "George tell me, 'I

know somebody crazy about you,'" says Dial. "After I found out that Clara liked me and I liked her, we would do some talking and I'd take her a little candy sometimes and go to the picture show." At first Clara resisted her Romeo's amorous advances. "Sometimes I tried to get her to go to a rooming house with me," Dial says, "and she wouldn't go." But after seven years of courting, in 1951, Clara Mae Murrow gave her hand in marriage to Thornton Dial.

The 1950s were years of new beginnings for Dial in other ways. He built their first home in Pipe Shop, enabling the newlyweds to move out of relatives' homes and into a house of their own. "We never rented a house since we been married," Clara Mae notes proudly. Dial learned to build a house the way he learned everything—by paying laserlike attention to others and what they did. "You keep things in here," he says, pointing to his head, "and you always got it inside."

When Dial needed materials for the house, he invented them. He filled old soda and beer cans with cement and stacked them as bricks. Even today visitors can still see half-buried cans lining the walkway to the home's front steps.

Thornton and Clara had five children in short order. Little Buck, Patricia, Mattie, Richard, and Dan. And though the family was poor, the kids never knew it. "He was a good provider," says Clara Mae Dial with pride. She never worked outside of their home. With food on the table and the children nearby, she could be satisfied with their lot, but Dial never could. One day after deciding that his family needed a bigger house, Dial started building it right then and there, in his backyard. When he was done assembling the new structure, he literally tore his old house down and moved the new one into its place.

Thornton Dial was determined to lift himself and family to a better economic position and believed that owning his own business was the way. "I wanted to work for my own self," says Dial. For a while, as Dial worked full time during the day, he and Clara Mae ran a neighborhood café built on to the side of their home to bring in extra money. There they served the best barbecue, pig ear, and baloney

sandwiches in town. Mostly, though, Dial combined his natural creative instincts with the industrial crafts he learned on his day jobs. Acting as Pipe Shop's Thomas Edison, Dial spent many nights and odd hours cobbling together scrap materials in the hope of making useful things to sell.

In addition to selling his inventions, Thornton Dial would come home from work and immediately take care of his livestock and the crops he grew to pull in more money. When Dial plowed the field, he brought the children along to help, sometimes carrying them all on his back just to prove he could do it and to make them laugh—all except Patricia Ann. Patricia Ann, born with cerebral palsy, couldn't play like the other kids outside. But even as he was just making subsistence wages, Dial would regularly buy Patricia Ann steak, which he'd put in a blender and feed to her through a straw. And though steak could be seen as a luxury at that time, when it came to providing for his family, Thornton Dial always wanted more.

"I always had that mind, dream of life, vision, that I should have been up in the world, flying, traveling, doing things," says Dial. He resolved to find any way he could to bring himself up in the world. "A big man can make big money in animals," he figured. He tried chickens. He wanted thousands, and while he didn't reach his goal, he came close. "I don't know how many chickens we had," says Thornton Dial's son, Richard, chuckling, "but let's just say we had lots and lots of them." When Dial ran out of space for the birds on the family property, he reared them in a neighborhood vacant lot. Dial also had pigs, over five hundred head, and well over eighty cows. But his vision was not confined to livestock.

At one time, he even considered improving the model for the American stop sign. "He was going to build stop signs, do it better," says Dan Dial. "We had to tell him, 'Dad, you can't just go changing the stop sign. That's a government thing.'"

But Thornton Dial believed in the impossible. "You couldn't tell him that it couldn't be done. He would do it anyway," Richard Dial

says. "Once Daddy wanted a tractor, and we couldn't afford one," Richard continues. "So he took his pickup truck and designed plows to go behind it." Like the hoppergrass wagons of his childhood, Dial was certain this would work. "He always convinced you that it was going to work, and whatever he did, we were involved. And if it was successful, he was gonna share the success with us all," Richard offers. But Dial's makeshift "tractor" didn't have hydraulics to position the plow, and it proved useless.

Failure never seemed to slow Dial's ideas. The concepts themselves seemed to bring him as much joy as the results, and there was always a healthy dash of aesthetic flavor baked into most of his concoctions. "Everything I made," says Dial proudly, "I tried to make look good."

Indeed, the will to create was Dial's fuel, keeping him in constant productive motion. "Daddy been doing art ever since I can remember," Little Buck recalls. "I used to laugh at a lot of the work that he did. Once he made a fence out of fishing poles, and it looked like a fish bone and went all the way around the yard. I thought, *That's weird*. But he kept on with it. You couldn't discourage him."

Dial's work ethic also translated to his job at the Pullman. By the time his children were of working age, Dial had advanced in position from a welder's assistant to a machine operator's assistant. Though he would always rank below any machine operator at the Pullman, a machine operator's assistant was the black man's top job. Dial easily formed relationships with people in authority and over time developed a "close association" with the Pullman superintendent—for whom his mother-in-law once worked as a clerk. That relationship opened the door for numerous Dial family members to easily acquire work at the Pullman. Other nameless men stood outside of its gates seeking employment, hoping that they too might be pulled from the line.

Dial's relationship with the superintendent, however, had its limits. Once Dial developed an idea for machine redesign that could potentially save Pullman thousands of dollars. As Dial drew the schematic, Clara Mae rearticulated the concept in words. When done,

he optimistically dropped their precious blueprint in the company's suggestion box. The design was readily accepted and implemented; however, Dial got no reward. Credit was given to the white plant foreman instead. Dial remembers, "They never said nothing to me about it. Not even 'Thank you, Dial.'" Of those times Dial says, "You get angry with that, but yet and still you had to go along with it."

Dial went along with it but prayed that the unions would some day give him some power as a worker and a man. Labor unions struggled in Bessemer and Birmingham ever since Henry Debardeleben's son Charles and a personal army of his loyalists fired machine guns at unionists striking Charles's mining company in 1934. In the 1940s, the United Steel Workers of America formed and from then until the present day actively organized Bessemer and Birmingham in attempts to level the traditional management/worker playing field. Conflicts between the unions and plant owners grew ugly with race and communist baiting that led to violent disagreements. In one encounter, a union official had his eye kicked out in a brawl. While Dial wasn't on the front lines of these battles, he never ran. "Negroes used to run from the white man when he see him coming," Dial says. "'Captain coming!' they'd say. I never run." As Dial's time in the Pullman wore on, his hopes centered on the leadership efforts of Perry "Tiger" Thompson, the first black president of the Pullman's Local Union 1466, the largest fabricating union in the United States. Thompson was seen as a radical leader who, in 1948, despite intimidation by the Ku Klux Klan became the first Negro to run for lieutenant governor for the state of Alabama. His opponent was no less than George Wallace, an avowed segregationist who would later serve four terms as Alabama's governor. "My idea is to take and whip a man with his own thing. Whip and fight him until the end," Thompson said when asked about Alabama politics. In the race against Wallace, however, it was Perry who took the political whipping. "Perry fought for black people as much as he could," Dial recalls. "He went far as he could, you know."

The Ku Klux Klan also fomented its fair share of the conflict between steel company management and the labor unions and seized any opportunity to rule through terror. Men in pointy white hoods ran rampant in Bessemer. They passed by the Dials' home at night as his family sat on the porch, drove through the streets with lit crosses on top of their trucks, and shouted warnings against "niggerism" and "communism" through their megaphones. "They come through and go into homes—with hoods and everything," Clara Mae Dial remembers matter-of-factly. "They burnt some crosses up from us—at Miss Penny's house. It was pretty rough at that time. If you didn't say 'Yes sir, no sir,' you'd get killed."

Generally, the Dials kept their heads out of the rumpus, but entanglement was often unavoidable. Once, after a long day at the Pullman and then putting down some whiskeys with his buddies, Dial decided to head home. He wasn't in much shape to drive, and, it turned out, neither was his car. The engine sputtered, jerked, and halted. He got it rolling, but then found that it was his own head that felt like it was sputtering, jerking, and halting. Dial pulled over to the side of a road in Pipe Shop to find that his car wouldn't start again. Figuring that he would deal better with things after a quick nap, Dial lay down across the front seat and shut his eyes.

Suddenly he was startled by the blazing beams of police flashlights flickering in his face. He smiled, relieved. Dial figured that the police were there to help him. He was wrong. After exchanging a few harsh words, the officers yanked Dial from the car and tried to beat him. But Dial outsmarted the cops. He held one of the officers from behind and maneuvered him as a shield so that the other officer's blows landed on his colleague's nose instead of on Dial's. That enraged the police further. They tore into Dial with flailing hands, booted kicks, constable sticks, and angry epithets. Dial was preparing to die. But as thoughts of his daughter, Patricia, ran through his mind he grew more angry and defiant. "Not only will *my* blood be on your hands!" Dial screamed, "but so will the blood of my crippled child!"

The mention of a crippled child was enough to soften the officers' attack slightly, and they finally relented. With drawn guns, they handcuffed Dial and took him to the Bessemer jail for an evening lockup while they determined his fate. Thornton Dial was released, uncharged, the next morning. Apparently, one of the Pullman higher-ups passing by told the cops to lay off. Dial, it seems, was too good a worker to destroy.

After that, Dial figured that his best chance of coexisting with his white neighbors was to simply lay low. Living near Birmingham in the time of Bull Connor, the KKK, and George Wallace's reign, Dial decided to observe only and remain silent. In 1963, Dial watched as Fred Shuttlesworth and other Birmingham civil rights leaders were ostracized for speaking "too much." He watched as the series of bombings that earned Birmingham the nickname "Bombingham" exploded. And he watched as the Klan committed that city's most heinous crime, in September 1963: the bombing of the Sixteenth Street Baptist Church that killed four girls—Denise McNair, age eleven, and Cynthia Wesley, Carole Robertson, and Addie Mae Collins, all age fourteen.

"You look at how it happened," says Dial of the Sixteenth Street Baptist Church bombing, "and it kind of showed the world how people was living in the state of Alabama. If you goin' go in the church and tear the church up, well then you might as well tear up the world!"

Though Dial's mouth was silent, he couldn't stop his mind or his hands. "I done did a lot of things," he says.

After the fishbone fence that crowned his yard, Dial made fishing nets. He extracted the inside of cable lines, wove them together, heated them on the stove, and welded the parts, much to Clara's chagrin. "He'd run the gas bill sky high!" Clara says. After cable lines, Dial experimented with cement. He made cement flower stands, more canned bricks, and increasingly his work took on a sculptural form. Clara was still not impressed. She wouldn't let him put his concoctions in the house, so they cluttered the front yard instead. Ashamed

to exit the front of the house, Clara would sneak out of the back. "I said, 'You just messing up,'" remembers Clara. "So he went to hiding a lot of that stuff he made." Thornton Dial hid his work in the tool-shed, he buried it in the backyard, he tore it up and made something else out of it. He was not hiding and recycling merely to appease Clara Mae. He knew somehow that whatever he was making could bring far more danger than a tongue-lashing from the wife. As his work became less practical and more aesthetic, it began to reveal Dial's emotions about his plight and about the civil unrest around him, and these feelings—too dangerous to let escape his ever-closed mouth—now seeped from his whirring mind to his hands and out through metal and cement.

Dial created his "things" while still working full time at the Pullman. The Pullman was the economic bulwark of Bessemer. By the mid-1970s, the plant employed nearly four thousand workers. In 1979, two months before the Pullman's fiftieth anniversary, it celebrated producing Pullman-Standard's one millionth freight car: a shiny blue and silver boxcar with the number "1,000,000" painted on top. "The one millionth car symbolizes the past, present—and most especially, the future," bragged a Pullman senior executive at the time. As it turned out, he was wrong; it represented the end.

By the late 1970s cheap steel imports from abroad and a tightened labor supply at home eroded the Bessemer economy, and the Pullman was hit as hard as any. Less than a year after cranking out boxcar number one million, the Bessemer plant closed. Its workforce was dismissed, including Thornton Dial.

"Pullman shut down, and I didn't have nothing else to do," Dial says. "So I just went to work for myself." Being self-employed full time gave Dial more freedom to create his "things." He found a home in his junkhouse. No more than five feet tall and ten feet square, the junkhouse was a ramshackle shed behind Dial's brick home and was originally designed to raise calves and chickens. It soon became Dial's studio. There, Dial not only worked his raw materials into tables and

chairs and other items that he might sell but also into six-foot-tall turkeys and tigers and other "things" that seemed to have no purpose but to unburden Dial's soul. Soon the junkhouse was like an overrun metal zoo.

Thornton Dial's yard wasn't the only thing in Bessemer that was overrun. The city's sacred water source, Valley Creek, which once gave rise to Debardeleben's great new city, had grown filthy from a century of industrial runoff and was filled with toxic waste and sewage. It was such a cesspool that Bessemer residents considered the words "Valley Creek" synonymous with "Shit Creek." "We'd say, 'You are up Valley Creek without a paddle," recounts Dominga Toner, director of the Bessemer Hall of History. In 1983 more than nine inches of torrential rain flooded Valley Creek's banks, resulting in the drowning death of one man and leaving the houses in Pipe Shop under several feet of water. Thornton and Clara Dial's home was among those partially submerged. The junkhouse was in ruins, and amidst the persistent waves of "shit creek" that washed through Bessemer, Dial's concoctions floated away. Once the waters finally receded, Dial discovered that any of his creations that hadn't washed away had been buried deep beneath a thick crust of hardened mud. None of Dial's embryonic art would survive.

Chapter 2

SPIRIT OF MY GRANDMOTHER WRAPPED IN THE BLANKET OF TIME

VULCAN IS A WORKINGMAN'S BEACON OVERSEEING THE DAILY MOVEMENTS of Birmingham, Alabama. He is a fifty-six-foot tall, one-hundred-thousand-pound-plus colossus—the largest sculpture ever made in the United States—and he towers over the Magic City from his perch atop Red Mountain. The giant statue, god of fire and forge, was created as an exhibit commemorating Birmingham's iron economy for the 1904 St. Louis World's Fair Palace of Mines and Metallurgy. But since *Vulcan*'s birth, the citizens of Birmingham have never been quite sure whether to embrace him, reject him, or laugh him out of town. With a huge slap into the world, *Vulcan*'s sculptor had left the big man's iron buttocks naked for all to see.

After the World's Fair, the bare-bottomed icon returned to Birmingham and spent months in purgatory stretched by the side of the railroad tracks, the fallout of unpaid freight bills and indecision about his next home. Afterwards he was hauled to the Alabama State Fairgrounds, where he stood for the next thirty years hawking pickles, ice cream, and Coca-Cola from the giant hand that once clutched his hammer and spear. Prudish marketers covered the statue's exposed rump with a painted-on pair of blue overalls, and from that point forward it seemed that *Vulcan* fell to disrepair. During the mid-1930s,

after one of his seventy-five-pound thumbs rusted and crashed to the ground, the city sought euthanasia for the colossus. The local Kiwanis Club rushed to *Vulcan's* rescue, and in 1937 they arranged to return *Vulcan* to Red Mountain, from which his body had been mined, to a spot carved out and named just for him: Vulcan Park.

Secure in his new home, *Vulcan* assumed a new role: helping Birmingham motorists drive more carefully. Instead of drinks and snacks, the big deity now held a "safety torch" that changed from green to red when traffic fatalities occurred. Age and elements ultimately prevailed, and by 1999 *Vulcan* was falling apart again. Vulcan Park closed shortly after, for fear that *Vulcan's* torso chunks would break off and crush the many tourists who came to see Birmingham's famous metal man. More than $10 million was needed to repair him, much more than the city had, so the torch-holding giant was dismantled and his decapitated eight-foot-tall head displayed as the centerpiece at the sculpture garden of the Birmingham Museum of Art. In 2003, after enough funds had been raised and repair work completed, *Vulcan's* noggin rejoined the rest of him, and the sculpture garden was handed over to a more ethereal Alabama icon: Lonnie Bradley Holley.

The center of the Birmingham Museum's sculpture garden, a sunken rectangle lined with pebbles and surrounded by concrete walls is called the Lower Gallery. Lonnie Holley refers to it as "the pit." In the Alabama sun on any July day the pit's temperature easily feels like one hundred degrees. Lonnie Holley spent the summer of 2003 there. Even with salty drops slipping down his forehead and sneaking behind his wraparound sunglasses, he still looks cool. Lonnie Holley, who speaks with the charisma of an evangelist and stands with the kind of tall and lean that some women call "fine," slurps Sprite out of a Big Gulp cup as he engages with a cameraman filming him for a documentary. The film would be released in conjunction with Holley's first solo museum exhibition, a retrospective, following his improvisational art-environment performance in the pit. On this day Holley, taking a break from sculpting society's debris, directs the documentary.

Holley's head has always been a little big. He called her "Big Mama." But as much as she cared for her Tank, the truth is that Big Mama was sickly. She seemed never to leave the house, and she was frequently confined to her bed, which often left Holley in hands that weren't so soft and tender, those of Mr. McElroy.

Mr. McElroy, whom Holley had taken to calling "Big Daddy," was a small-time entrepreneur. In addition to his bootleg business, he ran a backyard bait farm that sold worms to fishermen. When the bar was too crowded, the cussing got too awful, or fistfights broke out, Big Daddy sent little Lonnie to dig for worms in the dirt.

With his knees and hands buried deep in soil, Holley could see the towering screen of the drive-in theater that was separated from his yard only by a drainage ditch. Holley was entranced by the images that flickered while he groped for crawlers. After a year of digging worms, at age five, Holley sloshed through a sewer pipe to discover the other side of the ditch. Thus began Holley's career of trash picking for the theater manager who paid the boy a pittance to clean up the parking lot after the films. Lonnie Holley claims that he saw nearly every movie released from the years 1955 to 1957: from *Abbott and Costello Meet the Keystone Kops* and *Godzilla* to *The 10 Commandments* and *Twelve Angry Men*. What he didn't see while picking up theater garbage, he watched from home, perched atop the McElroys' roof to see the big screen. Holley counts his drive-in viewing as his primary source of education.

One morning in 1957, with Big Mama once again incapacitated, Big Daddy took Holley aside and said, "Every morning before you go to school, you leave her something to eat and put some water by the bed." Then Big Daddy left and didn't come back.

The boy dutifully carried out his orders, but Big Mama needed more. While her husband was gone, Mrs. McElroy had lost control of her bladder and bowels, and her bed was heavily soiled. Holley, at age seven, did not know how to clean her. After three weeks, Big Daddy finally returned, smelling of whiskey.

"How she doing?" he asked Holley.

"I don't know," replied Holley. "Last three days, she be the same. Just lying back in bed with her arms out and her mouth open. I sit up there talkin' to her, but she don't have nothing to say."

Bolting past Holley, Big Daddy ran into the bedroom where he stayed for an interminable while. He came out with a glazed look in his eyes, brandishing an iron fireplace poker, and headed straight for Holley.

"You killed her. You KILLED her. YOU KILLED HER!" he screamed as he beat on the boy.

"Get the fuck out!"

Holley pulled himself from the floor, shuffled out the front door, and was nearly down the porch steps when Big Daddy called again.

"You damn little motherfucker! Get your sorry ass back in here!" Holley went back inside, and the man beat him again.

Afterwards Big Daddy started the record player and mounted a vinyl disk that his wife cherished. "Swing Low, Sweet Chariot" emanated from the box, repeating itself at full volume. Song ends, tone arm back, needle down, replay. Song ends, tone arm back, needle down, replay. And again. Lonnie squatted outside, listening, shivering.

Neighbors began to approach the house. Ms. Claudia, proud and pretty, lived next door. She marched up to Holley and knelt down next to him.

"What's wrong?" she asked, and after hearing what happened, she told Holley, "She not your real mama anyway.

"I know you all along. Your real mama got so many children. And she live near the Birmingham Airport, across town."

Holley stared off into no place, eyes wide, looking into the past and the future. He saw a *real* mother there. At that moment, Holley made it his mission to find his real mother and escape the McElroy house for good.

In the meanwhile Big Daddy took his vengeance out on Holley through beatings and constant work demands.

"Find worms. Clean the drive-in. Clean the yard. Clean the house. Fetch wood."

With his little red wagon trailing behind him and loaded with worms or twigs or empty popcorn boxes, Holley was quiet and careful to obey. After a particularly brutal lashing left him in tears and blood, he grabbed his wagon and deciding to break free. He ran into the street and into the path of an oncoming car. It struck him squarely and pulled him nearly two and a half blocks before coming to a halt. Holley was unconscious for almost four months. Hospitalized. When he finally awoke, Holley was immediately released back into Big Daddy's clutches.

For a while after Holley's return, Big Daddy softened his attacks but not because of the boy's injuries. Rather, a new woman had entered Big Daddy's life, and he didn't have to walk far to find her. Ms. Claudia had moved in, though not for long. Two years later, when she caught Big Daddy with another woman, Ms. Claudia stomped out the door, and the beatings began again for Holley. After a particularly savage beating with an ironing cord, Holley knew it was time for him to go too. He says, "I had blisters all over me, bloody blisters, that next morning. I said I wasn't going to take no more whippings, and I meant I wasn't going to take no more whippings. So I left." He packed a satchel with meager belongings, and wandered east to seek out his real mother.

Miles later, when he reached the enormous beige Byzantine building with red roof, domes, spires, and gables, he didn't know that he stood at Terminal Station, less than five miles from his mother's house. Tired and cold, he helped himself to two quilts from a nearby clothesline, climbed atop an idling train, and snuggled between the rooftop pipes. Holley nestled in the warmth from the diesel car's exhaust and was lulled to sleep by the engine's steady rumble.

He opened his eyes as the train crossed a large body of water from which the morning sun seemed to rise. The pulsing locomotive pulled into a station and stopped. Holley, still on top of the train, watched

carefully for a chance to sneak from his perch while workmen tended the car. He climbed down without a sound and softly turned to find a mechanic staring at him, eyes stretched as big as his mouth.

"Holy Jesus! Voodoo!" the man hollered and attracted a woman nearby.

"Voodoo!" they screamed, pointing at Holley. "What the hell is you?"

Unbeknownst to Holley, his rooftop ride left him covered in soot and still wrapped in his crud-encrusted quilts. The only things not filthy were his teeth and the whites of his eyes. Lonnie Holley looked like an ebony cinder phantom.

"I'm a boy. I'm a boy," Holley cried and tore off the quilts to reveal his clothes and skin.

"Where you come from, boy?" the man asked, who a moment before thought him an evil spirit.

"Lomb Avenue, over by the Fairgrounds, from the other side of town," said Holley.

"I don't know nothing about no Lomb Avenue," the man replied.

"What you live by?" the woman tried.

Holley repeated that he lived next to the Fairground, out there by Constantine's Restaurant and B&B Barbecue.

"You know the address?" she said.

"Lomb Avenue," said Holley. "Birmingham, Alabama."

"Damn, this ain't no Birmingham," the man said.

Holley was unaware that he had left the state of Alabama, had crossed Mississippi's delta, watched the sunrise in Lake Pontchartrain, and now stood in the Union Terminal of New Orleans, Louisiana—a magic city of another sort.

"He a runaway child. I know where he need to go," said the woman. "We'll take him to Uncle's house."

To a nine-year-old child with nothing, Uncle had everything. He had money and endless ways to earn it. Uncle peddled vegetables, pots, pans, brooms, and mops that dangled from a mule-drawn wagon he guided through New Orleans streets. Uncle had something

else, too, that Holley had never seen before. Uncle had respect. Admired for his willingness to take in runaways and his ability to straighten them out, Uncle ran his house with a firm but gentle hand.

"The kind of spirit I got from that man was before it rot, give it away," Holley says. "He had so much and he gave a lot of it away or made it cost so little that it was almost like giving it away,"

Trolling the streets one morning near the French Quarter with Holley at his side, Uncle stepped off the cart to attend to business, gave Holley his trust, and handed him the horse's reigns. Like Uncle, his horse was regal, disciplined. It stepped slowly down the streets, head erect as if it were carrying a king. But Holley, sitting atop the wagon, peering over the road with reins in his hand, didn't think about royal processions. He didn't think about Uncle or the old man's livelihood that was held in the back of the cart. Holley only thought one thing: *How fast can this horse go?*

Holley cracked the reins and suddenly the horse was off—a rocket over the cobblestones as pots and pans clattered, tomatoes rolled, heads of lettuce flew, and eggs burst like white grenades. It was a galloping gift horse run amuck, and people grabbed what they could from this peddler cart free-for-all.

After that, Uncle said nothing to Holley. He simply walked up to a police officer and told him to take the boy away.

Down at the Juvenile Center, the officers gleaned enough information from Holley to track him to Mr. McElroy.

"Then," says Holley, "they put a tag on me, put me on the bus, and sent me back to Birmingham." Straight back to Big Daddy.

On Lomb Avenue again, Holley immediately plotted his next escape, but it didn't come until he turned ten. Then, slipping out of his window, he made it to downtown Birmingham one night, climbed onto the roof of a grocery store and slid through its ventilation system. Inside the store, Holley grabbed a crumbling handful of cookies and bread for rations and made a break for the rear exit. Holley got out undetected, but set off the security system as he went.

Police quickly responded to the alarm and tracked the boy down. They found him in the streets outside of the store. The cops took him to Birmingham's Juvenile Center and shut Holley in with a group of tough boys. He wasn't locked up for long. One of the tough boys pushed a quarter out of the cell, and it rolled to a janitor who was mopping the floor. The janitor kindly picked up the quarter and walked to the cell to return the money, and when he opened the cell door, the boys knocked the old man down. They bound him, gagged him, and locked him up in the cell. With car key in hand and Holley in tow, they clamored into the janitor's car, started the engine, drove two blocks, and slammed into a telephone pole.

"Police came and brought us all right back," says Holley. "Next morning we didn't see no judge. They just loaded us up in the patrol cars and took us away."

The police drove Holley and his new friends two hours south to Mount Meigs, Alabama—twelve miles outside of Montgomery—to a place that had sometimes been called the Reform School for Juvenile Lawbreakers and sometimes the Alabama Industrial School for Negro Children, but which the inmates simply referred to as Mount Meigs. Holley's new home was a one-level concrete barracks with barred windows in the middle of twenty-four hundred bleak acres. Founded in 1907 by Mrs. Booker T. Washington's State Federation of Colored Women's Club's Executive Board, on which Mrs. Washington governed as president and vice president at large, Mount Meigs claimed her husband as its North Star.

"We follow the educational philosophy of Booker T. Washington," wrote the institution's superintendent in a 1945 Mount Meigs annual report. "25% of juvenile delinquents committed to this institution came here as a result of laziness and loitering. We are not only training these children to do effective work with their hands, we are trying to inculcate in them a spirit of work no matter how meager the job may be." And the five hundred boys confined to Mount Meigs, no matter how meager the job, worked like they never had in their lives.

In the early 1960s, when Lonnie Holley was in residence, the boys of Mount Meigs harvested eight hundred acres of corn, wheat, oats, peas, sugar cane, pecans, pears, apples, and potatoes, and two hundred acres of cotton. They tended one hundred hogs, seventy-five sheep, thirty-five cows, twenty-seven horses and mules, ten turkeys, two bulls, and enough chickens to send Thornton Dial into a tailspin. They learned woodwork, auto repair, electricity, maintenance, plumbing, quantity cooking, and shoe repair. Such work was meant not just as punishment but as training for the "real" world, should they ever see that again some day. An elect few of the inmates even had supervisory positions. Known as "charge boys" they were given authority to impose order whenever and however they saw fit. When it came to imposing discipline, the charge boys mirrored the staff—staff like Miss Sally in the kitchen, who favored slapping disobedient children across the face with the flat side of her butcher's knife, or Mr. Reddy, who preferred the fan belt from a rusted tractor.

Reddy guarded the dining room with the fan belt in one hand and a cedar stick in the other. Any child whose spoon hit the iron plate before he said "off table" would receive three swift fan-belt blows to the head. Then Reddy would swing with the stick, busting open the welts left on the offender's skull. Anyone with the audacity to visit the nurse after such an episode had their bandages beaten back off upon their return.

Mr. Glover, another staff member and an oaf of a man who had been transferred from an adult prison, kept watch over the children while they worked outside. He favored touring new inmates around the unmarked children's cemetery known as Horseshoe Bend. "This could be you," Glover would say, pointing to an overgrown weed patch from which a random set of dilapidated stone tablets peeked through the scrub. Holley was certain he would end up in that graveyard if he stayed at Mount Meigs much longer, so Holley decided to go.

"The way I did it, it was in February," says Holley. "We were pulling corn stalks, and you had to pull the corn stalks and lay them

down. You had two rows to work. So you're laying the corn stalks down and then you had another crew of boys that come behind you picking them up. That day I was on the pickup, putting corn on the mule and the wagon, so I told Mr. Glover, I said, 'Mr. Glover, I need to do number two,' that's goin' to the bathroom. So I get down there in the gulley and dig myself a hole and then squat and do my number in the hole."

Holley stepped far back in the field and turned to see the two lines of boys and Glover moving steadily in the other direction, growing more distant with each step. They seemed to have forgotten that Holley was there. So he squatted until the crew got so far up the field that he could only see the dust rising as they worked. Then, pants still around his ankles, Holley scooted backwards through the field. For nearly a half mile he backed up like a crab in retreat. Then he stood, pulled up his trousers, turned and sprinted until he pushed himself beneath and beyond the fence line. Then he ran. He ran through thick brush and briars scratching his body. He ran as his chest ached and his legs cramped. He ran until dark and exhaustion took over. He ran until he fell into a hole filled with leaves and slept in the sunken earth with his jacket over his head. Holley awoke the next morning, pulled himself up by a tree root, and realized he had crashed in an open grave.

From Mount Meigs, Holley hiked the twenty-five miles to Tuskegee where he spotted a farm equipment shop with a stocked kitchen visible from the back door. Using a brick to knock out the door's glass, Holley entered and made a beeline for the refrigerator. He grabbed a package of saltines, a can of sardines, and a few slices of cheese from the shelf and had a feast. Stuffed and weary, Holley rested his head on the kitchen table and dozed off.

"The next thing I knowed," says Holley, "somebody was slapping me in the face saying, 'Come on darling, darling.' So I looked up." It was Mr. E. B. Holloway, the superintendent of Mount Meigs. "He had some charge boys around me," continues Holley, "and he was

asking me, 'Darling, why did you run away?' Before I could say anything, he took his fist and knocked me out."

Back at Mount Meigs, Holley was strapped to a makeshift wooden bench bolted to the base of a majestic cedar tree. He was laid face down, arms secured to the front leg of the bench and legs tied to the back. The entire student body was lined up to watch an example being made. Since Holley had run away from Mr. Glover's watch, Glover had the privilege of inflicting the punishment.

"He took a stick out," says Holley. "It was a white oak stick, and he had soaked it down in the tractor oil, which make a piece of white oak almost like rubber."

Superintendent Holloway instructed Glover to lash Holley 150 times. The jailer began by striking Holley's upper buttocks down to his thighs and then on to the calves of his legs. He beat the crook behind Holley's knees so hard that nearly forty years later Holley's legs still occasionally lock. As Glover swung the oil-soaked oak, Holley's thighs swelled and then burst open. Mercifully, Glover clubbed Holley in the back of the head so that he was unconscious for the remaining 50 licks. When done, they dragged Holley's body up to the main building and cut off his blood-soaked clothes with sewing sheers.

Prisoners at Mount Meigs were allowed occasional visitors. One inmate and his visiting family noticed that no one ever came to see Holley. After talking with Holley, they revealed that they lived in Birmingham near Holley's mother, Dorothy Mae. They took word of the boy back to the Holley family, and when Lonnie Holley was released from Mount Meigs at age fourteen, it was into the custody of his natural grandmother.

Holley says his grandmother's name was Ixie Canady, but he called her "Momo." Grandma Momo, together with Holley's one-legged Uncle Jesse, earned the family's meager living at the city dump up the hill from their home near the Birmingham Airport. Each morning before the dump officially opened, they ascended the

mounds of debris carrying long rake-ended poles, like Moses mounting Sinai. They plunged their sticks deep into the rubbish pits and drug out all of the aluminum, copper, and tin they could pick. They rolled their findings into metal balls, deposited them in sacks, and hauled it all back down the hill to be sold as scrap metal.

Lonnie Holley had a different idea. He aimed to save the trash from death by scrap machine. On his first attempt, he twisted a baleful of aluminum wire into an enormous metal butterfly. Momo was impressed, and she displayed the creature in the front room of her home for everyone to see. She told Holley that of all her grandchildren, he was the only one who had the talent to make something so beautiful. He was the only one who could make art, she said. After that, Holley scoured the leftovers from his Grandma Momo and Uncle Jesse's salvage missions. In Holley's gentle grasp, the copper wire torn from an old electric motor became hair. Hair flowed into a face and body. The pieces he made were miniature tributes to his mother, grandmamma, and uncle. Mostly, Holley kept them to himself.

Momo made sure that Holley went to school upon his return from Mount Meigs, but having lived an unbounded life to that point, he couldn't stand "confinement." Before a year passed, Lonnie Holley left Momo's with one of his brothers and headed to Florida, where they both took groundskeeper jobs at an Orlando country club. Later, with past experience under his belt from the Mount Meigs kitchen, Lonnie moved indoors as a dishwasher and then traded up to cook. Holley left the country club and cooked at a variety of Orlando's lesser restaurants, later scoring a spaghetti chef's gig at Disney World after its opening in 1971. Along the way, Holley discovered something he enjoyed as much as he did art and cooking: making love. Lonnie's first girlfriend was pregnant before he turned fifteen. By the time Holley found his way back to Birmingham just before his twenty-fifth birthday, he had fathered ten children, and never married any of the mothers.

When Holley returned to his home in the Airport Heights section of Birmingham in the mid-1970s, he finally got reacquainted with his

own mother. He stayed with her, moving onto property that had been bought by his grandfather, Willie Holley—a house built by the old man out of scrap and the materials he could buy on his World War I veteran's pension. It was no Disney World. "My mama and them were still living in the 1800s, with slop jars and outdoor bathrooms and no running water and pigs in the house, and chickens and things in the backyard and ducks and things roosting in the house," Holley recalls.

Holley found himself suddenly as the primary breadwinner for the family. His occupation was self-styled, though. "If I didn't have the money, I would go behind the stores and get the very best they was going to throw away, just taking my broom and my mop and water bucket and doing a little bit of volunteer cleaning up. So, for me, life was not hard, and I wanted to make others realize that life wasn't hard if we didn't want it to be. But that was the hardest thing to do, making them understand," he says. Realizing he couldn't mop up everything around him, Holley slipped into a grinding depression. "It was so much, because I had so many people that I was trying to think about, until one day it just all blew up." He drank too much wine, smoked too much pot, and crashed another car into another phone pole.

The crash snapped him out of the doldrums long enough for him to land a job flipping pancakes at a breakfast joint and long enough for him to court and marry a fellow foster home refugee, Carolyn Rose Babcock. "I saw her easily being turned into a street person in the wrong hands, 'cause she was beautiful," Holley remembers. "And it was just—I just loved her."

Holley's respite from the edge didn't last long. Within the year, a fire ravaged the home of one of Holley's sisters, taking the life of her two children. Distraught and near broke, Holley scavenged the grounds of a nearby pipe manufacturing plant for remnants to sell while he considered ways to kill himself.

The industrial property was littered with broken sand cores, molds made of compacted sand, clay, and water that once held

molten iron. Noticing that the shattered sand core pieces were soft enough to scrape with a sharp blade, Holley snatched several blocks and carved two child-size tombstones for his grieving sister.

As he carved Holley's funk lifted slightly, and he convinced himself that a market existed for low-cost tombstones for poor families. So he toted his sand sculptures to Poole Funeral Chapel, AG Gaston's Funeral Parlor, and any others he could find. They told him his materials wouldn't withstand the elements and sent him away. Undaunted, he began to shape the stone into the images of black leaders of Birmingham, and he gave them away to those he met. The works were richly sculpted with details of the city and of the lives of the men that he scratched in sand. Meanwhile, Holley continued assembling art from the refuse his family picked from the dump. As his yard filled with his artwork, he displayed some on the roadside, hoping passersby would notice and buy. None did, and his yard art display soon became a forest.

During this time, Holley befriended many of his older neighbors. They were infirm and feeble among increasingly hostile surroundings, and Holley looked out for them. He brought them wood. He brought them coal. He brought them groceries.

"Ms. Sara Kelly was supposed to been the bad lady of the neighborhood," says Holley. "Everybody picked at her 'cause she so old. Sometime she would pee and it would run down her leg. I went and got wood and stuff for her. She treated me nice."

One day over a glass of sweet tea, Ms. Kelly spied Holley's artwork on the side of the road and sensed that he was close to tears. With a bony finger she leaned close to him, tapped him on the cheek twice, and said, "Lonnie, you need to stop waiting on town to come to you and take your works to town."

So he did. He took them to *high* town. The next day Holley carted a load of his assemblages and sandstones to the back door of the Birmingham Museum of Art and told the security guard that he wanted to see the head man. Shortly Richard Murrey, the museum

director, appeared. He examined Holley curiously and stepped past him to look at the art that lay beside the door.

Murray was instantly moved. He sent several photographs of Holley's work to the Smithsonian Museum of American Art, which was mounting a show called *More Than Land and Sky: Art from Appalachia*. Two of Holley's pieces, *Baby Being Born* and *Time*, were accepted for the 1981 traveling exhibition.

"Now the piece called *Baby Being Born*, my wife had my son Ezekiel in her womb," Holley explains. "She went to a place where they take an X-ray of her stomach and you see what was in it. I was fascinated with technology, being able to see what was alive in a person. I was trying to honor technology and honor human life at the same time. Children come out of the womb and grow and crawl and begin to walk and then begin to stand up tall."

The Smithsonian exhibition was also Holley's birth, his introduction to the art world. He traveled for the first time to Washington, D.C., for the show's opening and spent much of his time touring the museums on the mall, absorbing everything he saw. The show, Lonnie proudly reminds, traveled "to the thirteen original colonies of the United States of America, sixty-four cities, and everybody through all of those museums and galleries had learned about me." He was no longer just a garbage picker. He was Lonnie Bradley Holley, African American artist.

Chapter 3

BIG MAN

BILL ARNETT IS A VORACIOUS COLLECTOR. HE COLLECTS ART AND enemies. He contemplates his combatants with the same ferocity that he cogitates his gargantuan art hoard. He effortlessly scrawls a list of names on a dog-eared yellow pad. At the top it reads, "Enemies List," with an asterisk next to it. At the bottom, Arnett explains the notation: "Please keep in mind, I AM NOT A CROOK."

Arnett believes he is a wronged man, falsely accused. He sees himself as the embodiment of Jonathan Swift's prophesy: "When a true genius appears in the world, you may know him by this sign, that the dunces are all in a confederacy against him." The dunces, in Arnett's case, include art museum directors, wealthy connoisseurs of culture, Fortune 500 CEOs, university presidents, and even a former president of the United States of America. But he can handle their attacks on his credibility, he says unconvincingly. "It's Thornton Dial they really fear," Arnett says, "and all the other potential Thornton Dials they fear," and therein lay the stuff of tragedy.

It is possible the alleged conspiratorial attacks on Bill Arnett's good name have taken a toll on his health. In recent years he has often been too ill to leave the confines of his home. Seated in his den, nestled in a beige corduroy recliner, Arnett spends long stretches

recovering from various surgeries. "Over the last nine months," says Arnett, "I've spent at least 60 percent of my life sitting in this chair. I love this chair. It was bought for five dollars at a flea market."

Bill Arnett works in his chair, takes his meals there, sleeps in it. But mostly he passes what he worries may be his last remaining moments watching an endless string of TV and films.

Arnett favors HBO, especially the cable channel's quirky comedies like *Da Ali G Show* and *Curb Your Enthusiasm*. He is not above network TV or movies either. If he could choose a movie to represent his life he might pick the 1988 film *Tucker: The Man and His Dreams*. The movie is a true story of visionary automobile entrepreneur Preston Tucker and his grand scheme to build the best cars ever made. In the film, powerful and wealthy enemies view Tucker as a threat to the auto industry status quo and plot to bring him down, publicly accusing the car pioneer of fraud. To Arnett, the maverick, Tucker was a hero, not a crook. Tucker was the champion of the pure, generative, beautiful, creative force that changes everything—the way Arnett sees himself.

"People say to me all the time, 'Bill, you're a visionary,'" Arnett scoffs. "I mean, I hear that so much I'm sick of it. 'You're a visionary. You see all of this. You understand way more than anybody in the art world about what is and what's going to be and what's important.' You know I hear that every fucking day of my life. You think I want to hear it? I don't give a damn. I know I'm a visionary, whatever the fuck a visionary is. What the fuck's a visionary?" Arnett looks you in the eye and, pointing to himself, challenges, "You got to decide, 'Is this a guy who's just pumping up his own net worth, or is this a guy who really believes in something and wants the world to know about it?'"

The maiden's hands are bound with a blue silk sash, tied tightly behind her and to a massive tree. Her fleshy alabaster shoulders,

exposed bosom, and delicate neck offer themselves to the viewer. She casts a terrified but hopeful glance behind her and sees her hero, a knight in armor. He stands virile and righteous, ready to plunge his sword into the lecherous villain sprawled beneath his boot. The nobility of the knight's cause is clear, the outcome assured as a divine sunrise illuminates him from a distance. Sir Francis Bernard Dicksee completed this romantic image—the oil painting, *Chivalry*—in 1885.

"Oh, shit," Arnett recalls. "That's the first painting I ever bought. I bought it at an antique place in London. Off Portobello Road. I think I paid a few hundred dollars for it, but I'm not sure." Forty years after Arnett purchased it, in 2003, *Chivalry* sold at Christie's Auction House in London for over $550,000. Such was Bill Arnett's natural eye for art.

Some art connoisseurs come with regal pedigrees steeped in classical scholarship. Take, for instance, Thomas Hoving, former director of the Metropolitan Museum of Art. With a Ph.D. from Princeton in art history and having run what is arguably the world's most prestigious museum, Hoving is an art world heavyweight. Or consider the pioneering gallery owner Betty Parsons, who studied art for eleven years at an academy in Paris, where she hobnobbed with famed artists the likes of Man Ray, Calder, Brancusi, and Giacometti.

On the other hand, some achieved aficionado status rising from coarser beginnings. Legendary art dealer Leo Castelli was once a lawyer working at an insurance firm. The famed Sidney Janis owned a shirt company before starting his gallery.

Bill Arnett came from neither extreme; neither business success nor art scholarship prefaced his art world career. Arnett relied simply on his built-in instinct for what he believed to be great art.

Born William Arenowitch, Bill Arnett was raised in 1930s Columbus, Georgia, in a family that blended old world and old South. His father's father, Isaac Arenowitch, had fled Lithuania in 1922, escaping the intensifying anti-Semitic mood of Eastern Europe. "My grandfather came to the country with the proverbial

bag full of nothing," says Arnett. Isaac Arenowitch found fortune in a Columbus-based wholesale dry goods business. Mr. I.A., as he was known, was warm, even-keeled, and liked by both the Gentile and Jewish communities—an important symbol of American success for a boy who hailed from the European Jewish ghettos known as shtetls.

Bill Arnett's maternal grandfather, Sidney Arthur Moses—or "Sam" as he was known—was a sixth-generation American. Sam Moses was born in Terrill, Texas, but migrated north to Birmingham, Alabama. The Moses clan had deep southern roots, and many family members fought in the Civil War for the Confederate side. The book *Jewish Confederates* lists at least twenty Moses family members in its index, more than any other single Jewish family surname.

Sam's business dealings are remembered differently by his surviving family, as are the circumstances of his death. He was either a movie theatre owner or an insurance man or both. Before the 1929 stock market crash, it is generally agreed, Sidney Arthur Moses was a wealthy man. It is generally agreed that he lost a fortune in the Depression. While the family generally agrees that his death was a suicide, there are those who believe that Sam died from an overdose of pills and others who believe that he climbed to the tallest building in Birmingham and jumped.

Sam's oldest daughter, Minna Moses, was born in 1908 while Sam Moses was still flush with cash. She was a fetching girl, the pride of the Ballyhoo cotillion for the South's Jewish elite. Minna caught the eye of Hilliard "Billy" Arenowitch—Mr. I.A.'s son. Billy courted Minna aggressively, won her hand, and convinced her to settle with him in Columbus. Soon after, they had two sons, William and Robert. People in Columbus thought of Hilliard as their own father: a smart, gentle, warm, and prosperous man who once had been a star baseball player at the University of Georgia in the 1920s and who now coached their children's baseball teams. Minna, on the other hand, brought mixed reviews. Many friends and relatives remember her as a generous and handsome woman with a great deal of energy

and charm, but some remember a different side. "My mother was from a family that had lost its money. She didn't grow up with a lot of things, and so she was sort of scrappy and aggressive," Bill Arnett recalls. One grandson remembers her as "stern and inflexible with coal-black eyes that could burn a hole through you."

Like many Southerners at the time, Minna Arenowitch was not particularly open-minded when it came to issues of race. "My mother was a bigot," Arnett says. Back in Bill Arnett's youth, there were black women who traveled door-to-door selling produce with boxes of goods balanced on their heads. One day young Bill answered the door and told his mother, "There's a black lady at the door," to which Minna replied, "There is no such thing as a black *lady*. Call her a black woman if you must, but nothing more." The Arenowitch's black maid, Flora, however, had enough lady in her to essentially raise Billy Arenowitch and his brother, Bob.

Arnett's Columbus was a scene out of a Norman Rockwell painting: malt shops and apple pie; obedient housewives and bubbly cheerleaders. "It was like, what's the black-and-white movie that the people suddenly turn to color in? You know, a Reese Witherspoon movie. *Pleasantville*, maybe. I grew up in Pleasantville," Arnett remembers. It was, for white folks at least, idyllic.

In this picturesque setting, Billy Arenowitch was an all-American kid. He excelled academically without much effort, leaving him plenty of time for extracurricular activities. At Columbus High School, Arenowitch participated in the Reserve Officers Training Corp (R.O.T.C.), Student Council, and Key Club and he played varsity baseball and basketball all four years at the school. He had a girl, too: Judy Mitchell, a pretty Methodist sweetheart whom he courted over soda pops at the Jacobs Pharmacy downtown.

Billy Arenowitch's intensity was palpable. He had a fierce competitive spirit, a drive to win, a focus to excel. He was the fastest runner in his class. He could bat .400 consistently with baseball skills that would ultimately earn him a college scholarship. Arenowitch's per-

sonal drive manifested itself throughout his early life. He was obsessed with collecting. First it was marbles, an enormous set meticulously sorted by color and size. Then Topps baseball cards; Billy Arenowitch knew all the ballplayers' statistics. Then stamps; he filled books with them. He had complete sets of Marvel comics and *Mad* magazines. For a while, he collected matchbooks, memorabilia from family visits to assorted restaurants. Then rocks and minerals. Then butterflies. Then college pennants. He joined several record clubs and compiled a respectable jazz collection. Then he got interested in classical music and joined several different classical record clubs. He researched the music extensively and acquired hundreds of LPs. During high school, his taste turned to rock and roll. Hilliard and Minna believed jazz and rock were "Negro" music, and they forbade him from listening to it. Billy Arenowitch crept across town, over the railroad tracks, to the taboo black record stores of Columbus so he could secretly stockpile Fats Domino and Chuck Berry 45s.

Despite his clean-cut image, Arenowitch cultivated a small-town sense of teen rebellion. A southern James Dean with a Bob Hope sense of humor, he once came to ROTC class wearing a pink shirt and pink tie. Billy Arenowitch was opinionated, with a blunt, bombastic approach. "He never had any respect for authority purely for the sake of authority or tradition. It had to prove itself worthy," says one of Arenowitch's high school pals. And there were those who would simply describe Arenowitch's demeanor as having a "facility to make people mad." However, Billy Arenowitch viewed himself in a more august light. Under his 1957 high school yearbook photograph he penned his favorite quote from a Tennyson poem about King Arthur to describe himself, "For bold in heart and act and word was he." To Billy Arenowitch, he was no less than the second coming of King Arthur.

Tennyson had it right: Bold and kingly acts require words of the same nature. One word Billy wasn't very happy about was his last name: Arenowitch. Hardly regal. Much too Jewish. Too old country.

A shtetl name. "Arnett" sounded better, more American. Years later, people would whisper that Arnett changed his name because the Mafia was either after him or had bought him. But he was not escaping organized crime, just his ethnic identity, which was much tougher to shake than the Mob.

After high school, Bill Arnett bounced from college to college, marching to his own beat, from engineering major at Georgia Tech on baseball scholarship to accounting major at the Wharton School in Philadelphia, and finally graduating from the University of Georgia. Through his travels one thing remained constant: Arnett was fascinated with black culture and black music, especially jazz. When in Atlanta he often went alone to listen to jazz and blues at the renowned Royal Peacock. Arnett's was usually the only white face in the crowd.

During Arnett's senior year at the University of Georgia, he developed a serious case of wanderlust. He started scraping together money to travel: three thousand dollars from his grandmother, one thousand dollars in card-game winnings, and savings from his sporadic employment. With a five-thousand-dollar grubstake, he went on a five-month postgraduation overseas jaunt. And it was then, Bill says, while traveling Europe for the first time, "I *really* got hooked on art."

When Arnett returned to Georgia, it was with the sole intention of getting a job that could take him back to Europe. He landed a sales role with Bainbridge, Georgia–based Miller-Hydro Company, which manufactured bottle washing equipment. "I didn't give a shit about the company," he says. Miller-Hydro sent their loyal servant back to London to grow their business across the United Kingdom and continental Europe. Between sporadic business meetings, Bill Arnett museum- and cathedral-hopped across the glorious art history of France, Italy, Germany, and Spain. He wanted to be in the presence of grandeur all the time.

In a sense art became Arnett's religion—the ordinary lifted to the spiritual through aesthetic grace. "I believe that art is easily the most

important single contribution that man makes to the planet that separates him from other things. I love art. I love *great* art. I love the *great art of history*, no matter what continent it comes from or what century. If they find a new continent, an undiscovered world out there that had art, I'd want to be the first one to get in there and look at it. Not to own it. Not to buy it. Not to corner the market. Not to enhance my own fucking net worth. I think the things that can be viewed and judged by aesthetic terms are what make this world interesting. That's all I go to see in the world. I mean I don't make long trips to see a mountain. I don't make long trips to see a forest. I don't make long trips to see the seacoast. I make trips to see old towns, specific buildings, specific paintings or churches. I love cathedrals. I could stay busy for many lifetimes traveling around to them and I know where all of them are, and I've been to most of them and I can go back anytime," Arnett says.

While Arnett embraced the culture of Europe, the civil rights movement back home battled hatred. As Arnett chased through the rambling French countryside, future Georgia governor Lester Maddox chased nonviolent Negro protestors from his restaurant with a pickaxe and gun. While Arnett was sipping espresso in Italy, Martin Luther King was thrown in jail for attempting to sip coffee in downtown Atlanta at the whites-only restaurant in Rich's department store. And while Bill Arnett coveted the relics in the British Museum, the Atlanta arts community struggled to gain even modest support.

Atlanta's business elite could make no clear connection between art and commerce. The city's arts activities received little attention or funding from the town's boosters. In 1917, the writer H. L. Mencken described the American South as a cultural desert: the "Sahara of the Bozart." He singled out Georgia in particular as being "perhaps the worst" of the southern states. "There is no gallery of pictures. No artist ever gives exhibitions. No one talks of such things. No one seems to be interested in such things," Mencken sniped. And as his ultimate affront to the cracker South, Mencken proclaimed that the

"negros of the South" held the only hope for southern culture. "The only visible aesthetic activity in the south is wholly in their hands." While Mencken's words bruised the egos of Atlanta's boosters, the city's most influential business leaders did little to change their views on the arts. The "Big Mules"—as one *Fortune* magazine writer called these captains of southern industry in a 1961 profile of the town—left the art world to their wives.

The Mules indeed abdicated cultural stewardship to their "better halves." In 1905 a group of wealthy local women formed the Atlanta Art Association. They dabbled in the fine arts until 1926 when Hattie High, a wealthy local dowager, transferred title of her Peachtree Street mansion to the Art Association in order to host a museum. Even with a grand building for their museum, the Association sputtered lamely through the mid-1950s, until another home nearby was bequeathed to the Art Association's collection of properties that constituted the High Museum of Art. The newly donated home came with a carriage house that the Association's Women's Committee turned into a tea-room, gallery, and gift shop. It was called the Coach House, and the grande dames who ran it became known in the community as the "Coach House Ladies." The Ladies' restaurant project was a smash hit among society matrons. One society writer described the Coach House dining experience as "an introduction to Atlanta Society . . . operated by the local nobility." If the Coach House Ladies wielded tremendous influence on Atlanta's social register, they held even stronger sway over the Atlanta Art Association. When, in March 1962, a civic study of the Atlanta Art Association characterized the High as facing "disastrous disorganization which can no longer be tolerated," the Ladies decided that something must be done. The trustees voted to adopt all of the civic study's proposed improvements, but the group's leadership would not be around to implement the changes.

The Atlanta Art Association's leadership had arranged a tour of European art treasures in order to raise cultural sensibilities among Atlantans and to bring in some money for the High Museum, and

also just because it would be a lot of fun. On May 9, 1962, Art Association trustees, Coach House Ladies, local artists, art patrons, and other prominent Atlantans took off from Atlanta bound for Paris. Several weeks after gallivanting through the cultural icons of Europe, 106 of the travelers boarded an Air France jet in Paris' Orly Airport for their return flight to Atlanta. Just past noon, the plane taxied down the runway gathering speed for ascent. Careening along the tarmac at nearly 180 miles per hour the jet bounced briefly off the ground before it plowed through an airport fence and into a series of concrete poles. The Boeing 707 skidded, toppled, and exploded in flames, consuming all the Atlantans and incinerating the backbone of Atlanta's arts community.

In the wake of the Orly disaster, Robert Woodruff, CEO of the Coca-Cola company and the most powerful man in Atlanta, donated funds that enabled the creation of a significant arts center for Georgia's capital. The High Museum of Art was a core part of what became the Woodruff Arts Center. In 1963 the High board convinced a young Norwegian named Gudmund Vigtel, who had studied at Piedmont College and the Atlanta Art Institute, to leave his post as assistant director of the Corcoran Gallery in Washington, D.C., to come back to Atlanta and lead the High.

It took tragic flames to wake the somnolent Atlanta arts scene, but it still had a long way to go before it rose from the Sahara. Atlanta needed art champions. It needed pioneers to lift it to higher levels of cultural awareness. What it got was Bill Arnett.

With not much more than an unshakeable aesthetic confidence and an art education garnered while poking around Europe, Bill Arnett moved back to Atlanta, married his high school sweetheart Judy Mitchell, and in 1965 opened an art gallery with an acquaintance he met through a mutual chum. Arnett's first gallery, West 11th, was located on Peachtree Street just south of the regal Peachtree Battle Avenue, and named after the antique district in London near Portobello Road.

Arnett's memories of his first business partner are not fond ones. "Piece of shit," he says. "He didn't do anything much. He had another income doing real estate, so he continued his real estate business while I did art. We weren't profitable. He was just basically using the business to furnish his houses and collect stuff for himself." Arnett continues, "He also became very jealous of me because people would come in there and want to talk to me and not to him. I mean who would you rather talk to? Somebody that knows about stuff or somebody that doesn't? He was a good schmoozer, but he wasn't really an art person." After six months West 11th dissolved. The associates split what remained of the inventory, and Bill's partner walked away with the painting *Chivalry* in hand.

In 1967, Bill moved his business dealings further north on Peachtree Street—near what are now Atlanta's ritziest shopping centers, Phipps Plaza and Lenox Mall—in a new gallery called Magellan.

"Some people in Atlanta came to see me and said they wanted to start an art business," Arnett says. "They were an unusual bunch. Nice guys but politically sort of right wing. John Birch Society members. These guys, they had something else going on. I don't know what. They wanted me to be the manager of it and travel and buy art for them. They got some money together. I put in some of mine. And I made a trip around the world. I couldn't have brought more than about $10,000 on the trip. I bought all kinds of stuff that in those days was probably worth $150,000." Buy low, sell high—that was the game. "Came back and opened a gallery, and it was very nice. We opened a nice place," Arnett asserts.

Magellan featured high-end, unique pieces from Europe, Asia, and Africa. It was an exquisite house, full of paintings, porcelain, pottery, and sculpted wood. It housed artwork that was great, perhaps, but beyond the tastes of the late 1960s art market in Atlanta.

Today, Bill Arnett speaks only in vague terms about what happened to Magellan. "I left there because they fired me and kept everything. I got nothing. I mean I left with zero. They just totally took

my stuff 'cause I was finding out all kinds of stuff about these people, and it was just a nasty thing. Too many shady people in my life."

In 1969, Bill Arnett's younger brother, Bob, was stationed in Turkey finishing his tour of duty in the army as the Vietnam War raged. Bill had recently come off his own term of service with the Air Force, stationed at Dobbins Air Force Base in Atlanta. Bob had promised his father that, upon his return, he would join the family dry goods business, but Bill had other plans. He convinced Bob to help him start an art gallery back in Columbus. Bob knew little about art, but that didn't bother his brother. After his Atlanta gallery experiences, Bill Arnett wanted a partner whom he could trust unconditionally. "Blood is thicker than water, and Bill had some less-than-ideal experiences with others in his earlier art business," Bob says.

They bought an old house on sleepy Oakview Avenue across the street from the current Columbus Museum of Art. They renovated it, turned it into their retail gallery, and called it simply William and Robert Arnett.

Bill and Bob Arnett sold art to a small group of Columbus patrons: good old southern folk, the wife of a federal judge, the doctor and his spouse. And they sold nationally, too. They traveled to antique shows and art exhibits to establish their name and encourage people to come to see their inventory in the South. They started with Greek and Roman antiquities and some pre-Columbian art and Oriental art. "It wasn't *un*successful," Bill Arnett recalls. "We more than made ends meet."

An African art dealer who heard about the Arnetts' collecting and gallery efforts wanted to visit Columbus. At first Bill Arnett said no, but the dealer persevered until Arnett finally said that he would spare him a few minutes. When Arnett gazed into the eyes of an Ashanti queen's mask, it was love at first sight. He shifted gears and began to load up on African art in his collection. Meanwhile, brother Bob was becoming enamored with Indian culture—Buddhism and Eastern religions and their influence on aesthetics—and the Arnett collection began to include Southeast Asian art.

The William and Robert Arnett gallery flourished in Columbus, Georgia, but paradise was short-lived. "We needed to be somewhere that people could get to 'cause we were meeting people all over the country. People would hear about us and want to come visit. We needed to be in a city that was a lot more convenient," says Bill Arnett.

But there was another story, too. The Arnetts' relationship with the Columbus Museum went sour when the longtime museum director retired and was replaced with somebody Bill and Robert Arnett viewed as hostile to them. It wouldn't be the last time Bill Arnett would butt heads with the museum world.

The final straw that drove the Arnetts from their hometown occurred with kin. The Arnett boys stored the bulk of their art inventory in their father's dry goods warehouse, which, they reasoned, was secured against theft and fire.

While the Arnett brothers rejected their father's request to join the family business, one of their first cousins agreed to join. This cousin, who still bristles at the words "Bill Arnett" and prefers not to be named, today holds a steady spot near the top of Bill Arnett's elastic enemies list.

"He is one of the people in this world that I truly detest," Bill Arnett says of this cousin.

"I think Bill Arnett is a first-class S.O.B.," the detested cousin drawls. "He probably did *steal* art from those *darkies* down in Alabama," he adds.

The cousin complained to Hilliard about the Arnett boys keeping art inventory at the warehouse. Sure this was a family business, but the key word was "business," not "family." The warehouse space wasn't to be doled out as charity for wayward family members' hobbies, he reasoned. "They used us as a depository for a lot of that damn junk from Africa and China and wherever," Bill Arnett's cousin remembers.

The cousin vigorously lobbied to evict the Arnetts' art inventory and threatened to quit the family wholesale business unless the art was removed. "He got very furious and created this big fight and

told my father he was gonna quit if my father didn't tell us to get out. So my father said, 'This ain't working. Why don't you find somewhere else to keep your stuff so we can get him calmed down?'" Bill Arnett remembers.

But it wasn't just the cousin who needed calming down. "You son of a bitch, I'll kill you!" Bill Arnett screamed once in the heat of an argument while his cousin trembled, turned pale, feared for his life. "We moved all that stuff out," says Arnett. "I just said, 'Let's just get the hell out. Let's just leave Columbus.' Wasn't any point in staying there."

Soon after leaving Columbus, Bill, Robert, and Judy Arnett toured Atlanta with a real estate broker from the prestigious Harry Norman Realtors firm. From house to house the broker tried to show off each home's modern 1970s features, but Robert and Bill Arnett cared about just one thing. They went straight for the basement every time. Figuring they would conduct their art dealings out of the house, they wanted to see if the basement would be big enough to store their inventory.

The trio bought a house with a huge basement in Atlanta's Sandy Springs suburb, and in 1972 they traded it for an even bigger house with an even bigger basement in the tony Buckhead neighborhood. Once they left Columbus, Bill and Bob Arnett never again had a physical gallery space. They serviced customers by appointment only out of the rooms of their posh, eight-thousand-square foot red brick home, where art spilled beyond the basement into the garage, the living room, the dining room, the kitchen, and even the bathrooms.

Bob Arnett was on the road constantly, traveling to antique shows and to art exhibitions to establish the Arnett brand and encourage collectors to visit Atlanta, meet Bill, and see their inventory. Bill Arnett had traveled too, initially. He was often gone for three to four months at a time. As his family grew from one to three and ultimately four sons, however, Arnett stopped traveling routinely and stayed behind to manage efforts from the house.

Through the early 1970s the William and Robert Arnett dealership was seemingly victorious. Bill Arnett claims, "We did well but

never had a penny—no cash, no savings, and no retirement." When Bill bought collections of art, he kept the unique pieces, sold the rest, and bought more with the proceeds. He may have been cash poor, but Arnett's wealth was anchored in an ever-enlarging, enviable collection and a growing reputation as an expert with a keen eye.

As in Columbus the Arnetts' customer base was national, but Buckhead matrons bought the most steadily. "Nice people would come in and buy. Yeah, good folks, and I would do antique shows. The High Museum had an antique show, and I did that for, shit, fifteen years or something. St. Philip's Cathedral, there was an antique show over there that I used to do. You know, the wealthy Atlanta people would buy from me. I had interesting stuff. I was really young and interesting to people like that, so I had a lot of good friends. I was a fair-haired darling in Atlanta. Everybody loved me, and the newspapers wrote wonderful stuff about me. I was in magazines and on the radio and television all the time. My house was on tour with museum groups, and they'd have parties there. I gave, I think, something in the neighborhood of forty lectures, either in my house or at the museum. I was quite all right."

Through the 1970s, Bill Arnett kept company alongside Atlanta art royalty. Lucinda Bunnen was one such friend. A collector, philanthropist, and photographer, Bunnen snapped Bill Arnett's picture for her locally acclaimed book *Movers and Shakers in Georgia*, which chronicled "the power elite of the new South: the dynamic, creative, influential people in Georgia who make things happen." The black-and-white portrait shows a handsome, thirty-something Bill Arnett in suede jacket and jeans crouched and contemplating an African statuette. On a contact sheet printed from negatives not used in Bunnen's book, one can see the extent of Bill Arnett's African interests. In these mini-portraits, Arnett poses variously in his darkened living room full of artifacts—surrounded by sculptures carved to honor spirits of the dead Fon people of Benin, costumes and masks used in Yoruban dance ceremonies, Eshu and Shango staffs, divination trays, staffs, amulets,

and on and on. As he vogues for Lucinda Bunnen's lens, Bill Arnett cracks not a smile. "He was *so* intense," Bunnen remembers.

Heiress-cum-artist Judith Alexander was another of Arnett's art-elite friends during that period. Alexander was old Atlanta with a twist. Her great-grandfather, Aaron Alexander, was the first American-born Jew to settle in Atlanta, and he built a fortune in hardware and real estate. Aaron married Rebecca Moses of Charleston, South Carolina, forging a distant familial bond with Bill Arnett, who also sprang from the extended Moses clan. Judith's father, Henry Alexander, was a well-respected and successful Atlanta attorney, so successful that even as the Great Depression raged, he erected a fifteen-thousand-square-foot Peachtree Road home with thirty-three rooms and thirteen bathrooms, and so respected that Atlanta elders turned to Henry Alexander to draft and file the original papers of incorporation for the Atlanta Art Association. An appreciation for the arts was deep in Judith Alexander's blood. At age twenty, the aspiring bohemian Alexander hopped a northbound train to Philadelphia, where she studied art at the exclusive Barnes Foundation. There, among works by Renoir and Rubens, Judith Alexander was first exposed to folk art: the paintings of African American self-taught artist Horace Pippin hung alongside the Academy's masters. Later, Alexander migrated further north, to Provincetown, Massachusetts, and studied painting with world-renowned abstract artist Hans Hoffman. Upon her return to Atlanta, Judith Alexander itched to indulge her art interests. The Alexander family owned a major tract of land in the heart of Buckhead and, in an old abandoned white frame house on the property overlooking Peachtree Street, Judith Alexander launched one of the few contemporary art galleries in the city, the Alexander Gallery.

Arnett says of his friendship with Alexander, "Judith and I, we'd go to movies. We knew each other fine. She appreciated me because I was totally into things that had nothing to do with her. She loved what I was doing. Used to come over to my house and sit and talk for hours. We were friends." Increasingly, the things that Alexander was into and

which held no sway for Arnett were the works of untrained, unsung African American artists: in particular, the art of Nellie Mae Rowe.

Rowe maintained a minuscule home in Vinings, Georgia. Though only ten miles from downtown Atlanta, it was truly a different world. Rowe called her home a "playhouse," and she decorated the modest house, swept-dirt yard, and shrubbery with all manner of bric-a-brac formed into folk art. She sculpted in chewing gum and made dolls from hand-me-down clothing and quilt scraps. Using felt-tip pen, crayons, and pencil on paper, she drew brightly colored pictures with detailed imagery of animals, friends, and her surroundings, with cheery titles like *Lod* (Lord) *Is So Good to Us*. Judith Alexander was far from the first person to discover Nellie Mae Rowe, but once she did Rowe became her obsession. Alexander extensively collected, catalogued, maintained, and sold Rowe's work from her Buckhead gallery well after Rowe's death in 1982. It was pleasant enough stuff to Bill Arnett—how could one not find some charm in it?—but to Arnett it certainly wasn't serious art. He may have been inclined, at the time, to nod his head in affirmation at another collector who meandered through the Alexander Gallery's Rowe collection and quipped, "I didn't know you could find art in the trash can."

At the time, Arnett had more cerebral endeavors to attend to, such as launching the *Beyond India* exhibition in 1974 at the High Museum. As the U.S. involvement in the Vietnam quagmire drew painfully to a conclusion, Arnett educated Atlantans on the role of Buddhism on Southeast Asia, including porcelains and art from Indonesia, Thailand, and Cambodia. He followed with a show on Yoruban art and another showcasing the art of Cameroon held at the Mint Museum in Charlotte, North Carolina. After that came an Arnett-engineered show on art from the West Guinea coast done at Agnes Scott College in Atlanta. Drop by drop in rapid succession Bill Arnett filled a canteen of cool cultural water for southerners stranded in Mencken's Sahara. Gudmund Vigtel and the High Museum drank generously from the canteen.

Vigtel was a friend of Arnett's, too. In 1976, when the acclaimed artist and sculptor Isamu Noguchi completed his sculptural playground for Atlanta's Piedmont Park, Bill Arnett and Gudmund Vigtel would occasionally stroll over from the High Museum to admire the geometric jungle gym as they sat on the swings and chatted.

It was no wonder that Vigtel would entertain Bill Arnett strolling, swinging, or standing still. Arnett had art that the High Museum needed to advance its reputation. Arnett claims that during the 1970s he lent the museum hundreds of pieces of art from his various collections. Among these pieces were antique Chinese porcelains. By 1976, Bill Arnett had circled the globe seven times in search of art treasures for himself and his clients. He had spent extensive time in the Orient studying porcelains and collecting them. He believed he knew more about the subject than anyone in town. In time, he would lengthen his list of enemies proving how much he knew.

———

In the fall of 1976, the United States was still celebrating its bicentennial birthday. Fire hydrants throughout Atlanta were painted to look like miniature Uncle Sams, MinuteMen, and U.S. flags. In Washington, D.C., Gerald Ford stumbled through the end of his accidental presidency trying to steady the home front while his secretary of state, Henry Kissinger, sought to further détente efforts abroad. China was a special focus of Kissinger's international effort, and he had brought Ford into the budding friendship too. Capitalizing on the warming of Chinese-American relations, a New Yorker named Charles Abrams arranged a U.S. traveling tour of ancient Chinese art and furnishings under the auspices of the Chinese Trade Commission. Abrams was a tall, handsome, educated man with the air of a government official. He promoted the tour as part of a cultural exchange between the People's Republic of China and the United States, initially arranged by Kissinger through the Nixon and Ford administrations.

According to Abrams's glossy marketing materials, the Chinese government had decided to let some of its most important art treasures leave China for the first time, and they had selected a handful of American cities to display the treasures. Some of the work was to be auctioned in Atlanta because, the supporters said, they wanted the southern United States, which had no exposure to Asian or Chinese civilization, to have major Chinese works in the possession of local collectors and of the High Museum of Art. Great pieces, circa Ming Dynasty, they said. Paintings, furniture, rugs. The most notable of the items were porcelains that actually came from Abrams's own collection. They were to be the highlights of the auction.

"The High Museum was in on it and saying if you buy these pieces and give them to the Museum, we will arrange a healthy tax write-off for you. And we want to make it just one piece per collector that can be acquired in the auction, because we want everybody to have a chance," Arnett says.

As an active dealer and collector of Chinese porcelain, Arnett was invited to be on the event's advisory panel. But he declined. "To me, the whole thing didn't make sense. Why would the Chinese government make a decision to send major porcelain items to Atlanta to be auctioned? It sounded like just an illogical cover story. The whole thing stunk. So I just said, 'Leave me out of it,'" Arnett remembers.

On the Saturday eve of the auction preview, event sponsors hosted a black-tie catered dinner in a large tent on the front lawn of a mansion on Peachtree Road. It was billed as the social event of the year. According to Arnett, Charles Abrams begged him to attend the event despite Arnett's constant refusal to participate. "He said to me, 'You'll see. It's wonderful. We have this magnificent collection of porcelain. A lot of people are interested in buying it, but they won't buy it unless I can get you to look at it and authenticate and recommend it to them. Please come as our guest, and I'll send a limo to pick you up.'" With that, Arnett relented. "The Midnight Sun restaurant catered it," says Bill Arnett. "I had never eaten at the Midnight Sun restaurant,

and I thought I would go to eat the food. So I went. I ate. I stayed out in the yard. I never went inside where the porcelain was."

He never went inside, that is, until one wealthy Atlanta matron persuaded him to provide an expert opinion on a porcelain piece that she was considering purchasing.

"Would you come in and look at some porcelain for me?" she said.

"Why? I would rather not," Arnett said.

"I told Charles Abrams to get you here, because I wanted to buy some of the best pieces, and I wanted your opinion," she replied.

"Well, you know," Arnett said, "I'm going to be very honest with you. This whole thing smells like a rat to me. And I've purposely not gone inside because I'm trying to preserve deniability. I mean, if I go in there and there's something wrong with what I'm seeing, I have to say it. And that's going to cause a lot of problems. I would just as soon stay out here and eat my smoked salmon, you know?"

But she persuaded Arnett to go inside and to see the pieces.

"I went in there, and they got all this stuff just gloriously displayed inside this big house. And I looked at it, and it was like eighty-three pieces," Arnett says. "And I think later I determined that seventy-six out of eighty-three pieces were fakes, misrepresented and priced way out of proportion to their actual worth. In other words, this was a scam."

Arnett tried to remain silent, but that was like a bull trying to walk daintily through a china shop. This, of course, actually *was* a china shop of sorts, and Bill Arnett was a conversational bull, tact not being one of his finest talents. Carolyn Buckley, an attractive southern bouffant blonde who owned the gallery where the auction was to take place, approached Bill to ask his thoughts on the porcelain. "I took her downstairs into a bathroom and locked the door," says Arnett. "It was the only place that people weren't mulling around. I was trying to keep this quiet. I said, 'Carolyn, I don't know how to say this, but I've got to. Almost all of the porcelain out there is fake.'"

"That's impossible," Buckley insisted, horrified at the accusation. The artwork had come complete with piles of documentation certi-

fying its authenticity. Buckley had even gone the extra step of having the work appraised by another local expert. She was certain that Arnett must be mistaken. But Bill Arnett held firm. It was all a sham as far as he was concerned.

According to Arnett, Carolyn Buckley "immediately went and told everybody there that had anything to do with it, 'Bill Arnett says that this stuff is all fake!'" Charles Abrams was outraged.

Arnett's comments spread quickly around the city, and the *Atlanta Journal-Constitution* fanned the flames on its pages. The Atlanta art establishment was in an uproar. One simply did not question the good word and good works of Atlanta's boosters. The more that Arnett was challenged, the more he persisted in his statements. Gudmund Vigtel was humiliated and furious. Arnett had always acted like he knew more than others, Vigtel believed, but now he had gone too far.

Threatening to sue for slander, Charles Abrams sent a tough New York lawyer after Arnett. "They said, 'We're going to sue you and destroy you,'" Arnett remembers.

The porcelain was removed from the auction; the gauntlet was laid. Unless Bill Arnett could prove that his opinion of the pieces was correct, he faced an imminent and public slaying and a likely lawsuit. For two days he called every museum he could think of that had a Chinese porcelain expert, but none of those Arnett called wanted to get involved. Bill Arnett imagined that the High Museum had been one step ahead of him all along. Probably, he figured, they had called the other museums and warned them that he would be reaching out for help.

"At the end of the first day," Arnett recalls, "I hadn't found any-body to help evaluate the pieces, and I was getting very nervous. The Metropolitan Museum people said they wouldn't come down here and do it. One woman who works there said she could do it privately, for a fee, but she couldn't come for two weeks. I was thinking that I had better get out of this, just say, 'I'll leave you alone and you leave me alone and go ahead and do what you want to do.'"

As word spread further, Bill Arnett began getting calls from the city's power brokers accusing him of interfering in a charitable endeavor, of trying to harm Carolyn Buckley, of ruining Atlanta's reputation. "The word was out, and they were telling the newspaper that 'Bill Arnett thinks of himself as the main collector of Chinese art and the expert of Chinese art in Atlanta, but all this work is so much better than what Arnett has that he's trying to squash it because of his own ego,'" Bill Arnett remembers. "All that did was make me mad."

With no luck, Arnett kept dialing for Ming Dynasty experts. Finally he called the former director of the Smithsonian Institution's Freer Gallery, which specialized in art from the Orient. He tracked the director down at his home near D.C. His wife answered and wouldn't let Bill speak to her husband. Bill explained his situation again. He tried reason and logic. He tried begging. She hung up. He dialed back. She said no again. Her husband couldn't help him. Arnett called again, and finally the curator himself answered the phone. As the wife had claimed, he refused to help.

But Bill Arnett was desperate, scared . . . and persistent. He gave an impassioned speech.

"Please assume there is a possibility that I am telling the truth. I'm fighting against the kind of thing you have fought against all your life," Arnett pleaded, "to keep fake porcelain from being bought and sold."

"All right, I'll do it. Come to D.C. I'll give you one hour, and I'll look at the pieces," the curator relented.

If Bill Arnett was nervous, Charles Abrams was frantic and hostile, and the combination was explosive. The two met at the Buckley Gallery for a last-minute clash before the trip to Washington. It was a classic confrontation in a closed room with Abrams, his friends, and lawyer on one side and Arnett on the other. "I was hotboxed," Arnett says. "Abrams said that Gerald Ford was going to hear about this because on his last trip to China he had made good friends with the two men whose porcelain this was and who authenticated it. And Ford was not going to like this at all. And, he said, Henry Kissinger

knew these people too, and he had a call into Kissinger's office right then." In other words, Bill Arnett was not only threatening the art world, he was destroying détente.

Charles Abrams would allow only fourteen pieces of the eighty-three in the collection to be taken—chosen at the sole discretion of Abrams and his lawyer. Arnett worried that they would somehow switch what he perceived to be the fake pieces and replace them with real ones prior to the Smithsonian visit, or that they would choose to take only those few pieces in the collection that might actually be what they were represented to be.

Arnett was certain that a conspiracy was afoot, that he would be set up, sued, ruined. While he was confident that most of the pieces had been grossly misrepresented, Bill Arnett had also calculated that a few pieces were potentially legitimate. "After a fashion their description was not that incorrect, and they were trying to nail me on a technicality. They were saying that if just one piece was good, I was subject to a lawsuit," he says.

"But they picked the most valuable fakes. I mean they picked all the showiest things that were supposed to be the great pieces. They picked the pieces I would have picked, the ones that were the most expensive fakes. And they were represented to be the most important pieces. So we took them to Washington."

The auction took place the night before the D.C. trip. It was a failure, and blame fell on Bill Arnett. Still, Arnett was so frightened that he couldn't pay attention to the finger pointing. Nor could he eat or sleep. One of his cousins, a High Museum trustee at the time, told Arnett, "You don't understand what long tentacles the High has." Another telephone caller told him, "If you get on that plane, you may not come back."

Bill Arnett feared for his life. He hired a former Jacksonville, Florida, sheriff, Al Cahill, to be his bodyguard during the trip. Cahill was no young stud, but he was tough and seasoned, having been suspended as sheriff some twenty years earlier while under grand jury

investigation for bribery, gambling, and illegal liquor sales. Cahill was a middle-aged James Cagney, a guy who didn't back away from trouble. But Cahill's presence didn't calm Arnett's nerves, and as he moved through the Atlanta and D.C. airports Bill Arnett literally walked with his back to the wall.

The meeting began in the staid halls of the Smithsonian Institution on the Mall in Washington, D.C. "And so the first piece they open was the biggest, fanciest, most expensive piece in the lot, supposedly. I was just sitting there. My heart, I mean, I could hear my heart beating. The guy from the Smithsonian, who is now the director, picks it up, and says, 'Now, what is this supposed to be?' He looks at it and he says, 'This is totally a replica, made probably around 1900. What is it supposed to be worth? Thirty-five thousand dollars? Oh, no, no, no. This may be worth one thousand dollars at most,'" says Arnett. Thirteen of the four-teen pieces examined were fakes as Bill Arnett had described them. The fourteenth was not a clear fake, but not a clear gem either.

"This guy Abrams comes over, hugs me. He's crying. He's apologiz-ing profusely, and he's saying, 'I commend you for having the courage to stand up for what you believe in. And, you're right, and I've been duped myself. I'm sorry.' And his wife was there, and she was crying. And I started realizing that maybe he was on the level and somebody else had pulled a fast one on him or on someone along the line. I never knew. But it did turn out that Abrams's alleged Chinese Trade Commission, or whatever it was supposed to be, was really a corpora-tion that could have just as easily been called Chinese Imports, Ltd.," says Arnett. It had no official or government affiliation at all.

Threats of lawsuits were dropped. Calls came in from around the country praising Bill Arnett. He was lauded in the Atlanta Sunday newspaper in a six-page article entitled "The Porcelain Affair: The Oriental ceramics exhibition drew special praise until the Smithsonian turned thumbs down."

Regardless, according to Arnett, "From that point on, I was a pariah in Atlanta."

Shortly after the porcelain episode, Bill Arnett and his family went to Mexico on vacation. When they returned, according to Arnett, hundreds of art pieces collectively worth millions of dollars that he had loaned to the High Museum were stacked in crates on the front porch of his house.

———

Arnett steadily withdrew from the Atlanta art scene that had previously sustained him. For a while he continued to share his treasures with the city. In 1978, the High Museum of Art and the Museum of African Art sponsored an exhibition entitled *Three Rivers of Nigeria: Art of the Lower Niger, Cross and Benue. From the Collection of William and Robert Arnett.* But, behind the scenes, Arnett was persona non grata at the High. His former friend Vigtel had virtually banished him. High curators knew to stay away from Arnett. Peter Morrin, curator of twentieth-century art at the High Museum at the time, says, "I never had an encounter with Arnett while I was at the High Museum. You didn't want to cross Vig. You wouldn't want to go out of your way to piss him off." Fraternizing with Bill Arnett was piss-off material.

Bill Arnett did not go too far to piss off Vigtel. Arnett, in fact, pissed at close range and often. Arnett told an *Atlanta Journal-Constitution* reporter some fifteen years later that for a very long time professionals at the High Museum "characterized me as one who thinks he knows more than they do, who thinks he has better art than they do, and as one who must control the projects he is involved with. Well, sort of."

If the prior blood wasn't bad enough between Vigtel and Arnett, the battle now was public. The *Atlanta Journal-Constitution* again contacted Arnett for a profile they were writing about Gudmund Vigtel and asked him for a statement. Arnett told the reporter, "I don't want to say much about this. I'll simply say that Vigtel acts as

a custodian for those people in Atlanta who don't want to see things move too far too fast." Vigtel responded with a letter to the editor and told whoever would listen that, "If I had known Arnett was going to be popping off his mouth I could have shot him down like a turkey." Arnett's response was straightforward: "I went and made a tape recording; got a gun and got these turkeys gobblin' and they were going bawk bawk bawk bawk bawk bawk, and then you hear a gun. Boooom . . . And then you hear silence and then after about fifteen seconds the turkeys start gobblin' again. And I was gonna send Vigtel the tape recording but everyone said, 'Just leave him alone. Don't provoke this anymore.' So I didn't do it, but that's so much what it was like, you know. 'Any dissenting voice, we gonna shoot him down like a turkey.' And all I said was something that was true. Vigtel is a fanatic about hands-on management of the museum; he could even be seen sometimes in the morning in the museum restroom polishing the faucet fixtures or something like that. Now that's a custodian, is it not? If that's not a custodian, what is? He's just a watchdog 'cause he was not a creative man. He wasn't a bad man when I look back on him. He was just pathetic, he was insecure, he was over his head being a museum director. He wasn't trained for it."

Today, nearly thirty years since the porcelain episode, before Gudmund Vigtel says anything about Bill Arnett, he slips in a disdainful preface, "He buys *and* sells the art. . . . Keep that in mind." Vigtel ends his comments about Arnett by retelling a story he relishes about famed collector Ben Heller's visit to Atlanta. Heller had recently sold a major work from his collection—Jackson Pollock's *Blue Poles*—to the Australian government for over $2 million. The subsequent scandal over the high-priced purchase helped to bring down the regime of Australia's prime minister at the time. While Heller lectured a crowd at the High Museum, Arnett sat enraptured and impressed, and he invited Heller and a group of Atlanta art aficionados to his Buckhead home. Heller toured Arnett's African collection and other objets d'art jammed into all corners of the house. In front of the gath-

ered art dignitaries, Heller declared loudly, "Why don't you sell all this crap and buy one *real* piece?" Gudmund Vigtel still chuckles at this.

––––––––––

After the porcelain episode with the High and public debates with Vigtel, life stopped and crumbled for Bill Arnett. His father, Hilliard Arenowitch, fell victim to Parkinson's disease in the late 1970s, and the unforgiving disease finally took his life in 1985. At his father's death, a battle quickly erupted between Arnett and his embittered cousin over equity ownership and outcomes from Hilliard's business. It was near that time that Arnett's brother, Robert, abruptly quit their art partnership and announced his intentions to sell his one-half stake in the Arnett art collections and donate the entire proceeds to a vitamin-peddling huckster by whom he had been charmed. Bill Arnett fought the effort. He had no intentions of selling the art and wasn't going to let his only brother join what he characterized as a cult. The brothers scuffled and called in lawyers. Arbitration began, but before a settlement could be hammered out, Robert Arnett backed off. He ditched his vitamin-cult plans, but he also ditched his brother. Robert Arnett moved back into the family home in Columbus, shifted his attention to caring for his aging mother, and threw himself into the world of Eastern philosophy and the study of India. He would eventually publish an exquisitely photo-illustrated and award-winning book, *India Unveiled*.

Too much change finally took its toll on the previously indefatigable Bill Arnett. His heart stopped for the first time before his forty-fifth birthday, and then it stopped again. Arnett was flown to Kansas City in late 1985, where surgeons made a needle puncture in his groin and snaked an angioplasty balloon up through his body to push out the plaque suffocating his heart. As Bill Arnett lay recovering in Atlanta, he became increasingly hungry, thirsty, and irritable. Doctors had forced Arnett to drop his cigarette habit, and that was a

partial factor. But the other factor was diabetes, which rapidly manifested as the number-one problem devouring Arnett's body. Arnett was urged to keep his body more or less in one place. Bored and debilitated, he settled, his son Harry says, into "an emotional breakdown." He "checked out" for nearly eighteen months, according to Harry Arnett. "He didn't work. He sat in the living room and listened to music all day long," Harry remembers, "and he made music compilations. He recorded thousands of compilation tapes of all kinds of music. Reggae, opera, '50s and '60s tunes. It was like a little Rhino Records; you know, 'greatest hits of the '70s' kind of thing."

As the music floated through the living room, swirled around African masks and porcelain vases, through one ear of Bill Arnett's weary head and out the other, his mind churned, concocting ideas for escape: away from the tyrannical closed art circles of Atlanta; away from the pristine, putting-green lawns of Buckhead that surrounded big brick estates like smothering emerald pillows; escape to someplace else where sophisticated people shared his lofty aesthetic value, where historical depth reached far deeper than the seamy nightclubs of Underground Atlanta, and where cultural heights soared high above the Confederate faces etched onto Stone Mountain, a place where he could breathe. He considered Europe. The French countryside. A villa could do the trick, with Paris and the Louvre a stone's throw away. He made plans in his head as the melodies enveloped his broken body. He would go far, far away. He would find redemption and his raison d'être elsewhere. As it turned out, Bill Arnett's salvation was much closer to home.

Chapter 4

GOD'S WOMB

BILL ARNETT WAS DEFINITELY MOVING TO FRANCE. IT WAS, HE BELIEVED, his only avenue of escape from the Atlanta art establishment that had banned him. "I don't really have a life here," he skulked during his darker moments. Happiest in his life touring Europe during post-college days, Arnett fantasized that he might recapture that joy in the majestic cathedrals and museums of the old continent. Bill Arnett convinced several loyal friends to pitch in money to enable him, Judy, and their four sons—Paul, Matt, Harry, and Tom—to occupy a country house in France from which he could buy and sell art.

He just needed a little time to get his affairs in order.

"I had been planning to go to Europe and just start life over," says Arnett, "but things got fouled up and I couldn't leave. Mostly health problems. I was afraid to go live in a remote place and have another heart attack."

His heart wouldn't let him leave, and while he stayed in Atlanta longing for France, something else grabbed at his heart. Arnett's friend Roy Craven, an art historian at the University of Florida, first introduced him to the work of self-taught wood carver Jesse Aaron in the early 1970s, and the collector added several of Aaron's pieces to

his trove. Aaron's sculptures were like totems, made from tree roots and limbs, carved, adorned simply. In the waning days before Bill Arnett's planned move across the Atlantic, Jesse Aaron's totems somehow seemed imbued with a powerful force, a mystical one, divine. Part black, part white, and part Seminole Indian, Aaron was eighty-one years old when, he said, "At three o'clock in the morning, July the fifth, the Spirit woke me up and said, 'Carve wood.'"

Perhaps, at this point in his life, Arnett longed for his own divine calling.

———

Sam Doyle had been called. Doyle lived in a small enclave off the coast of South Carolina where most people spoke Gullah, a West African–influenced tongue. Sam Doyle was a former laundry worker at the Parris Island Marine Corps base who painted vibrant figures on corrugated tin and scrap wood.

"I knew about Jesse Aaron," Arnett says, "and then I learned about Sam Doyle." Something was definitely different and surprising in their art. This was not the sentimental, memory painting, nostalgic sap that Arnett had sloughed off in the past. Doyle's art, like Aaron's, had ferocity in it—rebellion, raw and seething. Bill Arnett looked at Doyle's and Aaron's artwork and, perhaps, saw himself. "I understood them, and I understood there must be much more," he recalls.

While on a road trip to Houston with a friend, Arnett began his search for much more. His hypothesis was formulating: there is a hidden world of untrained African American artists who are making work of equal importance to any other living artist, but no one is giving them much credit. Arnett convinced his traveling companion to let him stop and see other black artists like Doyle and Aaron that he heard about while they traveled west. Another hypothesis was surfacing, and it was wrapped in the notion of exploration: a throwback to his Indiana Jones art days traipsing the world for hidden or, at least,

undervalued art treasure. He could have all of this adventure here in the United States, no move to France necessary.

"That trip got me started," says Arnett. He and his companion pulled off the highway at Montgomery and hunted down Mose Tolliver. Mose wasn't too hard to find. Everyone knew him and that he lived on Sayre Street with a front porch loaded with art. "Mose T.," they called him. He was a folk art celebrity. "The old ladies just want to touch my head, and the rest of them just want to take something with Mose T. writ on it," he once said. Long ago, at the furniture factory where Mose T. had worked, a container full of marble stone tumbled onto his legs, crushing them. Permanently disabled, Mose took to painting and drinking. He spent much of the day on the edge of his bed—bottle of Red Dagger wine at the ready—dabbing house paint onto wooden boards. Arnett arrived, looked at Mose T.'s artwork. Straightforward, vibrant, sometimes erotic. Bill Arnett could almost hear the bells go off . . . *ding, ding, ding* . . . hypothesis validated. Before long, Arnett's detractors would claim that what he heard was more like the *ka-ching* of cash registers rather than the tones of enlightenment.

And then again, farther down the road. Arnett and his road trip buddy veered south at Jackson, Mississippi, and rolled for an hour down to Hazelhurst where an eighty-plus-year-old former housekeeper sat in a yard, waiting. She was recovering from a stroke, this old woman, and so her productivity was lower than usual. Instead of painting more on the corrugated tin slabs and wood sheets that surrounded her, Mary T. Smith was taking a rest. Arnett arrived, looked at Mary T. Smith's artwork: two-color paintings of faces that might as well have been modeled after the African totems in Arnett's living room. The bells sounded again. Louder.

"That was the first time I had ever seen Mose Tolliver, the first time I had seen Mary T. Smith. They had things about them that made them very unusual in terms of my own experience of art. This stuff was important. This was not just some whimsical junk on the side of the road."

Arnett felt he not only connected intellectually with the art done by these African American outsiders, he connected with it personally. "I feel blacker than black people sometimes," he said. He was smitten with the art and he bought it, a lot of it. "In fact, on that trip I bought so much art from Mose Tolliver we had to turn around and come back to Atlanta and empty the car before going on."

Over the span of a year, Arnett's collection of black folk art and relationships with the artists grew quickly and in grand scale, which was of no surprise to others in the field. "I had big collections of things," says Arnett, "and people assumed, 'Arnett just likes to scoop up stuff and go fill up a warehouse with it.'" Scoop it up, he would. Fill a warehouse, also. But Bill Arnett had other things in mind. He envisioned unveiling the largest and best collection—his collection—to the world, and rewriting art history in the process.

One of Arnett's favorite artists was Bessie Harvey. Born in 1929 in rural Georgia, this mother of eleven children lived in Alcoa, Tennessee, just outside of Knoxville. She found her muse in the branches, roots, and stumps scattered in her yard. "I knew from the time I was a child that I had a friend in nature; the trees, the grass, and wind," Harvey once said. To her, trees were "soul people" and, like Jesse Aaron, she also brought wood to life. But unlike Aaron, Bessie Harvey did not carve wood but started with it just where it was. "Who are you?" Harvey asked the wood. And when it answered she responded by inserting doll's eyes into the wood flesh, affixing wood putty in the shape of nose, and draping strands of human hair from the figures' skulls. Neighbors whispered that she was dealing in a form of conjure, but Arnett saw a different magic in her work. He continued to collect Bessie Harvey's art—voodoo notwithstanding.

As Bill Arnett's collection expanded, so did his status in the folk art world. "I had a certain notoriety as a collector when I got into this," Arnett recalls. "So when the word got out that I was collecting this art, the other collectors invited me into their combine." But even while gaining status in the folk art combine, Arnett was not what his

collector colleagues expected, and neither was the art he found appealing. "The interesting thing was that the black artists I was finding and collecting were, for the most part, artists that nobody was interested in," Arnett says. "Their work wasn't small and easily transportable, cute and homespun or easily saleable. It wasn't colorful. Wasn't what people expect black folk art to be." Bill Arnett wasn't what people in the folk art "combine" expected a folk art collector to be. Like the art he selected, Bill Arnett was far from cuddly and homespun. But he sure was colorful.

Charlie Lucas, though colorful, wasn't what people expected him to be either. One of the younger artists in the folk art market, Lucas lived in Pink Lily, Alabama, and after suffering a back injury, he had his own conversation with God. "That's when I started working in metal," Charlie remembers. "I asked God to let me do something that nobody else can do." Art was the answer. Lucas made rusting metal pieces from auto remnants like wheels and mufflers shaped to resemble animals, dinosaurs, or people. They appeared to be simple concoctions, but when asked about any piece Lucas would launch into an evangelical speech about the deep meaning of the work.

The more Lucas talked and flashed his easy smile, the more people bought from him. He was a handsome man and charming. The ladies seem to find him irresistible. "I called myself the Tin Man," says Lucas, "and when I started I only had ten dollars in my pocket." *Slick and somewhat unstable*, Arnett thought when he first met Charlie Lucas, but this Tin Man and his art had heart. And Arnett wanted it. Lots of it. So he brokered a deal with Lucas that was unprecedented in the folk art world.

"I wanted the right to buy his work first. I made the same deal with everybody. I would pay them enormously more than anybody else, but that artist had to put away the stuff they made until I came back, which was every week or two. So all I was really getting was the right of first refusal," says Arnett. The second part of the deal involved Arnett setting the bar for the value of the artist's art. "You

figure what I'm paying you for each painting, and you charge other people the same," Arnett told the artists. "And as long as you do that, I'll keep paying it to you and I'll keep raising it."

Arnett says that through his unique deal with the artists he was really saving them from exploitation, returning to them some of their works' value. "They were poor," remembers Arnett. "Anybody could see that they were getting nothing for the art; over the course of a year a white keeper would give a black artist two hundred dollars, a big chocolate birthday cake, maybe a sweater or a hot water bottle in the winter time or a little heater that cost thirty-five dollars. Sometimes they'd give them nothing or they might bring them food. Give them art supplies and take all their art. That might be alright if the art is of no interest to anybody and no importance. But this art was good, and sold for handsome prices. I'm telling you, and I'm not exaggerating this at all."

Arnett's deal indeed raised the value of the artist's pieces so that they were getting more for their work, Arnett says sometimes ten times more than the initial amounts. He also gave them a monthly stipend that supplied his artists with steady income that, in turn, provided freedom to create.

Some artists and other collectors, however, had different opinions about Arnett's deal. What Arnett saw as generosity, some saw as monopoly. "He wanted everything I did," recalls one artist who prefers to go unnamed. "He wanted to say who I could sell to and who I couldn't sell to."

Referring to Arnett, Alabama art dealer Robert Cargo remembers, "He called me one Sunday evening and talked for two or three hours. He attempted to get deals with artists that he knew I collected. He tried to get them to sign exclusive contracts with him because he wanted exclusive rights. I could understand why someone might want to get exclusives. It is expensive and time consuming to promote an artist. It can be undertaken only if you have exclusive rights. It can also be a burden because you have to create a market—have to

advertise, work to get the art included in exhibitions that are traveling around the country."

But with dogged determination and a sense of higher calling, creating a market for this art to Arnett seemed less of a burden and more of a cause—one that he pronounced from the belfries of ivory towers and the grounds of galleries and museums across America.

"I'd been all over the world and seen all kinds of art in museums and cathedrals and temples," says Arnett. "But I'd never seen anything so moving. . . . I had to go out and tell the world that there's this forgotten civilization doing this great work!"

"He got drunk with it," remembers Arnett's anonymous former artist. "He let the art kind of drink him up."

———————

Anne Arrasmith is heavyset with short-cropped silver-gray hair and cool blue eyes, a fifty-something Scarlett O'Hara crossed with a 1960s flower child. She seems to have anointed herself Lonnie Bradley Holley's true protector: one of the righteous, sensitive few who have only pure intentions for the artist. She has, in fact, helped to consistently support Holley. Arrasmith founded Space One Eleven, a nonprofit gallery and arts center, in Birmingham, Alabama, in 1986. Since then, she has shown works by Holley and Charles Lucas alongside those by trained white artists like Joni Mabe.

It was, in fact, Joni Mabe's art that lured Bill Arnett to Space One Eleven. Arrasmith had decided to showcase Mabe's art for the gallery's inaugural exhibition, which was a curious choice. Today referred to as "Joni Mabe the Elvis Babe," Mabe currently manages the Loudermilk Boarding House Museum in Cornelia, Georgia, which contains her *Everything Elvis* collection of Elvis art, including a vial of Elvis's sweat, a toenail that might have been Elvis's, and a wart from the King's right wrist that floats suspended in a tube of formaldehyde. It stood to reason that Mabe was more than enough

to shake Birmingham out of art complacency. The Space One Eleven kickoff exhibition of Joni Mabe's work took place in 1986. Bill Arnett heard about it and decided to take a ride.

"He pulled up to the door in a big black truck, walked right up to me, and asked, 'Do you know any black artists?'" Arrasmith says.

Arrasmith in turn asked Arnett if he had heard of Lonnie Holley. Arnett had, and was reluctant to meet him because, "I heard that this guy Holley is half crazy and that he is very difficult to deal with and he just sits there and makes things by the thousands and gives them away to everybody, but these things don't last very long and they break easily. That's what I heard. That's not what I'm looking for."

"Oh, no, no, no. I don't care what you've heard about Lonnie Holley," said Arrasmith. "You really should go meet him because he's not that way at all."

"I just haven't got any interest," Arnett repeated.

"Lonnie does all types of art that you don't know about and nobody realizes he does or gives him credit for," Arrasmith told him. "You and Lonnie need to know each other. He'll become your best friend, and you'll become his. "

"I think the first time I met Bill he came to my place," Lonnie Holley remembers. "He didn't call me. He just came to my place and looked around and looked at my work, taking pictures of my work and he heard me talking about a few things that I had created, and he kind of liked the way that I talked about them, I reckon."

Holley had struggled since the Smithsonian tour. He lived out of cardboard boxes and makeshift shanties on his grandfather's land by the airport. He squeaked out a few occasional dollars bringing sandstone to Birmingham area schools and teaching children how to carve. "The little bitty children would take my scraps and make they own little thing. It made me feel proud to know that I had an opportunity to tell the children that you could take this home and you can get a kiss from your mamma for it. You can get a hug. You can get appreciated for just doing this," Holley says.

Holley earned some money selling his sandstone carvings too, but in limited quantity. Mostly people came unannounced to his sprawling yard museum like anthropologists studying the Birmingham native in his environment. Art dealers and gallery owners snapped up his work for their clients. Some drove by and picked up pieces from the lawn without paying for them—or even acknowledging Holley's presence. To Holley, it was bad enough when lurkers came to ogle him like he was a sideshow act; it was worse when they took his precious creations without asking. What really irked him, though, was when they came and looked but didn't take time to *listen*.

"The yard was telling a story, and most folks missed it," Holley recalls. "The things that I created was mostly memory of something that happened or that was happening around somebody. It come from that part of your mind, the memory part, how you took the stone and moved it from one level to another level, and each side of it had a story to tell. It had a story about the communities, the workers, Mrs. Kelly, Grandpap, Uncle Jesse, Mama. It had a story about all them people that I had been around. The average folks got in there and just wanted to take the sandstone and try to make money off of it." To Holley, Bill Arnett did not appear to be like average folks.

Bill Arnett wandered the property before venturing up to Holley's door on his first visit. He thought, *This guy is a troglodyte; some kind of recluse.* Holley's house appeared to be buried in the ground, in the woods, like a cave. It was unbelievable, and it was like nothing he had imagined. Tens of thousands of art pieces were hanging from trees and lounging against rocks and nearly jumping from box springs and crawling across the acre of art that was Holley's yard. Anne Arrasmith had been exactly right. Arnett knocked on the cave door. No response. He knocked again. Nothing. And, then, from the depths of the cave, he heard a small voice, "Who's out there?"

"Mr. Holley . . . ," Arnett began.

"Who are you?" the voice interrupted. The door cracked open.

"My name is Bill Arnett," he said and then quickly, "Before you go shutting the door on me, let me tell you that I've been all over the world looking for art. That's what I do with my life, and I've never been any place that's more interesting to me than your place. So I just want to talk to you about it."

Lonnie Holley emerged, and the talking began and didn't stop until Bill Arnett looked him square in the eye and said, "Listen, the two of us can change history together." And then the talking started again.

Holley spun stories about his life and art, all the while watching Arnett's expressions closely. He might not have been much of a word reader, but Holley sure could read faces. He wondered whether this white man really wanted to be bothered with him and his yard and his Sandman tales. His intuition said yes. Here was a man who seemed truly interested in coming back and seeing and listening and understanding the development of something big. "His mind was like *huuuummmmm*," Holley remembers. "With Bill, you could see his mind just reading my art."

Arnett's mind not only hummed, it sang. And it wasn't simply Lonnie Holley it heard. To Arnett, African American vernacular art was a common visual language that, like jazz—a common musical language—originated in the South. They both—the art and the music—had powerful cultural influence, and both were languages that Arnett felt he understood.

"I have come to realize, understand that black culture in the South is not what people think," Arnett told Holley. "It's not a bunch of dumb darkies that don't know what they're doing. There are people all over the South doing phenomenal things that the art world doesn't appreciate but which it needs to know about."

When Arnett shared his vision with Holley, the artist heard the same music. Holley realized then, "I'm not the only artist on the earth. We artists all got to realize that and help each other."

Lonnie had been called, and Arnett's determination galvanized. "I didn't have a mission before that," says Arnett. After that, "Lonnie

became a partner of sorts." Holley and Arnett became more than friends; they were each other's muse.

The partnership started slowly. First, perhaps, a hunt for undiscovered artists in Birmingham. Then, maybe, a search of a slightly broader territory—say, out to Tuscaloosa and up to Fayette. Maybe Montgomery next and then more, and farther until they had unearthed the visual magic that lay hidden in the bowels of the black belt. Together, they would drive through the backwoods of Georgia, over the rivers of Alabama, around the hills of Tennessee like Lewis and Clark in a minivan searching for "lost civilizations" adorned with vernacular art.

And, just to be sure they were really in it together, Arnett guaranteed Holley two thousand dollars each month, provided that Arnett be given an exclusive on Lonnie's best artwork.

———————

In March 1987 the youngest of Thornton Dial's children, Patricia Dial, died. "She never could walk. She couldn't talk," Dial would later say. "She could just laugh and smile when you talked to her." Despite her cerebral palsy, Patricia Dial, who turned twenty-seven earlier that year, had been the light of Dial's life. He and Clara had fought hard to give her a good life, but by the summer of 1987 there was nothing left of Patricia but bittersweet memories and a mountain of unpaid medical bills.

Dial's wife, Clara Mae, was also rapidly adding to the tower of health-care bills. She had fallen sick soon after Patricia's death. By the summer of 1987, Clara was spending most of her time in a sterile white room at Bessemer's Lloyd Nolan Hospital, the victim of diabetes run rampant.

Dial began to wonder how he was going to make it through. Since his days toiling in the bowels of Bessemer, he harbored one constant, quintessentially American dream: to be his own boss. "I didn't have no

learning," Dial recalls. "I had worry. Bothered why I can't be this and why I can't be that. I was bothered with that, and I watched the white man and wondered why he could work with clean clothes on and I got to go nasty all the time. I used to wonder about life a whole lot, about why I was a human being just like anybody else but I can't get up in the world. Nobody. No Negro. I don't see none of them get up in the world. That used to worry me." But after Patricia's death and with Clara in the hospital, Dial had no choice but to get up. "I just went to work for myself," he says. "I was just thinking, *Well, I'm gone make something myself even if no one else got nothing for me to make.*"

Dial Metal Patterns was actually the inspiration of Dial's second son, Richard. While all the Dial boys had some of their father's talent, thirty-two-year-old Richard seemed especially inventive at shaping metal into beautiful designs. From the tin shed behind the family's house, Dial and his sons—with Richard at the helm—launched the new venture, welding patio furniture that they sold through local hardware retailers. Richard designed the fledgling company's "Shade Tree Comfort" line, and all the Dial men worked together to build the furniture by hand, but the business struggled and the Dials took on an increasing debt load.

Thornton Dial sought other paths to financial gain. First, he picked up a few extra dollars cutting his neighbors' hair. Next, he turned to cement and invented a line of cylindrical cement cases topped with steel tubes. Dial tried to convince his neighbors that these containers would make great flower holders for graveyards. "I done made so much stuff for the cemetery. A lot of that is still down there, flower stands out of cement and iron; crosses and cement blocks for grave markers," Dial says, but not enough neighbors felt like hauling unwieldy cement flower holders and heavy iron crosses down to the cemetery for Dial to make a go of it.

Without missing a beat, Dial collected used beer and soda cans and filled them with concrete to produce can-shaped bricks, "so many canned bricks until they looked like a trailer house of them

sitting there," Dial says. But his efforts to find brick buyers quickly fizzled. Afterwards Dial used the tin from the cans to make fishing lures. Impractical, perhaps, but interesting just the same. Dial recalls, "I made a heap of fishing baits. Used to make them by hand for bass fishing. Made them with screen wire, telephone cable line, aluminum, and plastic. I couldn't never get the baits to work. Maybe they was art all along, but I didn't know it. . . . Well, I had did all them kind of funny things in my yard. Folks told me, 'Dial, you need to know somebody, you need to know somebody.'"

Lonnie Holley was somebody to know. At thirty-seven, Holley was going through a mid-life awakening. He was gaining a larger sense of himself as an artist, and he wanted to feel like he was a part of something bigger still. Bill Arnett was an evangelist, explorer, and discoverer, a part that Holley felt that he could play just as well. He could talk as good as anyone, he figured. And he was the consummate collector. Put him on the street or in an alley or anywhere at all, and he could accumulate the sculptural material for a masterpiece in no time flat. If he could do it with scrap, he could do it with people who others thought were scrap. He'd asked Arnett to introduce him to other artists like himself, and Arnett had obliged. During his tour of the southern states with Arnett, at a stop in Memphis, Holley made his first discovery. Arnett had taken him to meet an artist named Joe Louis Light. An African American who had converted to Judaism during a prison stint, Joe Light had long ago left a life of crime, and channeled his vocation as a sign painter into purely creative expression. Painted as if possessed partly by French surrealist Henri Rousseau and partly by Walt Disney, Light's self-decorated home and art were well known in folk circles, and Bill Arnett favored him—both as an artist and as a man. Light lived by a rigorous personal ethic: "standing up for truth and honor no matter what the consequences," Arnett would later write.

Light lived on Looney Street in Memphis, in a house swathed in red and black and white. Inside, cans of spray paint stood beneath a

work in progress. Outside, wherever flowers wouldn't grow, Light had painted bright blooms. Signs scattered in the yard testifying:

I AM SENT ME INTO THE WORLD; i AM The MOST RiGhTEOUS MAN THAT EVER liVE'd, i AM ThE GREATEST PROPhET ThAT EVER liVE'd.
written in Light's hand.

Holley instantly liked Joe Light and identified naturally with his environment in which paint played games with words. In a mix of envy and inspiration Holley wandered from Light's home in search of his own materials to shape. Not one hundred yards away, across Looney Street, he came upon an alley. Drawn in by the allure of unknown danger, Holley walked nearly to the end where a sign stopped him: "Harry Club Store—Office." Holley wandered inside the Harry Club Store. It was the art workshop of Felix Virgous Jr., nicknamed Harry Club.

At thirty-nine, Virgous was still living at his mother's home. Learning disabled, he had never attended school nor held a steady job. He spent most of his time in the garage hidden on the alley behind his house where, inspired by his accomplished neighbor Joe Light, Virgous began fashioning art. He decorated his clubhouse with objects, carvings, collage, and paintings. Like Light, Virgous drew upon religious themes that were tempered with pop culture. Plastered magazine ads sat amongst the rough-hewn carvings and decorations in his Harry Club. It was an elaborate setup, as layered as a museum installation, but the reclusive Virgous and his environment had remained invisible to Memphis at large. Within months of Holley's discovery, Virgous's art was hanging in Memphis galleries and the homes of wealthy folk collectors.

From that point on, everywhere Holley went he'd asked people if they knew of any "old, black artists."

One day he queried a former girlfriend in Birmingham.

"No, I don't know anybody like that," she'd said while they sat together on her porch.

"What's this here?" Lonnie had asked, pointing to a concrete flower stand perched in the corner. "What artist made these?" he'd questioned.

"He ain't no artist. My sister is married to a guy in Bessemer," she'd said. "His daddy made that thing."

Lonnie Holley wanted to meet that man.

A July sun torched the asphalt streets of Pipe Shop as Bill Arnett and Lonnie Holley drove slowly searching for that man's modest home. They were a modern-day Sancho Panza and Don Quixote. "This it over here," Holley said, gesturing toward a one-story red brick house. When they got out of the car, Holley coddled a small expressionist sculpture, careful not to let the protruding hooks cut his flesh.

Dial was wary of the odd couple as they approached his door: the radical black man with dreads and the pasty white man. Not long before, a friend had warned Dial that he needed a license to make the "things" he was crafting. Dial was sure now that the white stranger at his door must be a city license-man.

"Mr. Dial, please open up. We would like to see your art, Mr. Dial," Arnett coaxed, holding up the fishing lure. "Do you do anything besides these? Have you made anything else? Any other art?"

"No, man," said Dial behind the door. "I don't know what you talking about."

Arnett tried asking again, phrased it differently. Same response.

"Show him what you do, Lonnie," Arnett suggested.

Holley quickly gathered a soda can, twigs, string, and wire from the yard around him and conjured up a sculpture.

"Oh, you mean that kind of thing?" Dial said as the door eased open. "Yeah, man, I done some of that."

In fact, since the flood that destroyed years' worth of his work, Dial

had continued to create "things" obsessively—not just useful, marketable objects but also things that gave him personal pleasure just in the creation. Many mirrored the world he saw around him—a harsh, unforgiving place—but he didn't imagine anyone would ever care about them. After Clara Mae had told him to "get that shit out of the house," Dial had stashed his art in the turkey coop out back, his junkhouse. What didn't fit in the junkhouse, Dial buried in the dirt.

Thornton Dial disappeared into the junkhouse and reemerged with an eight-foot scrap-metal bird, a turkey tower mounted with an abstract gobbler. Arnett and Holley looked at each other like gamblers facing a machine that blinked "Jackpot!"

"Would you be willing to sell that, Mr. Dial?" Arnett asked. "How much would you take for that piece?"

"What? You must be crazy," Dial said, but thought he was beginning to like this white man. "I don't know, man, give me twenty-five dollars for it," he continued.

"Naw, I'm not going to take it away from you. Give me a price for it," Arnett insisted while Holley stood at his side.

"Well, I don't know give me thirty dollars, thirty-five dollars for it," Dial said.

"No, Mr. Dial, I still won't take it away from you," Arnett said. "I'm gonna *pay* you for it."

At that moment something stirred inside of Thornton Dial, something that he hadn't experienced in a long time. He thought it might be excitement. "Well, *you* give *me* a price on it then, if you think you taking it," Dial countered.

"Will two hundred dollars do?" Arnett offered. "Do you make anything else I can see?"

"What?" Dial said. "Ooh, yes, man, I can make *any*thing. Man, you crazy. You got to be crazy."

By then, Dial's sons had gathered around the negotiation. They were laughing, saying, "You paying him for *that*? Man I'm gone tell you, my daddy gone make a whole lot of stuff for you now."

Chapter 5

CIRCUS OF
THE WORLD

BACK WHEN THORNTON DIAL WAS STILL PLOWING THE FIELDS OF Sumter County, a new syncopated improvisational beat pulsed through the South and radiated around the globe. During the 1930s, jazz single-handedly changed the fortunes of the American music industry and drove record sales up 500 percent. Jazz was an inherently African American musical language, a potent brew of Jim Crow defiance and empowered shout of joy. Louis Armstrong, Duke Ellington, and a host of mega-talented black Americans became international superstars jamming on vibrant, complex tunes that bulldozed classically trained musicians.

At the same time, in the world of visual arts, a similar tectonic shift was afoot. Scattered randomly through the African American South, certain individuals were being compelled by unseen energy forces to toil away at seemingly aimless visual creations that would later be called "folk art," "outsider art," "self-taught art," "visionary art," and a semantic stew of related labels. The field of artists was large and largely disregarded. In rare cases, when aesthetic efforts were uncovered and rewarded, the near-term impact came nowhere close to that of the artists' musical counterparts. Two standouts— Horace Pippin and Bill Edmondson—managed to score well-heeled

patrons and solo shows by 1940. Another, Bill Traylor, would blow the doors off the art world but not until thirty years after his death. But the creative output of these men and women was mostly scattered to dust, lost in attics and buried beneath the sharecropper's plow.

————

William Edmondson was born in 1874, the son of freed slaves. He was a slight man, stretching just five feet tall, who worked odd jobs and lived in a cramped brick house with a narrow yard in a little section of Nashville, Tennessee. In 1931, Edmondson says, Jesus visited him. "I was out in the driveway with some old pieces of stone when I heard a voice telling me to pick up my tools and start to work on a tombstone. I looked up in the sky and right there in the noon daylight he hung a tombstone out for me to make." Edmondson gathered remnant limestone blocks, crafted his own tools, and began carving tombstones for African American cemeteries. The stones filled his yard, and their powerful abstract figures of animals, angels, and people caught the eyes of passersby. One day, a Nashville friend of *Harper's Bazaar* fashion photographer Louise Dahl-Wolfe tipped the shutterbug off to Edmondson. Dahl-Wolfe photographed him carving stone, and, in turn, she passed those photos on to Alfred Barr. Barr was the thirty-something savant of the new twentieth-century aesthetic who, eight years prior, was hand-picked to be the founding director of the Museum of Modern Art. He quickly launched a one-man exhibition for Edmondson in 1937 that was not only the artist's first show; it was also the first-ever solo show of any black artist at the Museum of Modern Art.

Horace Pippin had a similar rocket to fame. Pippin's right arm was blasted by a sniper's bullet during his stint in the trenches of World War I. He settled upon his discharge in a small Pennsylvania town near Philadelphia's elite Main Line and taught himself to paint by holding a brush with his right hand and guiding the maimed arm

with his healthy left one. He made images of war with titles like *Dogfight over Trenches* and *The End of the War: Starting Home*, and later he painted scenes of African American life like *Cabin in the Cotton* and *Mr. Prejudice*. His military disability pay wasn't enough, so he took small jobs as a handyman for retail shops—stocking displays, doing maintenance, and cleaning windows. He also bartered his paintings in exchange for household goods or sold the art on consignment in local stores. "You sure have a nice window display, but you need a painting in there," he would say to the merchants. They put his work up, but it went largely unnoticed until N. C. Wyeth saw it and Pippin's fortune changed. N. C. Wyeth, father of a dynasty of well-respected painters including the famed Andrew Wyeth, was a successful illustrator who lived on a farm not far from Pippin. N. C. Wyeth's eldest daughter, Henriette, suffered polio as a child and her right hand was crippled, but she learned to paint at age eleven by steadying a brush between two disabled fingers. Perhaps it was a combination of Pippin's powerful painted images and Wyeth's respect for what it took to overcome a handicap to make them, but the famed illustrator knew he had stumbled upon greatness when he wandered by a shoe-repair shop one sleepy afternoon. Next to a newly polished pair of loafers, Wyeth spotted a Pippin painting and did a double take. From that chance encounter, it wasn't long before Wyeth helped to organize the first exhibition of Pippin's work outside of a storefront display. A year later, four Pippin paintings were included in a 1938 Museum of Modern Art exhibition, *Masters of Modern Painting*, and within two more years Pippin was being promoted by the prominent Robert Carlen Gallery in Philadelphia. He began scoring wealthy patrons like the eccentric Alfred Barnes, who later included Pippin in his renowned Barnes Collection, and the artist's paintings were collected by Hollywood stars and major museums.

By contrast, during his lifetime, Bill Traylor's marginal recognition was mostly confined to a pint-sized cluster of white Alabama artists. Traylor was born into slavery in 1854 Alabama on a plantation about

forty miles west of Montgomery. Traylor worked on his former master's land after Emancipation, until 1938. That year, with his wife passed, his children scattered, and while Pippin and Edmondson were enjoying their New York premieres, Traylor at age eighty-four suddenly opted for a change. He left the farm and made his way to the city of Montgomery. Traylor was imposing—six feet, four inches tall—a quiet, balding man with a full beard. There in the gritty metropolis, the big man worked a series of jobs until rheumatism finally hobbled his mobility. Amidst the squalor of the Great Depression, he sold pencils on a downtown street corner by day and by night he slept in a room full of caskets at a nearby funeral parlor. Not even Traylor knew what compelled him to switch from selling pencils to using them to draw on a ragged piece of cardboard. "It just come to me," he allegedly said later. But once he started he couldn't stop, and he is said to have churned out nearly eighteen hundred drawings in just over three years. The drawings were what some white observers called "primitive but powerfully drafted" silhouette figures of animals and vignettes of local life. Traylor's makeshift sidewalk studio on Monroe Street was no more than a wobbly chair and an orange crate tabletop.

It was on Monroe Street that Charles Shannon saw Traylor for the first time. Shannon was a young, idealistic artist who had joined forces with six other artists to form the New South School—an art movement meant to "broaden the cultural life of southerners of all classes." Legend has it that Shannon passed Traylor on the street, was instantly smitten with his work, and quickly convinced his cohorts of Traylor's greatness. They brought him professional-grade art materials to work with, and his art became more color-filled. They paid Traylor pennies for his work and collected as much of it as they could to encourage the budding artist. In 1940, Shannon and the New South artists sponsored an exhibition of Traylor's work in downtown Montgomery. The public reception to the drawings of an old, uneducated black man in a city that prided itself on being the "birthplace

of the Civil War" was chilly at best. Still, a year later, Shannon arranged for a showing of Traylor's drawings in New York—at Riverdale's Fieldston School. Traylor's art made its way to Alfred Barr, who presumptuously sent a check to Shannon to purchase several pieces for twenty-eight dollars—no more than two dollars per work. Insulted, Shannon sent back the letter and the check and had the art returned.

Shannon left Montgomery to serve in World War II. For the next several years, Traylor's health worsened and he spent most of the war years traveling back and forth between the Northeast and Midwest seeking the care of various relatives. Traylor returned in 1945 to Montgomery where, according to Shannon's recollection, he died at the age of ninety-three. Shannon had lost touch with Traylor during the war years but held on to his collection of nearly thirteen hundred Traylor drawings. They remained tucked away in storage for the next three decades.

By the late 1970s, Charles Shannon had become a well-known southern artist, a professor at Auburn University at Montgomery, and a respected friend of the Montgomery Museum of Fine Arts where he was valued for the potential of bequeathing his own artwork, not Traylor's.

After persistent urging by his second wife to "do something" with the Traylor pieces taking up space in their attic, in 1979 Shannon connected with the R. H. Oosterom Gallery in New York, and they launched the first exhibition of Traylor's artwork in thirty-eight years. The show received a relatively warm reception. Back in Alabama, however, Traylor's reintroduction to society was met with about the same fervor as it was in 1940. When Shannon donated thirty-seven Traylor drawings to the Montgomery Museum of Fine Arts there was dissent among the curatorial staff as to whether or not to accept the gift. A young staff member at the time, Marcia Weber, said the overriding feeling was that "this didn't belong in the museum because it wasn't fine art." Still, Shannon was a fine artist from an old Montgomery family, the gift was generous, and the curators hoped Shannon would eventually donate his own artwork to the museum. They took the Traylors.

The terms of Shannon's gift included one stipulation that set an awkward challenge for the genteel curators: Traylor's art must be given an opening exhibition. The task fell to the newbie, Weber. According to Weber, the curators told her, "We are not going to embarrass the docents by training them on this material. . . . You'll have to do the tours." Since the more "appropriate" art was already occupying all of the best exhibition space, the only section of the museum available for the exhibition was known by the staff as "the hallway to nowhere." Weber cleaned out this makeshift storage hallway next to the museum shop and hosted the early 1980s exhibition of Traylor's art there. "I ran out and bought Pepperidge Farm cookies and wine for the opening. I would be speaking and could hear the cash register going *ka-ching* in the shop next door. What a dog-in-a-manger show that was," Weber recalled.

Three hours drive northeast on I-85, in Atlanta, Peter Morrin had settled in to his new role as the curator of twentieth-century art at the High Museum. In 1981, Morrin had been invited to lecture at the Montgomery Museum. Since he was helping to build the High's nineteenth- and twentieth-century drawings collection, he asked to see their collection. He was shown Traylor's art. Morrin had never heard of Traylor but was struck by how much the artist's aesthetic tied into the more contemporary work of trained artists. He was intrigued and reached out directly to Charles Shannon, who was still determined to get Traylor's work in major museum collections. Shannon had divided up his cache of Traylor drawings into five groupings of twenty to thirty, reflecting several different themes: thirty street scenes, thirty with horses, thirty with dogs, thirty scenes of drunken revelry, and so forth. The High Museum was the first to purchase a bundle of Traylors. Peter Morrin picked up thirty drawings for ten thousand dollars in 1981.

While Morrin was passing through Montgomery, representatives of Washington, D.C.'s oldest art museum were hot on his heels. The Corcoran Gallery of Art focused on American art, and under the

leadership of a rising superstar director, Peter Marzio, the museum had made enormous strides.

Marzio was a museum director of unusually humble stock. His father died when he was a child, and young Marzio came under the care of three Italian professional prizefighter uncles who raised the boy in tough New York neighborhoods. "One of the first black people I ever saw was Sugar Ray Robinson because one of my uncles worked out in the same gym," Marzio remembered. He also recalled the racial tensions he saw growing up, and he said he could never quite understand the reasons. He later became an active participant in the civil rights movement, including, he claims, participating in the Selma-to-Montgomery march in 1965. Marzio's sports were wrestling and football, and his athletic ability earned him a scholarship to a small liberal arts college in central Pennsylvania. He caught the art bug after a trip to a New York museum, and he went on to earn a Ph.D. in art history from the University of Chicago. As he climbed the museum ladder, Marzio's pluralist past influenced his professional thinking about art. "I was interested in how the Academy—the traditional arts power structure—could accommodate something new," Marzio said. His scholarly work increasingly reflected this interest as he published books exploring "the democratic art." Marzio's sentiments weren't always well received by his art-world counterparts, "When people want to knock me they see me as a populist. Critics use it in a demeaning way."

On the other hand, some embraced Marzio's notions with passion. In Jane Livingston, Marzio found a chief curator who shared his vision of art democratization. Livingston was a Southern California native educated at Harvard who joined the Corcoran staff in the mid-1970s. Livingston and Marzio both noticed that energy seemed to be seeping out of the American art scene. They also saw that the Corcoran's programming, while relatively cutting-edge, wasn't particularly diverse, nor did it appeal to a broad audience. Marzio challenged Livingston to develop exhibition ideas that could address this problem without compromising artistic standards.

In 1975, Livingston learned about the art of O. W. "Pappy" Kitchens, and she included his work as the sole "folk art" representative in the 1977 Corcoran biennial exhibition. What struck Livingston was not just the aesthetic quality of Kitchens's art but the invisibility of it to almost anyone in the art world or beyond. She was certain that there must be more artists like Kitchens, and she began to seek them out. She suspected that black folk art represented a phenomenon that didn't register in the art world but that needed attention and was worthy of it. In 1979, Marzio gave Livingston the go-ahead for an exhibition idea that would be ripe with energy and controversy . . . and would stretch the notion of the populist museum.

Livingston recruited a young freelance curator, John Beardsley, and together they set about on a yearlong odyssey of the southern United States in search of the most notable self-taught black artists. "We got in the car and cruised up and down I-85 from Atlanta to Montgomery down to New Orleans and up and back again," Beardsley said. They checked out the yard shows—creatively arranged displays of found objects that appeared occasionally in the yards of black southerners. The curators also put the word out to folklorists, museum curators, and the dearth of folk art collectors: people like the flamboyant Herbert Hemphill, who was perhaps the most voracious folk collector at the time.

The southern art grapevine generated a cold call from a man named Charles Shannon who told Livingston and Beardsley about an artist whose work, he proposed, they needed to see. They had never heard of the late Bill Traylor, but on a trip to visit Montgomery artist Mose Tolliver they took time to meet the man who championed Traylor's work. They remember Shannon as a soft-spoken southern gentleman who was anxious to get more recognition for the black artist he had befriended in the years before World War II. "We had no doubts about Traylor's work from the beginning," Beardsley claimed. They liked it so much, in fact, that Traylor's work would not only be included in the exhibition, but one of his drawings would adorn the show's catalog.

In no more than eighteen months, the curators had completed their search, chronicled their findings, and mounted an enormous exhibition that spanned several Corcoran galleries. They brought together twenty artists—most from the South, and many of whom came to Washington, D.C., for opening-night festivities. *Black Folk Art in America: 1930–1980* opened on January 13, 1982, coincident with a nasty blizzard of snow blanketing the D.C. area and the horrific crash of an Air Florida 737 into the Potomac River. "The catering truck got stuck in a snow bank, and helicopters were hovering overhead lifting people out of the water," said Beardsley. The show went on.

The night of the *Black Folk Art* opening, the Corcoran crew stayed up late enough to catch the early edition of the *Washington Post* on the newsstand before heading home. A review by arts columnist Paul Richards gave the show thumbs-up. Glowing reviews poured in from then on from leading publications like *Time* magazine and the *New York Times*. Beardsley remembered that *Washington Post* metro section columnist and prominent African American journalist Dorothy Gilliam "came in before the show opened and was ready to slam us because we weren't regularly showing sophisticated, trained black artists at the Corcoran and here we were showing these untrained, uneducated guys. Jane said, 'Please see the show and then we will talk.'" Gilliam did see the show, and even she admitted it was a great exhibition.

Not everyone agreed. It was hard to find takers, for instance, for a traveling exhibition of the show. "In the beginning no other museums wanted the show, and we couldn't find anyone to fund it. They just didn't think it was art," then–Corcoran director Peter Marzio says.

Then the charges of racism began. Many trained black artists felt they had been passed over. After years of toiling and playing by the rules of the art world and applying their classically trained skills in exchange for meager exposure and even less money, here came these illiterate nobodies to steal their thunder. And all in the name of highfalutin' white people championing African Americans who by association, the argument went, would be displayed as quaint rural *Negroes*

under the paternalistic thumb of the intellectual urban regime. Cultural warriors in support of trained black artists went into battle. "I was visited by a number of women from the Links (a national association of professional women of color) and from various African American sororities who berated me for doing black folk art because it was demeaning to show blacks as untrained and uneducated."

The attacks came not just from African Americans but from white academics too. Dr. Eugene Metcalf, then an associate professor at Miami University in Ohio, wrote a scathingly critical tome for the journal *Winterthur Portfolio* called "Black Art, Folk Art, and Social Control." In it, he argued that those who have the power to label something have the power to control it. By labeling the work "black folk art," the curators had—though perhaps unintentionally—demeaned the art and artists. The exhibition exploited them. "The promotion of folk art, like the promotion of black art, was carried on by an elite and served to support and extend the status of that group, often at the expense of the people whose work was being promoted," Metcalf wrote. He claimed that the Corcoran's description and presentation of the work shown pandered to "dangerous and socially debilitating a priori assumptions about black people and their art." Even more than twenty years later, Metcalf believes the show was off the mark. "I think the show was racist. When white people call black people's art ugly, there is something going on there," he said.

Curiously, Metcalf received almost as much backlash for his black folk art article as the Corcoran received for its *Black Folk Art* show. In some ways, it could be circuitously claimed, simply by writing the article Metcalf was building his own reputation off the backs of the black artists just as he accused the curators of doing. What right did a white man have to address this topic? More offensive to those who found it so was the stance Metcalf took. He remembered, "A lot of people didn't like it. White folks didn't like the article because a lot of good-hearted white folks were supporting black art, and here I come along and said this is racist. Blacks didn't like it even more. The middle-

class black communities always had problems with black folk art, but here's this white guy that seemed to be saying this is no good, and that was equally unacceptable."

While the battle of the politically correct simmered, the artists of the Corcoran exhibition were becoming celebrities. Nancy Reagan attended the show, and the paparazzi snapped photos of her with each of the artists attending.

Another phenomenon drove the market for folk art in the early 1980s, and his name was Reverend Howard Finster. Finster retired from his role as a Baptist preacher in the mid-1960s, about the time he had a new "calling": In the course of a bike repair, a smudge of white paint on his finger developed a face and spoke to him: "Paint sacred art!" it said. His new sermons took the form of paint on wood—illustrated stories in acrylic and magic marker that implored viewers to seek salvation. He painted incessantly and scraped together materials from his hometown of Summerville, Georgia, that he shaped into painted sculptures strewn about his yard. He built entire structures to house these objects, and the structures themselves became painted art until he had transformed his home into a fantasy of folk art called Paradise Gardens. One inscription from his Garden best describes the place and the man:

> I TOOK THE PIECES YOU THREW AWAY
> AND PUT THEM TOGETHER BY NIGHT AND DAY
> WASHED BY RAIN AND DRIED BY SUN
> A MILLION PIECES ALL IN ONE.

In the mid-1970s, word had spread about the zany painting preacher from north Georgia, and he was recognized in national publications like *Esquire* magazine. Curiosity seekers by the thousands made the pilgrimage an hour north of Atlanta to check out Paradise Gardens. They could leave the Gardens with a Finster original for next to nothing. Among the visitors were rock stars from the bands

R.E.M. and Talking Heads, and each band soon used Finster paintings as the artwork for best-selling albums. By 1983, Finster was featured on the *Tonight Show* with Johnny Carson, where he played the banjo and regaled a national television audience with Appalachian folk songs.

As the 1980s advanced, so did the stock market. As Wall Street fortunes rose to spectacular heights, they were rivaled only by a swollen Japanese economy linked to skyrocketing land prices. Massive pools of disposable personal wealth from Manhattan's financial moguls as well as from Japanese and European industrialists seeking conspicuous outlet found their way into the art market. The staid Christie's and Sotheby's art auction houses became casinos for the nouveau riche. Swarms of Gordon Gekkos ran up auction prices for masterworks and minor works alike. Van Gogh's oil painting *Irises* sold for a record $53.9 million in 1987. Works by Picasso, Monet, Renoir, and other masters were topping $20 million at auction easily and regularly.

The folk art market, too, was riding a financial boom, though not of the same proportions. The cache of Bill Traylor drawings that Charles Shannon collected for loose change in 1940 and Peter Morrin had picked up for ten thousand dollars in 1981 was worth over $1 million by the close of the 1980s. Edmondson's work similarly skyrocketed, fetching tens of thousands a piece.

Buying low and selling high is the economic DNA of American enterprise, and this doctrine now replicated itself through the folk art world. Buying folk art was like buying penny stocks: inexpensive and accessible to regular Joes who wouldn't ordinarily be allowed through the hallowed halls of Sotheby's Auction House. Dealers, scholars, curators, and collectors rushed across the folk art landscape like pioneers staking homestead claims.

The savviest pioneers stake the best claims. In the case of self-taught art those pioneers were called "pickers," and they already had their ears to the rural ground. Pickers are a street-smart breed of antique dealers who scour the backwoods poking their heads into the

homes of the recently deceased or the soon-to-be, into the attics and closets of those who might not know better in search of antiques that the picker can get for next to nothing and resell for a small fortune. Atlantan Jimmy Allen was once described in a *Los Angeles Times* article as "king of the pickers." Allen bragged in the report, "Oh, there's no doubt. I'm unquestionably the best." Allen got his start as a picker in the mid-1970s seeking handcrafted decorative items and furniture that caught his fancy. He had an innate drive to possess objects of great beauty. "I had a huge emotional investment in these things. I was so heavily invested in them that, in some ways, I swapped self-esteem for the objects," he says. Allen was a scrappy fighter in the realm of ultracompetitive antique dealers. "One guy I know would carry a basket of apples around in rural areas selling five apples for a dollar. He had no bags to give over the apples, so the woman answering the door would have to go into the kitchen to get a bag. She would invite the guy in, and he would go in and look around to see what she had in the house. He might come back for years and years trying to buy her stuff. It was a very competitive knife-in-the-back existence," Allen remembers. Allen played the game as well as any. He describes one instance when he saw an object he wanted so badly that he sat on the doorstep of the owner in the north Georgia hills "through lunch and dinner" until the family let Allen in and sold the one-of-a-kind piece to him. In the early 1980s, soon after the Corcoran show, Allen's interest in self-taught art grew. To be a successful folk art collector required the same skills he already had honed in the antiques world. He found the competition was just as fierce. He remembers, "A curator I knew in Alabama took me to see the folk artist Mose Tolliver who lived in Montgomery. It was the first time I had seen his stuff, and I hated it at the time. We got there, and there was a huge Lincoln Continental rental car sitting out front. Two white people came out of the house talking in a feverish, almost-repugnant way about what they had bought. They opened their trunk, and inside was a mountain of Mose T.'s work."

How does a professional artist—educated in art at the university and then setting out on his or her own in the great art metropolis—learn to deal with the commercial aspects of the art world? They might pick up Caroll Michels's book *How to Survive and Prosper As an Artist*. There they would learn about the nuances of a consignment contract with art dealers—the gatekeepers of the art marketplace. Mainstream contemporary art dealers most frequently agree to represent an artist's work in the dealer's gallery only on a consignment basis. No risk for the dealer if no sale is made, and a 50-50 split of the price if a sale occurs. In her book, Michels cautions artists about the hidden costs of dealing with certain less-than-scrupulous dealers. She writes that art dealers often "see themselves as martyrs who are taking a big risk simply by selling art for a living." Michels, a sculptor herself, goes on to say that because of this art dealer self-perception, many dealers "rationalize that it is fair and just to use an artist's share of a sale to offset gallery cash-flow problems." As a result, some artists only get paid by their dealers when it suits the dealer's economics, which may be never. In her chapter "Dealing with Dealers and Psyching Them Out," Michels offers three key pieces of advice to artists entering the market for a dealer. First, she says, "Beware of dealers who don't use contracts." Next, she offers, "Think twice about entering into an exclusive relationship." Third, "It is important that artists develop an autonomous posture and make their own career decisions."

How does a self-taught artist who never made it past the third grade but who wants to offer his creations to the world learn to deal with the commercial aspects of the art world? It is unlikely that he or she would mosey over to the Barnes and Noble, pick up Michels's book, and sit in the adjacent Starbucks with a Venti Frappucino to learn the ropes. Besides, the ropes of the folk art market were unlike any that stretched across the contemporary one. For one thing, folk art dealers in the mid-1980s didn't usually operate on a consignment basis. Rather, collectors or pickers or the dealers themselves would buy directly from the artist—at which point, the folk artist earned

whatever pittance he ever would off of his imagery. Then, once in the dealer's hands, the gallery would sell the art for whatever it could—often marketing it up multifold over the original price—and would pocket all of the proceeds. For another thing, contracts with self-taught artists were often nonexistent or oral at best. Further, collectors and dealers developed close bonds with their folk artist friends, and exclusive—or, at least, favored—relationships often were forged. Last, it was a topic of some debate as to whether or not the average "naïve" outsider artist had the capability to "develop an autonomous posture and make their own career decisions."

Nellie Mae Rowe had a primary art dealer: Judith Alexander. Rowe landed a role in the Corcoran's *Black Folk Art in America* exhibition in 1982. Of the twenty-five Nellie Mae pieces on loan for the Corcoran show, nineteen of them came directly from Judith Alexander's stash. Nellie Mae was not the star of the show, but she was at least a significant supporting actress, which provided great satisfaction for both her and her patron. "When Nellie knew that she was in that Corcoran show in Washington she knew she was important and said she wanted to be an artist. I think she always knew that she was an artist though she hadn't used that word before to describe herself," Alexander says. The Corcoran show put both Nellie Mae and Judith Alexander on the national art scene. When, ten months after the *Black Folk Art* show opened in D.C., Nellie Mae Rowe quietly died of cancer at her Playhouse, Judith Alexander continued Rowe's legacy at the Alexander Gallery in Atlanta. Alexander added a bevy of Georgia artists to her folk art assembly: Linda Anderson, Ned Cartledge, Benjamin Jones, and a host of others. She championed each with all she could muster and, as she did, her reputation as the "folk art lady" grew to vaulted proportions. Alexander was the source, the authority, the sage, the prime dealer—at least in Atlanta, at least for the moment.

While pickers, gallery owners, and dealers were seeking folk art bargains that could be resold for big profit, many collectors were simply in it for the "rush." Foraging for folk art was a hobby that offered travel,

shopping, adventure, and great stories to tell friends at the next cocktail party. Getting in the Volvo and schlepping across Alabama with picnic lunch, camera, and cash provided respite from the overblown status-seeking 1980s decade that transformed former flower children into brazen capitalists. Those who didn't want to go on expedition by themselves could join a group tour. The Folk Art Society and the Museum of American Folk Art sponsored guided explorations into the woods of Alabama, Louisiana, and other self-taught-art hideaways. "It was fun going out and finding and meeting the artists. Their works were new, different, visionary, and really pure," remembers one enthusiast. Unlike trained contemporary artists, folk artists were directly accessible. Therein lay the real buzz. One could drive right up to their homes and load up the car; one could rub right up against their "purity," and then take home some of the magic, vision, and purity to hang on one's very own wall.

In 1983, Yale University art history professor Robert Farris Thompson penned a landmark book that took the lines formed by the Corcoran's folk art exhibition and extended them beyond the horizon. Thompson's *Flash of the Spirit* sought to demonstrate how the cultural traditions of various African civilizations continued and flourished once they leapt to the other side of the ocean and flashed in the aesthetic traditions of contemporary American black culture. *Flash of the Spirit* is about visual and philosophic streams of creativity and imagination, running parallel to the massive musical and choreographic modalities that connect black persons of the western hemisphere . . . to Mother Africa," Thompson wrote. Robert Farris Thompson was an unlikely author for a book about black culture, having been born to a wealthy white New England family and schooled at the elite Phillips Academy in Andover, Massachusetts, and at Yale. Still, he crafted a careful argument demonstrating the startling similarity between symbols and objects of the black old and new worlds. Spirit-embodying materials used in Yoruban culture popped up centuries later in the works of folk craftsman. Gnarled, twisted tree roots that protected Kongo warriors rose from the ancestral ether in the form of High John the Conqueror Roots conjured to fend

off unseen enemies. Bottles hung from trees to invoke magical energy forces. Flowerpots upside down on gravestones and old tires planted in the garden and an assortment of reclaimed doodads all linked somehow back to Africa. These visual traditions perpetuated themselves, though in increasingly diluted form, as successive generations of African Americans exposed each other to their collective heritage. Thompson wrote of one folk artist's influences, "His travels through Louisiana, Alabama, and Mississippi took him through bottle-tree territory, past cemeteries gleaming with the traditional deposits, past black houses with automobile tire sculptures in their yards, past other fleeting images of artistic motion redistilled."

The curatorial writings of Jane Livingston and John Beardsley, alongside the critically acclaimed Thompson work, invigorated academics in universities and education directors at museums across the country. In academia and in the arts academy, a parallel land grab began, one in which ideas, not land nor canvases, were the golden prize. Scholars wielded folk art hypotheses like pickaxes with questions that joined museums and the ivory tower in a mental circle jerk of inquiry. "What should this art be called? Folk art? Outsider? Visionary? Self-taught? What is the role of biography, and why can't this art stand on its own? What is authentic, and what isn't? What is art, and what isn't?" Those who could put forth the most impressive and original theories about folk art would reign intellectually supreme. Tenure might follow, or a book deal with the university press. Those in the lowly role of museum education director might receive promotion to curator, and curators might move up to museum director. While folk art explorers were scrounging for "pure" authenticity, their intellectual counterparts were digging purely for reputation.

Through the folk art 1980s, scholars, collectors, and dealers mingled together in a folk art fraternity. They traded artwork, and they traded ideas. Beyond a common interest in the creations of untrained artists, folk fraternity members shared a rivalry to possess the best that those artists produced. University of Chicago sociologist Gary Fine

spent years studying the behaviors of participants in the folk art market and found a closed community filled with turmoil. For his 2004 book *Everyday Genius: Self-Taught Art and the Culture of Authenticity*, Fine revealed the dynamics of this insular clique in which he was compelled to conceal the names and identities of the "informants" who spoke with him about peers in the folk art cabal. "On some occasions (once with a widely admired dealer), I found myself turning the tape recorder on and off repeatedly as my informant wished certain remarks off tape, but couldn't quite decide which ones. Further, as this was a tight-knit world with friendships and animosities, informants could be quite pungent in their assessments," says Fine.

The folk art market in the 1980s indeed was a small town where merchants competed during the day and played together on the weekends—a town where rules existed but informality was most cherished, and where barter rather than cash was the means of exchange. In this unique town, carved roots and painted tin replaced livestock and fall harvest as trading currency. As in most towns, there were haves and have-nots. Collectors, dealers, scholars, and curators had resources and access. The artists had talent, but were outsiders in this world. Without the collectors, dealers, scholars, and curators, artists' entry into certain sections of this town was closed, though it was better, some thought, not to fetter the artists' purity with exposure to those sections of the art world and the filthy lucre that circulated there.

Still, whether rich or poor, the folk art citizenry shared a common joy for their idyllic world outside the mainstream, and they also shared a protective instinct to keep it to themselves. It was not to last. This particular town was growing faster than anyone expected, and it couldn't retain its mom-and-pop character much longer. Sooner or later, every small town with a spark of life is visited by Wal-Mart. To many, Bill Arnett was starting to look like Sam Walton.

Chapter 6

FOLKS LOST
IN THE WOODS
FOUND BY MR. DIAL

FOLK IS A FAMILY BUSINESS. "FOLKS," AFTER ALL, IS OFTEN USED TO mean members of family, as in, "Come on over and meet my folks." Sometimes "folk" extends to a broader community—encompassing not just blood relatives but others who share a common bond.

John and Alan Lomax were folks of the family kind: father and son. For the better part of the twentieth century, they dragged a five-hundred-pound tape recorder through southern cities and rural back-waters to find the most authentic sounds of the nation. Together, they were known as the men who discovered the blues and were cred-ited with revitalizing folk music in America.

Over time, Alan's prestige overshadowed his father's and, when Alan died in 2002, the *New York Times* wrote: "He did whatever was necessary to preserve traditional music and take it to a wider audi-ence. Although some of those he recorded would later become inter-nationally famous, Mr. Lomax wasn't interested in simply discovering stars. He advocated what he called 'cultural equity: the right of every culture to have equal time on the air and equal time in the class-room.' Lomax once said, 'I've devoted my entire life to an obsessive collecting together of the evidence.'"

Some folks say that Bill Arnett and his family are the Lomaxes of

folk art. Arnett's oldest son, Paul, looks as though he just walked off the Yard at Harvard: wearing a thick gray cotton sweatshirt with red letters bearing the name of his elite alma mater, sandals, no socks, khakis, and a day's beard stubble. He has a professorial manner—a slow, considered meter to his speech. About a quarter-century younger than his father, Paul has the old man's intellect. His brothers call him a "brain on a stick." He introduces himself as an art historian, and though he has not earned a Ph.D. in the subject, in many ways he has served a lifelong art history apprenticeship. Paul Arnett's formal field training began when he joined his father's folk art collecting in 1987 shortly after his undergraduate education at Harvard and just prior to Bill Arnett's first encounter with Thornton Dial. By the end of 2004, all four Arnett sons would work in the business alongside Bill Arnett.

The Arnett family art enterprise is centered on a sixty-thousand-square-foot warehouse stuffed with self-taught art of every kind and especially the artwork of Thornton Dial. Arnett critics say woefully, "They've got the best pieces locked away in there." It appears that nearly any completed Dial piece that has not been sold or given away resides in this vast storage facility. The first piece Bill Arnett purchased from Dial, the towering turkey, is tucked away in the farthest reaches of the dark, cavernous space, and you can view the rest of the Dial inventory positioned variously throughout the building. Near the turkey are several other early works made not long after the Arnett/Dial acquaintance began. Paul Arnett leads visitors through the warehouse like a Louvre curator: describing, educating, persuading viewers to understand and embrace Dial's work. He points out an iron and tin sculpture that Dial has made—birds perched on a wire. It has the title, *Birds Don't Care Whose Head They Shit On*. Paul Arnett explains, "There is a pervasive theme in African American folklore about nature's indifference to human classifications and differences."

Paul Arnett traveled with his father regularly through the late 1980s. Bill Arnett needed the help. Not yet medicated for the diabetes

that was exhausting him, Bill Arnett's stamina was eroding and his low-blood-sugar bouts of irritability were becoming more noticeable. After 1987, the year the Arnetts first met Thornton Dial, Paul and Bill Arnett visited Dial with increasing frequency. They claim that, right from the start, they knew that Thornton Dial was a standout artist—different, special, better than the rest. Dial was more skeptical of the relationship, but money made the risk worthwhile.

"Paul told me, 'You just stick with my daddy,'" Dial says. "He said, 'Now we can keep up with your art, and we'll hold it all together. Eventually you will be making more money than you ever made in your life.' I said, 'Well, I'm gone stick with it.' They asked, 'How much is it going to cost you to retire from the stuff you are doing to paint full time?' I said, 'I don't know . . . maybe six hundred or seven hundred dollars a month.'" Dial went on the Arnett artists' payroll, and from that point on he had full freedom to create art and nothing else if he chose.

Still, it took time before the artist and patron fully understood each other. During one visit, Paul Arnett recounts, Bill Arnett was asking Dial about a color field within one of his paintings.

"What's that orange part about?" Bill Arnett asked, pointing to an orange field of paint on the wood surface.

"There's no orange. That's not an orange. That's yellow," Dial asserted.

An elliptical "Who's on first?" dialogue proceeded through several rounds until Arnett, bemused, finally broke the cycle. "That's orange. Are you color blind?" Dial was not color blind. He thought Arnett was saying there was an image of *an* orange—the fruit—in his painting. It had never occurred to Dial that orange was the name of a color. Before meeting Bill Arnett, Dial identified any color that was more yellow than red as the color yellow. To make communication with Arnett even more complicated, Dial's hearing was going bad from all the years working next to screeching boxcar machinery.

Though Dial's and Arnett's facility with each other's language took longer to develop, Dial's development as an artist was a rocket

shot. He discovered that there were more ways to produce art than welding scrap metal and bending wire. He was introduced to the notion of assemblage, sculpture, and painting. Coupling found objects with professional-grade art materials that Arnett began to supply him during regular visits, his work evolved rapidly. Many in the folk art community bristled at this. It was a poisoning of the artist's purity, they claimed, to bring him materials or influence him in any way. What made an artist like Dial a true "outsider" was that he had to create within his isolated, poverty-stricken conditions without contamination from the real world. Then, it was argued, his work was truly authentic. Arnett ignored this dictum. "I've changed my view from 'no patron interaction' regarding the art to 'artists need mentoring,'" he says. "Conscientious artists want to know what I think about their art. We don't have prolonged discussions, but I'll tell them now, where for a long time I didn't." This infuriated his detractors, but that didn't stop Arnett. Besides, says Arnett, "It doesn't matter what you do, people will jump on you."

Then and now, for the most part, Dial provided his own art materials. Scavenged them, really. Ask where he gets his creative supplies, and the artist provides a cagey response. "We finds it. We finds it," he says, careful not to reveal where or how. You can find just about anything in a Dial work: rope and carpet and metal, house paint and old dolls, wire and tin and wood, road-kill, pig bristles, a dead house cat—things that are not typical fare in an art supply shop.

And while the Arnetts may have offered money, paint, and brushes, they also offered much more. They delivered encouragement, respect. They referred to Thornton Dial as "Mr. Dial," for instance, not "Buck" or "Thornton." And whatever the initial motivation, real friendship and genuine trust seemed to grow: not just among the men but also among their folks. Clara Dial says, "They would come spend the night here. We would spend the night at their house."

"They good people, man," Dial agrees. "I didn't know he was gonna be. I had a lot of collectors to come out, because you know, after he

started, people begin to find out about me, but I didn't never fool with nobody but Mr. Arnett. I try to be as true to Mr. Arnett as I could be."

Dial still couldn't get over that he might make a living through art, but here was this white man and his son giving him money each month, so that's all he would have to do. It seemed as if sixty years of bottled-up observation and frustration poured out of his hands and took life. Honoring his past heroes and struggles became a common theme of Dial's art. His relatives were frequent subject matter. Most often, the women in Dial's life were front and center: Sarah Dial Lockett, his grandmother, and the other women who raised him. Resurrected through Dial's art, these heroines were icons of the broader category of African American women of their generation and of strength, love, and generative creativity.

Through art, Dial could do the things he never could do before, and he could express what he had for so long not been able to describe in words. But a lifetime of learned caution taught him to do so carefully. Dial created in code. Symbols and veiled references were his words representing the violence and cruelty around him.

"Everything is done obliquely with Dial—for pragmatic reasons," says Paul Arnett. He likens Dial's approach to the African American tradition of signifying—a language within the language that is twisted and reshaped, using recognizable words and symbols but with an innuendo of meaning encoding a scaldingly sarcastic message.

Dial began to use the image of a tiger in his work. Some would say that his use of the tiger image was influenced by Dial's proximity to Auburn University, whose mascot is the tiger. Others would claim that he took his cue from oral African American tales or "toasts" that often feature stories of lions, monkeys, and elephants, where the signifying monkey taunts and teases the uppity lion into battle with the elephant, who roundly trounces the feline. Dial's early work was tiger and monkey heavy. While these factors may somehow have come into play, to the Arnetts the tiger was symbolic of black men struggling in a white world, like Tiger Thompson, the black union leader

whom Dial had admired earlier in his life. Dial himself says Thompson was the person he had on his mind when the tiger first emerged from his paintbrush.

In 1987 Dial continued to work with metal and found objects. His first piece featuring a tiger, for instance, was made of steel, tin, enamel, tubing, and tape. Another smaller piece at this time, *The Old Cat*, was made with a steel chair arm, plastic, wood, house paint, and industrial sealing compound. As 1987 progressed, Dial began to produce more painterly work. He found large sheets of wood and spread color across it and then bound the detritus of society to the painted wood with industrial sealing compound. When Dial learned that fabric held paint better than wood, he created makeshift canvases by taking old cloth, stretching it over plywood, and applying paint in dense impasto strokes. Over time Bill Arnett began supplying Dial with more traditional, professional canvases stretched by John Ricker, a hired hand who camped out in Arnett's warehouse. Ricker had recently joined Arnett's team and was saddled with a variety of odd jobs like guarding the warehouse, building canvas stretchers, hauling art from Dial's home back to Atlanta—all in exchange for shelter for him and his dog.

"What do you call that piece, Mr. Dial?" Arnett would ask early on.

"What do I call it?" Dial would say puzzled. "I don't know about calling it nothing."

"What's it about?"

"That's about boys fighting and dying in Vietnam, man. In the hills and mountains of Vietnam."

Arnett would write the title *The Hills and Mountains of Vietnam* on the back.

The titles of Dial's pieces from the late 1980s show Dial's ability to penetrate the calloused surface of life to the pain, politics, and absurdity that lay below. Sometimes Dial's work reflected warmer topics. The powerful women who guided his life appeared frequently in works like *The Mother Tiger Will Scramble for Her Cubs*. Sometimes

he shifted to observe and chronicle his present conditions as in *Folks Lost in the Woods Found by Mr. Dial*. Other times, he touched open wounds in society and in his personal history such as the work honoring his daughter Patricia, entitled *Handicapped Tree*.

Whatever the subject, Dial was a fury of constant motion, reminding Paul Arnett of Goethe's famous line, "Never hurry, never rest." Thornton Dial puts it more directly: "Art ain't about paint. It ain't about canvas. It's about ideas. Too many people died without ever getting their mind out to the world. I have found how to get my ideas out, and I won't stop. I got ten thousand left."

———————

Dial's folk had things to say as well.

Arthur Dial began to paint. He had always been lockstep with his brother Buck in just about everything. Whether it was working the fields of Emelle or working the steel at the Pullman. Now, with the attention and money Thornton Dial was receiving from Arnett, Arthur began to spend more time making things of his own. Arthur had talent, too, though his pieces lacked the pure, original passion of his brother's. The Arnetts encouraged Arthur and bought work from him, but he was no Thornton Dial.

Thornton Dial's oldest son, Little Buck, also turned to art. His work had more of the raw intensity that his father's pieces displayed. Little Buck's intensity revealed itself in a religious passion, seen in the crucifixes that he created during a particularly productive creative period. The Arnetts bought from Little Buck, too, but he was no Thornton Dial.

Little Buck's younger brother, Richard, thought that he might have inherited the artistic gene too. He had a flair for furniture design, which was the basis for his struggling business, Dial Metal Patterns. During downtime at the furniture factory, Richard experimented with one-of-a-kind chairs that looked more like modernist sculpture than

like seating. Bill Arnett was impressed and added Richard's works to his expanding collection. Still, he was no Thornton Dial.

By 1989, the *Atlanta Journal-Constitution* reported that Thornton Dial "is not only making things, he is making an impression on the art world from Bessemer to New York as the patriarch of a family of 11 folk artists." The newspaper noted that in addition to Dial's brother Arthur and sons Richard and Little Buck, Arthur's son, Arthur Jr.; Arthur's grandson, Carlos; Dial's other children, Mattie and Donnie; two grandchildren, Thornton III and Richard Jr.; and cousin Ronald Lockett were also creating art.

The first official exhibition of Dial family artwork took place in 1988 at the home of Bill Arnett, just behind the Governor's Mansion in Atlanta. It was a group show featuring all of Arnett's artists, and works from his extensive Chinese and African art collections. The occasion was a fund-raiser for *ArtPapers* magazine—an inventive, Atlanta-based, not-for-profit operation that covered contemporary art topics on an increasingly national basis.

That night, armies of Dixie mosquitoes braved the citronella torches and staged persistent blood-raids on the mostly white-skinned crowd. The party guests didn't notice. They were busy chatting, drinking, and soaking up art and atmosphere. The Georgian sky was clear through the rich back-yard foliage. Son Thomas—a former graveyard worker turned blues singer and artist, featured in the 1982 Corcoran exhibition—graveled out a rendition of "Catfish Blues" over his slide guitar, with a chorus of cicadas.

Through the living room of Bill Arnett's house, Dial, dressed in suit and tie, could see out into the dusky backyard where some people gathered around a table. Dial's cousin and fellow artist, Ronnie Lockett, motioned to the gathering,

"Them white folks is fixing up drugs to give you," Lockett explained. "Man, you know they got some *dope* out there."

Dial sweated through his dress shirt for fear of the white pushers.

There were no drugs at the party. The table that Lockett and Dial worried about was the bar.

Dial stood stiffly on the sidelines. The high-toned insiders raved to him. "Thornton," they called him, "we love your work." He forced a smile.

"Pleased to meet you," Dial cordially replied. He stuck his hands deeper into the pockets of his suit and looked around quickly to make sure Clara Mae was nearby.

Jerry Cullum, a respected Atlanta art critic, met Dial for the first time at this party. "People kept calling to Thornton Dial on a first-name basis. 'Hey, Thornton,'" Cullum says of the night. "Bill Arnett would only call him *Mr.* Dial. It was very noticeable and seemed symbolic to me, like Bill was harkening back to the older South that was more formal. Except that's how blacks addressed their white superiors, not the other way around."

Across town, the High Museum of Art was planning a folk art show of its own. For eight years, Barbara Archer had risen through the High's ranks as part of its education department. She shared curator Peter Morrin's interest in self-taught art, especially in the educational implications of the work. Morrin proposed to Archer that they co-curate the first encyclopedic exhibition of self-taught art of the South. The result was *Outside the Mainstream: Folk Art in Our Time*, which launched in 1988 at the High Museum. The show included work by Thornton Dial, Lonnie Holley, and Ronald Lockett, as well as a slew of others both white and black. It would be Thornton Dial's first inclusion in an official museum show. Still, some at the High didn't believe that this was real art. As if the title of the show willed it to be, *Outside the Mainstream* was relegated to a facility outside the mainstream of the Woodruff Arts cultural hub: the High Museum's downtown adjunct space below the lobby level of the Georgia-Pacific Building.

Despite its stepchild treatment by the High, *Outside the Mainstream* drew huge crowds to the downtown museum location and drove revenue and membership increases for the High Museum. "Even Vig, who didn't like the idea of self-taught art and was very against it, couldn't help but be pleased with the results," Archer recalls. With

confidence bolstered by the exhibition results, Archer tried to talk Vigtel into mounting a solo exhibition of Reverend Howard Finster's "sacred art," and she had bigger plans in mind: like establishing a folk art department at the museum.

"Vig said that it will never happen at the High," Archer says. "He said you can continue your efforts and I know you want to be a full-time curator, but let's be clear that there will never be a full-time folk art curator at the High Museum of Art."

As far as he was concerned, the High wasn't welcoming folk.

Chapter 7

LIFE GO ON

PRICES FOR FINE ART WERE SKYROCKETING AND HAD BEEN SINCE THE early 1980s. A confluence of factors pushed the art world from cloistered playground of the genteel to wide-open capitalist marketplace. Wall Street baby boomers were raking in the cash, having traded their peace symbols for Mercedes hood ornaments. Artists of the same generation had a more commercial view of the world than their prewar predecessors. Through the 1960s, Andy Warhol set the tone with his focus on fame and fortune. "In the future, everyone will be famous for fifteen minutes," goes the oft-quoted Warhol one-liner, and in case that didn't make his intentions crystal clear he painted images of money to further clarify his ambition. Abstract painter Julian Schnabel picked up Warhol's baton and ran. During his nascent painting days in 1970s New York, Schnabel boasted that he planned to be the greatest artist in the world. His ambition exceeded his talent. Early reviews of Schnabel's art were often mixed. Still, his first exhibition in 1979 at the Mary Boone Gallery in Manhattan launched him into stardom. By 1981, the thirty-year-old painter who embedded broken plates in his canvases had conscientiously driven his prices to $40,000 from $4,000 just a few years earlier (they now average $250,000). He took to wearing fur coats and silk shirts. Even

his paintings touted his monetary success, including some done on velvet with gold leaf.

Jean-Michel Basquiat, who favored painting in Armani suits, was another sign of the times. A black artist from a middle-class family in Brooklyn, Basquiat lived on the street and tagged graffiti around lower Manhattan before he was twenty. In the early 1980s, Basquiat turned to tagging canvases instead of subways. He was picked up by art dealer Anina Nosei and then cranked out canvases from the basement confines of Nosei's SoHo gallery. He befriended Andy Warhol and collaborated with him on a series of paintings for a much-awaited exhibition, but his rise to fame didn't last long. Basquiat died of a heroin overdose in 1988, just twenty-eight years old. A year later, his art was selling at auction for upwards of $500,000.

Even the stock market crash of 1987 couldn't cure the art market fever. By 1990, a Renoir painting sold at auction for $78 million, only to be topped that same year by a Van Gogh painting—*Portrait of Dr. Gachet*—which went for $82.5 million.

Traditional art world trackers marveled at the prices of contemporary works; contemporary art buyers could afford the price lift, after all. But folk art aficionados as a group were economically diverse, a much different crowd.

Roberta Griffin was a part of that different crowd. She first got to know Bill Arnett by phone when she lived in Miami. She earned three art education degrees from the University of Miami and, while still in South Florida, curated a show that included pieces from Arnett's African art collection. When she moved to Atlanta and joined the faculty of Kennesaw State College, Griffin reconnected with Arnett. "I had been going over to see Bill to think about an exhibition of Cameroon art. I walked into his house in Buckhead, and of course the whole place was covered in art. You couldn't even find a place to sit. I saw root sculptures in the yard by Bessie Harvey and a lot of other artists packed in each room. When I went into the living room, I saw an enormous piece that was called *Slave Ship*. I said, 'Bill,

who did that?' He said, 'That's Thornton Dial. Do you think that stuff is any good?'" Griffin didn't think that it was good. She thought "that stuff" was spectacular, and together Griffin and Arnett agreed to mount the first solo exhibition of Thornton Dial's artwork at the Kennesaw State College art gallery.

Kennesaw, Georgia, is a tiny, almost entirely white town twenty miles north of Atlanta. It is known, among other things, as the city that requires each of its homeowners to arm themselves with gun and ammo. Kennesaw State College, situated behind a Cracker Barrel restaurant just off of Interstate 75, in 1990 was an institution with big plans. Kennesaw was a most unlikely place to host the first solo exhibit of the seething works of Thornton Dial, and when a tiny group of Kennesaw State students helped to set up Dial's exhibition they were in for a big surprise. "Dial's work was so raw—like the ideas you get before people tell you what you should or shouldn't do. It was free, authentic, primal imagery," recalls Griffin. And it was big, too; enormous, two-hundred-pound constructions dense with everything from plywood and hammered tin to braided rugs, twigs, and layers of paint. The Kennesaw students who helped move Dial's art into the gallery wore thick cotton gloves to protect their hands against the nails and other razor-sharp protrusions poking out from all sides. One piece had remnants of an old shed from Dial's house; another, a dried-out cat carcass; still another piece was so heavy the crew had to hoist it on chains and support it on the bottom by a wooden podium. They barely squeezed it through the back door of the facility and were afraid that it might bring the gallery ceiling down.

Bill Arnett knew that Dial's first one-person show was a huge career moment and felt that it deserved a huge, impressive book to match. Griffin wanted a catalog too, but argued that Kennesaw State didn't have the money for a book that could match Arnett's ambition. "Bill and I had written essays, but he got carried away with what was possible and time ran on, and the printer had the color separations and they had put lots of money into it, but Bill didn't like it," Griffin says.

In the end, the best Griffin could do was scratch together a lengthy essay that she copied and had available for pickup by gallery goers.

Ladies in the United States opened in January 1990 at Kennesaw State and showcased Dial's art honoring the strength of the women in his life. With great trepidation, Thornton Dial traveled to Atlanta for the opening event. Dial's wife Clara pleaded with Bill Arnett prior to the launch to protect her husband and keep him calm. "Please stay close to Buck," she told Arnett, "'cause he's scared to death." With Clara's plea in mind, Arnett drove to Bessemer and picked up Dial; they traveled back across I-20 together for the opening. *So far so good,* Bill Arnett figured. On their way, Arnett stopped at a Po' Folks restaurant to have a quick stick-to-your-ribs meal.

Po' Folks is a Deep South restaurant chain known for its "Hearty Homestyle Cooking." Folklore on their Web site champions the surveyors of the Mason-Dixon Line, and menu items like Chicken Livers an' Gizzards, Kuntry Fried Steak, Mashed Po-Taters, Niller Ice-Cream, and sweet tea all served with a big "Howdy" on Dixie-checkered cloths. It was a place where Thornton Dial might not have felt quite at home. In the Po' Folks parking lot, Arnett, ready to eat, parked his truck, looked at Dial, and said, "Come on. Let's go on in."

"No man," Dial hedged. "Just bring me some food."

Arnett thought Dial was reluctant because he couldn't read and would be forced to struggle through deciphering a menu. Figuring he could take care of that for the artist, he kept on.

"Come on in," Bill Arnett persisted.

But Dial wouldn't budge.

"It turned out that Dial had never in his entire life been in a restaurant," Arnett says, "not in a McDonald's or a café or anything."

Though his folks may have been poor, they were definitely not Po' Folks, and Dial's homestyle cooking had always been served from his family's hands.

At Kennesaw State College, Dial wouldn't go in to the opening reception either. "He stayed in the hotel the whole time," Griffin

remembers. "He came later to see it. He liked it, but he was very quiet, dignified, modest. At the same time, he had a very sure sense of himself as an artist."

Others were less hesitant to see the show. The Kennesaw College faculty came out in full force and brought their students along. "Then the word got out," recalls Griffin, "and people just kept coming."

One who came was Catherine Fox. Fox was a Midwest native who, in 1982, became the *Atlanta Journal-Constitution*'s first art critic. In her brief newspaper review of the *Ladies* show shortly after the opening, Fox wrote, "Mr. Dial's drawing is crude and his palette sometimes sour. The effect can be almost ugly considered in purely visual terms." Later in the piece, Fox noted that the meaning of many works in the show could be "overly private and opaque. In such cases, the viewer must rely on the titles and text that William Arnett—Mr. Dial's patron and owner of these works—and his son, Paul Arnett, have extracted from rambling conversations with the artist."

When Bill Arnett read the Fox article he was close to detonation. Jerry Cullum recalls, "We told him, 'Cathy doesn't like anything.' But Bill was convinced that there was a conspiracy in town to make sure black self-taught artists wouldn't succeed."

Cullum also believed Cathy Fox's review was too negative, and he volunteered to write a more balanced one for *ArtPapers*. However, when Cullum's article appeared, it showed that he was not yet fully convinced by Dial's work either. Little was written about the quality of Dial's art or about the exhibition itself. Cullum's critique focused, rather, on the context within which the art was portrayed and the societal quagmire presented by the Arnetts' translation on behalf of Dial. He said, "How does *anyone* ever undertake to speak for someone else, even with someone else's permission, without seeming or *being* patronizing or colonizing? There's an unresolvable debate about what 'giving permission' means when one party is weak and the other party is strong, *even if the result benefits the weaker party*." Still, Cullum's take on the Arnetts' translation was that it was better than having no guide at all.

Though Cullum's review offered slight consolation to Arnett and despite glowing comments from attendees, Arnett remained fixated on Fox's negative words. "Sticks and stones may break my bones, but words, they're going to boomerang and bust your fucking asses. That's an old proverb," Arnett says. In this instance he may have been right.

Days after Fox's stinging words appeared, Arnett laid out a copy of the Atlanta paper on Dial's kitchen table and read the article aloud.

"Everybody was saying this is the greatest show they ever saw in Atlanta, and here Cathy Fox is trying to shoot you down before you ever get out of the box," Arnett told Dial. "You could expect this," he seethed. "As great as you are, you can expect it," Arnett said.

"What does that mean, 'the drawing is crude'?" Dial asked.

"She just means you can't make beautiful watercolors like trained white artists," Bill Arnett said.

When Arnett returned the following week to visit Dial, he found Dial drawing on grocery bags, surrounded by food color and clothing-dye snitched from Clara Mae's kitchen cabinets. He had gathered walnuts from the yard and smashed them and boiled them for their staining juices and made his own watercolors. But the paper bags he used were acidic and the dyes were fugitive, apt to fade rapidly. There was no archival permanence to Dial's homemade materials, so Arnett decided to help. He bought Dial "every kind of paper known to man" plus inks and acrylics and pastels, but Dial's primary interest was watercolors. Arnett says, "The Watercolor Society of America could have made him a poster boy."

With that, Dial began a series of his own fluid-line graphite draw-ings—twisting images of women intertwined with tigers and birds and highlighted with fields of color wash. Sometimes the drawings contained just a woman's head staring out with attitude or tilted as if resting on a color swatch; sometimes the woman was bodily present with nipples and vagina bared, legs stretched over head. The series of drawings, collectively called *Life Go On*, and myriad other drawings that Dial generated in his first months responding to Cathy Fox's

barb yielded a body of work that Arnett thought could compose a complete exhibition.

Fay Gold thought so too. On the strength of these early drawings, Arnett landed an exhibition for Dial at Gold's contemporary art gallery located in the heart of Atlanta's Buckhead Village.

On any given Friday night, Buckhead Village swarmed with tanned, miniskirted belles searching for Mr. Right in glitter-ball dance clubs lined with drunken frat boys. On this particular Friday night, though, Thornton Dial stood at its center quietly, dressed in a freshly pressed suit and tie. He watched as the gallery filled with people admiring his art, but Dial's art was not the only thing attracting viewers. "The gallery show had all these Buckhead woman and young ones, too," Bill Arnett says. "Teenyboppers in short skirts coming in there. Of course, by now Dial is kind of a celebrity. There'd been a big article in the paper before the show opened that was very nice and talked about all the stuff that was going to happen, and these white women were all just kind of lined up and coming up and hugging him and rubbing on him and kissing him, and I didn't know who was going to shit first: Dial or them women."

Later, Dial would remember other times. "I never even looked at no white women. I would just turn my head the other way if they was around," he said. Dial knew, like many African American men of his era, that a misunderstood glance at a white woman by a black man could be the recipe for a brutal death at the hands of police or hyper-vigilant white mobs.

After the exhibit and his interaction with the women there, Dial crafted different sculptures: a chair, for instance, shaped like a white harlot wrapping her arms around the sitter in her lap. Dial says, "Yes, this a really great chair. White womens used to didn't sit in Negroes' lap. . . . You used to hug a white woman and they'd kill you, wouldn't they? Now they don't."

That same year, some of Dial's paintings sold for as much as fifty thousand dollars—more than a threefold increase from two years

earlier. In the minds of many traditional folk art collectors, their world was not only being invaded by contemporary art commercialism, but the work was getting to be priced above their ability to pay. Arnett became one of the favorite scapegoats. "Arnett is hoarding the best work in his warehouses—keeping it off the market—trickling it out for sale in only limited quantity, especially Dial's work," they'd say. Folk art insiders and trained artists were getting louder in their disdain for what they considered Arnett's efforts to drive up prices. In its spring 1990 issue, one of the combine's publications, *The Folk Art Messenger*, printed the front-page headline, "Folk Art at Fancy Prices: The Case of Thornton Dial." The story was written by two New York artists who expressed their concerns that Dial's record-breaking prices for folk art provoked "serious questions about the relationship between folk art and big business."

The artist writers went on to say in the article, "Precisely because this accomplished naïve artist spans the gap between history-conscious contemporary art and art naïf, the case of 'Buck' Dial has stirred up controversy." They pointed one finger at money motives while the other four digits fingered Arnett. "Like Dial's ambiguous and dreamy imagery," they said, "the issues surrounding his work invite more questions than answers. Many of these questions revolve around the factor of money and its effect on outsider art." And, "Is it possible to make outsider art when this art commands five-figure prices? When folk art and outsider art fetch top dollar, how are the profits divided? Are its entrepreneurs heroes or villains?"

No answers were given, but none were needed. To Bill Arnett, the questions did damage enough. When Arnett read the *Folk Art Messenger* article he fumed, "There they go again! These people are threatened by Dial and his art. That's what their slurs are all about."

If Alan Lomax had known of Arnett, perhaps the musicologist would have commiserated. Lomax, too, survived accusations of exploitation. Even in 2002, after Lomax died, music critic David Marsh wrote an article entitled, "Mr. Big Stuff: Alan Lomax: Great

White Hunter or Thief, Plagiarist and Bigot?" All folk explorers, Lomax might have told Arnett, are subject to an occasional barb.

But what to Lomax might have looked like a random barb, looked to Arnett like a barbed-wire fence. He filed away the "Fancy Prices" story along with Cathy Fox's article as additional evidence of a mounting conspiracy against him and his artists.

While Arnett was seeing fences, Thornton Dial was starting to see open fields. In August 1991, the Birmingham Area Chamber of Commerce featured a cover-filling headshot of Thornton Dial on the front of its monthly magazine aptly titled *Birmingham*. Next to Dial's face was the headline, "Is This Man the Art World's Next Genius?" They described his art as, "Bold. Energetic. Riveting." They raised the art world quagmire that Dial presented. "What is it?" they asked. "What do the images mean? Where does this fit into the grand scheme of the art world?" Again, only questions were offered, yielding only shadows of doubt alongside the high praise. For the moment, Dial's tremendous market momentum would have to provide the only answers.

With his two solo shows, the rising value of his art, and the critical discussion around his works, Thornton Dial was on a fast track. He was a Horatio Alger story of the twentieth century: a rags-to-riches success complete with money, female adulation, and fame.

"Everyone who comes by, and I mean museum curators, critics, collectors, everybody—including me—thinks you're a star," Bill Arnett told Dial after the *Birmingham* article appeared. "I mean they think you are on your way to greatness alongside Chagall and Picasso," continued Arnett. "They're calling you a genius."

To that, Thornton Dial responded flatly, "Man, if I'm that good, they gonna have to kill me."

Perhaps they would.

Chapter 8

STRATEGY OF
THE WORLD

THE ART WORLD'S MAGIC FLYWHEEL WHIRLS WILDLY, RANDOMLY SUCKING into it seemingly ordinary artists who are spun around and spat into the marketplace as superstars. It works something like this: an artist is lured into the gyro mechanism, and patrons set the wheel in motion; dealers accelerate the revolutions by hyping up buyers who spin the device faster still; critics attempt to clinically analyze the dervish without being toppled by its hypnotic force; museums just hold on for the ride. Thornton Dial was flywheel fodder. The artist, Dial, continuously created better and bolder work while the patron, Arnett, noisily evangelized. Prestigious dealers showcased Dial's work, well-heeled collectors bought, art critics cooed, and museums added Dial to their hallowed walls. The wheel would twirl many times more before anyone realized that its bolts were loosening.

Thornton Dial glanced out the window of the Delta Air Lines jet and saw black waves rushing toward the cabin. Adrenaline flooded his sixty-year-old body and kicked his heart into overdrive. The end was near. He grabbed Clara Mae's arm and mumbled a prayer. "I looked down at all that water down there. I'm flying over the water and see it coming up and I thought, *Oh man, this plane is falling.* And these folks talking on the speaker about 'Welcome to New York,'" he

recalls. Despite his fears, Dial's plane descended easily along its regular landing route over Bowery Bay and glided smoothly onto a LaGuardia Airport runway. His landing in the New York art scene was just as smooth.

The Southern Queens Park Association instigated Dial's first plane trip and first visit to New York in September 1990 when they mounted a solo show of his work entitled *Thornton Dial: Strategy of the World* in the basement of the Association's community center. Arnett had set it all up. He worked with the Association to ensure that Dial's best and most current work was well represented, properly mounted, and actively promoted. Though the venue was modest, the occasion was significant: Dial's New York debut.

In the world of contemporary art, the magic flywheel only runs full force, 24/7, in one place: New York City. If an artist is to achieve true recognition, real cachet, he must be a success in the Big Apple. This was Thornton Dial's first big chance, and all he could focus on was getting back to Bessemer. Before the exhibition opened, he and Clara hopped aboard Carmichael's, a retro bus-shaped diner serving ribs and fried chicken and a smorgasbord of southern home cooking while a blues band jammed nearby. It was as close to home as Dial could get in Queens.

The *Strategy* show spotlighted a group of works that Dial made during a twelve-month period from mid-1989 to mid-1990. The show's catalog touted an opening essay titled "Thornton Dial: An Ordinary and Unique American Artist," written by Bob Bishop, then head of the Museum of American Folk Art, the primary institution supporting the field. Bishop's essay was a ticket of admission into the rarefied world of art museums, the equivalent of a Good Housekeeping Seal of Approval for Dial's work. In the essay Bishop proclaimed, "Dial is now a major artist whose paintings, sculptures and assemblages are fast becoming important news in the national art scene." Bishop alluded to his museum's plans for upcoming promotion of Dial and hinted that Dial's path was well paved. "This and several

other exhibitions contemplated by museums and galleries, including the Museum of American Folk Art in New York City," he wrote, "will ensure Dial the recognition he so well deserves."

As if to confirm his welcome, Dial's New York arrival was hailed with a reception in his honor hosted in a posh Greenwich Village apartment bordering Washington Square Park. The home was packed with art as well as aficionados, curators, collectors, and sundry Manhattan socialites, who swarmed the artist. Dial shook hands, exchanged pleasantries, soaked up the environment, and wished desperately that he were at home.

After less than a week in New York, Thornton Dial did go home. But New York would call him back again soon. After the success of his first arrival, Bishop's Museum of American Folk Art began to plan a major exhibition of Dial's work for 1993 plus a book about Dial to match; if that weren't enough, the New Museum also agreed to host a simultaneous show of Dial's art.

Thornton Dial's mind spun like a wheel. Everywhere Dial now looked, there was art and opportunity.

"Who do you think is goin' to look at your art?" Arnett asked Dial during one of his regular pilgrimages to Bessemer. "A wife or some-body at a museum, or do you care? Does it even come to your mind? Just do it for yourself?"

"No, you don't do it for yourself. You do it for everybody. You understand?" Dial said.

"Do you expect that your art will have influence on other peo-ple? When they see your art is that gonna make them think about something different, or are they just gonna see it and walk away?" Bill asked.

"I think they gone buy it," Dial said flatly. "Art is a business."

"Aside from buying it, what do you think?" Arnett persisted.

"They'd be happy," Dial responded. "Art can make you happy, and art can make you sad. Art can make you anything you want to be. Art can make you rich."

Thornton Dial, Arnett believed, "was conceivably the greatest artist that had come down the road in a long time," and what he and Dial were doing together "represented the future of Western art." So Arnett spun up Dial to whoever would listen. "Dial is as good as or better than any modern artist, even Picasso," he raved.

"Whoever the great artists of the twentieth century are, none are greater than Dial," Arnett preached. "I'm just being charitable. I mean we can name fifty or one hundred twentieth-century artists and say they were really good, but there's none that are better than Dial." He paused—not for long. "*You* know this. I mean I know you *know* this," Arnett goaded his listeners, as if to disagree was to admit lack of an artistic eye.

Those who saw Dial's work firsthand in the early 1990s wondered if there wasn't truth behind Arnett's bluster. But opportunities to see Dial's art up close were relatively few. Aside from the shows, artwork purchased by museums, and the works on display in elite collector's homes, Bill Arnett guarded the supply of Dial's creations closely, trickling select pieces into the marketplace judiciously to ensure they were in the right hands. As for Dial, he preferred to have only Bill Arnett serve as his front person. "I didn't never fool with nobody," Dial says, "but Mr. Arnett." He recoiled at the demands of public interaction, preferring his family or farming or painting to rubbing shoulders with art's upper crust. Folk art aficionados were used to having direct access to their artists any time they chose. Not so with Dial; he just didn't want it. Neither, it seemed, did Bill Arnett. To get to Dial, collectors had to go through Arnett. But if Arnett was saying Dial paints better than Picasso, some members of the folk art inner circle were determined to see for themselves. Arnett be damned, they told each other. They would go to the source and buy the art directly.

"Tell this story," Arnett prompts Dial as they reminisce while sitting around the artist's Formica-topped kitchen table some ten years later. "You woke up in the morning at 7:00 a.m. and found this

one collector and his wife walking around your house, this house," Arnett starts Dial off on the tale.

"Yeah, yeah," Dial says, thinking back. Arnett doesn't let him get started though. Arnett jumps ahead. He can't wait.

"First of all, Mr. Dial changed phone numbers so people couldn't keep coming and finding him. Hundreds of people just coming. Not for good reasons. Not to say you're a good man," Arnett recalls.

"I knew what that early morning collector and others like him was doing, but yet and still I didn't fool with nobody but that man you see sitting right there, Bill Arnett. 'Cause I'm a straight guy. You want to know the truth. I'm a straight guy. I'm not no crooked guy," Dial says. But it wasn't Dial the collectors were accusing of crookedness. It was that man sitting right there.

"People would say to him, 'Bill Arnett is charging your stuff too high. You should sell it cheap,'" Arnett says. "I told Dial that if you want to be like most other black folk artists and let people come give you five, ten dollars, maybe one hundred dollars, then you can sell everything you make for one hundred dollars, but what's that gonna do for you? I mean you get no respect. Those kinds of artists have never gotten respect, plus you are too good for that. I'll bet you that Dial has had at least three hundred white people come to him out of the art world, dealers, collectors, sometimes lawyers, and they'll say that man Bill Arnett ain't treating you right."

"Oh yeah. Yeah," agrees Dial.

"'We know from people in New York that Arnett is cheating you,' they would say to him," Bill Arnett continues.

"Yeah, I had that happen too," Dial admits.

"Oh yeah. Then they'll come to Dial and tell him like about a Van Gogh painting that sold for tens of millions or something and rile him up like, 'Why isn't Bill Arnett getting you money like that?' This exact thing happened one time, and it really pissed me off 'cause after Dial said to me, 'Man, there's a piece of art sold for $56 million. How come my art doesn't?' I said, 'You just don't understand. I'm under a

lot of pressure,' and he comes in saying, 'Well, everybody is telling me I should be making millions.' I said, 'Well, Mr. Dial, if you were white, if you were educated in college, and if you were living in New York you'd be making millions and millions and millions," Arnett insists.

"He done said that many a times," says Dial. "I never trusted nobody but Bill Arnett. I just tell you like it is. That's all I know," says Dial.

"I think your trust was justified," Arnett responds. "I think I trusted you too."

"And I love you for that," says Dial.

———————

Art dealers are the salesmen of the art market. They are the primary channel by which artists and buyers connect. Dealers may own a gallery in which they facilitate the exchange of money and canvas or they may operate virtually—out of their apartment or house or even over the Internet. Still, the gallerist is the most prestigious of all art salespersons, the big dogs of dealer-land. To have the power and success to command a physical presence—the gallery—in the most powerful city in the art world—New York—trumps all. "The private act of making art and the private enterprise of selling or acquiring it come together first and foremost in the precincts of the gallery. By truck and by limo this convergence occurs in a confidential transaction, concluded before the very eyes of the public with celebrity appearances at gala openings, price-lists in open view, and gossip column reportage," wrote Alan Jones as a forward to his 2002 book about the machinations of gallerists, *The Art Dealers*.

Bill Arnett saw the possibility for convergence not just between buyer and seller of Dial's art but in the concept that Dial's art was at once "folk" and "contemporary." To cross over fully to "contemporary" would dramatically and positively impact Dial's market prices and reputation—pulling him out of the "folk" "outside" and into the mainstream. The credentialing and market power that a well-known

THE LAST FOLK HERO

contemporary art gallery might provide to Thornton Dial would be priceless, especially a Manhattan gallery situated in the heart of the world's prime contemporary art district. Within that cloistered domain of chic art venues and loft studios, Arnett could have chosen no better-equipped gallery than Ricco-Maresca in Chelsea, launched in 1979 as one of the first galleries in America committed to contemporary folk art.

"What we've been about more than anything else is the concept of the crossover of this material," says the gallery's co-owner, art dealer Frank Maresca. "Virtually everything that we deal in has an element that could place it in the contemporary art category. A lot of the material is undervalued and underappreciated because a broader audience hasn't recognized it yet. We try to open the market and increase demand for this art, and we do it more actively than anyone out there.

"The marketplace is political to a great extent, and it can be driven by influence," Maresca explains. "Influential representation makes a big difference. When you are talking about things that are unique, supply is historically controlled by small groups of influential people. Like deBeers with diamonds. You can't just go to Africa and mine a diamond. In art, people can't find and polish and cultivate things the way a skilled dealer can. Like we can or Bill Arnett can or well-known contemporary art dealers like Mary Boone or Larry Gogosian can. If we see an artist who has a high level of excellence; and all of a sudden I decide to spend a lot of money and exert a lot of influence over a person who is excellent and introduce them and help make them; and when that person is capable of helping him/herself, is smart, can't help but do the right things, and has a charismatic persona—it is a powerful combination. This holds true for anything: show business, sports, art. An entertainer with the right package is often created by an influential entity. It just has to do with marketing."

Frank Maresca and Roger Ricco agreed to place their influence squarely behind Thornton Dial. They gave him a one-man exhibition in November 1991, another Manhattan victory for the artist. "We

represented Thornton Dial more or less exclusively at the time, depending on whether or not you think Bill Arnett is an art dealer," Maresca says. He cannot help himself from an aside on the Arnett topic. "Arnett is a dealer who won't call himself a dealer. That's the worst insult to him. He considers himself to be a scholar and educator. There is no one more passionate than Bill; he truly believes he is not a dealer, but he's a dealer in every sense. He has been a tremendous promoter and champion, yet he has been criticized constantly." Like many who get started on a Bill Arnett sidebar, Maresca expresses his unwillingness to elaborate. "I can't say, and I won't say," what he has been criticized for, Maresca resists. And then, with a less direct approach, he continues, "There have been tremendous abuses in the folk art world. It is no different than Egyptologists with the London Museum carting away boatloads of Egyptian art from its original resting place and moving it to Great Britain or a folk art collector finding a treasure trove in someone's backyard for next to nothing. It is human nature. If they see something that costs close to nothing and it's great art, they acquire it." Then, perhaps remembering his own role as a dealer, Maresca adds, "If nothing is acquired, what is it all about? Art would just be a philosophical thing. Acquisition of art is a key element in making of art." Maresca's acquisition of Dial's art may have been an indirect element in helping Dial to make an enormous number of new art pieces. Collectors acquired nearly every piece of Dial's art displayed at the Ricco-Maresca gallery in the early 1990s.

William Louis-Dreyfus is a buyer *and* a seller. As president and CEO of the Louis-Dreyfus Group, William Louis-Dreyfus presides over one of the largest commodity trading firms in the world. The Louis-Dreyfus Group is very big in cotton, for instance. Louis-Dreyfus handles nearly 4 million bales of cotton each year, supplying up to 20 percent of cotton consumption in U.S. textile mills alone. Louis-

Dreyfus companies are situated in over fifty-three nations and reap gross revenues greater than $20 billion each year. Besides cotton, grain, and other staples, William Louis-Dreyfus likes to deal in art.

French-born and New York–based, William Louis-Dreyfus is the great-grandson of the Louis-Dreyfus Group's founder, Leopold Louis-Dreyfus, who established the firm's world headquarters in Paris in the 1870s. William is also the father of Julia Louis-Dreyfus, better known as Elaine Benes on TV's *Seinfeld* sitcom. William Louis-Dreyfus is small, stocky, and swarthy with wavy, receding dark hair combed from front to back. Wide blue suspenders yank his oversized pants high above a full belly. He supports his small round mass by leaning on a rubber-tipped aluminum cane. Inclined to call people "Sweetie," even men, his demeanor is at once gruff and warm. He is a rumpled-looking gentleman who cherishes beauty. William Louis-Dreyfus adores beauty in words, for instance. He is a poet. In addition to his duties running the family enterprise, Louis-Dreyfus is president of the Poetry Society of America. His verses about lambs and death appear at times in lofty publications like *The New Criterion*, a monthly review founded by an art critic and which considers itself the last word in high culture. To confirm his commitment to beauty over wealth, *Forbes* magazine quoted Louis-Dreyfus in 1999 saying, "Business is a waste of time compared to poetry." Of course, over the years, *Forbes* has also included Louis-Dreyfus in their "World's Richest People" issue. In 2005, he and his family were listed with a net worth of $3.2 billion, making it a bit easier for William to wax poetic.

Louis-Dreyfus worships more than just literary beauty. He loves visual aesthetics too—poetry in pigment. He owns the Four Seasons Hotel in Washington, D.C., where public areas display portions of his significant personal collection of sculptures, paintings, and embroidery. Among the pieces hanging from the sumptuous hotel walls are works by Thornton Dial.

In the late 1970s, Louis-Dreyfus happened upon an episode of *CBS Sunday Morning* with Charles Kuralt featuring a segment on

Nellie Mae Rowe. The billionaire-poet was amazed by Rowe's story and her art. He tracked down Judith Alexander and flew to see her collection of Nellie Maes. Soon after, word spread through the tiny folk art combine that William Louis-Dreyfus was interested in this kind of art.

"Ricco and Maresca came over to meet me because they heard I was buying a lot of Nellie Mae's stuff, and they had found a bunch and wanted to sell a bunch to me," Louis-Dreyfus says.

Frank Maresca was as impressed with William Louis-Dreyfus as Louis-Dreyfus had been impressed by Nellie Mae Rowe. To Maresca, Louis-Dreyfus's passion for art—combined with his massive bank account—made him the perfect client, and this client's passion for beauty extended far beyond paintings. During one of the earliest meetings between the dealer and client, Louis-Dreyfus suddenly broke away. "He threw his arms around a tree telling me how much he loved the tree. He loved it as much as any piece of art," Maresca says.

The billionaire's passion for so-called outsider art swelled quickly. From Nellie Mae Rowe, Louis-Dreyfus moved on to the grand folk master, Bill Traylor. Ricco-Maresca had a bountiful supply of Traylor drawings, and William was smitten. "I was not aware of Traylor's work at all. I was completely blown away. The prices were higher than Nellie Mae's, so I didn't buy them at first go. I waited a year and then couldn't resist. Then I started buying them in as much volume as I could get," Louis-Dreyfus confesses. Today, with over 130 pieces, Louis-Dreyfus arguably has the largest and highest-quality collection of works by Bill Traylor held by a single private collector. "I sure am happy I do," he says. "They really are the cat's meow.

"From there I remember Ricco telling me the cream of the cream was this guy Thornton Dial. So we went down to Atlanta and met Arnett," Louis-Dreyfus says. After that, Louis-Dreyfus began to stock up on Thornton Dial. Paul Arnett recalls that one of the earlier pieces which Louis-Dreyfus bought was a portrait of Pablo Picasso entitled *Hank Williams's Daughter, Picasso, and the Tiger That Hold to the*

Power. Dial had heard of Pablo Picasso but never seen a photo of him. He asked Paul Arnett to describe the famous artist and, based on that, using enamel, plastic hose, foam rubber, broken glass, and other paint-coated refuse, Dial created a primal and distorted bald figure with piercing eyes and jug-handle ears sprawled across the canvas, overwhelming the tiger and young woman who stand alongside him. The bald-headed tour de force bares a striking resemblance to Picasso. "Art people all speak about Picasso. He got to represent the power," Dial said.

William Louis-Dreyfus represented power. With one of the world's richest men on his side, partnered with the leading contemporary folk art gallery in New York, the flywheel whizzed even faster for Thornton Dial.

––––––––––

If William Louis-Dreyfus was a Parisian come to America, Henry Pillsbury was an American in Paris. If William Louis-Dreyfus's family bought and sold commodities, Henry Pillsbury's family turned those commodities into food. Henry Pillsbury is an heir to the Pillsbury Company flour fortune—a direct beneficiary of the pudgy white doughboy. Like Louis-Dreyfus, Pillsbury is an arts devotee. Both an actor and a poet, he also served for eighteen years as director of the American Center in Paris. Founded in 1931, the American Center brought to Parisian audiences the elite of American contemporary artistry, film, dance, and music—people like Gertrude Stein, Henry Miller, John Cage, Phillip Glass, Merce Cunningham, and Allen Ginsberg. "In 1969–70, it was the only place in town where you could see American experimental music and theater," Pillsbury told *Paris Voice* magazine in a 1999 interview.

In 1987, with a worn-out old headquarters facility but pressing full steam ahead from programming success, the American Center sold its original building in the historically artsy Montparnasse section

of Paris and began a $40 million project to build a new Center in the drab industrial Bercy neighborhood. Pillsbury hired famed architect Frank Gehry to design the new structure, and creative ambitions soared. Gehry's finished product resembled a traditional office building that had morphed into a concrete cubist sculpture. Such a dramatic architectural design deserved a dramatic opening art exhibition. A friend of Pillsbury suggested the doughboy heir take a look at the work of Thornton Dial.

Henry Pillsbury and his wife Judy flew to Atlanta to visit Bill Arnett's art warehouse of a home. "He walked into my dad's house and within fifteen minutes Henry said this is it; this is what was meant to be in our place. And he immediately made plans to have the Thornton Dial solo show that was going to happen at the American Folk Art Museum also be the inaugural art exhibition at the American Center's new building," says Paul Arnett. Thornton Dial was going global.

Now Dial needed a critic. Tom McEvilley's credentials included a Ph.D. in classical philology; twenty years on the faculty of Rice University's Art History Department; a long list of published scholarly monographs and articles in publications on Greek poetry, philosophy, religion, and art; and a slew of books. But it was as a contributing editor with the leading contemporary art magazine *Artforum* where Tom McEvilley earned his real chops—specifically, with a controversial critique he penned in 1984. That year the Museum of Modern Art opened a show pointing to the influence on modern art of tribal objects and various non-Western art forms called *Primitivism in 20th-Century Art: Affinity of the Tribal and the Modern*. The exhibition showcased art by the likes of Picasso and Matisse alongside cultural materials from Africa, pre-Columbian America, and the South Pacific. "See how the work of modern geniuses," the show seemed to

say, "was influenced by these noble savages!" McEvilley wrote a scathing review of the show in the November 1984 issue of *Artforum* in which he tore at the colonialist premise of the show that defined the world of art purely by white Western European standards and shunted off certain "other" cultures as mere primitives. McEvilley's review spurred a heated intellectual debate on multicultural art. If every culture is equally valid, as the multiculturalists stated, then art that comes from differing cultures is equally valid. Taken a step further, McEvilley's reasoning argued that self-taught art from the African American culture was every bit as valid and worthy as work by educated artists out of the mainstream white world. For a self-taught black artist looking to break out of the folk art box and into the mainstream—like Thornton Dial—Tom McEvilley was a helluva good art critic to have on your side.

The Arnetts first met Tom McEvilley when the critic participated on a panel with Lonnie Holley in 1990. They invited McEvilley to Bill Arnett's big house off of Tuxedo Road to see the collection, and before long they began talking about how to get him involved in their efforts. "I flew up to New York and spent a day with Tom discussing the terrain and what needed to be done to advance the field. He said he knew how important this material was, including Dial," says Paul Arnett. The Arnetts had already gotten an exhibition project, *Thornton Dial: Image of the Tiger*, in the works with the American Museum of Folk Art. The show was scheduled to open in fall 1993, but they still were seeking the right curator. With the Arnetts' endorsement Tom McEvilley landed the job, despite the fact that he had never curated a show before. Now the critic was not only engaged, he had clearly taken sides: theirs. McEvilley's next point of impact was just as significant. "He said that he wanted to get the show contextualized in the dialog about contemporary art and believed doing the show in a second museum at the same time as the American Museum of Folk Art would be needed to accomplish that," Paul Arnett remembers. McEvilley thought the New Museum of

Contemporary Art might do the trick. Less than fifteen years old at the time, the New Museum was formed to showcase only avant-garde art made roughly from the time of the museum's inception until the present—the new, new art. McEvilley presented the concept. The New Museum agreed. Dueling Dial shows in Manhattan.

In the fall of 1991, *People* magazine featured Thornton Dial in its "Amazing Americans" issue, including Dial among those who "beat the odds with brains, guts or just plain luck." Dial's picture and biography were spotlighted right next to American heroes like baseball legend Nolan Ryan and retail giant Sam Walton. With celebrity status that had hit full tilt, Dial couldn't help but be pleased. "It just mean so much, man, to be free. Oh yeah. You walk in and somebody can say 'Yes, sir' to you, you know. Ain't always like that. I been all over. I seen it. How people treat people. How they scold them. When these things begin to come where white people say 'Yes, sir' to me, it scare the shit out of me because, hey, where you gonna say that to me and I been saying this to you all my life? . . . Oh yeah. Oh yeah. It take a while, but things come."

Of course, with celebrity often comes resentment. "People in his community in Pipe Shop were starting to taunt him because he was getting so well known," remembers Bill Arnett. "People were stealing things from his house too. Taking art and everything. We finally said, 'We need to get him out of there.'"

Chapter 9

OBSTACLES
BEFORE THE GOAL

GETTING THORNTON DIAL OUT OF PIPE SHOP MEANT MOVING HIM into a twenty-acre compound just a few miles west, one highway exit past Bessemer's VisionLand amusement park in the heavily wooded, Rock Mountain Lakes community of McCalla, Alabama. Dial's new estate came fenced with a metal gate that rolled shut to keep visitors from riding up the long driveway to the modern gray clapboard and stone house, complete with swimming pool, stocked pond, barn, poultry, and other assorted livestock.

It was just a few miles from his self-built house in Pipe Shop, but those miles made all the difference. "When I came down here I'm goin' tell you the truth. I was scared. Because it was so much stuff goin' on at that time back in Pipe Shop. I didn't know if somebody was gonna kill me or shoot me," says Dial. "By 1989, crime in Dial's neighborhood had increased to the point where gunfire was heard almost nightly," Bill Arnett remembered in a 1998 interview with *ArtPapers* magazine.

"The Dials asked me to help them move to a more secure place," according to Arnett. "I then began trying to find someone to agree to give a mortgage to Dial so he could buy a new house. At that point in his career, no one would do it." So, Arnett refinanced his own

Atlanta house in order to generate $340,000 cash to pay for the estate the Dials wanted; the deed to the new home and property was made out in the name of William Arnett.

Dial may have moved from troubles brewing in Pipe Shop, but moving to an all-white neighborhood such as Rock Mountain Lakes held its own dangers. He couldn't help but recall his days in Pipe Shop sitting on the front porch as the Klan marched by. "He didn't want to come down here," says Little Buck. "Just didn't want to come. Not by his self. So I decided I would come on down here with him." So did Mattie and Don and Richard and spouses and others until a gaggle of children and grandchildren inhabited the Dial compound.

With his family nearby, Thornton Dial settled in, but not completely. Despite newfound national recognition and his new Rock Mountain Lakes residence, Dial retained title to his built-by-hand shotgun house in Pipe Shop, just in case the Welcome Wagon paid drive-by visits in McCalla.

Bill Arnett bought a new house for his family too, right around the corner from his previous home just off Atlanta's exclusive Tuxedo Road. Aptly named for the formality and grace of its homes, Tuxedo Road winds through a lushly wooded area nestled behind the Georgia Governor's Mansion. Though its stately manors are known for generous lots that slope gently upward as they showcase exquisite putting green lawns, Bill Arnett's new eleven-thousand-square-foot contemporary sat in a rut, a rut that ensured seclusion and plenty of space for art. Bill Arnett thought he could turn the house into a gallery showcase for Dial and the other artists in Arnett's collection. "But it became like our previous house—a big warehouse filled with art," remembers Harry Arnett.

In Dial's 1989 painting, *Everybody Can See the Tiger Got a Monkey on His Back*, eyes watch from the jungle to see how the tiger will fare. A parasitic red monkey has jumped onto the back of the tiger, and the

big cat carries the crimson chimp with a steady posture and a sleepy gaze. Is this Dial's recognition of the responsibility he now shoulders on behalf of other African American artists, as some critics claimed? Or is this a sign of Dial's distress with the burdens of success? Is the monkey showing us the sycophants who attempted to pile on to Dial as his fame and wealth grew? Or is it a signifying monkey going for a trickster's ride? Or is it just a damn monkey and tiger?

Symbols of any kind, in any art, bring with them a multitude of interpretations with an equal range of consequences. Such was the case with the new homes of Thornton Dial and Bill Arnett, their most visible symbols of success. Were these plush abodes the well-earned rewards of an artist/patron phenomenon or the ill-gotten booty of a scoundrel and his toady? Inside folk art circles, Arnett and Dial's abundance crystallized a sense of scarcity among others. An article on outsider art in the summer 1990 issue of *Art & Antiques* painted Bill Arnett as a gluttonous, greedy white man eager to play the plantation owner with an industrious stable of black artists and willing to keep them afloat for as much art as his "warehouses and warehouses" could hold.

In Arnett's opinion, however, he and Dial and any of the other artists that ran with them were the high-minded, irreproachable ones while their critics were the ones with faulty morals. Didn't they see that he was protecting the artists and their works? He had planned all along, he claimed, to amass the definitive collection of these artists' best work so that it could be displayed appropriately to the world, perhaps in a museum of his own making. The *Art & Antiques* article only shared the gossip that flowed through the folk art community about collectors who were doing wrong. It read, "Everybody knows the stories and they're sordid: the dealer who got an artist drunk so he could buy his work cheaper, the dealer who traded a green felt-tip marker for an entire suite of paintings, the dealer who took an artist copies of *Hustler* magazine so he would paint naked women that would be easier to sell." None of these collectors was Bill Arnett. Bill

Arnett was disgusted by collectors who he believed perpetrated these heinous exploitive acts. Bill Arnett was paying more than asking price. Through monthly stipends paid out of the Arnett Artists Fund, Bill Arnett was putting artists in business and keeping them there. Bill Arnett was supporting whole families of artists—at least according to Bill Arnett.

"I was motivated primarily with cleaning the folk art market up. Just simply get rid of the crooks," Arnett says today. "I ran into all kinds of art fraud, and the people who were committing the frauds were prominent dealers and collectors and members of academia. Most of these artists were extremely happy to have a college professor or a wealthy woman in the town or a lawyer or a psychologist or whoever would come see them and tell them how great they are. These artists weren't starving to death, although they lived in some of the lousiest conditions you've ever seen. They were glad to have company, and somebody paying them attention and even one hundred dollars once a year or once every six months was gravy. So they would just sit and draw, and people would come and just take their work. I'm not exaggerating this at all, and I don't mind naming the artists and the keepers. Shit, they all ended up causing me trouble anyhow."

Sometimes it was old friends who caused Arnett trouble. An ever-increasing number became increasingly skeptical of Arnett's actions in the folk art field. "I was getting nasty phone calls," says Arnett. "Judith Alexander called me once, and she was just like an angry banshee. She told me I was paying too much money to artists and that I was ruining the folk art field and ruining the artists because all they did with money was buy drugs. She just was off the deep end," Arnett claims.

Lucinda Bunnen, however, tells another part of the story, "Bill would have hundred-dollar bills in his pocket and then hand Ron Lockett a hundred bucks and put a load of Lockett's art pieces in his car. He would buy Ron's whole body of work. Bill could get a whole life's work for one thousand dollars and sell it off for one hundred thousand dollars and not give the artist any more."

Word spread. With collectors acting as surreptitious information conduits, the alert that "Arnett was trouble" began to seep into folk art's isolated pockets. Says Bill Arnett, "I became the dragon that needed to be slain."

In the foothills of Tennessee's Smoky Mountains, sixty-one-year-old root artist Bessie Harvey was up for the job of slaying a dragon. In a 1989 interview with *Antique Magazine*, Harvey stressed, "I've got a free spirit and I won't be under nobody's thumb. Nobody will conquer me. . . . I'd rather not sell to greedy people, greedy, just greedy, just want to stores things up for theyself." Many in the folk art combine figured she meant Bill Arnett. One day, not long after the *Antique Magazine* interview, Bill Arnett opened his mail to find a battered envelope stuffed with pages torn from the Bible. "I don't even remember what it said," Arnett recalls about the package sent to him by Bessie Harvey. "But it was some kind of passage that sounded like a curse."

Bill Arnett, to this day, insists that he viewed the jinx as nothing but a joke. However, others who knew him at the time remember differently. "I went to see Thornton Dial and stayed overnight at Dial's house," says Lucinda Bunnen. "Bill Arnett stayed too. He and the Dials were talking about Bessie Harvey putting a hex on him so he wouldn't be able to sleep. That night the Dials put me in a room near Bill's, and he didn't sleep all night. He blamed his lack of sleep on the hex."

Born in 1910, Jimmy Lee Sudduth was in his late seventies and already well known by the time Bill Arnett began to work with him. Sudduth had been exhibiting his work since 1968 and had even been featured on a 1980 segment of NBC's *Today* show. Working from his modest home in tiny Fayette, Alabama, Jimmy Lee Sudduth dredged mud from around his house, mixing the slop with wild berries, flower petals, grass, and house paint, and stirring in sugar water to make the concoction

adherent. He then smeared the sticky mud on scrap plywood, pushing his fingers along the paneling to shape images of nearly everything in his world: self-portraits; buildings like the nearby Fayette County Courthouse; his beloved dead dog, Toto; animals that wandered his yard. He became famous for these mud paintings.

Lonnie Holley had been telling Bill Arnett that he had to visit Sudduth and "see if you like his work and can do something with him." So, with Lonnie Holley in tow, Bill Arnett drove north from Tuscaloosa up to Fayette, Alabama, to the home of Jimmy Lee Sudduth. Sudduth's art was everywhere Arnett looked. "Lots of it. Lots of it. Lots of it," says Arnett. It was love at first sight—Bill Arnett and the mud paintings.

"Mr. Sudduth, I'd love to get your work," Arnett said.

Holley saw Sudduth smile, but a hint of skepticism crossed the old artist's face. Holley piped up, pointed to Arnett. "Mr. Sudduth, this is the man that's been helping me, and he's the best man out there," Holley said. "He'll be so fair with you and take you to the top, and you can trust him."

Arnett picked out forty small pieces of art from Sudduth's yard and put the paintings down on the porch. "What will you take for these?" Arnett asked.

"I don't know. The most money other folks has ever given was $100. There's a man in Washington who gave $900 one time," Sudduth told him.

Arnett opened his checkbook, scribbled something, tore out paper, gave it over to Sudduth. It was a check for $1,450. Jimmy Lee Sudduth was so flabbergasted he couldn't speak.

Arnett wasn't worried by the silence, and he filled the void.

"Mr. Sudduth, I do things with Lonnie and some of the other artists. I give them a certain amount of money, and that guarantees me that I get to look at their artwork first," Arnett said. "So what I'm willing to do is I'll buy a certain number of pieces from you and pay you a certain price for them and you see how you like doing that and,

if you do, I'll come back every two weeks and do the same thing. But here's what I need from you. Whenever you paint anything, put it away and let me see it first. I'll guarantee you that every two weeks I'll spend $1,000 with you assuming you continue to make paintings that I want," Arnett proposed.

Sudduth's front porch was layered with paintings, and Arnett figured the old man still had plenty to sell to others. The deal proposed wouldn't curtail his sales. Arnett turned to leave, stopped, looked back. "Now whatever you make, you've got to promise me you'll put it in some back room and not let anybody see it until I come back," he said again to Sudduth, just to be sure the deal was firm.

Arnett returned to Fayette just about every two weeks for the next several months. He spent several thousand dollars buying Sudduth's art, and the artist seemed pleased. But the happy relationship between Bill Arnett and Jimmy Lee Sudduth was short-lived. "A number of people told me not to deal with Arnett," recalls Jimmy Lee Sudduth's cousin Seebow, who serves as Sudduth's de facto caretaker and business manager. "Arnett had Lonnie and the Tin Man Lucas all tied up. I wouldn't let Arnett make a fool out of Jimmy Lee. We was told about the Social Security scheme with checks, but Arnett never pulled that around us. It got too hot for him around here."

It got as hot as gunfire.

One night, while Arnett was making his rounds to Thornton Dial and Lonnie Holley, he decided to pay a visit to Jimmy Lee Sudduth. He stopped at a service station to use the payphone, figuring he would call Sudduth to let the artist know he was on the way.

"Mr. Sudduth, this is Bill Arnett," he said.

"Yeah, you son of a bitch," came the response. "You better not come here anymore."

Arnett looked at the receiver, dumbfounded. Sudduth was hard of hearing. Maybe that was the problem. He tried again. "Mr. Sudduth, this is Bill Arnett calling."

"I know who you are, you son of a bitch from Atlanta," Sudduth said.

"Yeah, I'm coming over tonight and I want to see you," Arnett said cheerily, still confused but pressing on.

"You better not come near my house, you son of a bitch," Sudduth said. "I've got a .45 in my hand, and I'll blow your brains out!" He hung up.

Arnett stuck another quarter in the payphone slot and dialed again. Mrs. Sudduth answered.

"Mrs. Sudduth, this is Bill Arnett. Please don't hang up," he said.

"You better not come over here. My husband has got a gun. He says he'll shoot you, and I think he will," she warned.

"Well, has he calmed down any?" Arnett asked.

"Yeah, he's okay now," she said.

"Would you put him back on the phone, please?" Arnett pleaded.

Jimmy Lee Sudduth came on the phone. Arnett could hear the rustle of cheek against receiver, and then, icy silence.

"Mr. Sudduth, look, I've given you a lot of money, right?" said Arnett.

"Yeah, you've given me more than anybody else," Sudduth admitted.

"Well, now you're telling me you're goin' kill me if I come over there? Please at least explain to me why," Arnett said.

"I know what you do to artists, and you're not goin' do this to *me anymore*," Sudduth replied.

"Well, what is it that you know that I do to artists?" Arnett asked.

"You go to artists and you talk real big about giving them a contract and you're goin' to give them all this money and they're gonna make all this money from you and how you going to take them to the top," Sudduth said. "Then you pay them with *checks*. You don't ever give 'em cash. Everybody else pays with cash," Sudduth asserted. "Then you go and tell everybody that you're getting all my best paintings and that they can't get my best paintings because you got my best paintings until everybody quits coming to see me 'cept you," he went on. "Then you go to the Social Security people and you show them where you've given me so much money, and they cut my Social Security off. Then there ain't nobody coming to see me but you, so

you go and take what I got and you don't give me nothin' for it then," he claimed. "That's what you're doing, and I'll kill your ass if you come anywhere near me," said Sudduth, heating up again.

"Mr. Sudduth, if that's what I do I'm sorry, but that *ain't* what I do," Arnett told him. "How do you know that's what I do? Who says that?"

"All my other art collector friends have told me about this. All of them tell me the same thing, and they couldn't all be lying. They done told me this, and those are my friends," Sudduth said.

"Mr. Sudduth, that's not true about me, but if you want I'll promise never to come here again," Arnett said. And he didn't.

"I never went back, but I wanted his artwork," says Arnett. "So my brother Robert—who didn't collect this kind of art but was around and didn't have anything else to do—he would go over, take cash and pay cash. He went over there, and he didn't lie to him at all. Just said, 'How are you, Mr. Sudduth? My name is Robert, and I've heard about you and would like to see your work,' and he got to be good friends with Mr. Sudduth, and Bob had better taste than any of the other people who were going over there. So Bob would buy Sudduth's work, and this went on for a year or two. I got plenty of work from Sudduth, and he, to this day, never knew."

While Thornton Dial's success was roaring and Arnett was under fire, Lonnie Holley's light burned low. During the late 1980s and early 1990s Lonnie Holley was short of funds and long on art. "He would do these works and just give them to you," gallery owner Anne Arrasmith remembers. "I don't know how he made a living. He never cared about that," she says. Arrasmith was irritated by the fact that Holley was so talented and yet so poor. She was irritated, too, by Bill Arnett—not solely for the monetary exploitation she believes he perpetrated against Lonnie Holley but also "for dumping Lonnie in

favor of Dial." Such were the whispers that flowed endlessly toward Holley like shards of glass through a tender heart.

"Dumping Lonnie" is a claim that Arnett vigorously denies. Once, a museum curator toured the Arnett collection with a particular interest in the works of Lonnie Holley. "I took this curator downstairs with the lights off to see where I had my Lonnie stuff because I absolutely know, don't call this paranoia, I absolutely know 'cause I been through this a freaking hundred times that if I showed him through the warehouse he would go back and say to Lonnie, 'It's clear from seeing Bill's warehouse that he is pushing Thornton Dial,'" says Arnett. "Then Lonnie would start getting his feelings hurt doubting that I'm really dedicated to his welfare, which I am by the way. I mean I have kept Lonnie spiritually and financially afloat during the hard years."

Word regularly slipped back to Lonnie Holley about Bill Arnett's favoritism toward Dial, and with it Lonnie and his delicate temperament would be beckoned by the woods. "Lonnie battles depression," Anne Arrasmith notes. "He just shuts down and goes in the woods and drinks."

According to Arnett, on at least one occasion during one of Lonnie Holley's emotional down cycles, someone called the Holley household falsely claiming to be Bill Arnett and threatening to blow up Holley's home. "Then Lonnie called me on the phone," Bill Arnett says. "He threatened to kill me. He started screaming at me. 'You don't come near me! I'll kill you!' he said." It was then that Bill Arnett engaged John Ricker, who worked at the warehouse, for a different purpose. Ricker, with his gun and his dog, became Bill Arnett's personal bodyguard.

Relations between Bill Arnett and Lonnie Holley normalized not long after that, only to be torn asunder again. In support of Dial, Lonnie Holley flew to New York for the opening reception at the New Museum's showing of Dial's one-person exhibition. During cocktails, a New York socialite pulled Lonnie Holley aside, waved her

jeweled arm across the Dial-filled gallery, and pronounced, "It should be *your* art on these walls, not *his*. This should have been *your* show."

It wasn't only artists who were out for the blood of Bill Arnett and, by extension, Thornton Dial. Arnett's arrangement with Dial and other artists increasingly infuriated competitive folk art collectors who wanted what they viewed as their own fair share of the artists' best work. While Bill Arnett was attempting to strengthen his relationship with professionals at the Museum of American Folk Art, one of the museum's trustees received this letter:

September 5, 1990

I am somewhat alarmed at the interrelationship of the museum staff with an individual named William "Bill" Arnett from Atlanta, Georgia. In order not to spread rumors, I can say that I have witnessed examples in which Mr. Arnett has acquired large amounts of aesthetic material from poor folk artists, and then attempted to sell them for five figures without reimbursing the artist his fair share. A case in point would be artist Lonnie Holley in Birmingham, Alabama, who lives in abject poverty while Mr. Arnett has hoarded the best of his material worth upwards of one quarter million dollars. I have experienced this personally, and when the other collectors like myself try to purchase from the artist for fair sums, which would aid in abetting his predicament, we are rejected due to some false promises between Mr. Arnett and the artist. This is not a simple case of not being able to obtain desired aesthetic material, but rather a case of the dealer/collector Arnett falsely misleading an artist to the disadvantage of both the artist and other collectors. There have also been reports, and I believe they are true, of William Arnett and his son legally and physically threatening elderly folk artists and dealers in the field.

The museum's director faxed a copy of the letter to Arnett to warn him of enemy activities. However, the politically savvy administrator blacked out the name and address of the sender, and all Arnett could do was fume and brush it off. "We looked at these people as nuisances

and didn't take them seriously," Paul Arnett says. Perhaps they should have paid closer attention. Elsewhere in the folk art market, accusations of exploitation were snowballing into nasty litigation.

———

Like Thornton Dial, Bill Traylor—African American self-taught artist from Alabama—continued his ascent up the folk art success ladder, albeit posthumously. In less than ten years since his 1982 showing at the Corcoran Museum's *Black Folk Art in America* show, the value of Traylor's drawings on cardboard skyrocketed to twenty thousand dollars, and Frank Maresca had penned a book about the artist published by Alfred Knopf, Inc. All of this success could be traced to the persistent championing of Bill Traylor's artwork by the man who claimed to have "discovered" him: Charles Shannon.

Marcia Weber wondered about Charles Shannon. She had spearheaded the show of Bill Traylor's work at the Montgomery Museum of Art after Shannon's generous gift years earlier. That act, that gift, seemed to say Shannon was a generous man. But Weber noticed that he was an extremely circumspect one, too. She wondered whether Shannon was completely forthcoming about his relationship with Bill Traylor. Through her work at the Montgomery Museum of Art and later, in her efforts to launch her own art gallery, Weber encountered other members of the New South artists' group of which Shannon had been a part during its brief existence in 1939 through 1940. She learned that some of the other New South alumni had encountered Traylor. After all, Shannon and the New Southers hosted an exhibition of Traylor's work in 1940. Perhaps some of the New South alums saved Traylor's work too. Weber brushed such thinking off as purely speculative, but in 1985 something happened that drove her to take her concerns much more seriously.

"Jay Leavell had been a member of the New South artists group in Montgomery," Weber says. "Around the end of 1985, Jay Leavell had

died of bone cancer. His widow, Jo, and their daughter, Candy, called me and said, "We've sold the house." They had a big house down from the Governor's Mansion on Cherry Street in Montgomery. "Mom needs to be out in two weeks. We need you to help us handle cleaning out the art studio area. Would you help Mom go through it?" I jumped at it. I spent two to three days helping, and during that time I found a brown paper bag with ten Traylors in it, complete with the string Traylor tied them together with and memorabilia and articles about Traylor. That bag in my hands changed the direction of my life," Weber recalls.

As Marcia Weber and Jo Leavell reviewed the preserved articles, Weber noticed an article from March 31, 1948, that stirred her spider senses. It showed Bill Traylor sitting under a fig tree at 314 Bragg Street—his daughter's house in Montgomery. Charles Shannon had repeatedly stated that Bill Traylor died in 1947. Amidst Jay Leavell's memorabilia, Weber unearthed a New South membership roster, and she began to track down all the members, yielding another ten works by Bill Traylor. "That set me on fire to think there were more pieces out there," Weber says. "We had taken Shannon's word for everything, and this all immediately cast doubt on what else might not be accurate." She set about to determine the real record of Bill Traylor. Miriam Fowler, then with the Alabama State Arts Council, joined Weber in her quest. Together, they began a hunt for Bill Traylor facts with an emphasis on tracking down surviving family members. The Traylor descendants were vaguely aware of their ancestor's artwork, and some had become increasingly aware of his rise to fame. The efforts of Weber and Fowler at locating family members catalyzed the extended Traylor family, which reconnected and began holding family reunions. The family invited Weber and Fowler to attend one such reunion in the summer of 1992 in Atlanta at the home of Antoinette Beeks, Bill Traylor's great-granddaughter.

Fowler and Weber presented the findings of their Traylor research alongside New York gallerist Louise Ross, who showed slides of the

artist's work. After the presentation, Antoinette Beaks mentioned to Ross that she wanted to buy a piece of Traylor's work. Ross responded that she had none for sale; she was keeping the ones she owned. Discussion turned to the tight grip held on the supply of Traylor's work in the marketplace. Weber had tried in the past to persuade Charles Shannon to let her sell some of his Traylor cache, but he refused. He had chosen to sell his holdings primarily through the Hirschl & Adler Modern gallery in Manhattan. But Beeks was Traylor's family: shouldn't *she* be able to buy direct? Had this work been misappropriated in the 1940s? Did it rightfully belong to the Traylor family? Weber gave Charles Shannon's address to Beeks and suggested that she write to Shannon and ask if he would sell some of Traylor's work. "Beeks wrote to Shannon directly, and he passed the letter on to Hirschl & Adler and she got a curt, businesslike letter back. This infuriated her," Weber says.

It infuriated Beeks so much that she retained legal counsel, which promptly filed a lawsuit against Charles Shannon and Hirschl & Adler Modern. The plantiffs' attorneys did what they could to make things as painful as possible for the defendants. "We got the press actively involved. We maneuvered to try the case in the press," boasts William Gignilliat III, one of the Traylor family's attorneys and an Atlanta arts activist. In the fall of 1992, the lawsuit became national news, receiving prominent coverage in the *Wall Street Journal* and *New York Times*. Charges of thievery and exploitation slammed against the aged Charles Shannon like a tsunami.

Lifting the waves higher, the lawsuit was also filed against Shannon's wife, Eugenia. "We did depositions with Eugenia Shannon where we asked her if she knew about the affairs her husband had. We were lawyers playing hardball," says Gignilliat, who remains convinced that Shannon's integrity was questionable. "I think he knew enough about the mechanics of the art world to create the value for Traylor's work. Shannon was an average artist, but he knew that the art he was bringing home of Traylor's was important and special. Was

Traylor free and equal? No. He was dealing with white southern males in Montgomery, Alabama," Gignilliat insists.

Charles Shannon hired lawyers of his own, no less than the white-shoed eighty-year-old global law firm Hunton & Williams. They began to battle back and, coopting their adversaries' tactics, they battled as much in the press as in the court. John Charles Thomas, an attorney at Hunton & Williams, told the *Atlanta Journal-Constitution* in a January 1993 article, "I could look back and see my grandfather sold the land that is now Manhattan in 1853 for X number of dollars and I think that he should have sold it for more, so now I want to go and sue for more."

A year after the suit was filed, in October 1993, the parties announced a settlement with a surprising twist. They released a joint statement saying, "In truth, the relationship between Charles Shannon and Bill Traylor was founded upon fair compensation, support, and mutual esteem." It went on to state the resolution: "The settlement involves a gift by Charles Shannon of twelve Traylor drawings to a trust for the benefit of the Traylor family. Hirschl & Adler Modern, Inc. will act as the dealer for any sales of art from the family trust, and will continue to act as art dealer for Traylor works offered for sale by the Shannons."

Could the simple statement and settlement compensate for the phenomenal creations of a family's poor and weathered slave descendant? Could the simple statement compensate for the public indignity suffered by a well-meaning man of the arts who championed the artist? The answers remained unclear, and the hot-potato question of exploitation would not fade but, instead, grow—and the fingers would point persistently at Bill Arnett and Thornton Dial.

They have yet to stop pointing. "Would I look for a chance to drive a stake through Bill Arnett's heart?" asks Bill Gignilliat, who would play a role in later Dial-Arnett intrigue. "Absolutely."

Chapter 10

TIGER GOT A
MONKEY ON HIS BACK

ONE SUNDAY IN FEBRUARY 1987, ATLANTA LAWYER BILLY PAYNE experienced an "extraordinary sensation" that dashed like a sprinter through his arm to his fingertips which, clutching a pen, quickly jotted the words, "1996 Olympics." His life's work then became immediately clear. He would secure Atlanta as the host city for the 1996 Olympics. The Centennial Olympic Games in Atlanta, Georgia? Ridiculous. Athens, Greece, the birthplace of the modern Olympiad was the natural home for its one hundredth anniversary. To many, Atlanta made about as much sense as host city for the 1996 Olympics as Athens, Greece, made for hosting a cheese grits cook-off, but the following three years of Payne's life were consumed with the pursuit of his Atlanta Olympics vision. Payne promoted his big idea ceaselessly. He got his high-powered good-old-boy friends to cough up money to help with his promotions, and even landed former diplomat and Atlanta Mayor Andrew Young's support to sell the big idea to the world. Despite Atlanta's underdog status, on a Tuesday in September 1990 after a secret ballot election, International Olympic Committee president Juan Samaranch announced to the globe that "the 1996 Olympic Games" would be awarded ". . . to the city of . . . Atlanta!"

Entrepreneurs throughout the capital of the New South—from T-shirt vendors to soft-drink giants—flew into immediate motion to capitalize on the town's new worldwide marketing platform. If Atlanta was a place where ambition, pluck, and PR could catapult you to the top, that identity had just been confirmed through Billy Payne. Atlanta might finally earn its long-desired reputation as a great international city. But the Olympics meant more than globalism and sports pride for Atlanta. It meant a Cultural Olympiad and the chance to give the aesthetic Sahara some rain.

Bill Arnett had big buckets in hand to catch the downpour.

"When they announced, 'It's Atlanta,' the first thing that popped into my mind was what a wonderful opportunity for the world to see this art," Arnett says. "It was going to take decades to get this work out; now it would take two weeks!"

The exhibitions that Arnett had in mind were *Souls Grown Deep*—a panorama of African American vernacular artists—and *Thornton Dial: Remembering the Road*—a solo show of recent Dial works. Arnett believed these shows were essential to convincing the art establishment to favorably reconsider the role that the southern United States—and, more important, the African American South— played in the history of Western art. He fully expected the *Souls Grown Deep* exhibition to be the centerpiece of Atlanta's Cultural Olympiad. In addition to producing the shows in Atlanta, Arnett believed he could convince the Whitney Museum in New York and the National Museum of American Art at the Smithsonian in D.C. to mount the exhibitions as well. Grander still, Arnett envisioned that his growing art collection would be the corpus of a new museum housed in a renovated warehouse near the Carter Center, home to Jimmy Carter's presidential library. He had begun to rally several major Atlanta folk art collectors around the museum idea that he promoted as a prominent Olympics showcase.

Many great activities, one big problem. For Arnett to pull off his Olympic vision in appropriate style, he would need the endorsement

and participation of the High Museum of Art . . . and his old nemesis, Gudmund Vigtel.

In the years preceding Billy Payne's Olympic coup, the High's cool Scandinavian chief executive, Gudmund Vigtel, had warmed neither to Bill Arnett nor to folk art.

"I was unwilling to support uncritical acceptance of this art on the part of curators," Vig remembers. "For the most part, this art is easy to fake and makes no real demands on the viewer." However, regarding Thornton Dial, more than discriminating taste tainted Vigtel's view; it was clouded by his perception of Bill Arnett. "Dial is definitely a talent. It is amazing that his work doesn't look like folk art. It could come right out of the New York School," Vigtel comments about Dial. "But he is a product of Bill Arnett's relentless promotion."

Vigtel, who had been with the High Museum for twenty-eight years, was the longest tenured of any American museum director at the time. He would be there until he died, Arnett figured. Arnett's dream seemed to float on lead clouds. Given Vig's attitude toward folk art and disdain for Arnett, the collector's Olympic task seemed impossible. Then the impossible happened. In 1991, Gudmund Vigtel announced his retirement.

As the old guard of Atlanta cultural leadership retired, a new breed came on the scene. Maxwell Anderson stood confidently at the front of the new guard. In 1987 Michael C. Carlos Hall—the Emory University Museum of Art and Archaeology, which was named for an Atlanta liquor distributor—hired the thirty-one-year-old Anderson away from New York's Metropolitan Museum of Art to serve as its new director. Grandson of famed American playwright Maxwell Anderson, Maxwell-the-younger had a gold-leafed pedigree including attendance at the finest prep schools in the United States, France, and England plus a college degree from Dartmouth and a master's degree and Ph.D. from Harvard. Anderson was handsome with a thick dark mane, a Neiman Marcus wardrobe, and the rich, deep, slow-tempo voice of an FM disc jockey. If that wasn't enough, his resonant words

fluently spilled out in any of five different languages. "Everyone was awestruck with Max Anderson," says Atlanta art critic Jerry Cullum. "He was just so patrician."

Perhaps High Museum patrons and staff figured they needed their own young, handsome gentleman running the High to outpace their crosstown rival. Shortly after Gudmund Vigtel announced his retirement, the High announced that it snagged as his replacement Ned Rifkin, an athletic-looking Yankee with a full crop of dark hair and the ability to pour on the charm. Rifkin's voice was so mellifluous that years later, as director of the Hirshhorn Museum in D.C., Rifkin's recorded voice greeted all callers who dialed the Hirshhorn's main line.

It looked like, in Ned Rifkin, the High Museum now had its own Max Anderson—though without quite the pedigree and polish. Born in Alabama in 1949, Rifkin was raised outside of Manhattan, attended Syracuse University, and earned a Ph.D. from the University of Michigan's art history program. He subsequently worked at the New Museum of Art in New York and served in curatorial roles at the Corcoran Gallery and Hirshhorn Museum. After spending fourteen years in the upper crust of contemporary art museums, Rifkin moved to the High.

"I remember talking to the search committee when they were interviewing," Rifkin once told a reporter ten years after coming south. "And I said, 'Are you sure you want a contemporary-art specialist coming from a museum like the Hirshhorn as your director? I never hear anything about contemporary art in Atlanta.' They said, 'Yes, but you're the one who's going to bring us into the twentieth century.' I thought, *I suppose it's not too late; the century's not over yet.*"

"At first, people were favorably inclined toward him," Jerry Cullum remembers. Ned Rifkin took charge quickly. Rifkin defrayed the museum deficit that was inherited from Vigtel, and he grew audience interest in museum programming. "Ned wanted to see people lined up around the block at the museum, but he held the Atlanta

audience in contempt and he did lowest-common-denominator programming. . . . So, he alienated people in the core art community through his personal manner and exhibition program," Cullum says.

But Rifkin didn't alienate all.

"I was interested in sports as a boy." Rifkin has said. "I was interested in girls as a young man." Some say Ned Rifkin "courted" his Atlanta female donors. "Ned went to see the dowagers, the old ladies, and he had them virtually seduced," Atlanta art matriarch Lucinda Bunnen claims. "They were in love with him—honestly and truly—they gave more money to the museum than they ever had before. Ned would sit by the bedside of one wealthy matron I knew who was the grandmother of a well-known local industrialist. And she was in love with Ned."

But not all ladies were swayed by his charm. "Judith Alexander hated him," says Genevieve Arnold, an Atlanta artist, curator, and collector who ran one of the city's first contemporary art galleries and who saw an occasionally darker side of Rifkin. "Ned was like two different people with me. He could be charming and I respected his eye for art, but he turned on me and jumped down my throat many times," Arnold recalls. Such was the experience of some of Rifkin's museum staffers. "I'm not comfortable talking about Ned," says Susan Crane, who served at the time as Rifkin's curator of modern and contemporary art. "Vig let curators do their own thing. Ned centralized decision making. He *assigned* projects to people. Ned didn't tolerate a lot of critical dialogue. He came to the High, and there was a mass exodus of senior curators."

Regardless, Atlanta now had two high-profile, pedigreed museum directors with enormous challenges, enormous opportunities, and egos to match. "I used to describe the difference between Max Anderson and Ned Rifkin like this," notes Jerry Cullum. "When you talked to Ned, he seemed to remind you in his way that 'I am Ned Rifkin and you, unfortunately, are not.' He looked at you as someone just wasting his time. When you talked to Max, he seemed to remind

you in his way that 'I'm Max Anderson and although I know I'm superior to you, I'm going to listen to everything you say on the off chance you say something interesting.'"

The one hundredth anniversary of the modern Olympic Games was the perfect platform for ambitious men of the arts like Maxwell Anderson and Ned Rifkin. They could put their city, their institutions and themselves on world view. Their only obstacle was that another strong-willed art personality wanted to share the stage, too: Bill Arnett.

———

When it came to art-world aristocracy, neither Maxwell Anderson nor Ned Rifkin came close to matching the lofty credentials of J. Carter Brown. During his reign at Washington, D.C.'s National Gallery of Art, Brown was hailed as one of the nation's leading museum directors. Tall, thin, and elegant, the fifty-six-year-old Brown descended from a prestigious American lineage whose ancestors included pioneers of the Rhode Island Colony and founders and namesakes of Providence's Brown University. J. Carter Brown did not attend his eponymous school but rather earned a college degree and master's in business administration from Harvard and a master's degree from the Institute of Fine Arts at New York University. To top it off, Brown was later granted honorary degrees from twenty of the finest universities. He was a member of the Committee for the Preservation of the White House and spent his career at the National Gallery of Art—a tenure that included accomplishments like tripling the museum's attendance, and growing its annual budget by nearly $50 million and its endowment by nearly $150 million. He commissioned a massive expansion of the Gallery with an at-first controversial and later widely praised addition designed by I. M. Pei. He added nearly twenty thousand works of art to the Gallery's collection and mounted blockbuster exhibitions like *The Treasures of Tutankhamen* in 1976, which drew

record crowds to the museum. If the American art scene had its own King Tut in 1991, it would have been J. Carter Brown.

In fact, in the American art world, J. Carter Brown was second only to one man and only in one particular area. While Gudmund Vigtel had served as the director of the High Museum of Art for twenty-eight years, Brown, in runner-up status, was director of the National Gallery for only twenty-three. So, when the High held a black-tie retirement dinner in Vigtel's honor, the museum's board invited J. Carter Brown as a special guest.

"I was assigned the task of picking J. Carter Brown up at the airport and squiring him around Atlanta," says Ned Rifkin. "I had met him before when I was at the Hirshhorn but can't say I really knew him." But that didn't stop Rifkin from quickly taking advantage of his captive audience to pitch an exhibition idea. "He asked, 'What are your plans for the Olympics?' I told him I want to do something memorable and impressive," Rifkin says. Then, seeing a slight opening to build a relationship with a mentor who could "make" his career, Rifkin seized the moment. "Perhaps I could come to D.C. and talk to you about it?" Rifkin offered.

One week later, in late January 1992, J. Carter Brown announced his retirement from the National Gallery of Art. Ned Rifkin immediately called Brown and congratulated him. "I said, 'Can I still come to see you?' He said, 'Of course, now there's all the more reason. I might be able to help out with the Olympics. I have more time on my hands.'"

In considering the High's role in the Cultural Olympiad, Ned Rifkin looked backward, not forward. He considered the Cotton States Exposition that Atlanta hosted one hundred years earlier to promote the South's technological progress. The Cotton States Exposition showcased the latest industrial, agricultural, and cultural advances in the midst of southern Reconstruction after the Civil War. There John Philip Sousa debuted his musical score "King Cotton," and Thomas Edison exhibited his hand-colored movies. African

Americans were given their own Colored Building in which to display their accomplishments. Among these were cotton quilts picturing Bible scenes by quilters like the accomplished Harriet Powers. And it was at the Cotton States Exposition that Booker T. Washington issued his historic "Atlanta Compromise" speech, in which he called for social separation of the races while advocating for equal economic opportunity. As the Exposition came to be known by the shortened "Cotton States Exposition," it was forgotten to many that the official name of the event was the Cotton States and International Exposition. This nuance was not, however, lost on Ned Rifkin.

"The exposition was a very critical moment for locating Atlanta as the potential capital of the New South. The event brought art from all over the world to Atlanta. So I wondered, almost exactly one hundred years later, what could we do of comparable consequence that would propel Atlanta into a new position?" Rifkin says. "I had decided, being a former athlete myself, that since the Olympics had to do with world competition in all disciplines, we needed the equivalent for world art. What if we asked each country to send not just their best athlete but also their greatest works of art? We would deal with the idea of 'masterpiece' in a cross-sectional cultural way. We would deal with excellence as perceived by each nation revealing the notion of shifting aesthetic values through cultural lenses."

For all his grand visioning, however, Rifkin was no match for J. Carter Brown. "When I came into Carter's new offices on Pennsylvania Avenue in D.C., I didn't realize I was walking into his grand plan," Rifkin remembers. "I was like a character in *his* film. He said, 'Tell me what your thoughts are,' and I told him. He said, 'Ned, that's a great idea.' And then he said, 'Here's an even better idea. What if we took your idea and refined it in this way: take the visual image of five Olympic rings and instead of the rings representing continents, we use them to embody different values of human experience?'" Rifkin recounts. "Yeah, that's what I meant," Rifkin replied tongue-in-cheek to Brown. "Carter made me feel like *I* brought *him*

a great concept and he said, 'I have some core ideas that could help you.' That's when I realized that I could do something really remarkable, which was to hire J. Carter Brown as curator of this exhibition." Rifkin and Brown's Olympic exhibition at the High Museum of Art was titled *Rings: Five Passions in World Art.*

———

There was one trend in the Atlanta art world that seemed to carry nearly as much frothy enthusiasm as the pending Olympics, and it was folk art. Bill Arnett was the frothiest and most enthusiastic of its champions. With Gudmund Vigtel now out of the picture, Arnett believed he could convince the *new* High Museum director that African American vernacular art should be the centerpiece of the Cultural Olympiad. The only problem now was the new director's budding relationship with J. Carter Brown. Something was afoot behind the scenes that Arnett couldn't see, but it smelled like a road-block. Arnett wondered how Thornton Dial and Lonnie Holley and the entirety of black southern folk art would be seen by the world if they were boxed out of the High Museum yet again. But instead of giving up, Arnett figured he would just have to push harder. He would have to pull out all of the stops.

Ned Rifkin's apparent indifference to folk art didn't help Arnett's mission. Rifkin had seen the *Black Folk Art in America* show in 1982, claimed that it was "a revelation," but seemed to keep a professional distance from the material. Just two years after seeing the Corcoran show, he was working at that very museum under Jane Livingston. "Ned Rifkin and I went to visit Lonnie Holley around 1984, and Ned was uncomfortable, squirming," remembers Livingston. Rifkin brought his skepticism about the folk genre to Atlanta. "Is Thornton Dial an artist or just a guy who makes things? With self-taught art it's like one day the work is in a guy's garage getting rained on and the next day it is being handled by museum curators wearing white

gloves and doing long reports on it," Rifkin laughs. "There was a swelling, an irrational exuberance, a hurry up, dot-com, gold rush—a super-heated market hype in the folk field."

Still Rifkin recognized folk art as a key part of his High Museum mandate. The noise from his board of directors—many of whom were burgeoning folk art collectors—was palpable, and he understood that "whether you like this work or not, it is endemic to southern culture." And if southern culture was important to the High Museum, folk art was important to Rifkin's success at the institution. Like it or not, Rifkin couldn't ignore Arnett and his folk art stockpile.

The real problem that Arnett faced in promoting his Olympic agenda at the High Museum wasn't Rifkin's own Olympic ambitions; nor was it Rifkin's ambivalence about folk art. It was, instead, Ned Rifkin's immediate and intense *personal* dislike for Bill Arnett.

"Bill alienated me, and I'm sure it was mutual," Rifkin remembers of his early Arnett encounters. "Everyone in the art community was polarized around Bill. *He* was saying what's right and wrong like *he* was the authority. It is the role of the museum to adjudicate these issues. He couldn't help himself from playing God. He had his own pantheon of hierarchical dimension about this art. He would say, 'Dial is Picasso, this one is Matisse, that one is Chagall.' Bill was manic about all of this, and if you didn't agree with Bill Arnett you were 'bad' in his eyes. The first time I went to his house, he couldn't help but narrate the work, and I just wanted to look. Bill Arnett was trying to push *Souls Grown Deep* on the High Museum. He pushed so hard on me that I said 'Go away.' Doing his show wasn't worth the effort that was involved in dealing with Bill," says Rifkin.

Rifkin saw himself as a museum director with ethics as lofty as his aspirations. As a member of the Association of Art Museum Directors, Rifkin was mindful of the organization's *Professional Practices in Art Museums* guidebook's Code of Ethics for Art Museum Directors. "Museum directors, trustees and others in positions of responsibility must be alert to situations in which conflicts of interest may occur,"

the guidebook reads. "The position of a museum director is one of trust. The director must act with integrity and in accordance with the highest ethical principles." Rifkin agreed.

"Institutionally I had to distance myself from Bill Arnett," Rifkin says. "I did the honorable and ethical thing with regard to self-taught art instead of getting in bed with people who were selling it and doing a show for their artists. Bill made claims for artists that I found so hyperbolic. He clearly had another aspect of his interests that were commercially driven. Bill Arnett was selling art. He was dealing art. So he couldn't curate a museum show of his collection. There was no way we would let him curate a Thornton Dial show. Bill Arnett wanted to sell Dial's work at high prices. There was no basis for those prices except Bill's passion about Dial. Dial made some terrific things, but some I don't like. He is like many artists in that field. He would over-produce when he was told to, and the result is some bad art."

Others on Rifkin's staff were skeptical too. "I saw Arnett's collection. I had questions. There was so much stuff, it was just like rabid collecting," says Susan Crane who served as curator of modern and contemporary art under Rifkin. "To Bill Arnett everything in his collection was created equal. I also had questions about Bill's involvement in the artists' work. Like asking Dial to take up drawing. It is hard to divide the artist's intentions from the dealer's. Bill stood to make a lot of money from Dial. Nothing about the way Bill approached things was clean. It was all complicated and multidimensional, and in the nonprofit world that is not good. There was tons of conflict of interest. He's interesting and smart, but I always felt I was subject to the missionary sell. He was trying hard to build a market. The Dial drawings were really about the making of a market. As a museum person, I have to resist that. Museums rarely get funding for private collection shows because a museum show will increase the value of the collector's work, and that creates conflict," Crane points out.

But in Arnett's mind his own motives were pure, and he bristled at anyone who might question them. "I was determined to do things

for Atlanta that I thought I could do that would help Atlanta and . . . that hurt because I was willing to give. That's 'give,' spelled g-i-v-e," Arnett says, articulating every letter crisply and loudly. "*Give*, meaning no money, no strings attached. Give Atlanta and Atlanta's institutions literally every single piece I had. I wanted to give it all away . . . get it out of my possession so that it would have a better chance of sticking in the history books." No one, it seemed, was willing to take the collection on Arnett's terms.

With every encounter, the estrangement between Rifkin and Arnett deepened. "He is so disdainful of other people that he is poisonous in terms of organizations," Rifkin says, sharing his concern about the impact he thought Arnett would have on his High Museum staff. "He is so intolerant of others. When you deal with folks of such extreme personalities like that, they will push you to intolerance."

Anyone who came in contact with Bill Arnett knew of his intolerance of Ned Rifkin. "Narcissistic sociopath" was one of his favorite descriptions of Rifkin. "This is a man with no eye for art," Arnett announced to anyone who would listen, "with no taste, with no historical knowledge, and that's why he's drawn into minimalism because less is less. He is less." Arnett said that Rifkin was jealous of his own eye for art and that Rifkin just looked at what *he* was doing and copied it. "If I farted," Arnett proclaimed, "he would go out and buy beans."

"Ned Rifkin told me," Arnett recalls, "when I was trying to tell him what a genius Lonnie was, Ned Rifkin actually said to me, 'I've been to his house. I've walked through his yard, and it's nothing but junk.' He said, 'You're not going to convince me that this junk is great art, and I don't think you're going to convince anybody else.' Rifkin tried to spread word that he'd *seen* Dial's work and only a few of his pieces were good, and most of them are no damn good."

To Arnett, those were fighting words. One afternoon, Bill Arnett was summoned to the director's offices at the High Museum of Art. Paul Arnett accompanied him but was told by Ned Rifkin's administrative assistant that the director wished to speak with Bill Arnett alone.

Rifkin got straight to the point. "You've been bad-mouthing me all over town, and it needs to stop."

"I'm not saying anything that isn't true," Bill Arnett shot back.

What happened next is unclear, but it is confirmed by both sides that expletives ricocheted like pinballs off the bumpers.

"Fuck you, fuck you, fuck you!" Paul Arnett claims he heard while waiting outside the office. He thought it was his father shouting—on another binge of bluster.

"Fuck you, fuck you, fuck you!" Bill Arnett claims Ned Rifkin shouted at him.

"I think I said, 'Go fuck yourself' or 'Fuck off, I don't need to hear this from you,'" Ned Rifkin admits. But the triple F-bomb attack was unlikely, he says.

By the fall of 1993, Bill Arnett's battles with the Atlanta art establishment became increasingly public and so heated that the *Atlanta Journal-Constitution*'s Cathy Fox chronicled the "bad blood" in the publication's arts section. In a feud that harkened back to his clash with Gudmund Vigtel, Bill Arnett complained, "The relations between that institution (the High Museum) and me have been bad for years."

"A friend of mine in Atlanta who's in real estate explained this to me once. He said, 'If you own all the valuable real estate in an area, nothing is gonna happen in that area. People will just find somewhere else to make something happen,'" Arnett says.

Bill Arnett scoffed at the property maven, and though Arnett owned a wealth of artistic property in Atlanta's land of folk art, he continued to ignore whomever he was excluding from the territory. He was too busy making things happen somewhere else—globally to be precise, in Paris . . . a real estate zone where neither Bill Arnett nor Ned Rifkin held any cultural property. There, hope sprang eternal.

Arnett's negotiations with Henry Pillsbury to mount a Dial exhibition as the opening for the new American Center were progressing smoothly. "They were hailing me as a hero over there," says Bill Arnett. "I met with the board of directors at the Centre Pompidou, which is the contemporary arts center in Paris, and I met with all kinds of other people in Paris like the lawyer for the International Olympic Committee who was there, and all these people were saying, 'This is heroic of you to fight for these artists.' It was just halcyon days. I mean nothing could stop this."

Rifkin, however, was busy finding other cultural real estate, literally. To assuage his board constituents and as a counteroffensive to Bill Arnett, Rifkin ostensibly embraced folk art and found somewhere else to make something happen. The somewhere else began with someone else: Marshall Hahn, CEO of Georgia-Pacific, the world's largest producer of tissue paper. The somewhere else was Hahn's Fortune 500 corporate headquarters basement.

In February 1986, Hahn allowed the High Museum of Art to open a business district branch in the basement of the fifty-two-story Georgia-Pacific Center in downtown Atlanta. The branch was first used as an overflow display facility for the Museum, and it had floundered in that role. In 1993, the sixty-seven-year-old Hahn was retiring from Georgia-Pacific and at the peak of his interest in folk art. He had been collecting art of various kinds for thirty years and had a particular interest in the memory paintings of Georgia folk artist Mattie Lou O'Kelley. Now he was ready to take his collection to a new level.

Those who knew Hahn's collection believed the quality-lift was badly needed. Among the curators and art elite, Hahn was known for his general inability to decipher great works by great artists from third-rate works by mediocre artists. Instead, quantity was the order of the day. "He was buying with abandon," says folk art gallerist Frank Maresca. "We were an advisor to Marshall's collection. We got in and assessed the collection and vetted it and eliminated 85 percent of it." In addition to Maresca, one of the aficionados whom Hahn engaged

to raise his collection to a higher level was Bill Arnett. Arnett helped Hahn buy, among other things, works by Thornton Dial and Lonnie Holley. "I was educating him way more than Maresca was educating him. I mean, Marshall might have had three sessions with Maresca, but he was calling me every week. Every week to have lunch with him or dinner with him or come to his house. Every fucking week. Fifty-two times a year," says Bill Arnett. According to Arnett, he and Marshall Hahn were best buddies, until Ned Rifkin came to town.

With the starched, unflappable demeanor of a NYSE company CEO, Marshall Hahn achieved a ready connection with the business-minded Rifkin. And, in Hahn, Rifkin saw the chance to kill many birds with one stone: lower the noise about folk art from board members, place this questionable art in a downtown basement away from the main museum, and neutralize Bill Arnett by championing a collector of greater community stature. Hahn had been a power-ful voice on the High Museum board, advocating for folk art's place in the schema of the museum's collection. Rifkin recognized that CEOs like Hahn don't lack for ego. As a shrewd museum director he intuited Hahn's ambition to leave a legacy in this area to which his name could be attached and glorified. Rifkin helped to enable this ambition through a series of initiatives that would benefit both Hahn and the High. First, in 1993, Hahn and Rifkin came to an agreement to shift the focus of the High Museum's space in the Georgia-Pacific building and dedicate it to the exhibition of folk art and photography.

"The idea was to push folk art away from the main museum and solve the problems of Marshall Hahn and what to do with the down-town space which had languished," says Rifkin. This move was accompanied by the High's acquisition of sixty works of folk art from collector and Georgia artist Andy Nasisse. Next, with Hahn's help, the Museum snagged an anonymous nine-hundred-thousand-dollar grant supporting folk art programming; persuaded Norfolk Southern Corporation to provide funds for folk art acquisitions; and hired a

curator, Joanne Cubbs, to form in 1994 the first folk art department of any major general museum in the United States.

At that point, Arnett's relationship with Marshall Hahn went completely awry. "Marshall went around telling everybody we couldn't be trusted, and he told everybody that he can't deal with Bill Arnett anymore," Arnett spouts during a Rifkin-Hahn-bashing tirade. "He had been just hanging onto me for a year. I mean I looked like his boyfriend or something. I mean really. He's taking me to lunch. He's taking me to dinner. He's taking me to events and we're hanging around together, and I'm trying to share my collection with him but that was the scheme. Rifkin told him, 'Put a collection together that looks like Bill's.' Rifkin was using Marshall to kill my exhibits and books, and Marshall was using Rifkin to put his name up on the wall and spread propaganda. So it was working fine for both of them.

"They did all that as a kind of a buffer against me," Bill Arnett says. Though others accused Arnett of paranoia on this issue, Atlanta art critic Jerry Cullum crystallized the situation with the old line, "Just because you're paranoid doesn't mean people aren't out to get you."

"I created a folk art department in reaction to zealots," admits Ned Rifkin with the self-certainty of a righteous man. "There were certain people trying to make a living from this art, and their claims about the art were so extreme that people at the time thought these were the authorities instead of the museum. There was a confusion of people who owned the work for themselves but also sold it and promoted their favorites. The museum has a role to play in adjudicating situations like this."

Still, the Arnett Collection was the crown folk art jewel. Through his relationship with Marshall Hahn and the creation of a folk art department at the High Museum, Rifkin believed he was gaining leverage in negotiations with Bill Arnett to secure his collection for the High. Siding with Hahn was a direct "we don't need you to succeed" in-your-face gesture toward Arnett. But, instead of weakening Arnett, the collector began a counteroffensive. Arnett began building

a close relationship with Ned Rifkin's Atlanta arts challenger: Emory University's beloved Maxwell Anderson.

"I once was with the three of them—Max, Ned, and Bill—looking at artwork together. There was so much ego in the room I thought the roof was going to blow off. It was like three male peacocks strutting around each other," Susan Crane remembers. The competition among the museum directors, in particular, had reached Olympic proportion. When asked about the supercharged rivalry Arnett says, "It's about the Olympics, stupid. I mean, that's what it was."

Mediating among Atlanta arts adversaries like Max Anderson and Ned Rifkin during the run-up to the Olympics often fell on the shoulders of Jeffrey Babcock. In 1991 the Atlanta Committee for the Olympic Games recruited Babcock to lead the 1996 Cultural Olympiad—a four-year cultural program that led up to and alongside the Summer Games, and which included the Olympics Arts Festival. Babcock coordinated the involvement of 125 local and regional arts organizations and found ways for all parties to participate and benefit. "Everyone was trying to one-up everyone else for money, power, and recognition during this time," Babcock recalls. "Max and Ned were almost open combatants for attention. Max is an incredibly creative and persuasive guy, and I happened to feel very strongly about the work he was doing at Emory. Ned was running the flagship institution, and so he had more organizational firepower than Max. It was a little bit of David and Goliath, with Bill Arnett in the middle as Merlin," says Babcock.

If Arnett was Merlin, Max Anderson was under his spell. "I came to know Bill Arnett as one naturally would in Atlanta," Maxwell Anderson recounts in his sonorant tone. "Anyone with a pulse is aware that Arnett is a phenomenal force of energy and creativity. I was aware of his collections and his extraordinary, insatiable appetite for art. In any other community, he would be one of many collectors like this. In Atlanta, he was one of one."

To Maxwell Anderson, Arnett was "one of one" who might help the Carlos Museum dramatically grow in volume and stature. The Carlos had launched in 1919 to display antiquities that Emory faculty amassed from ancient Mediterranean and Middle East sites. The Carlos collection was housed in a striking building that had been renovated and expanded by internationally acclaimed architect Michael Graves. Graves's design for the Carlos building was modern architecture colliding with ancient Egypt, prompting some Atlantans to nickname it "the Mummy." Though the Carlos was already a great sarcophagus of a building, Maxwell Anderson wanted still more space. He needed an expanded collection to justify a building fund.

"Bill had amassed a big collection of Nigerian wooden sculptures and masks," Anderson says. Actually, Arnett had amassed much more than that—some nine hundred West and Central African works from the nineteenth and early twentieth centuries. "I wanted to acquire this," Anderson continues, referring to Arnett's collection of African art. "If I got this, I could make a case for the Carlos Museum becoming more encyclopedic. We could go after some pre-Columbian collections, too."

Anderson was successful convincing himself of Arnett's tremendous cultural value despite his controversial style. "I got to know Bill quite well," Anderson says. "I think Bill is his own worst enemy. He speaks in hyperbole. This is exacerbated because Bill has deaf ears toward others, so he thinks he has to constantly raise his own voice to be heard. His all-consuming passion turns people off to him and turns them off to the artists and artwork he champions. The problem he caused unwittingly is that he put the art establishment in a defensive posture. They felt it was 'us versus them' with Bill because he singled out certain artists and claimed that African American vernacular works were neglected. He was attacking that mainstream art establishment structure," Anderson continues. "Bill Arnett is an ethical person," Anderson insists. "He is someone for whom reorienting the world is his main mission. He is not just interested in extracting value from artists. His motives are to teach and open people's eyes. Other

motives are often ascribed to Bill, but he is about something so pure that others can't accept it. That's why he attracts such loathing. The existence of someone like Bill Arnett wrenches our souls because we are not as pure. There is nothing else in the world to Bill except putting these artists in front of an audience. Bill has been adroit at helping deserving talent get recognized.

"When he asked me to look at his self-taught art collection," Anderson says, "the siren song of the work was inescapable. Here I was, a Yankee in Atlanta, and thought I understood. But I knew nothing. I wasn't even aware of yard art. I thought I knew about installation art from my time in New York. I didn't realize there were people doing that in the South in their yards. Lonnie Holley and Thornton Dial are the equals of any artists in United States. They are men of extraordinary talent and achievement. I was smitten and said that was what we should do for the Olympics."

As Anderson agreed to embrace the *Souls Grown Deep* and Dial exhibitions during the 1996 Olympics, Arnett in turn agreed to transfer his African collection to the Carlos Museum. Win/win, it seemed.

———————

If art were an Olympic event, Thornton Dial was training like an aspiring champion. Dial created feverishly in the two-year period prior to his exhibition. His art was included in over twenty exhibitions during the 1991–92 period. When his one-man show *Thornton Dial: Image of the Tiger* launched in New York at both the New Museum and the Museum of American Folk Art in 1993, Dial's hard work had clearly paid off. He had broken through the ranks of "folk" and into the mainstream.

Lowery Stokes Sims, a renowned African American in the art scene who later became director of the Studio Museum in Harlem, confirmed Dial's revolutionary role in her exhibition brochure comments: "As Dial continues his artistic journey, following his own

agenda, it will be increasingly difficult to classify him simply as 'folk,' or 'naive,' or 'outside,' and thus Dial will forcefully challenge the hierarchical language that we bring to the discussion of various genres of art. A quiet revolution may indeed be in process. A revolution that may very well effect a reexamination and reconsideration of the centrality of the 'outsider' experience to mainstream art experience, namely the black experience to that of the American experience."

Museum of American Folk Art director Gerard Wertkin wrote of Dial's work in the 160-page hardbound book that accompanied its exhibition: "For me it speaks to rootedness and authenticity, to self-knowledge and soul and spirit, and Dial possesses these qualities in abundance."

Renowned art critic Thomas McEvilley curated *Thornton Dial: Image of the Tiger* and also wrote a twenty-three-page essay for the book in which he praised Dial's creations as "beautiful works, with their staggering clarity and subtlety of feeling" and claimed that Dial was "producing the work of a sophisticated and highly aware contemporary artist."

In the *Tiger* book, both McEvilley and Wertkin acknowledged the importance of Bill and Paul Arnett. "Thornton Dial's work has been an overarching cause in their lives. . . . The project could not have been accomplished without their caring commitment and wholehearted collaboration," Wertkin wrote. McEvilley roundly dismissed accusations that the Arnetts wielded inappropriate influence upon Dial.

Even the most finicky and prickly of art critics were praising Thornton Dial's New York shows. Roberta Smith of the *New York Times* compared Dial's work to modern and contemporary art stars like Jackson Pollock, Julian Schnabel, and Anselm Kiefer. Cathy Fox of the *Atlanta Journal-Constitution* reviewed the New York exhibitions and wrote, "Hold onto your hat. Thornton Dial's powerful paintings in 'Image of the Tiger' just might blow you away."

Dial's audience, it turned out, wasn't the only crowd that needed to hold on to their hats.

Chapter 11

BIG BLACK
BOWL OF LIFE

THE JOKE AMONG PUBLIC RELATIONS PROFESSIONALS GOES SOMETHING like this: "What are the ten words that no CEO wants to hear?" Punchline: "There is a film crew from *60 Minutes* waiting outside." In early 1993, Morley Safer had put in twenty-three years as an investigative journalist for the long-running TV newsmagazine, *60 Minutes*. He was one of the show's stars alongside tough-minded reporters like Mike Wallace, Harry Reasoner, and Dan Rather—one of the four white knights, as they had often been called, battling corruption and evildoing among powerful people and defending helpless victims via the CBS network airwaves. But unlike his gun-slinging counterparts, Safer regularly crafted stories that displayed the lighter side of life. In particular, as an amateur artist himself, Morley Safer liked to do stories about art. Mostly, these stories received polite accolades but no substantive response. That is, until the fall of 1993.

On a Sunday evening in September 1993, the crusty newsman aired a sardonic attack on the contemporary art scene entitled, "Yes, But Is It Art?" From the episode's onset, ridicule was the tool that Safer used to make his case that the emperors of the contemporary art kingdom were stark naked.

Sitting on the *60 Minutes* set and looking squarely into the camera Safer told TV audiences, "It may have escaped your notice that recently a vacuum cleaner, just like this one and the one down in your basement, was sold for $100,000. Also, a sink went for $121,000, and a pair of urinals for $140,000. All of the above, and even more unlikely stuff is art. That's what the artists say, the dealers and of course the people who lay out good money. It all may make you believe in the wisdom of P. T. Barnum, that 'there's a sucker born every minute.'"

Safer lay the blame for this cultural flim-flam not just at the artists' feet but also at the toes of art dealers and art critics. The entire contemporary art system, he seemed to argue in "Yes, But Is It Art," intellectually intimidated the populace into believing that a vacuum cleaner—straight from Hoover's factory floor—could be considered art if put in the right context. Safer went further still. Playing to the old insult that a child could paint as well as some of the most revered artists of the late twentieth century Safer showed an unidentified child a Jean-Michel Basquiat painting and asked, "Do you think you could do as well?"

"Yeah," the child responded quite confidently. "I could do better than that."

The reaction to Safer's "Yes, But Is It Art?" was immediate. Safer's ridicule boomeranged vengefully back at him. The humorless art cognoscenti lashed out at what they considered to be Safer's unen-lightened, cretinous viewpoints. Obviously, he didn't know priceless art from worthless junk, they said. The *Village Voice* called Safer a "pre-impressionist." The *Washington Post* labeled him "the art world's enemy No. 1."

"You can question people's sex lives, you can question their religion, you can question their politics certainly, and they'll deal with you in a very fair-minded way. When you question their art, their taste, you go to the very soul of their being. And because I didn't like some of that contemporary art, they accused me of being in bed with

Jesse Helms, of being a Philistine of Philistines," Safer told his colleague Andy Rooney on a nostalgic *60 Minutes* episode in 2001.

But in the fall of 1993 Morley Safer needed a different art story, one that could restore his reputation as a heroic journalist. For that, he needed someone worth saving, and a newsworthy villain from whom the victim could be rescued. Fortunately for Safer, he already had just such a story in the works.

Lynn Rabren considered himself a friend of the *60 Minutes* team. He had done camera work for them on and off, but he loved boats more than journalism, and so in the early 1990s he moved to Orange Beach on the Gulf Coast of Alabama and began selling his own line of handcrafted wooden skiffs. Boaters loved them, and even Morley Safer had bought one from him. But it wasn't quite enough. To supplement his income and satisfy his creative passions, Rabren continued to do freelance videography—a skill he had honed through the 1980s in New York and Los Angeles working for leading outlets like CBS, where his wife had been a producer.

Having grown up in Alabama, Rabren was familiar with folk artists like Mose Tolliver. He hoped that, during a lull in the boat business, he could develop and market a documentary about Alabama folk artists. Then in 1993 an old friend of Rabren's tipped him off to Montgomery's Marcia Weber. By then Marcia Weber had turned her investigations of Bill Traylor's work into a full-fledged art dealership called Marcia Weber/Art Objects on the fringe of an affluent Montgomery neighborhood. Weber's gallery dealt in art by leading Alabama folk artists ranging from Woodie Long and Jimmy Lee Sudduth to Charlie Lucas and Mose Tolliver. Weber, Rabren's friend indicated, could help Rabren shape the concept for the film.

"Marcia was our entrée to Mose Tolliver," says Lynn Rabren. "She told Mose we were coming. In that first day of conversations we started

to get a sense that something more was happening here. There was some heavy-handedness and profiteering taking place from Mose's work without Mose profiting. There was a circle of people swarming around trying to muscle in to become the representative or dealer or agent. People like Mark Kennedy and Bill Arnett."

Though Marcia Weber didn't want to be filmed, she told Rabren, she didn't mind talking. And whenever she started talking, it seemed she might never stop—frequently ending her garrulous diatribes with a drawling, "Do you know what I mean?" Weber was Alabama homegrown with long straight brown hair, a broad smile, and an earthy, artsy, Birkenstock style. She was schooled as a studio painter at Birmingham Southern University and sold cars at a Montgomery dealership for two years before picking up work at the Montgomery Art Museum and kicking off her gallery career. She had built significant affection for the folk artists in her realm. She had also built a lot of pent-up anger for the likes of Mark Kennedy, an Alabama judge and art dealer, and for Bill Arnett. So when Lynn Rabren came calling, Weber was ready to tell what she knew.

"I first met Charlie in 1982 or 1983 when I was working at the Montgomery Museum," Weber's story began. "I always felt that Charlie Lucas was an absolute creative genius. He was one of the artists that came to demonstrate his work during the Museum's Spring Festival. That was when Judge Kennedy met Charlie and became his agent for five years. That is a story of exploitation!" Weber continues, "Mark Kennedy was an Alabama Supreme Court justice. He was married to Peggy Wallace, Governor George Wallace's daughter. Kennedy and Bill Arnett had a five-year automatically renewing contract with Charlie to the exclusion of all others, so they were the sole marketers of his work."

According to Weber, Lucas was afraid of Kennedy. "I can understand," she says. "I just don't like to mention his name." But it wasn't only Charlie Lucas who Weber told Rabren about.

"Lonnie Holley, too, is in the same situation," she said. "You just wonder why someone would want to take advantage of those two. Someone needs to go after people who are exploiting artists like that."

She continued, "I mean, when a Supreme Court justice says, 'If you try to market Lonnie Holley, Charlie Lucas, or Mose Tolliver's work, we will bury you!' and I say to him, 'Do you mean bury me legally?' and he says, 'No, I mean *bury.*' . . . Do you know what I mean?"

Lynn Rabren knew what Weber meant, and he followed her story straight to Charlie Lucas. "I met Charlie Lucas through Marcia, and he was reluctant to talk about anything except to say he hadn't been paid," says Rabren. "This was where I realized the deeper you dig, the deeper it gets. I went into it naïvely, but all the dirty secrets that surfaced were appalling. We realized that there was something wrong about the accounting and dealings between the collectors and the artists. There were lots of promises and no deliveries. I was still planning to do a documentary at that point, but what I saw was the classic passion play, a tale of exploitation that had been told too many times."

Rabren called his producer friend, Jeff Fager, at *60 Minutes* and told him that this budding story might be more than a little documentary. It might be a *60 Minutes* episode. Fager flew down to Alabama to scope the story. "The whole folk art area was wide open, and I dug into it and found it filled with intrigue and characters," Fager recalls. "Slowly but surely it became more and more interesting and colorful."

Jeff Fager told Morley Safer about the surfacing story that he and Rabren were investigating, and Safer found the issues at hand to be black and white—literally. Instead of cynical artists and dealers in SoHo taking advantage of the public, the cynical public and dealers in the South were taking advantage of the artists. The "Tin Man" story, as they decided to call it, was turnkey television. "It was a classic confrontation where the most moving demonstrations of the human spirit meet guys who see some monetary value in the work. It is probably as fundamental an example of that as you will find anywhere," Safer says.

"I hate labels like outsider, self-taught, or naïve or primitive," continues Safer. "People need labels for their own primitive minds. The primitivism is really in the collectors and how they behave."

In early 1993, Bill Arnett received a phone call from *60 Minutes*. "They said we want to do a story on Thornton Dial. As a hero," Bill Arnett recalls. "And, I said, 'I don't believe it.' I said this to him, I said, 'You're not the Norman Vincent Peale Hour. You're *60 Minutes*,' I said to the guy. Then he says, 'You don't understand. Morley likes to do special programs every few months praising things. . . . He likes to do these things to show the other side—that everything's not bad news. And we asked around and found that Dial is a real American hero.'" According to Arnett they said that they wanted to do a special in praise of Dial. But to get to Dial, they knew that they had to go through Arnett.

"So, I called Dial," Arnett says, "and I said, 'These people want to come talk to you. They say they want to do a show to praise you for what you've done,' but I said, 'This is a program that tries to hurt people. Most of the time they do, but they say they are not trying to hurt you.'" Dial agreed to talk.

"Dad said that *60 Minutes* was going to come and do a big piece and announce to the world that Dial is a great artist," Arnett's son Harry recalls.

But friends cautioned Arnett about *60 Minutes*, reminding him of the newsmagazine's history of ripping its subjects to shreds. Arnett dismissed their warnings.

"My friend, Lenore Gold, who was on the board of the High Museum, called me up," Arnett claims. "She said, 'Ned Rifkin is boasting about his friendships with J. Carter Brown and Morley Safer, and I don't like what I'm hearing. I'm suspicious, and you should be very, very careful of what's going on." But Arnett was unfazed. He was too excited about the national exposure to worry. He agreed to talk to Morley Safer.

In April 1993, the *60 Minutes* crew took position in Bill Arnett's living room, carving out a meager interview space among the piles of

strewn-about art. Arnett approached the day with calm confidence. He had walked among celebrities before. Hell, he recently visited with Europe's elite in Paris. *Safer's not an imposing guy compared with others I've known*, he thought.

For several hours, Morley Safer threw what Arnett considered to be softballs. Arnett told Safer about his philanthropic intentions— that he planned to give away his collection to whatever museum asked for it. He skirted negative issues about certain artists like Bessie Harvey and Charlie Lucas, who he thought were con artists and didn't honor their contracts.

Morley Safer watched Arnett as he responded to questions. Safer's keen journalist mind simultaneously had his questions at the ready, an ear open for the specific answer, and an assessment of what was taking place in the surrounding environment that informed the inter-action and, ultimately, the final piece. At the end of the interview he had one final question for Arnett.

"Is there anything that might be embarrassing for Thornton Dial if we brought it up?" Safer asked Bill Arnett as they sat together in his house.

"I told 'em the only embarrassing thing for Dial is the fact that I own his house. That people tease him about 'Whitey' owning his house, and it would be nice if you don't bring it up," Arnett says. Arnett thought that Safer was asking so that he could avoid that specific topic with Dial.

"I'll tell you the truth," Arnett remembers. "In all the preparation *60 Minutes* did for the show, I didn't feel the least bit threatened."

That same week, Judge Mark Kennedy had caught wind of the evolving *60 Minutes* story and decided to duck and cover. A vigilant administrative assistant intercepted Fager when the journalist called to request an interview with Kennedy.

"I'm sorry, the judge won't be in this week," she said.

"What about the next week?" Fager asked.

"No," she said again.

"Are you expecting him during the month of June?" Fager asked.

"No," she responded. "Not July either."

If *60 Minutes* was calling, Kennedy was going to be away forever.

The next morning as Judge Kennedy prepared to drive his son to school, he pulled the car down the driveway toward the entry gates, and a van blocked his path. Lynn Rabren jumped out, camera in tow, film rolling. Fager was there, and so was Safer, firing questions like a chafed police interrogator on a hot day. The judge babbled and bobbed. And after Fager was certain that enough embarrassing film had been shot, he softened the attack.

"We can run the film we just shot—showing how you are refusing to talk with us—or we can arrange a time to sit down with you later and do an interview in a calm setting. What do you prefer?" Fager offered.

Kennedy relented. Later that day, the judge and Morley Safer sat down for a chat that would air on national television.

"He was wringing wet with nervousness," Safer remembers with a chuckle. "It was icing on the cake."

If Judge Kennedy was icing on Safer's cake, Bessie Harvey was the cherry. She told Safer about Bill Arnett's first visit to her, when he paid one thousand dollars and drove away with a vanload of art. She told Safer that Arnett paid her a monthly fee of five hundred dollars for nearly half a year with no amount of art specified for that pay; presumably it was for whatever Arnett decided to take. She told him that Arnett hadn't paid her for purchases and that he had borrowed some work that he never returned. In particular, she told him about three pieces that Bill Arnett had borrowed to display at the 1988 party at his home; the party was Thornton Dial's debut. Then Bessie Harvey offered up something better still.

"He kind of got frustrated with me and he came and he told me he wanted me to take the hex off of him," Harvey stated.

"The hex?" Safer asked as the camera zoomed in on Bessie Harvey's sweet face.

"Yeah," she told Safer. "And I said, 'I don't have a hex on you.' I said, 'You put a hex on yourself because you don't treat people right.'"

––––––––––

On the frosty November 1993 night that the *60 Minutes* show was to air, Bill Arnett traipsed through the SoHo streets determined not to go back to the bar where he left Joe Overstreet, a well-regarded African American artist, to watch the episode. Bill couldn't bring himself to watch it.

"My goddamn life is over," he mumbled.

Inside the saloon, Overstreet knew it was trouble before Arnett showed up on screen. By that point, Safer had already skewered Mark Kennedy, made him look like a calculating racist from the old South, like he had swindled Charlie Lucas and done worse to Mose Tolliver. Safer nailed Kennedy double-talking and accusing Tolliver of being a drunk.

Now it was Arnett's turn to be laid bare. In a scene in Dial's studio where Dial and Arnett stand and flip through Dial's assemblages, in a voiceover Safer said, "Judge Kennedy, for all his prominence, is a relatively small player. The king of outsider art is an Atlanta dealer named Bill Arnett. He roams the back roads in search of the undiscovered. The inside of his house is stacked and piled with art. He covets it, hordes it, admits he's a fanatic."

Then the television screen switched to Safer as he interviewed Arnett with Dial assemblages in the background.

"The first rule of the art world is there are no rules," said Safer, facing Arnett.

"I—I agree with that," responded Arnett, who looked like he was about to break into a cold sweat. "And unfortunately," he continued, "that gets magnified in this sort of gothic Deep South setting in which traditionally the culture from which the work comes that we're interested in has been there for the taking. There wasn't a fee; it just simply took a—a request. 'I want that, give it to me.' 'Yessa, boss.'

Inside the bar Overstreet had to shake his head, look away from the screen.

"Did you borrow some pieces from Bessie?" Safer continued.

"No," said Arnett, narrowing his eyes, shifting in his seat. "I—I bought pieces from Bessie Harvey for more money than anybody ever bought pieces from Bessie Harvey for. I then took a few more pieces of—I think three pieces—for an exhibition in my house, which Bessie Harvey attended in 1988."

"Do you still have them?" Safer asked with a lift of his brow.

"I have the—I have some Bessie Harvey pieces that are . . . ," Arnett turned pale.

"The pieces in question?" Safer interjected.

"I have—yeah. You mean, have I sold them or disposed of them? No, I have them sitting in a warehouse," Arnett painfully got out.

"Why don't you send her the pieces that you have and—and it'll be over?" said Safer, leaning forward in his seat, raising his left hand.

"I've got my own way of doing things," Arnett quickly answered. He was breathing fast. "And I'm not sure what I really *do* owe her, if anything."

Outside of the bar, in the cold, Arnett imagined Joe Overstreet emerging through the doors, walking toward him, smiling and telling him that it wasn't all that bad. Instead, the doors opened and Overstreet walked toward Arnett with an expressionless face.

"Man, we gotta get you out of New York City now before they kill you," Overstreet said.

"You're kidding, aren't you?" responded Arnett.

"Hell no, I'm not kidding," said Overstreet. "Man, ain't nobody goin' deal with you the rest of your life."

That same night, Lonnie Holley turned off the VCR and stared at the TV screen, baffled. He had been mentioned only once on the show, with only one line: "Lonnie Holley, Michelangelo in the woods." He had spent hours with Morley Safer. "I thought *60 Minutes* was going to give us the credit for being the artists that we

were," he says. They didn't use the words that he had given them to use. Then Lonnie remembered a piece of art he had done almost ten years before: an old rusty oversized roll of film with a small worn-out pair of scissors stuck to it. The title: *Don't Edit Out the Wrong Thing*.

Thornton Dial stared silently at the television screen long after it had gone dark. In all his years, Dial had not learned to read or write, but he could usually make good sense of what he saw. Now he was confused.

Dial's sons and daughters and grandchildren surrounded him, shifting uncomfortably as they tried to make sense of what had just happened.

On the screen, Safer had told viewers, "Thornton Dial creates massive three-dimensional stories out of anything he can find. His wife, Clara, thought he was nuts. . . . His works now sell for more than one hundred thousand dollars each."

"Did you ever have an art lesson?" Safer asked Dial as they stood in his studio.

"No," Dial responded with a shy smile, "I never had nothing like that. The only lesson I got, I got it from God, so that's the way I got it. I get it like that."

Then Safer asked, "You don't let—you don't let the collectors come in here?"

"Nope, nope," Dial emphasized. "Nobody but Bill."

"Did you ever think that one of Thornton Dial's paintings would go for one hundred thousand dollars?" Safer asked.

With palpable pride, Dial smiled, stuck out his chest, said, "Never thought that in my life. Never thought I would make that kind of money."

Safer then pointed to an assemblage and asked, "How much did you make out of that one?"

Taken aback, Dial paused, looked down, "Well, I get part of it, you know." He said, then he looked back at Safer. "I get—I—I be satisfied with what I get."

"You don't want to say how much?" Safer prodded.

"Well, no," said Dial sternly. "I won't say how much I get."

"This success of yours," Safer continued. "You now have this house here."

"Well—exactly the truth," Dial eased a little.

"You own that house?" Safer asked.

"That's true," Dial answered and looked down, his eyes squinting a bit. "That's mine."

Then the screen showed footage of the house and a document with Arnett's name on it, as Safer's voiceover said, "Thornton Dial may *think* he owns the house. He doesn't. We're not sure what Arnett told him, but at the county courthouse, records show the sole owner to be Bill Arnett."

Sitting in his bedroom Thornton Dial turned from the TV, looked at his family, and spoke. "The television person talk about me in my face like white folks used to talk about their servants in the same room. Hurtful talk, like they ain't there, stuff like that. It got to be respect in the United States," he said exasperated. Then, he caught himself. "Well, you can't get angry with that because life go on."

At first after the show aired, Charlie Lucas felt as if *he* had won an Olympic medal. His phone rang constantly in the days following the "Tin Man" episode. Lynn Rabren called Lucas to get his reaction. "He said, 'Oh! We stirred up a hornet's nest now!'" Rabren recalls.

Gail Trechsel, director of the Birmingham Museum of Art, a diehard champion of Charlie Lucas and an avowed enemy of Bill Arnett, had been one of *60 Minutes'* informants. She called Lucas. He told her that he had seventy-five visitors and more calls than he could count. At least six lawyers had called from various parts of the country offering to help; one attorney was willing to help Lucas in exchange for art. "People want to know how I got on *60 Minutes*," Lucas told Gail Trechsel. "I guess they got a one-legged cat they want to get on the show," he joked.

But Charlie Lucas did not joke for long. "The *60 Minutes* show was really hard for Charlie, and it sent him into a big depression,"

says Trechsel. Lucas had taken particular note during the episode of the luxurious circumstances of Dial's new life and his art success. "So Charlie's neighbors looked at him like, 'What's wrong with *you*? Why don't *you* have a big house? You've had this opportunity. How are you blowing it?' And his family and friends were just like, 'What's wrong with you,' and like I said he just went into a huge depression. He's fragile," Trechsel explains.

Jeff Fager, on the other hand, was pleased. "I was proud of our reporting," he says. Morley Safer, too. "We re-ran the 'Tin Man' episode a couple of times. It was a good story with wonderful characters," Safer says.

Guilt was the emotion that overcame Bessie Harvey. Within weeks she apologized to Bill Arnett and told him she had mistakenly "let those people use me to get back at you." Still, when *60 Minutes* reran the "Tin Man" episode again in 1994, Safer added a voiceover ending, noting that Harvey had still not been made whole on the works that Arnett had taken from her.

Mark Kennedy felt betrayed. He shot back immediately with a press release justifying his actions and blaming any problems with Charlie Lucas on Bill Arnett. Kennedy explained in his statement:

As Mr. Lucas' agent, I was unable to control the flow of art between Mr. Arnett and Mr. Lucas. The two eventually had several disputes, which I attempted unsuccessfully to mediate. As a result of these disputes, their contract was eventually cancelled. Mr. Arnett, not me, is to blame for any financial problems that Mr. Lucas has incurred as a result of this contract.

As Judge Kennedy's campaign for reelection to Alabama Supreme Court justice progressed over the following months, he came to believe that someone else was to blame for his *60 Minutes* problem. Political strategist Karl Rove had been invited to Alabama to help Republican candidates to victory in the longstanding Democrat stronghold. Kennedy, a Democrat, was squarely in Rove's crosshairs. Rove was

just starting to establish his reputation as a vicious competitor, and he attacked Kennedy with full force. In a profile of Rove in the *Atlantic Monthly* ten years later, reporter Joshua Green wrote that the Rove team initiated a whisper campaign saying Kennedy was a sex offender. Joe Perkins, who worked on the campaign against Kennedy, admitted in the article, "Mark is not your typical Alabama macho, beer-drinkin', tobacco-chewin', pickup-drivin' kind of guy. He is a small, well-groomed, well-educated family man, and what they tried to do was make him look like a homosexual pedophile." Adding "exploiter of poor black people" to that charge fueled by national coverage on CBS certainly played into Rove's initiative. But whether or not Rove had any direct hand in the production of "Tin Man," Kennedy can only speculate.

Bill Arnett did more than speculate in the weeks following the show. Arnett spun speculation into a conspiracy theory that he continues to hold as a certainty. He does not blame himself for the accusations that were cast upon him by Morley Safer on prime-time television. He does not blame the Republican political machine. He blames a confederation of "art world scamps" out to steal the art history spotlight from Arnett, destroy Thornton Dial, destroy all of African American folk art, or all of the above. However Arnett's theory would manifest itself, it would always have at its center one primary villain, "king of all scamps": Ned Rifkin. "I came to realize Rifkin knew exactly what was going on," Arnett says. "He was in on the whole damn scheme, and so were a lot of people," Arnett contends. "So, Safer was a good friend of J. Carter Brown and a friend, apparently, of Rifkin. I mean Rifkin had the pipeline open to Safer, and Rifkin was boasting to a lot of people and to me, you know, that Morley is going to destroy Bill Arnett. A lot of my enemies were in on it. All of them were. All of them. *60 Minutes* wouldn't have given this a tumble if they hadn't had a bunch of dealers and collectors and museum directors throwing shit at me. Everything they did was timed and coordinated. They ran that piece three times in a period of eighteen

months, which is a world record. To run a little, trashy fifteen-minute segment three times in eighteen months, they don't do shit like that. They never do that. And, each one of the times they ran it was perfectly timed, coordinated to run with an event in our lives . . . a press conference, a funding request, a Dial show in New York. It was a complete setup, you see, to shoot down Dial at the moment of triumph. There was a hidden warped brain called Ned Rifkin who was orchestrating this thing all the way. Rifkin is gonna say, 'That's absurd, I didn't do any of that, Bill's paranoid, he's impossible to work with.' 'Cause that's what they go around saying."

When asked about his involvement in the *60 Minutes* episode, Ned Rifkin says, "They never talked to me. I didn't even see it when it aired."

Morley Safer, when asked about the role Ned Rifkin played in the *60 Minutes* episode, responds without hesitation, "Ned who?" he says. "No role. Didn't know him at all."

Chapter 12

THE BIG GAME IN
THE UNITED STATES

"THAT'S A BIG GAME. *BIG* GAME. THAT'S THE FOOTBALL PLAYERS. THIS is showing you the football players, powerful. You know, this is just showing you the power of the United States. This what get you so far in the world: power," Thornton Dial says of his sculpture *The Big Game in the United States*, which he crafted in 1995 after watching hours of televised testimony in the O. J. Simpson double murder trial. But Dial's optimistic comments about the American Dream cloak his true feelings about the Simpson case and about the labyrinth of racism, media exploitation, and money that ensnared the situation. In *The Big Game*, pale skeletal figures donning football helmets stumble across an abstract gridiron while rope-haired glamour girls pose seductively among random jigsaw puzzle pieces, raggedy stuffed animals, and broken toys. After the 1993 *60 Minutes* episode, Bill Arnett would later point out that Thornton Dial's art themes shifted sharply from optimistic visual metaphors filled with humor to "tragedies."

Bill Arnett's optimism was badly jarred, but he quickly refocused. With art world supporters fleeing and friends distancing themselves, Arnett sought refuge in what he still considered a sure thing: the 1996 Cultural Olympiad. In cahoots with Emory University's Michael C. Carlos Museum and its curator Max Anderson, Arnett

was planning *Souls Grown Deep* and its sister show, *Thornton Dial: Remembering the Road*. Arnett's Olympic effort took on Herculean shape and became his Big Game.

With the world watching, Arnett was determined that his Olympic exhibitions would be bigger, better, and more important than the 1982 Corcoran Museum's *Black Folk Art in America* show, *Souls Grown Deep*'s only historic rival. First, the press reported, the *Souls Grown Deep* show would include 250 paintings, drawings, sculptures, and assemblages. Months later another report listed the *Souls* display at 300 works of art. Ultimately, the show would grow to an encyclopedic 500 works of art by nearly thirty African American self-taught artists. Another 55 drawings, paintings, and sculptures would be on view in *Thornton Dial: Remembering the Road*, which was over and above all the artwork that Dial would have on display in the *Souls Grown Deep* show. "The show was so big, we were building a museum in a way to this art form. The whole show amounted to about thirty-five gallery areas for the art," says *Souls* curator Robert Hobbs. If all this wasn't ambitious enough, Lonnie Holley was to build an indoor replica of his Birmingham yard-art environment right inside the exhibition gallery itself.

Arnett was certain that *Souls Grown Deep* would be an Olympic cultural event like none witnessed before or after, and it was to be almost entirely stocked with the artwork he and his sons had accumulated in the William S. Arnett Collection since the mid-1980s. Even those artists who earned top spots on the Arnett enemies list would be included if their work was worthy. This was about art and history, not about ego. Yes, even Arnett's Judas, the Tin Man, Charlie Lucas, would have his art included in the show.

The big dogs at Emory University were ready for the cultural limelight, and they heard Arnett's P. T. Barnum promotion for the show loud and clear. Still, he was perhaps a bit too loud, and they still weren't certain about this folk art thing. Hadn't the Carlos Museum been about antiquities? About golden relics whose beauty and profun-

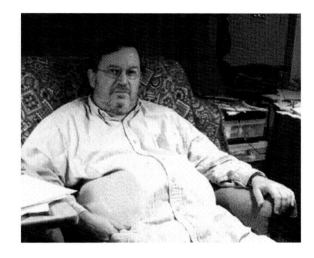

Bill Arnett in his Atlanta home, 2002.

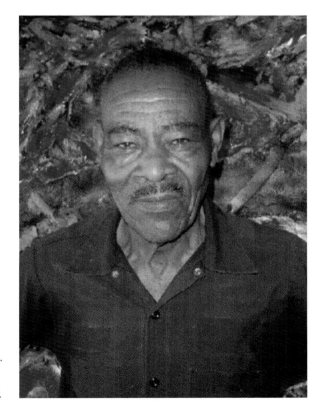

Thornton Dial in front of one of his assemblages in his Alabama studio, 2002.

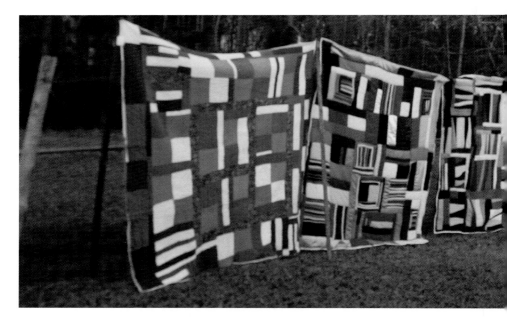

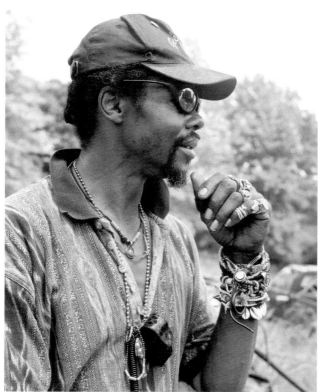

Lonnie Holley at his Alabama home, circa 2002.

Photo by Lucinda Bunnen.

Left: Gee's Bend quilter Mary Lee Bendolph in front of several of her creations.

Photo by Michele McDonald, originally published in the May 15, 2005, edition of *The Boston Globe*.

Below: Bill Arnett posing with objects from his African Art collection, circa 1976.

Photo by Lucinda Bunnen.

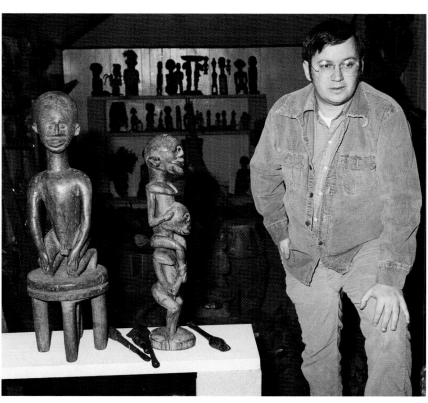

Lonnie Holley's front lawn and home in Harpersville, Alabama, 2003.

Thornton Dial's home in McCalla, Alabama, 2002.

Joe Minter's yard art museum honoring Africans in America, 2003.

Paul Arnett (left), Thomas McEvilley (center), and Bill Arnett (right) enjoying opening night of Thornton Dial in the 21st Century *at the Museum of Fine Arts, Houston, 2005.*

Thornton Dial's sculpture, The Bridge, *honoring John Lewis on the day of its unveiling in Atlanta's Freedom Park, 2005.*

Thornton Dial's Heading for the Higher-Paying Jobs, *1992. Enamel and oil paints, cloth, tin, wood, and industrial sealing compound on canvas mounted on wood. 64 ¹/₂ x 90 x 9 inches. Courtesy of High Museum of Art, Atlanta.*

Left: Untitled drawing by Bill Traylor, circa 1939– 942. Tempera and pencil on cardboard 22³/₁₆ x 14 inches. Courtesy of High Museum of Art, Atlanta.

Above: Lonnie Holley's Obstacles Before the Goal, *1994. Metal fencing and soccer ball. 15¹/₂ x 14 inches. Courtesy of High Museum of Art, Atlanta.*

Left: Lonnie Holley's Mystery of the White in Me. *Pigmented sandstone, 1983. Courtesy of the Birmingham Museum of Art.*

Bidding for a drawing by Thornton Dial at a folk art auction near Atlanta, 2003.

Vulcan's temporarily severed head on view in the sculpture garden at the Birmingham Museum of Art, 2003.

dity no mortal could deny? What was this art made from garbage and by men who looked like they had just emerged from the junkyard?

Max Anderson settled their nerves. He was Emory's tastemaker in residence. If he said it, it must be so. At a black-tie dinner for Carlos Museum patrons prior to the Olympics, Max Anderson introduced the dignitaries in attendance—senators, the mayor, high-dollar donors—and then, Bill Arnett. "I've saved the best for last," Anderson told the crowd in his FM radio crooner's voice. "Bill Arnett is now part of the Emory community, for which we are all grateful. We are planning shows for the Olympics that will change art history, and, for my money, Bill Arnett has the best eye in the entire art world," said Emory's tastemaker. The black ties clapped vigorously. The big dogs barked approval—smiled, relieved.

Bill Arnett once drew a diagram that maps the individuals and organizations that he believes conspired to halt the production of his Olympic exhibitions. Arrow-tipped lines, dotted lines and crosshatched ones, and solid and straight and curved ones all ultimately point accusingly to top art world, media, academic, and industry leaders, calling them out as cohorts in a cabal to kill *Souls Grown Deep* and, with it, the souls of all African American vernacular artists.

The trouble may have started with Maxwell Anderson's announcement in May 1995 that he was leaving Emory University and Atlanta to take a post as director of Toronto's Art Gallery of Ontario. Anderson's departure came as a blow to the local art community, which was left once again with a gaping leadership hole. For Bill Arnett the matter was worse: a powerful champion and diplomatic buffer between himself and the Emory University bureaucracy was high-tailing it north, leaving a vacuum into which fear and loathing would steadily seep.

The first breach of trust occurred in August 1995 when Paula Hancock, who had bumped heads with Arnett when she worked at the High Museum, was named project director for *Souls Grown Deep*, to Arnett's surprise. "She was a curator of education at the High for like twenty years, went to Emory and got a Ph.D. in art history, and

she was sort of Vigtel's Rasputin," Arnett says. "She hated my fuck-ing guts. Reason she hated my guts was we were doing an exhibition with the High Museum and a catalog to go with it. And I wanted to do the catalog myself 'cause I knew how it ought to be done. And she was saying she wanted to do it. I said, 'Paula, I want to do the cata-log. I've been planning it for years, and I know exactly how I want it to look,' and she got really pissed when I went to Vig and said, 'I want to do this catalog.' And, he told her, 'Let Bill do it.' She got real pissed off. I didn't know this, and she hated me from that point on," Arnett remembers. Then, reflecting on his great skill in accumulating enemies, "I don't know how I do this. . . . I don't do it on purpose, but I tend to alienate certain kinds of people to the point of turning them into piranhas. I don't know how. I don't do it intentionally. I don't know I'm doing it 'til it's too late."

Tensions between Arnett and Hancock resurfaced immediately, and within a month Arnett presented a complaint to Emory's univer-sity provost regarding Hancock's "problem with prevarication"—that is, he called her a liar. Catherine Howett-Smith, who was filling Maxwell Anderson's spot as interim director of the Michael C. Carlos Museum, became project manager for *Souls Grown Deep* and *Remembering the Road*.

Rumors rushed into the Arnett-Emory vacuum like surf into a sand castle. The source, in part, was one of the Carlos Museum trustees, Bill Thibadeau. Thibadeau was an insurance-salesman-turned-Atlanta-real-estate-tycoon who had a passion for Native American artifacts that morphed into a gigantic collection of indigenous art from South and Central America. Thibadeau donated nearly thirteen hundred pieces from his collection to the Michael C. Carlos Museum in 1990, the culmination of a collecting career that began in the 1960s and that once involved Thibadeau's own gallery. His gallery was called Magellan, initially manned when it opened in 1967 by an upstart impresario named Bill Arnett. Though Thibadeau fired Arnett after a short stint, animosity and insinuations about who stole

from who lingered for the next thirty years. "Bill Arnett got his start in collecting in the '60s when he swindled a group of investors led by Bill Thibadeau," said hushed voices not softly enough to avoid Arnett's ears.

By the fall of 1995, word filtered back to the Arnetts that certain staff members at Emory were describing his art collection as "a bunch of rusted tin and rotten wood." Giving credence to the chatter, Emory assigned its chief art conservator, Therese O'Gorman, to evaluate the physical health of the work selected for *Souls Grown Deep* and to advise the university of the art's current condition and the risks associated with it. O'Gorman worried about the stability and longevity of the tin and wood objects. In particular, she saw Lonnie Holley's assemblage *Fifth Child Burning* as emblematic of the physical problem of this self-styled art. Holley had pulled charred embers from a house fire that consumed at least one young life, and the artist had stacked the ashen wood as part of a memorial sculpture. *How long might such wreckage-as-art last?* O'Gorman wondered. *What if it crumbles in a room filled with Olympic visitors? Who might get hurt? Who might be held liable?* "So that we weren't held responsible, we were very careful to examine everything," O'Gorman says. "I identified the pieces that I felt were in a state of deterioration. We labeled them as 'transitional objects,' which was a new term we came up with, meaning the art might change condition or was in the process of changing, and at any time there might be disintegration of the material," she says. O'Gorman watched closely as the show was installed, especially the environment that Lonnie Holley crafted on location. "I was trying to get Lonnie to make sure his materials were well-secured if they were going to be hanging above people's heads. I might have asked him to move something a little bit to the right or left if it was looking precarious. Bill didn't want to hear about these issues, and neither did Lonnie. They just thought that we didn't get it," O'Gorman laments. If Arnett saw the conservator's actions as "not getting it," he believed her opinions about the content of some

of the pieces and Emory's response to those opinions to be deliberate sabotage of his exhibition. In notes to his lawyer at the time, Arnett wrote, "Emory placed a sign on the entrance to the exhibition that read, 'Some material may contain sexually explicit content. Viewer discretion is advised.'" To Arnett, Emory had labeled his entire exhibition "pornographic."

Arnett's relationship with Emory got worse. The *Souls* show was too big to be held at the Michael C. Carlos Museum itself. Another location had to be found. Emory staffers determined the chosen spot: the former regional headquarters and distribution center of Sears & Roebuck Company on a seedy strip of Ponce de Leon Avenue—far off the beaten path of Olympic transportation. The red-brick building stretched along a vast expanse, easily resembling a dismal edifice from one of Jimmy Lee Sudduth's mud-rendered paintings. After Sears vacated the building in 1991, the City of Atlanta occupied the gargantuan seventy-year-old structure, turning it into City Hall East. Still 80 percent of the bleak structure remained unoccupied. Even if Olympic visitors could find this gloomy fortress, it was questionable whether they would be brave enough to enter. Add this to Arnett's mounting evidence list of Emory's intention to tank *Souls Grown Deep*.

Kipp McIntyre delivered more evidence to Bill Arnett about lack of full support from the Carlos Museum. An employee of the museum, McIntyre's role was to help install the artwork for *Souls Grown Deep* and *Thornton Dial: Remembering the Road*. He befriended Matt Arnett, one of Bill's sons, and shared with Matt his worrisome observations. McIntyre had seen a videotape copy of the *60 Minutes* "Tin Man" episode on Emory University president William Chace's desk. "Why else would the tape be there unless someone is giving it to Chace to view and to say, 'This [Arnett] is the person we are getting in bed with?'" McIntyre says. He reported that Carlos staffers were complaining that Arnett acted as if *Souls Grown Deep* was "The Bill Arnett Show" instead of rightfully being Emory's show. He related how Emory staffers considered with disgust the Arnetts' warehouse

and artwork conditions, how rumor had it that the Arnetts' African collection could not be exhibited without first being taken to Orkin Pest Control for fumigation, how the Arnetts kept a strange man who ate dog food living in their shit-hole of a warehouse.

In this climate of suspicion Emory president Chace presented Bill Arnett with a legal contract for the exhibition. Arnett read deceit in every line of the document. "The agreement had all these different stipulations so in case one didn't work, they'd get me on another," Arnett says. "One of them said—oh, God—one of them said that if I refused to loan a certain number of pieces that they could cancel the show. Then what they did is they came out with these condition reports, and they had all these pieces that they said were not suitable to be shown, and it was a big number. They were implying that the art could hurt little children if it's shown. Statuary could fall on them because it was so fragile, and pieces of art could fall off the wall and land on kids. So they thought I would go and get pissed and say, 'Screw you,'" Arnett says. The Emory agreement included an addendum that raised the hairs on Arnett's neck. It began: "Termination of Contract. Emory reserves the right to cancel this Contract for its convenience at any time." No such right was to be granted to Arnett. "We wouldn't sign his contract. So Chace couldn't cancel the show. If I had just signed my name, they were canceling the show that day," says Bill Arnett. "Paul sent the contract to his brother-in-law, who's an attorney in Silicon Valley, and his brother-in-law said, 'This contract is what, in the field of law, we call an "asshole contract," meaning you give it to somebody you think is an asshole who'll sign it.' We didn't sign it. Emory went apoplectic."

With that, Arnett added more links to the conspiracy map in his mind. It all ran in circles. Emory University had long and deep ties to Coca-Cola. Asa Candler, Coke's patriarch, gave the school $1 million in 1914, and the Coke money fountain had not run dry since. Robert Woodruff carried on the Candler legacy for Coke. In 1979, Woodruff gave $105 million to Emory—the largest single gift to a single

educational institution in the nation's history. Since Atlanta's Woodruff
Arts Center, heavily funded by Woodruff money, was parent to the
High Museum of Art, then it made sense to Arnett that he faced a
powerful triumvirate: Woodruff money, Emory intelligentsia, and
High Museum bureaucrats. The threads of the web stretched every-
where. Marshall Hahn was an Emory trustee. Catherine Howett-
Smith's father was head of Emory's Art History Department and one
of the contributors to Ned Rifkin's *Rings* exhibition catalog. Therese
O'Gorman also did conservation work for the *Rings* exhibition. Paula
Hancock was a High Museum alumnus as well as an Emory one.
"The High Museum and Emory are all part of the same thing. I mean
they're like Siamese twin motherfuckers. They're a bunch of Coke-
suckers," Arnett quipped.

Arnett needed legal firepower. He turned, at first, to a college
buddy who was an esteemed partner with one of Atlanta's most pres-
tigious law firms, but Arnett quickly grew frustrated with this barris-
ter friend who, Arnett felt, did not display the requisite venom or
desire to compete with Emory president Bill Chace and his brigade.
Something else, too, may have shifted Arnett's legal interests. Arnett
had met another attorney who, he believed, had a more natural incli-
nation to fight for the cause of African American vernacular art. The
attorney was a black man named Jerry Thomas.

Arnett hired Thomas initially to generate sponsor funding for the
Souls Grown Deep book that was to accompany the exhibition.
"Within one hour of working with him, it seemed he needed my
legal help more than anything else. He doesn't tolerate fools or peo-
ple who don't see things his way, and he had pissed off both the High
Museum *and* Emory University," Thomas remembers. Thomas knew
of Arnett's reputation, and friends warned him off, but he decided to
take the collector's side regardless. "I did my research before working
with Bill Arnett. The art business is a cloak-and-dagger game. It is by
innuendo that people are hurt, and I think that's what happened with
Arnett. I didn't and don't buy into the exploitation accusation," says

Thomas. "Bill had relationships with some artists that were not reduced to writing, and that left room for artists to be confused and angry. Because of the educational discrepancy between Bill and the artists, it would have taken a saint to do everything perfectly, and he was not a saint. He wore so many hats—collector, promoter, dealer, scholar—that it begged the conflict-of-interest question, but no one else was playing those roles, so he had to do it all. It was all part of a grand plan that if he had the best art in this field, he would be in the best position to negotiate with museums around the country to advance the art. If there had been thirty different people doing it, no single one of them would have enough leverage. It took a personality like Bill Arnett to see the value of African American vernacular art and to forge ahead, notwithstanding all the resistance. You can't underestimate his influence," says Jerry Thomas, who, ten years after his *Souls Grown Deep* work for Arnett, now runs his own art dealership.

In one of his early meetings with President Chace and his staff, Thomas noticed that the administrator kept deferring to his colleagues rather than answering questions about the proposed contract directly. No one on the Emory team, it appeared to Thomas, was willing to make a decision about contract concessions or the fate of the exhibitions. Thomas snapped.

"Who is making decisions around here?" Thomas demanded of president Bill Chace. Arnett smirked and watched for Chace's reply.

"I am in charge around here," Chace said with a raised voice, emphasis on the word "I." Chace stood up to emphasize his presidential authority. "I am not a potted plant," he shot back, to be certain his opponents acknowledged his power.

The next day, in the hallway leading up to Bill Arnett's work area, a potted plant appeared with a small sign sticking out from the surrounding soil. Written on the potted plant's tiny billboard: "I am not a university president."

As the Olympics drew closer, the staff of the Michael C. Carlos Museum stumbled in uncertainty about whether or not the *Souls*

Grown Deep and Dial shows were on or off. The pressure of trying to mount an enormous exhibition the likes of which had not been done before in front of an Olympic audience in record time with no assurance that the show would actually take place pushed the exhibition to the edge of reason. Add to that maddening brew the Arnetts' intensive involvement in an effort to ensure perfection as they envisioned it. If a staff member was lifting a Dial piece, for instance, Matt Arnett might step in and recommend the best way to do it. The person lifting would say, "I'm a trained professional, I know how to do it." The common complaint among staffers was, "They're not letting us do our jobs. They stand over us while we're doing it." All of this— along with news of the troubled contract negotiations—filtered up to the Carlos Museum's leadership. "I'm not going to design this show if it is not going to take place," the lead preparator blubbered after one administrative meeting. "That's it. We are canceling the show," he said with certainty. Later that day, the show would be pronounced "back on." Robert Hobbs, the exhibitions' curator, threatened to resign, but then retreated. Interim museum director Catherine Howett-Smith, at least once, was reduced to tears in front of her team. "We were like a dysfunctional family," Kipp McIntyre remembers. The tensions and bad feelings were released against the nearest and clearest whipping boys: the Arnetts. "Our weekly staff meetings were nicknamed 'Bill bashing over bagels,'" McIntyre says. "Then, one time the senior staff of the museum was giving a pizza party to thank the junior staff for its effort and patience," McIntyre continues. "It turned into a little retreat. We divided into teams and each team had to make something out of Play-Doh. One team came back with a little Play-Doh man like the Mr. Bill character from *Saturday Night Live*. "This is Bill Arnett," one of them said. Then they took the little dough man and dunked him headfirst into a glass of olive oil and held him back up and said, "And this is his greasy hair."

Lonnie Holley's hair was stuffed under a baseball cap pulled down over his eyes. He knelt on the dirt-covered floor in City Hall East, knees to chin, rocking slightly. This space was Lonnie's, but it seemed to have escaped him even as he sat there.

People were watching. Three months earlier the *Atlanta Constitution* published a tabloid-size supplement titled "The New South," sporting a Lonnie Holley art piece on its cover. Lonnie was listed as one of 96 Southerners to Watch with the headline, "Your Junk Is His Folk Art."

Now Holley had earned the ultimate position of honor: the entrance gallery for the *Souls Grown Deep* exhibition and two additional spaces to showcase his work within City Hall East. Visitors to *Souls Grown Deep* would begin their immersion into the art of the African American South with a trip through the indoor re-creation of Lonnie Holley's Birmingham yard. Matt Arnett and Holley orchestrated a massive logistics operation to haul thousands of objects from Holley's airport environment to the old Sears building. They had arranged for black-and-white photos of Holley's yard to be enlarged life-size and pasted to the walls of the gallery. Soil was spread over the gallery floor with a path winding through it. Holley had spent the past three days in this space pondering his approach, but the muse abandoned him. He rested on the floor in fetal position while those around him wondered whether he might kill himself or someone else. Holley had less than two weeks to complete this installation—the most ambitious he had ever been asked to attempt—but little work had been done so far. Olympic crowds would be arriving soon to see his triumph—*or failure*, he thought. Holley stood up and walked quietly out of the building. No one followed, and he drifted along the crusty sidewalks of Ponce de Leon Avenue.

An hour later, Holley returned as quietly as he had left and began to create. He moved like a wind-up toy endlessly picking up parts and bending them to his will. Art went everywhere—hanging from a gate, stuck in the dirt, draped over the walls, and suspended from the

ceiling. The spirit and art of Lonnie Holley began to blast across the room and shrouded whoever walked through it.

At that moment the Carlos staff groaned; this show actually *would* go on.

————————

Souls Grown Deep and *Thornton Dial: Remembering the Road* launched on June 29, 1996. Nearly six hundred people attended the opening dinner event at City Hall East. Music scatted through the room as curator Robert Hobbs pronounced that the art in *Souls Grown Deep* was the visual equivalent of and had the same historical significance as the blues and jazz. Smiling, tanned, sport-jacketed country club men and their cocktail-skirted garden club gals wandered through rooms dedicated to the art of thirty shirt-sleeved artists, each with his or her own City Hall gallery space. Alongside the dignitaries walked Lonnie Holley and Thornton Dial. Holley: a hyper-charged docent touring and explaining the art to guests; Dial: a reluctant witness pressed to the wall by the well-wishing onslaught. Other *Souls* artists circulated through the crowd, met each other, and marveled at the artwork of their unknown contemporaries. Florida artist Purvis Young, also on display, had never seen Thornton Dial's art before and spent a portion of the evening silently gazing in awe. Purvis Young would be among the few who would come to gaze at the art as show attendance, which everyone thought would be an Olympic flood, turned out to be a minor-league trickle.

For Lonnie Holley, *Souls Grown Deep* was a gold-medal winner regardless of the show's ticket sales. Aesthetics mattered more than money in Lonnie Holley's land, and Lonnie was damn well going to prove it. He zapped visitors to *Souls Grown Deep* with his recycled brand of aesthetics—his yard-art world—as they first entered the City Hall East galleries. Whether the aesthetics were pleasing or disturbing depended on the visitor's orientation. Holley didn't care either way as

long as his audience *thought* something *different*, saw the world in a *new* way after experiencing his work. He titled his indoor yard-art environment *If You Really Knew*. Art critic Tom McEvilley described Holley's installation as a "grottolike entrance to an under-world of neglected cultural treasure. In this installation, the light was dim, a path curved between two earthy slopes and overhead, things were hanging everywhere. So extensive and fascinating was this array that the visitor got a sense that he or she might not get through to the rest of the show." Indeed, visitors were hypnotized by this cast-off material of the modern world which had been repurposed into a coded art form and hung from the walls, draped from the ceiling, and laced into each other. Woven and wired throughout the room were paint cans, telephones, doll pieces, woodcarvings, sandstone sculptures, sprinkler heads, paintings, bottles, buckets, and broken tombstones. Holley had not randomly scattered these elements but rather methodically placed and linked them—albeit on a decaying wooden fence and tilted-up bedsprings—to tell his myriad stories of struggle and conquest as embodied and etched eternally in the waste of our lives. Holley strung the elements like musical notes on a scale destined, he hoped, to carry the viewer along a raucous, mind-changing melody.

Holley's visual melody was a Pied Piper tune with special appeal to children. While the Carlos Museum was unsuccessful in luring large crowds to *Souls Grown Deep* and *Thornton Dial: Remembering the Road*, it did mount an educational program in part funded by a joint grant from AT&T and The Coca-Cola Company. The money enabled the museum to haul in busloads of children from local schools to see the shows. Over nineteen hundred kids from twenty Atlanta schools visited. A few lucky ones had even been selected before the opening to spend time with Lonnie Holley as he installed his yard show. The response of these kids to the *Souls Grown Deep* experience was like oxygen to Holley. "It was really <u>cool</u>, <u>cool</u>, <u>cool</u>, <u>cool</u>, <u>cool</u>, <u>cool</u>, <u>cool</u>, <u>cool</u>," one child wrote on a paper decorated with her own Lonnie-like doodles.

Immediately upon leaving Holley's grotto, *Souls* visitors stepped into a gleaming white gallery space where works by Lonnie Holley had been pulled individually from their natural cluttered habitat and placed pristinely on wooden pedestals, sitting spot-lighted with pinpoint halogen rays. This was crossover stuff, not folk and not contemporary. Something else altogether. The contrast shouted out, "I am Lonnie Bradley Holley, African American artist, and I can play in the dirt or on your parquet hardwoods with equal style! Ain't no formulaic *Rings* exhibition here! I'm gonna make you *think!*" In case the viewers didn't already get the picture, Holley's *Not Olympic Rings* drove home the punch line. This one didn't need a pedestal. It rose four feet from the ground with the help of a serpentine steel rod from which were suspended . . . rings—dozens of rings of all sizes made of wire and bracelets and can lids and washers and metal and plastic rings and machine part rings and, even, a television dial. Holley had crafted a title and a piece that forced viewers to think about the piece on several levels at once. These were not Olympic rings that viewers saw, and this was not the *Rings* exhibition; maybe they were just . . . rings. Or maybe not.

Visitors moved out of Lonnie-Land and into a dizzying maze of art. They stumbled upon Ralph Griffin's gnarled root sculptures, one painted to look like Felix the Cat; alongside Jesse Aaron's own carved wood icons; juxtaposed with Bessie Harvey's root magic; then spilled out into a clump of work by James "Son Ford" Thomas, whose unbaked clay heads stared down gallery-goers through oversized black sunglasses; to Archie Byron's sawdust art to Jimmie Lee Sudduth's sugarcane and mud-art and Nellie Mae Rowe's felt-marker drawings; past Mose Tolliver and the Mississippi River portraits of Henry Speller and the sex-filled sketches done by his wife, Georgia; and on to the Dial family. Power. Power of mind. Power to struggle and conquer. Power expressed. Black power through powerful art is what confronted travelers through *Souls Grown Deep*. Power and family. Arthur Dial got a gallery space of his own, and so did

Thornton Jr.—Little Buck. Richard Dial's wrought-iron furniture art was angled into the space that preceded a gallery filled with the early work of Thornton Dial himself. If the power wasn't already evident to the viewer by this point, Dial's daunting *The Last Day of Martin Luther King* painting with King-as-tiger on the prowl blazed out from the wall at them as a bright red exclamation point. But this was just a warm-up and introduction for visitors to the work of Thornton Dial. More was still to come. Those who had any inkling of the *60 Minutes* episode that had run three years earlier and several times since may have been surprised at what came next: an entire room dedicated to Charlie "Tin Man" Lucas. Whatever Lucas may have done to Arnett or vice versa, the collector was now honoring the artist for the world to see. After Lucas was a space for J. B. Murray, a former tenant farmer who, during the ten years before his death in 1988, created reams of drawings claiming the spirit moved him to scribble haunting figures surrounded by a "spirit-script" decipherable only by Murray. By then *Souls Grown Deep* visitors might be exhausted mentally and physically, which made them exceptionally vulnerable for the exhibition's final lap. Ronald Lockett started the last leg of the show with his intense, holocaust-like images etched in decaying metal and wood. His work *Instinct for Survival* showed a delicately drawn deer lingering in the woods as a spooky sense of imminent disaster lurks. Then on to a space reserved for the art of former-Florida-prison-inmate-turned-master-painter Purvis Young and the blind artist Hawkins Bolden and then through to a full room of vividly colored work by Memphis artist Joe Light and then to a corner where thick black paint images on corrugated tin sheets told Mary T. Smith's visions in pigment, and finally, finally to three rooms of art by Thornton Dial. The Arnetts knew it as fact. Lonnie was certain. Grown visitors agreed. So did the kids. This art and this exhibition were *cool, cool, cool, cool, cool!*

Nationally, critics agreed with the kids. Cool. *Newsweek* writer Malcom Jones called *Souls Grown Deep* "the show that ought to be

showcased at the High Museum, the show that best exemplifies the South's unique contribution to art," and he said it is "the show to see in Atlanta." "Every piece is a wonder," he wrote. Benjamin Forgey of the *Washington Post* told his readers that *Souls Grown Deep* "is yet another strong statement about how important African American culture is to the Southern culture as a whole." The *Los Angeles Times'* Christopher Knight dubbed the show "engrossing" and said it "demonstrates the potential power in a highly personal art commonly made from castoff materials, by artists who have themselves been castoffs from American society." *Art in America* magazine featured a nine-page article by Thomas McEvilley about the wonders of *Souls Grown Deep*.

Locally, however, critics discounted *Souls Grown Deep* as yet another attempt by Bill Arnett to pump up the value of his own collection. Amy Jinkner-Lloyd, art critic for Atlanta's alternative weekly newspaper *Creative Loafing*, had set the cynical stage in her 1994 article in which she warned, "Both 'Souls Grown Deep' and 'Thornton Dial' will comprise the work of artists owned and heavily promoted by Atlanta collector Bill Arnett. The Carlos is thus staking both its Olympic identity and its long-term reputation on what is in large part the contents of a private collection. Further, that collection's value stands to increase as a result of the Carlos Museum's Olympic promotions." And, even in a generally positive review of *Souls Grown Deep*, *Atlanta Journal-Constitution* critic Catherine Fox couldn't help but point out that "Dial's prominence reflects the view of Atlanta collector Bill Arnett, whose vast collection is the source for almost all the art here—a revelation in itself." She punched harder in a separate article assessing *Thornton Dial: Remembering the Road*. Her article on the artist's solo exhibition at the Olympics was sharply titled "Don't Bother Touching This Dial." For Bill Arnett, these backyard critiques loomed larger than any national praise.

Arnett was partially comforted by the dismemberment of his enemies in the same publications that heralded *Souls Grown Deep*.

J. Carter Brown and Ned Rifkin had mounted a blockbuster of their own across town at the High Museum with 125 works of art from around the world spanning six thousand years of art history. The *Rings* lot, which included pieces by renowned artists like Mary Cassat, Georgia O'Keeffe, and Auguste Rodin, was divided into five categories each showcasing one of five different emotions: love, joy, awe, anguish, and triumph. Brown and Rifkin may have reveled in the joy and triumph of their grand show, while art critics primarily experienced anguish. The High Museum's *Rings* exhibition was "a grand concept gone awry," claimed the *Boston Globe*, which in the same breath chastised, "If the leaders of the High Museum had real vision, they would have sponsored 'Souls' instead of Brown's five-ring circus." *Newsweek* slammed *Rings* as offering "vague, family-of-man generality." The *Los Angeles Times* declared Ned Rifkin and J. Carter Brown's *Rings* exhibition "silly institutional pap." The *Wall Street Journal* charged, "Never before have such sublime works of art been put in the service of such dopey ideas."

Despite the rave reviews for *Souls Grown Deep*, art critics were among the very few who braved Atlanta's summer heat to venture off the Olympic transportation routes and find their way to City Hall East. The twenty thousand square feet of *Souls Grown Deep* exhibition space could usually be criss-crossed without a visitor bumping into another living soul. Meanwhile the stark-modern High Museum, set conveniently on Peachtree Street in Atlanta's Midtown and looking like a cool southern gentleman in white formalwear, drew its second-highest attendance in the museum's history and pulled in record-breaking sales and membership revenues during the summer of 1996.

Chapter 13

NOT OLYMPIC RINGS

BILL ARNETT DID NOT WANT *SOULS GROWN DEEP* TO END. HE WANTED to extend the run of the show past its official November 1996 end date. A primary motive: to see the massive book that was supposed to accompany the *Souls Grown Deep* exhibition come out while the show was still open. The book's creation had run into at least as many obstacles as had the show itself, and the Carlos staff assumed the book was stillborn.

Arnett's idea for an omnibus book providing a panoramic view of black folk art in the southern United States originated in the late 1980s. He and Bob Bishop of the American Folk Art Museum brainstormed a group exhibition and book project that would be the sequel to the Corcoran show, *Black Folk Art in America*. After the museum began receiving scathing letters fingering Arnett as a scoundrel, Bishop told Arnett they had better back off and focus on a smaller show instead to fly beneath the burgeoning controversy. The result was *Thornton Dial: Image of the Tiger* and an accompanying book, but Bob Bishop saw neither. He died in 1992, a year before the Dial show launched in New York City. Still, the idea for an encyclopedic look at folk art stuck in Arnett's head. And if he were going to do it right, if he were going to write *the* book on African American

self-taught art, Bill Arnett needed the one man at the one company that could help him pull it off with absolute credibility. He needed Paul Gottlieb from the esteemed publisher of illustrated books, Harry N. Abrams, Inc.

Gottlieb was publisher and editor-in-chief of Harry Abrams, the first American publishing venture to focus solely on art books. The company was known for its lavish and large coffee-table books filled with eye-popping images of the world's finest art. Gottlieb ran Harry N. Abrams publishing efforts since 1980—just three years after the founder, Mr. Abrams himself, retired. He scored major victories in the decade since taking Abrams's helm, including launching a book on Andrew Wyeth that sold half-a-million copies, earning it the top spot with the Book-of-the-Month Club, and a one hundredth anniversary book about the National Geographic Society that ultimately sold over a million copies. He was a big man literally (he was usually the tallest guy in the room) and figuratively (he was a board member at the king of all contemporary art museums, the Museum of Modern Art, New York). If Arnett could get to know Paul Gottlieb, the big book idea just might become reality.

Someone whom Bill Arnett was just getting to know in the early 1990s, Ben Apfelbaum, claimed he had an "in" with Gottlieb. One of Apfelbaum's sister's friends was married to the Abrams executive. Through that convoluted connection, Apfelbaum convinced Gottlieb to look at some slides of the art from Arnett's collection. After reviewing the Arnett slides, Gottlieb flipped quickly through a catalog from the *Thornton Dial: Strategy of the World* show. Then he stopped and smiled. "It is ironic because I was on a panel at Sotheby's recently, and the question came to me, 'Is art dead?'" Gottlieb said. "I told them art is never dead," Gottlieb went on. "You just never know where the next great thing is going to come from. Now I think I've found it." A meeting with Bill and Paul Arnett ensued. Great visions were shared. They agreed on a big book. Shook hands on it. Gottlieb thought the big book should be done in conjunction with a major

exhibition hosted at one of the leading museums. Gottlieb promised to arrange introductions for the Arnetts at hallowed sanctums like the National Gallery and the Whitney Museum of American Art. Paul Arnett visited the Whitney's director, David Ross, on Gottlieb's glowing introduction. Ross, it seemed, was ready to go . . . with one caveat. "You don't know this yet, but my college roommate just took a job as the director of your museum in Atlanta. Since you have an Atlanta-based collection, it would be natural for us to partner with him on this exhibition. My friend's name is Ned Rifkin," Arnett remembers Ross saying.

Paul Gottlieb thought Max Anderson was the bee's knees. "The best of the young generation of museum directors," Gottlieb said of him. So, despite the Arnetts' ill-fated journey with Ned Rifkin and the High Museum, Gottlieb fully endorsed the Anderson/Emory/Arnett union and the accompanying exhibition and book to go with it. Gottlieb began sending letters to prospective contributing writers for the book, enlisting their participation. He assigned an editor. But there was just one more thing that Harry N. Abrams, Inc. needed to ensure their participation and support: two hundred thousand dollars.

Gottlieb told Bill Arnett that to produce the book he contemplated—at more than four hundred pages, full color, hundreds of photographs, top quality paper, a ten-pounder, two inches thick—Harry N. Abrams, Inc. would need some kind of subsidy to make the economics work and to mitigate the risk. Emory University and the Carlos Museum would have to guarantee the upfront money, the two hundred grand. "Since Emory is a nonprofit, they can't technically give a subsidy to a for-profit entity like Abrams," says Paul Arnett. "They can't give a subsidy. So the way that it works, it's just a standard formula, the participating museum agrees to buy a certain number of books well ahead of time, whether they sell them to museum goers or not. The museum agrees to buy X number of books for X dollars, which is a de facto subsidy. So in this case Abrams said they wanted essentially two hundred thousand dollars to underwrite the production

cost." Max Anderson assured Gottlieb that the university was good for the money. Emory's agreement with Arnett confirmed it. Abrams would get its cash. The book was a go.

With Gottlieb's endorsement, the Arnetts and curator Robert Hobbs pursued a cadre of dignitaries to contribute essays for the big book, each with a unique perspective on African American vernacular art of the South. "We wanted a multidisciplinary book that built awareness for the field as a legitimate part of art history and showing it as an art form with different dimensions that go well beyond 'folk art.' The artwork is so intertwined with cultural issues, we thought we needed to bring in writers with expertise in different aspects of African culture and who would add fresh perspective," says Paul Arnett. Andrew Young, former UN ambassador, U.S. congressman, Atlanta mayor, and civil rights leader, agreed to write for the book. So did Congressman John Lewis, the hero of the legendary Selma March across the Edmund Pettus Bridge that helped drive passage of the 1965 Voting Rights Act. Vincent Harding, noted African American professor of religion and social transformation, said he would write for the big book. So did Howard Dodson, who headed the Schomburg Center for Black Studies at the New York Public Library. African art historian Dr. Roy Sieber agreed to contribute, as did global arts and African American quilt expert Dr. Maude Wahlman and southern culture guru Dr. William Ferris, who, it turned out, was also a friend and champion of the *Souls Grown Deep* artist Son Thomas. In the presence of such solid citizens, who could question the scholarly authority of the Arnetts' big book? Of course, Bill and Paul Arnett would add a healthy dose of their own scholarship to the book too, and surrounded by notable experts, their words would gain extra merit. So would the artists and their creations.

In fact, the Arnetts wanted to show the world that the artists and their creations were not just societal phenomena to observe and comment on from the sidelines with no intelligent commentary of their own. The big book thus became a platform to give the artists a clear

voice. "These people are not just our subjects. They are our equals. We realized that we had to give the artists' voices a chance to be heard at equal volume," Paul Arnett says. "For any of the artists that were still alive and articulate enough, we wanted them to tell their own history in the book." Artists like Henry and Georgia Speller and Arthur Dial and a host of others were given complete license to print their own statements in the book. In cases where the artist couldn't read or write, the Arnetts recorded the artist's comments and reprinted them nearly unchanged. First among equals in the big book was by far the most articulate of all those presented: Lonnie Bradley Holley. "Lonnie had traveled to meet the artists, and he knew as much about the people as anybody and had talked about their work and provided insight into other artists' work, and we thought he ought to be one of the co-equals in the project," says Paul Arnett. He asked Holley to contribute a treatise to the book with free reign to "talk about anything you want to say that you think a reader of this book ought to know about this field and your fellow artists."

Bill Arnett says this highlighting of Holley in *Souls Grown Deep* proves that Arnett didn't just favor Thornton Dial. "Lonnie is treated throughout like a hero," says Arnett. "Like the central, core figure. Not Dial, because every time that we had a writer that was gonna write for the book I would play up Lonnie, not Dial, and take them to meet Lonnie and let them write around Lonnie because Lonnie is the one. Now, I can't keep him supplied with money at this point, and I can't keep him supplied with self-esteem. But he's kind of the core of this whole deal."

Paul Gottlieb told Bill Arnett that the big book, *Souls Grown Deep*, volume 1, was going to be one of the most important art books of the twentieth century. "We've been asked by Book of the Month Club to recommend an Abrams book in connection with the upcoming Olympic Games. I recommend that *Souls Grown Deep* is the book they buy," Gottlieb told Arnett. "We need to be prepared to reprint another twenty thousand copies after Book of the Month promotes it,"

Gottlieb added. Arnett beamed because, in addition to *Souls Grown Deep*, Gottlieb had agreed to publish *Rings: Five Passions in World Art*— the book to accompany the High Museum's grand Olympic event. Harry N. Abrams, Inc. had evaluated his work against that of Ned Rifkin and J. Carter Brown, and Arnett came out victorious.

With big plans for the big book now in the works, Paul Gottlieb announced that it was time for Emory to provide the promised subsidy. Despite repeated pleas from the Arnetts and from Gottlieb to everyone from senior Carlos Museum staff to Emory President Chace and his senior team, no money was forthcoming. At the same time, two photographers, hired by Emory to shoot photos of artwork for the *Souls Grown Deep* show and book, were struggling to get payment for their efforts and wrestling with the Carlos Museum staff over what they deemed to be an overreaching contract for the work they had already done. The photographers refused to turn over their work to the publisher, and so Abrams's specified deadline to receive the photos came and went with no pictures provided. Then, less than two weeks after Gottlieb boasted of Book of the Month Club glory, Emory informed the Arnetts flat out that the university would no longer support the big book in conjunction with the *Souls Grown Deep* exhibition, and it followed that they would not provide the two hundred thousand dollars in front money to Harry N. Abrams, Inc. The chain reaction continued. Gottlieb immediately informed the Arnetts that Harry N. Abrams, Inc. could no longer be the publisher of the *Souls Grown Deep* book. "Our relationship now has got to change," Gottlieb said. "Which means you are going to have to set up your own little cottage industry down in Atlanta. If you design, edit, and print the book, we would still be willing to distribute it as long as you get us the finished product. We just can't take the publishing risk." And there was another thing. The Book of the Month Club had chosen the *Rings* book instead of *Souls Grown Deep* as first choice for their catalog that year. With that, the Arnetts told Gottlieb he could forget about any distribution deal.

Perhaps as far back as his first big book conversation with Bob Bishop, Bill Arnett had been hyping the book to the self-taught artists in his stable. *This is what our whole mission is about! The big book is the big vision! With the Olympics, this is our once-in-a-lifetime opportunity to put the book in hands of people all over the world! And there will be another book after that too.* Souls Grown Deep, *volume 2. And probably a third one. That's how important this art is to the world!* But gossip was spreading through the Alabama woods faster than fertilized kudzu. White collectors and other self-proclaimed protectors of folk art were telling black artists that the book would never get done. The whole project was a hoax, a ruse to get you to sell your best art only to Arnett, who will hide it away in warehouses never to be seen. After all, they whispered, the Arnetts only care about promoting Thornton Dial. Bill Arnett pulled at his own hair, frustrated again at the sniping chatter that he could not control. He redoubled his commitment to produce the big book. "Bill's affiliation really changed midstream from the exhibition to the book," Robert Hobbs says. "What became most important was the book, scholarship, documenting it. Bill had been so deeply and publicly hurt by the *60 Minutes* show, and he was still trying to make up for that and probably will for the rest of his life. The book represented validation." Arnett had to get the book done, whatever it took.

It took a lot, especially since the Arnetts would settle for nothing but the best. With the money that Emory was still paying out for his African art collection, Bill Arnett anted up nearly two hundred thousand dollars for a special order of the best available paper. He had paid for two-thirds of the four-hundred-plus pages of *Souls Grown Deep*, volume 1, to be printed on the special-order paper, but it was a false start. One of the contributors decided she no longer wanted to be involved and she pulled her essay, forcing a complete redesign. When the Arnetts went to examine the printing that had already been done, one of the pressman took them aside and said, "You are clearly fanatics about wanting a great book, but I don't understand

why you guys are using such terrible paper. I've had to reject entire batches because it is too inconsistent to print on. You could never bind these sheets into a book, because every signature is on slightly different paper." There was already tension between Bill Arnett and the printer, who, Arnett was beginning to suspect, was bilking him and somehow in cahoots with Emory and Gottlieb. At two o'clock one morning, when Paul Arnett was certain the print shop owner would be home asleep, Paul entered the plant, collected all original materials for the book, put them in a box, and left to call his attorney. The Arnetts and the printer negotiated a settlement in which they received digital tapes containing ready-for-press typeset files. They found a new printer that promptly began printing the parts of the book it could, but when it got to the DAT tapes they discovered there was no data on them. Erased. Wiped out. Blank. The Arnetts would have to re-create the last third of the book from scratch. By then it was late June 1996. The Olympics had begun; the *Souls Grown Deep* exhibition had launched. The Arnetts still didn't have a distributor for the big volume. It was looking once again like the big book would never happen, at least not in time for an Olympic audience.

If the Arnetts couldn't get the big book out in time for the Olympics, at least they might get it out while their exhibition was still up and running, but that would take convincing Emory University to extend the run of the show. As it was, the staff of the Carlos Museum was counting with glee the days until the show's closing. No more Bill Arnett and his demands and quirks and greasy hair! No more art made of rust and rot by toothless men from dirty places. Soon the Carlos crew could return to keeping their mausoleum of a museum where it belonged—back in the indisputably fine art of antiquity. Since *Souls Grown Deep* had been cosponsored by the City of Atlanta Bureau of Cultural Affairs, Arnett imagined he could get the City to leave the show in place and available to the public in what was the City's space anyway, City Hall East. But Emory's property was inextricably entangled with Arnett's art. This posed a dilemma

made stickier by the fact that Atlanta City Council member Mary Davis gave a heads-up to the Carlos staff that she was proposing legislation extending the exhibition and asking the museum to hold off from de-installing the show until Davis could set the legislation in motion. Museum staffers dug in their heels. According to an affidavit signed by Carlos Museum senior preparator Kipp McIntyre, he witnessed a dialogue between Lori Iliff, the registrar of the Michael C. Carlos Museum, and Joe Crooks, Emory University general counsel. "She had seen the Arnetts' warehouse and was concerned that there was not enough room in it to receive the works to be returned from *Souls Grown Deep*," McIntyre recorded in his sworn document. Crooks, McIntyre overheard, replied, "Well, this is what we do. We rent a warehouse and move the stuff there. Then we don't pay the rent, they (the landlord) put it all up for auction, and when no one buys it they ship that crap to the dump."

"It was the 'final solution' for black cultural heritage," snorts Bill Arnett, applying Nazi terminology to the situation. "It's not like they thought we're just getting *even* with this dirty bastard Bill. It wasn't that. They totally understood what they were getting rid of. That's why internally at Emory they had this smear campaign going about the art being just rusty tin and rotten wood."

Councilwoman Mary Davis was one of Arnett's allies who worked to get a resolution passed by the Atlanta City Council Community Development/Human Resources Committee "authorizing the Mayor to enter into a short-term lease agreement with William Arnett for the purpose of exhibiting the *Souls Grown Deep* Collection in City Hall East during the period 7/1/97 through 12/31/97." By that point, however, the Michael C. Carlos Museum had pulled its resources from the show, yanking out everything that was considered Carlos property except a handful of art pedestals. The Emory crew literally scraped their text and placards and photos off the gallery walls and took their belongings home. The art of Thornton Dial and Lonnie Holley and Ronald Lockett and others remained alone in the

gallery, unidentified for the untrained viewer, as anonymous as if it were all buried in Dial's old Pipe Shop backyard.

The cost of extending *Souls Grown Deep* came directly from Bill Arnett's wallet, which left him little cash with which to finish the big book. "I panicked, and I guess if I had a little bit of foresight I could have seen this coming," Arnett says. "But I didn't and I was desperate, 'cause I had promised all these artists we were going to do a big set of books and it would come out at the Olympics and people all over the world would see it. I just felt an obligation to do it. By the time *60 Minutes* first ran we were not in any debt really and had a steady cash flow. After *60 Minutes* we had to live on borrowed money for the rest of the time. We mortgaged and pledged everything we had and borrowed $1 million to get the book done. We lost it all. We lost over $1 million. We're still in debt."

A reasonable man knows when to retreat—especially a reasonable man who has been publicly shamed and beaten down repeatedly; who has spent a large portion of his personal fortune chasing what others perceive to be quixotic goals; who claims to be deep in debt; whose health has begun to suffer; whose family has been dragged through the mud. But Bill Arnett pushed forward with a huge vision that trampled reason. He fought mounting depression in the years since *60 Minutes* by prescribing for himself the one antidepressant that was certain to rejuvenate his spirit: a healthy dose of exploration.

As the Olympics waned and his doldrums escalated, Arnett traveled extensively through the hidden South seeking new talent and photographing and documenting folk artists and their work. It was during this time that Arnett came upon Joe Minter, a former construction worker on the outskirts of downtown Birmingham who, after a heavenly vision, cultivated a sculpture garden to honor the memory of the known and unknown soldiers of the civil rights movement. During this time also Arnett discovered Emmer Sewell and Dinah Young, two elderly black women living in the forsaken mid-Alabama land photographed by Walker Evans in his 1939 book

about poverty-stricken sharecroppers, *Let Us Now Praise Famous Men*. Walker Evans's coauthor, writer James Agee, warned off readers in the book's "preamble," saying of the book, "Above all else: in God's name don't think of it as Art." Emmer Sewell and Dinah Young seemed to say the same about their yards. Art? Are you crazy, man? From a quick pass, Young's "art" looked like no more than bundles of sticks piled up for kindling. Sewell's stacked stones and tires and other refuse looked as if it were awaiting pickup by the Salvation Army. Arnett stopped and saw something else. Intricate patterns. Purposeful placement of materials. A leaf, for instance, suspended from a tree by a thread-thin piece of vine created the world's tiniest mobile. A fabric of twigs underfoot carefully laced to conjure a magic carpet in the woods. A picnic table and chairs set upon one another so that their intersecting wooden legs formed a triple-x signpost. These were sculptures in nature. They were African spiritual symbols casting off demons. They were poetry in pots and pans, in bark and twigs. They were prayers dangling from branches and leaning against corrugated tin walls. *Oh, this is definitely art*, thought Arnett. Spectacular art. And it was on display for the world to see. But the world didn't see. Arnett would fix that. Volume 1, therefore, must be reworked yet again.

Paul Arnett agreed with his father. As long as they already missed the Olympic window of publishing opportunity, why not take a step back to make the books as rich as possible? For that matter, why just include material from the Arnett Collection? To be more comprehensive, Paul Arnett believed they should include earlier artists whose work the Arnetts did not own, artists like Bill Traylor and William Edmondson. With all of this new material, the big book needed to be bigger. Instead of one four-hundred-page big book, why not two five-hundred-page books? More money, more debt, more time.

One thing was still missing: the anointing of artistic and scholarly credibility that an affiliation with Harry N. Abrams and Emory University would have provided for the big book. The proposed name of their little publishing venture, Stillwaters, meant nothing at

all in art and academic circles. The Arnetts needed a reputable ally with a known name.

Howard Dodson and the Schomburg Center for Research in Black Culture fit the bill. A part of the New York Public Library system, the Schomburg Center serves as a research facility and resource for scholarly and creative activity related to the African American experience. Dodson had since 1984 been chief of the Center, where he governed holdings such as the ashes of poet Langston Hughes and the collected letters and speeches of Malcolm X. The Arnetts had already tapped Dodson to write for *Souls Grown Deep*. They had discussed the possibility of copublishing the book even before Abrams had completely pulled out of the project. Now they needed Dodson's support and the Schomburg's endorsement more than ever. The Schomburg Center agreed to copublish the big book.

In February 2000, more than ten years after the first inkling of a big book entered the brain of Bill Arnett, nearly four years after the Olympic Games came to Atlanta, after borrowing and begging friends for funding, the big book was finally completed and on the bookstore and museum and library shelves. Paul and William Arnett were listed as the book's executive editors. Lonnie Holley was listed as a special consultant as well as a contributing writer. The big book had a big title—*Souls Grown Deep: African American Vernacular Art of the South: The Tree Gave the Dove a Leaf*—and everything else about it was big, too. This jumbo volume carried nearly 550 pages, including over eight hundred color images of art and some five dozen essays printed on lavish oversized paper stretching 12.9 by 10.9 inches, and weighed nearly 10 pounds. Size alone could have made a certain statement about the book, and that statement was strengthened by the art it pictured and the eloquence and passion of the contributing essayists, including the artists themselves. The statement was clear: the big book is the definitive work on a previously underappreciated art genre that demands attention and respect.

Even before receiving much critical attention, the first ten-thousand-book printing of *Souls Grown Deep* sold well. "It sort of became like a cult book. People knew about it and were asking how to get it," Paul Arnett says. Then the reviews came, and they were wholly positive. One reviewer called it "unprecedented, in-depth," "a must have—beautiful to look at and an accessibly informative read," and wrote that it "represents a landmark in art and cultural history." Another claimed, "It is a solid, unmovable cultural monument, a tribute to Arnett's astonishing resilience and determination." Peter Marzio would later say of *Souls Grown Deep* and its companion second volume, "So profound, it's subversive." The authority of *Souls Grown Deep* was unmistakable, and perhaps the most satisfying "review" of all for Arnett was also the most surprising: even in the homes of Arnett's harshest critics, the big book could be found displayed proudly on side tables and shelves. Art critic Jerry Cullum summed up its importance not only to the art world but to the Arnetts: "Until *Souls Grown Deep* came out, other people were taking over the dialogue regarding self-taught art. The *Souls Grown Deep* book helped turn things around for the better. There was huge documentation, and it was not all self-serving. In fact, it was, collectively, amazing. And Lonnie Holley and Thornton Dial stood out head and shoulders above the others."

By starting their own book publishing company, the Arnetts discovered a venue that allowed them greater freedom to tell their story and those of their artists to a broader audience than ever before, but the Arnetts wanted more. They had chosen the name "Stillwaters" for their publishing company, and they now hoped that name would appear on the many books they planned to create. Their publishing venture would grow and give them unlimited license to change the history of art. "It was like having a museum without walls. You're not beholden to anybody. You can control the editorial content and direction, and you can frame the issues in the way that you think they should be framed," says Paul Arnett. However, the name "Stillwaters"

could be found nowhere on *Souls Grown Deep*, volume 1, nor would it be found on any subsequent volumes the Arnetts published. The name, Stillwaters, it turned out had already been taken by a book publishing company in New Jersey. In the final throes of book production, the Arnetts scrambled for another name. They remembered the words that had filtered back to them from their experiences with Emory. Their collection had been laughed off as just a bunch of rusted tin and rotten wood. "So when we needed a name, we just thought, *Well, isn't that all that we're going to be publishing material about: rusted tin and rotten wood?*" says Paul Arnett. "So we named the company Tinwood."

Chapter 14

LONNIE HOLLEY'S VISIONLAND

IF TIN AND WOOD AND SAND ARE THE MASS AND MATTER OF LONNIE Holley's art, his words are the essence, the noise, the whisper, the singing spirit—the call *and* the response. Holley speaks a shamanic, incantatory language that ignites his art and transfixes his audience. With Holley's words and images emitting signals in unison, time vanishes and anyone in the vicinity tumbles into the spell of art and artist. Then words wash over art and art vanishes, and then it is the other way around again. Art resurfaces over words and words vanish, and around again.

Rarely have Lonnie Holley's words been recorded in print so that they can be experienced together with his artwork even when he is physically absent. Holley's words in *Souls Grown Deep*, volume 1, may have been the first time they received unfettered display on paper. In the big book, Holley talks of a visit to the Atlantic Ocean, and he uses that experience as a pivot point from which he reveals his ability to see beyond the corpus of his recycled materials and into history and future and into the junction of the two. "I travel around to see. It's like walking back in time, to walk along the ocean, the beach, to walk in the sand. I am not trying to find footsteps in the sand, but to put my own footsteps where my ancestors might have

stepped," Holley begins his story about the sands of time. He is, after all, the Sandman.

————

There is nobody in the world who knows so many stories as The Sandman, *or who can relate them so nicely. In the evening he throws a small quantity of very fine dust in the children's eyes. Then he creeps behind them, and blows softly upon their necks till their heads begin to droop. But* The Sandman *does not wish to hurt them, for he is very fond of children, and only wants them to be quiet that he may relate to them pretty stories. . . .*

This is how Hans Christian Andersen began his fairytale "The Sandman," aka "Ole Luk Oie." But Andersen could have been in 1990s Alabama, not nineteenth-century Denmark, when he wrote of Ole Luk Oie, and his model for the character might well have been Lonnie Bradley Holley. Like Andersen's Sandman, Lonnie Holley had many stories to share.

"They call me the Sandman," Lonnie Holley says proudly when he speaks of the children whom he meets when he travels to Alabama schoolhouses to share his stories and stones. "I've gotten letters from children saying, 'Thank you, Sandman,'" Holley beams. There are those who may claim that the children Holley teaches only call him the Sandman because of the grains of fine dust that his carvings leave on their tables. But they may be appreciative because they know that Holley's sand dust is a special dust that once held not the ocean, but the wet of molten iron.

But perhaps the children call him the Sandman because they have something else in mind. They may know what Holley's grandmother Momo knew when Holley was born: that Dorothy Mae Holley Crawford's seventh son would live up to his prophetic birth and be given the gift of sight—a gift quite valuable in Birmingham, Alabama;

Buford, Georgia; Biloxi, Mississippi; or anywhere that African American cultures thrive. Just like other cultural gumbos—English bedding turned into strip quilts, Methodist hymns turned into gospel music—if transported to modern-day Birmingham, Alabama, the Danish Dream God, Ole Luk Oie, can become one whose dreams are more than merely dust in children's eyes. They are dreams of possibility.

To the children, Holley the Sandman could be a "conjurer," a "medicine man," a diviner, all terms used to describe Lonnie Holley— one who has mastered the art of reshaping the forsaken objects of this world, seeing through their matter and deep into their spiritual substance. Perhaps Ole Luk Oie, as an Alabaman, would offer visions as well as dreams, visions that need not wait until evening, because they occur as easily when the sun rises as they do when the stars emerge.

Like the visions of Nat Turner before his famous rebellion, or Sojourner Truth before she decided to love *all* of mankind. Like the vision, not the mere dream, that many say Rev. Martin Luther King shared while he stood at the Lincoln Memorial and told the world that one day little Alabaman white and black girls and boys would play and hold hands.

"Visions do come true," says Lonnie Holley, and he should know. He has had more than one in his lifetime. In fact, Holley's art was inspired by a vision (God instructed him to carve stone, he professes). And the moment that he carved his first sandstone, Lonnie Holley came alive anew, a recycled man.

"Visions come in many forms," says Holley. When creating art Holley refers to his artistic vision and says, "I'm not speaking for myself as an individual; I'm speaking for the whole of life." Paul Arnett echoes this sentiment when he says, "Lonnie Holley probably has the biggest and most expansive cultural vision of any artist."

"ART IS: All Rendered Truth Internal Self," Lonnie Holley offers, highlighting the acronym like a Kabbalist churning Hebrew letters into spiritual icons. "Art is growing. Art is in cake and baking. Art is

singing, dancing. I think art really is energy. . . . I want people to learn how to use their energy. . . . It was energy that did all of this [art], and I use it for the goodness. You don't get much energy that you use in life . . . but it's how we use the energy. . . . I want that really with my art."

If it is true that the divine inspires visions, visions inspire art, and art as energy inspires life, then perhaps Ole Luk Oie as an Alabaman would sport dreadlocks and an armful of bracelets.

If Ole Luk Oie were to tell stories of Lonnie Holley's life in the 1990s they would be ancient ones, tales that have been told since long before the Sandman was born, tales that remind us that be it from the top of Mount Olympus or the top of our bed frames, along with mythic successes, the gods are prone to equally storied downfalls.

———————

In April 1995 Lonnie Holley rises from his bed, stretches, pulls his locks into a ponytail, goes outside to draw water from his well. He wets his face, dries it, pulls clothes from his dresser, selects a suit and tie from his closet, puts them in his bag. Planes fly overhead. When they do, his house rumbles as the vibrations from their mighty turbines threaten his walls. Holley opens his front door, walks outside. He doesn't stop to add a new layer of paint to a painting or straighten an assemblage in his yard. He doesn't even stop to spend time with the women whose wire faces look as if the wind sculpted their smiles. This day Holley has another date. This day other ladies come first.

One lady in particular had been preparing for him for a long time. She was preparing for him on the fall day in 1969 when she met her clever future husband, who volunteered to pick up garbage at a closed Yale Art Museum so that he could escort her to see the sculpture inside. That day she discovered that trash cans open pathways to great loves—and great art (which Lonnie Holley had known all the while).

Two decades later in the winter of 1993, the day after this lady and her husband moved into their new house, she walked the snow-laden acres of their yard, passed magnificent trees, gardens, rolling hills, and said aloud, "I can't believe there's no sculpture on the grounds."

So she gathered a committee devoted to preserve the house, stood before them, presented an idea, and got the unflinching support of longtime committee member J. Carter Brown.

When Lonnie Holley reached "the street where this lady lived" in April 1995 dressed in his finest dark suit, crispest white shirt, and most attractive necktie that April day, he likely sauntered southeast on Pennsylvania Avenue and stood at the corner of Pennsylvania and Seventeenth. He likely knew that a lift of his left hand would lead him to her house; a lift of his right hand would direct him to the Corcoran gallery (where he had been before). He likely chose to walk in the direction of his left hand—not only because, well, she was waiting for him, but it is the fancy one; it's adorned.

When he arrived at her house Holley may have straightened his shoulders before he entered through the East Wing. He may have passed the room that once accommodated Roosevelt's roller-skating children, recuperating Union troops, and the bodies of six U.S. presidents who had died, before he could look out of the East Colonnade window and see the garden named after Jacqueline Kennedy—the place that because of this lady, first lady Hillary Clinton, nearly a million people would see Lonnie Holley's art.

Chosen from the Emory University Collection, Holley's art piece *Leverage* was selected as one of twelve pieces for the White House's *Twentieth-Century American Southeast Region Exhibit*. Among renowned artists such as David Smith and Elizabeth Catlett, Holley's was the only work shown by an African American self-taught artist from the former slaveholding South. This was perhaps one of Lonnie Holley's greatest moments. That day among the many people at the opening Hillary Clinton told Lonnie Holley and the world that he was a "master artist." There is a picture of it. Holley keeps it in a

frame adorned with white silk flowers. Holley stands handsomely in his suit as Hillary Clinton looks slightly up at him, shakes his hand, and smiles.

But despite his glorious trek that April day—he must have known that once the snapshot was taken he would have to step out of that picture—Lonnie Holley had a reality to face as he made his own tracks down the road back to Alabama. His own lady, his wife Carolyn, had left him, this time for good, and he was left to raise their five children and one grandchild alone.

She had left before, the last time in 1986. Later, while visiting friends in Ohio she was arrested as an armed robbery accomplice, and during the six years that she spent in prison Holley held the lingering hope that when she was released she would come back home. She did not.

"Even after the woman gone the child got to be raised. So I'm learning to do my work and get up every day as a father. I'm learning to go on through with life," Holley says. Holley's life changed in other ways after his wife left. He stopped reaching for wine bottles and started reaching for books—spelling books, the Bible. He took his children to church and made sure that they attended school. He taught them how to make art. There would be many more changes to come.

In the first line of her autobiography *Dust Tracks on a Road*, Zora Neale Hurston shares that, "Like the dead-seeming, cold rocks, [she] had memories within that came out of the material that went to make her. Time and place had their say." Though Lonnie Holley's 1990s were peppered with successes like the White House exhibition, *Souls Grown Deep*, the landmark *Self-Taught Artists of the 20th Century* at The Philadelphia Museum of Art, and the High Museum of Folk Art and Photography's premiere exhibition *Dust Tracks on a Road*, during this time Lonnie Holley's "place" had its say. And it said a lot. It made others speak and debate. Bill Arnett said that he "had never seen anything as magical as this place." That "Lonnie and his environment were a part of a cultural phenomenon that repre-

sents American visual art at its highest level." Many others looked around and saw the scattered wire, rotting plywood, and old tires and called it simply "junk."

This place was Holley's grandfather's property, which his grandfather had bought in the 1940s for "pocket change" and from which he and neighbors like Mamma Reid built a community and on which he and his ox built a modest house by hand from "scraps." In the 1970s the place was enchanting enough to keep Lonnie in Birmingham after twenty years of traveling, and after 1986 it was the house in which he raised five of his children alone. Holley had been there for nearly two decades when another place—the Birmingham Airport (around since 1931)—decided that it had dreams of its own. It wanted to expand. The airport wanted to live up to its new name, Birmingham *International*, though, in truth, it only offered two international flights. The Birmingham Airport wanted a new runway with enough room for a fully loaded Boeing 747 to land or take off. But Lonnie Holley's place and others' places in his Airport Heights community were hindering how far Birmingham International could soar.

Holley's house was in the direct path of the runway. In 1993, with a $30 million voter-approved expansion project, the airport condemned more than seven hundred lots in Lonnie's surrounding communities. They offered a whopping fourteen thousand dollars for the place that Lonnie Holley saw as priceless. According to Holley, many of his neighbors, including Mamma Reid, "had to up and run away and leave stuff." The community dissolved. "A lot of the older ladies had to leave out of their homes in a rush. Leave all the trees. Leave all the flowers that they had planted," Holley remembers. "When the airport condemned the area everybody had to move away."

But early on Lonnie Holley decided that his place was too precious and that he would do what would be necessary to fight to stay.

Thornton Dial wrote a story about Holley and his place and the international airport. Instead of words and sand, Dial used can lids and mini metal Ferris wheels, circles, hoops, and iron. It is a sculp-

ture with primary colors atop what appears to be a rotting wooden fence but is actually a boarded-up window frame. It is graced by one of Lonnie Holley's ladies, circling airplanes, and replicas of Lonnie Holley hanging in effigy from a wooden cross. Thornton Dial calls it *Lonnie Holley's VisionLand*, and it is not the only place by that name where dreams and their gods, legends and metal collide.

Bessemer, Alabama's Marvel City, along with Debardeleben's Furnaces and Dial's Metal Works Patterns, gave birth to the dreams of other supermen. Larry Langford is one of them. He was born in 1956 and raised in Fairfield, a town equidistant from Bessemer and Birmingham. In his early years he was fed by the Fairfield steel factory where his stepfather worked. Langford was the first person in his family to go to college, and at the age of twenty-three, after completing his studies, he became Birmingham's youngest city councilman. Two years later, at the age of twenty-five, he even ran against Richard Arrington, a future twenty-year incumbent, during Arrington's second term as Birmingham's first African American mayor. Langford lost the election badly, but not his drive. In the early 1990s, after being elected mayor of his hometown, Langford wanted to do something about the economic reverberations from decades of steel mill layoffs in west Jefferson County, layoffs like those from Thornton Dial's own Pullman that left half of the area's metal workers unemployed. He wanted to bring Jefferson County a new stream of income and residents new jobs.

Larry Langford, like Thornton Dial and Lonnie Holley, knew how to cultivate a new seed from an old source. He turned his gaze toward the Marvel City and decided to plant a dream of his own.

Some seeds take a little while to grow. Planted in a plot reserved for a park initially named "Dixieland" Larry Langford's seeds took nine years to germinate. They sprouted in an unprecedented collaboration in which Langford brought together the mayors of eleven west Jackson cities—some from places like Sylvan Springs, whose population is 98 percent white, and Langford's own Fairfield, which

is 90 percent black—to breathe life into it. The result was what the *Birmingham Business Journal* called legendary.

Under Langford's plan, a major deal was struck by which nearly a dozen municipalities invested their own monies to produce the seventy-two-acre, $65 million VisionLand, Alabama's only amusement park, a "Deal of the Year" that made Langford something of a folk hero around west Jefferson County's twelve towns. "Twelve cities have said America can be a better place if we can come together," says Mr. Langford. "America can learn a lot from what we have done." Langford also saw VisionLand as a platform for his dreams of becoming governor of Alabama and possibly resident of that house on Pennsylvania Avenue that Lonnie Holley visited.

However, while Larry Langford was busy constructing plans for concession stands and VisionLand's steel roller coaster Marvel Mania, Lonnie Holley had ideas of his own.

"I have an idea for VisionLand," said Lonnie Holley in an April 1996 *Birmingham News* article, "It's called 'Defense.' 'Defense' means getting all the children together and working on a fence idea with me. That would put us in defense of taking care of what's happening in our environment." He proposed the idea to Larry Langford. 'Defense' should be done on VisionLand's turf. His proposal was declined.

As Thornton Dial tells it in his sculpture, by the mid-1990s Lonnie Holley had many reasons to think defensively about his environment. Despite his steady stance, Birmingham International Airport's determination to level Airport Heights for a new runway only grew stronger. No fence and no yard, no matter how artistic, could divert their plans. Lonnie Holley thus used the best defense he could think of: a strong offense with the local media as his offensive linemen.

In November 1996, after getting a call for "help" from Holley, *Birmingham News* reporter Nancy Raabe wrote an article entitled "'Sandman' Fights for Art" that appeared on the front page of that paper and which highlighted Holley's desire to keep his land. He was portrayed as the classic underdog under attack by soulless bureaucrats.

Afterwards there was an outpouring of attention to Holley's "fight." Over the next year, stories appeared in *Art and Antiques* and *Art in America*; there were articles following the situation in the *Atlanta Journal-Constitution* and the *Washington Post*, and a short feature on WAGA-TV in Atlanta. But despite the press, Birmingham International pressed on. By November 1997, Airport Heights was razed. Holley's house and hilltop acre were the last that remained.

Some saw the battle for Lonnie Holley's airport hill as a metaphor for the sentiments toward outsider/folk/self-taught/visionary artists by the greater art world. Others saw it as a racial battle. Still others just saw it as a good opportunity to get some art for nothing. As Holley's airport battle became more public, folk art bargain hunters wantonly scavenged Holley's' property. Once when visiting Holley, Nancy Raabe saw several human vultures load a white van with art pieces and drive off without saying a word to him. She traced down the license plate and discovered that wealthy local art collectors owned the van. At another time, five of Holley's completed pieces with a combined value of over one hundred thousand dollars were found by Holley at a local scrap yard. It was more than just art that slipped through Holley's hands. It was his recorded history, his identity, his Sandman's dreams.

In late 1997, after a seven-year stalemate, Holley reluctantly settled with the airport. "As often happens with the government," said Holley's attorney at the time, "you don't have a lot of options when they want to do something with your property." To Lonnie Holley the settlement award of more than $167,500 provided some comfort. But he had lost so much more: his family's land, so much of his work, so much of his life. "It's like landscape versus your whole life," Holley says when he speaks of that time.

As the yellow bulldozer trampled Holley's landscape and its powerful jaws uprooted trees, leveled hills, and flattened the foundation of the Holley family home, Holley and his family watched their entire environment crumble. Helplessly observing the carnage, Holley likened himself not to a god this time, but to a prophet. "I

look at myself like Moses," he said. Holley would soon find that if his exodus from Airport Heights were one day to lead him to Canaan, he still had a long, grueling trek through the wilderness left to go.

———————

Harpersville, Alabama, is a town of about sixteen hundred people; compared to Birmingham, it might as well be the wilderness. It was one of the first towns settled in Shelby County, an area southeast of Birmingham that calls itself "the heart of Dixie." It is mostly white (70 percent), derives most of its income from manufacturing, and has a median income below most of the state. Harpersville was once home to Elick McGinnis, a "colored" man and key witness in a trial that would dismember important moonshining and wildcatting rings in the area. But before the 1896 trial was over, one dark night McGinnis was seized from his house and believed killed by a band of men. Shelby County, with two major rivers running through it—the Coosa and Cohaba—has hardly been dry. Creswell, Alabama, is a neighborhood right in Harpersville, a community that many call "Crackwell," because it is so, well, wet, even though Shelby County didn't supply many of its predominately African American citizens with running water until 1993.

In 1996, a century after Elick McGinnis was seized, police arrested twenty-three people in an undercover drug sting operation at a well-known crackhouse in Creswell, on the 700 block of Shelby County route 85, less than a mile from Lonnie Holley's new home.

But Lonnie Holley didn't know that when he was making his exodus from Airport Heights. He didn't know it when he paid ninety thousand dollars in cash for his new sixteen-acre colonial-style home. Nor did he know that he was able to get such a bargain for the two-story, six-bedroom, two-and-a-half-bath, brick, wood, and white-columned house in 1997 because the government had confiscated it after they put a local drug dealer out.

On the day that Holley, his five children, and one grandchild moved in, they graced the hallways, admiring the basement, the bathrooms, and the central electricity and thermostat. Heat! They merrily selected rooms for themselves, a bedroom for Holley and a room to be used as an art studio. They walked outside and surveyed the grounds, breathing in the wilderness air. While standing in a cotton field on the edge of his property, Holley picked a piece of cotton, held it up for his daughter to see, and said, "Sometimes you've got to take what stalks you've got."

In 1898, in Harpersville, Mississippi, the state next door to Alabama, fourteen Negroes and one white man died in what was known in newspapers across the nation as a race war. It started over a shoe. One black man bought a pair of shoes from a white man in exchange for labor, and the half-day's labor that he gave to the man for the shoes didn't seem enough. Later that evening when a band of white men descended on his home he had his own army, armed with guns. One white man got shot, three were injured, and a mob returned, killing fourteen black men as they ran them into a nearby swamp. The then-governor of Mississippi had to ride to Harpersville with a train full of his own militia to call the remaining black men to surrender and break the violence up.

Just like in 1898 Harpersville, Mississippi, in 1998 Harpersville, Alabama—be it over shoes or shacks—fights about property are rarely just about property, and because of the underlying themes, the battles can escalate quickly.

Holley's new Harpersville neighbors, the Garretts, were relatives of his house's former occupant, and they didn't appreciate Holley's magic or that of his yard art. Actually they resented that, when the single father/artist moved in, Holley used old tires, sofas, sandstone, and steel cans to replace what before was a manicured lawn.

"I never take anything to the junkyard," says Holley, and it is true. Holley's Harpersville yard was full of things that many others would have rather thrown out. Because of that, the Garretts wanted Holley

to go. They weren't alone in their sentiments. Even Gloria Tate, Harpersville's mayor at the time, described Holley's property as an eyesore. But for the Garretts, the resentment was about more than what merely met the eye. The Garretts owned a little shack/country store/juke joint at the border of the property, and they wanted to continue using it for storing, shacking, and juking. Holley and his sons, however, wanted to use it for art.

They say that it started at the juke joint. The Garretts say that Holley's oldest son Ezekiel stole from their country store one evening. Ezekiel and Maurice Garrett, the Garretts' grandson, fought about it, and the next morning Holley's tires were slashed. Holley found Maurice in his yard, and Holley and Maurice argued before bullets started flying: Maurice aiming at the house; Holley's sons firing from inside. Bullets shattered windows and picture frames, and flying glass shards embedded in Holley's right arm, the unjeweled one. He was hospitalized for a day as news of the event made the front page of the *Birmingham Post Herald*. The article, entitled "Brewing Dispute May Be Cause of Shooting," was accompanied by a large picture of Holley in a Johnny-coat lying weakly in bed with his bare left hand over his chest and his right arm covered with a bandage. A few pages later a second picture showed Holley's release from the hospital as he returned to his house and walked toward his art-strewn garage.

Some years prior, Holley created a piece that he entitled *The Brass Bullet*. Perhaps it, too, was prophetic. In it, a shiny bullet is placed next to a replica of a handgun and a cutout shape. When reporter Nancy Raabe asked Holley to explain the piece he said, "Guns take away our religion, and when a child comes at us with a gun, sometimes it makes us suffer so." He paused and turned the piece upside down to reveal the cutout shape to be a child's silhouette before saying, "Then we have to turn it upright." But before Holley could turn things upright in Harpersville, he would be turned around.

At One Plantation Drive, Harpersville, in the property behind Lonnie Holley's cotton patch is the Meadows Golf Course, Holley's other neighbor. The Meadows is an upscale, daily-fee, sixty-eight-hundred-yard public golf course that was created after the success of such courses in the historically private golf state of Alabama in the late 1980s, courses that gave blacks, women, and "the common man" more quality places to play.

One December night while Holley was sleeping, less than six months after his last ugly encounter with the Garretts, his sons decided to play at the Meadows Golf clubhouse and help themselves to some of its inventory before they burned it to the ground: a crime that along with marijuana possession landed Holley and his sons in jail.

Paul Arnett says that the crime was "the kind of thing that if you were an upper-middle-class white kid, they'd probably call your dad in and say, 'Don't let your son be going to frat parties anymore.' They stole a pair of golf clubs . . . but if you are black in Alabama you get a different kind of justice." Harpersville police chief Larry Offord referred to the crime as only one of a "rash of burglaries" that he said occurred since the Holleys "moved beside [his] city," a crime that resulted in two of Holley's sons being institutionalized—Kubra in juvenile detention (at Mount Meigs, no less), Ezekiel being tried as an adult for burglary and arson—and Holley himself behind bars: a place very far from his dreams.

That was 1998, the year that VisionLand opened with huge hoopla and its steel roller coaster Marvel Mania soaring, with its "famous" ten-inch VisionLand hot dogs and pizza burgers (hamburger patties filled with cheese), and with nearly fourteen thousand park-goers entering its gates on opening night. "Larry [Langford] showed us when you have energy and vision you can accomplish anything!" said Mayor Leland C. Adams of Adamsville, Alabama.

Four years later, VisionLand went bankrupt.

VisionLand is where heroes meet, be they gods of fire and forge that can construct steel roller coaters, men from small towns in the

state of Alabama, or prophets from the land of dreams. Like in African American folklore, lands of visions are very similar to the way in which fire and sand-casing melt and mold iron: they make something out of nothing. They bring new life, new energy to things that have been tossed aside.

The Sandman, Lonnie Holley, knew about visions and fires, sand and dreams. "Yeah," he says after speaking of flames that once scorched his new property, "I had a fire up here and it burned a lot. . . . So I'm taking it and re-forming it. What's left you work with. I do with what's left. I pick a real strong surface from whatever that's left."

Indeed, in the 1990s, Lonnie Holley knew how to do that. In spite of the many flames that burned around him, Lonnie Holley continued to make art. He had three solo shows during that time period, was critically reviewed, and was compared to the revered modern artist Alexander Calder in publications like *Art in America* and the *New York Times*.

But neither gods nor prophets are honored in their own home. The same Birmingham Museum that discovered Holley in 1980 had not yet given the renowned hometown artist a solo exhibition more than twenty years later.

But what does that matter? They couldn't stop Holley from dreaming. He saw gifts in his dreams and in everything around him. As Hans Christian Andersen wrote of Ole Luk Oie: "Under each arm he carries an umbrella; one of them, with pictures on the inside, he spreads over the good children, and then they dream the most beautiful stories. . . . But the other umbrella has no pictures, and this he holds over the naughty children so that they . . . wake in the morning without having dreamed at all." Holley saw the pictures, for he drew them himself. He drew on paper, in sandstone, or with garbage what he knew of life. And what Lonnie Holley knew in the 1990s was that regardless of the forms that the dreams take or the ways that they materialize in the morn, the greatest gift is merely to have dreamed at all.

Chapter 15

DON'T FORGET ABOUT
MRS. BENDOLPH

ROUTE 22 WEAVES THROUGH THE CENTER OF SELMA, ALABAMA, NEAR the town's Old Live Oak Cemetery, a musty graveyard shaded by languid Spanish moss that drips from stately trees. Old Live Oak is home to an unusual range of monuments, from the tomb of Benjamin Sterling Turner, a freed slave who became Alabama's first black congressman, to the bust of Nathan Bedford Forrest, a Civil War general believed to be the first grand wizard of the Ku Klux Klan. From Old Live Oak, Route 22 whips south against wide, soft green fields with cracked tan furrows that are occasionally interrupted by crumbling antebellum homes. It nips past trailers with clean sheets that billow next to red, white, and blue "Dixie crosses" and tucks by herds of cows that use their bellies to fasten blankets of grass to the ground. Route 22 stitches beside an old-time full-service gas station and darts alongside sporadic strings of boxcars that rumble on tracks running parallel to the pavement. Traveling south from Selma Route 22 fastens you over Shell Creek once, Foster Creek twice, and then it leads you straight to nowhere. A left off of Route 22 to County Road 29 takes you through less than nowhere, past the sound of the bellowing rifles at Gee's Bend Hunt Club, and beneath a claustrophobic passageway darkened by the dense canopy of kudzu-infested trees. There, white

lines in the center of the road bounce off of the beams from your headlights, flashlight, lantern, and guide travelers like a seam. County Road 29 ends in a notch, one that opens away from you. And though standing at the end of County Road 29 you will be at the end of your journey, the people standing on the inside of that notch will take account of this fork in the road you just traveled, and call it not a notch, but "the Y." To them, the notch is not an ending but a beginning, the unofficial start of Boykin, Alabama: home.

Alabama has three Boykins: one in Covington County south of Greenville, east of Interstate 65; one in Escombia, twenty miles north of the Florida state line; and one in Wilcox that begins at the notch of a road. This last Boykin is known by folks who live there as Gee's Bend. As the 1990s drew to a close, it came to be known by Bill Arnett, Lonnie Holley, and Thornton Dial as salvation.

In 2002, with help from Bill Arnett, Lonnie Holley, and Thornton Dial, Gee's Bend and its citizens moved from a southern nowhere in particular to a global somewhere very important. Arnett and his crew weren't the first to discover the riches lying beyond the notch. There was, in fact, a long and deep history of well-intentioned discoverers who tried to lift this nowhere into public view. But none achieved quite the same level of success as Bill Arnett and his associates.

———————

The land beyond the notch wasn't always called Gee's Bend. Before Joseph Gee arrived in the early 1800s with cotton seeds in hand, Gee's Bend may not have been called anything at all. It is a stretch of ten thousand acres insulated by the Alabama River that snakes around it like a noose someone never bothered to tie. There, Joseph Gee staked his claim and his plantation full with crops, livestock, the latest in antebellum home furnishings, and African men and women whom Gee also considered his property. A visionary Joseph Gee may have been; an accountant he was not. And in 1845, due to the Gee

family's outstanding debt, Sheriff Mark Pettway, his wife, children, and at least a hundred of his own African slave laborers traveled the more than seven hundred miles from Halifax County, North Carolina, to displace Gee and inhabit his land. While Mark Pettway and his family sat high above the wheels of their wagon, their laborers sewed footprints in the soil, and the soil wasn't all that they sewed. In their skirt bottoms and collars, their blankets and knapsacks they hemmed memories of loved ones left behind. And there they carried their future, even if it had to be made clandestine—like Saul Johnson's mother who, after being ordered to leave him in Halifax County, tacked four-week-old Saul in bed ticking and carried him to Gee's Bend on her back.

When Sheriff Mark's caravan approached the notch, the Bend's Gees became Pettways. And even after the war that made black Pettways free in form, if not in fact, most of them kept the Pettway name. They became tenant farmers, and though over the decades they changed social position, they remained tied to the legacy of that land: ground that blossomed debt as wild as dandelions. That legacy—a fall in cotton prices, dying and absentee landlords, and a system of tenant farming that flowed like the river itself—caused the Benders, for every modicum of progress they made in one direction, to loop back around in the end.

In 1933 the federal government decided to give the Bend a hand. Through the Alabama Rural Rehabilitation Corporation they offered Benders work at fifty cents a day, and in 1934 through the Federal Emergency Resettlement Administration (FERA) they extended their assistance to credit for Benders to use for livestock and farm supplies. They bought the old Pettway Plantation House built in the nineteenth century and tore it down as if to wipe away any vestiges of slavery.

But Gee's Bend needed more. It needed to be shown to the world through artist's eyes. Sent by Roy Stryker, then head of FERA's Historical Division, photographer Arthur Rothstein documented the Benders and their land. In an August 1937 *New York Times Magazine*

article entitled "The Big World at Last Reaches Gee's Bend," Rothstein's pictures and John Temple Graves's words introduced Gee's Bend to the world. Though stereotypical characterizations of Benders as "happy Negroes" date the article to a time when Jim Crow's wings were widely spread, "The Big World at Last . . ." would be the first of many love affairs that the "Big World" would have with Gee's Bend.

During 1937, in response to the Bend's cycles of poverty and debt and as part of a New Deal experiment, the Federal Rural Resettlement Administration purchased Gee's Bend for nearly $125,000 and allowed the Benders to buy it back, at low interest, for themselves. The result was that many Benders for the first time in history would own titles to the land that they had sown for years as their own. The government did something else that year that would ultimately have as much impact on the Bend as any land or loan. In 1937, the government made sure that each home in Gee's Bend was equipped with a sewing machine.

The new government deal drew controversy and new visitors to Gee's Bend: visitors like documentary photographer Marion Post Wolcott, who in 1939 showed the experiment's progress by creating photographs like one of an elegant Gee's Bend man sitting atop a well-tended mule and facing the sun with a bale of corn in his hand; visitors like anthropologist and Guggenheim Fellow M. G. Trend, who determined that "from a government and societal view" the New Deal experiment "was not economically worthwhile"; and visitors like director John DiJulio who in the 1990s with M. G. Trend won three awards for the film *From Fields of Promise*, which, with civil rights activist and U.S. National Medal for the Arts recipient Ossie Davis as narrator, explored the complexities of how the Benders have come to "carve out a modest existence for themselves."

By the time Ossie Davis spoke about the Bend's fields, many other visitors had come and gone. Stimulated by the photographs of Arthur Rothstein, Pulitzer Prize–winning author William Saroyan visited the

Bend and wrote about it. In 1941, the same year that Henry Fonda starred in Saroyan's play *The People with Light Coming Out of Them*, speech professor and folklorist Robert Sonkin sought light in Gee's Bend. He visited churches and porches, fields and yards to record the voices of Gee's Benders as they shared sermons, invited him and his recording machine to their public meetings, offered the sacred memories of their elders as they "talked about slavery days," and sang songs. In Gee's Bend's fields Sonkin heard voices of light, not the cries of the downtrodden but hopeful songs aimed toward heaven. For in Gee's Bend the fields were also prayer mats laid before church temples, and the breezes carried promises that came only from God. Preacher, civil rights leader, and recipient of the Nobel Peace Prize Dr. Martin Luther King knelt in Gee's Bend to pray. On the way to his 1965 Alabama marches for Negro voting rights King set foot in Gee's Bend. There, he received "new courage and determination" as he spoke in Pleasant Grove Baptist Church, enough "courage and determination" to march across Selma's Edmund Pettus Bridge with John Lewis and some thirty-two hundred others on their way to rouse President Lyndon B. Johnson to sign the national Voting Rights Act. The citizens of Boykin considered changing the town name to King. And, an apocryphal tale goes, it was the well-tended mules of Gee's Bend that on a solemn Tuesday carried King's casket as his spirit traveled to its own promised land.

King wasn't the only clergyman called to Gee's Bend in 1965. Mobile, Alabama–born Father Francis Xavier Walter, Episcopal priest and then head of the Selma Inter-religious Project, visited the Bend after being seduced by the sway of Wilcox County quilts hanging from a line. Father Francis's influence on Gee's Bend would be almost as significant as King's, though his ultimate instrument of social change would be fabric and thread rather than sermons and sit-ins.

There hasn't ever been too much to do in Gee's Bend outside of church and family and farming. "Women would go in the field and chop cotton in July and August and pull cotton, peanuts, peas, millet.

Pull fodder for mules," remembers Mary Lee Bendolph. Piecing quilts was something the women of Gee's Bend could do alone—putting their personal touch on the quilt top—or huddled around a quilt frame with friends—bringing the whole thing together with cotton filling and a cloth back. For decades, the Benders saved whatever fabric they could lay hands on, from a feed sack to a worn pair of overalls. Sometimes they would use the sewing machines that the government had given. Other times they would do it by hand; communally, with their quilting time woven together with crying, laughing, praying, singing: "Jesus, Jesus is my only friend." They often chanted in unison, a sisterhood of quilters calling to their Lord.

Mary Lee Bendolph, born at the notch, was thirteen years old when she finished her first quilt. "Mama showed me how to make it," she says. "Mama bent the cotton out and spread the lining on the floor and put the cotton on and got the quilt on top, and we sewed it together," Bendolph recalls. Bendolph stopped her schooling at fourteen because she had gotten pregnant. "My parents never tell me about life," she says. So her body began to change without her fully understanding what was happening to it. "I cried and prayed," she says. "Schools wouldn't take kids back once they had a child." She worked odd jobs at textile factories outside of the Bend, and she sold quilts for ten dollars if she was lucky, or less on most days. When her daughter Essie turned twelve, it was her turn to learn the craft. "My daughter learned sewing from me," says Bendolph, who still turns out five quilts a year. Mary Lee Bendolph and her daughter sewed their life into the quilts, pieces that burst with color and joy. As they wrapped themselves in their creations to stay warm, they surrounded themselves with community and love.

Hemmed into the bold bed tickings of women like Mary Lee Bendolph, Father Francis Xavier Walter saw an economic future for Gee's Bend. So did many Bend women who, with Walter in 1966, developed the Gee's Bend Freedom Quilting Bee. Through the Quilting Bee, Gee's Bend women created quilts and shams for homes

across the nation that were sold in stores like Bloomingdales, Saks Fifth Avenue, Bonwit Teller, and Sears and hawked to the public with ads in *Vogue* magazine and reviews in the *New York Times*. Quilts galore, shipped across the country stuffed in plastic bags or secured within cardboard boxes. By 1987, the Bee sparked the attention of author Nancy Callahan, who devoted an entire book to the Benders and their quilts entitled *The Freedom Quilting Bee* that was published through the University of Alabama Press.

A little over a decade after Callahan visited the Bend and more than three decades since Father Walter, the notch was visited by another writer, J. R. Moehringer, an Atlanta correspondent for the *Los Angeles Times*. Moehringer wasn't drawn to the Bend because of its photos, its land, its folksongs, or its bed-linen; the river itself beckoned Moehringer to the notch. The 1999 article that Moehringer wrote entitled "Crossing Over" about the history of the Gee's Bend Ferry resulted in *60 Minutes* doing a feature segment on Gee's Bend in 2000 and won Moehringer a Pulitzer Prize. Gee's Bend quilter Mary Lee Bendolph was the star of Moehringer's award-winning piece.

———

When Bill Arnett found himself in 1997 flipping through Roland Freeman's book of African American quilts and quilters entitled *Communion of Spirits* and saw the bold bed stitching of Bender Annie Mae Young, one could say that he like many before him had been called. Soon after Arnett, too, weaved his way down Route 22 and County Road 29 to the notch, the most famous nowhere anywhere, to stake his claim.

The good people of Gee's Bend had seen a lot of white men come and go with hollow promises. Some of them delivered words; some, pictures; and some, money. Still, not much changed in the lives of folks on the far side of the notch. Whenever they felt called, wherever they tried to go, the Benders' lives kept looping back around to where

they had begun. To them, Bill Arnett was probably just another slack twist in the thread of their lives.

Bill Arnett had fallen in love with the fabrics and people of Boykin. Maybe love was just what Bill Arnett needed after his run with Emory and *60 Minutes*, and his ten-pound Tinwood *Souls Grown Deep* books that had buried him in deep debt: a divine calling combined with a feeling in his heart that like Jesse Aaron's woodcarvings would resurrect him from the dead. But this time Arnett didn't dream of the cathedrals of Europe; Gee's Bend and its ladies were his Notre Dame. "I believe Bill Arnett was led by God to come into this community," says Reverend Clinton Pettway, pastor of the Ye Shall Know the Truth Baptist Church of Gee's Bend. Arnett puts it like this, "I know how I feel about things. I know I can go to Arezzo, Italy, and look at Piero della Francesca's frescos and melt. I mean, honestly, it's like I'm in the presence of some kind of god. I'm a card-carrying atheist. I don't know about what's up in the sky guiding us, and if there is a God I don't believe he gave his only begotten son to Christians, nor does the idea of Jews being the chosen people make any sense to me. But when I stand in front of Piero della Francesca's fresco cycle of *The Legend of the Cross* I can't dispute God or Christ. I can't even feel any resentment against those who believe it. It's just better than I am, you know? It's bigger than I am. I'm in awe," Arnett says. It was awe that Bill Arnett felt when he saw the blue denim stitched together by the hands of Bender Annie Mae Young.

A higher spirit may have beckoned Arnett to Gee's Bend, but it was Mary McCarthy who served as his tour guide. McCarthy was custom-made for the role, too, with a deep knowledge of the Bend and its people as well as a keen sense of its quilting activities. She spent seventeen years living in the Bend after graduating from the University of Georgia in the late 1960s and was indoctrinated from the start into Gee's Bend quilt-making culture. Her first job in the Bend was serving as aesthetic quality control manager over the Freedom Quilting Bee's commercial activities. She lived in a cracker-

style dog-trot farmhouse with a Bender family named Witherspoon that kept an extra bed in McCarthy's room just to lay the quilts that Mrs. Witherspoon turned out. Even after she stopped her work at the Quilting Bee and turned to assisting in the Boykin school system, McCarthy continued to make quilts herself.

In 1985, McCarthy had returned to Atlanta but stayed in contact with her Gee's Bend friends who remained in Boykin during the interceding years. And, it seemed, the Bend never left McCarthy's heart or her hands. She continued to quilt. When Arnett called in 1997 asking her to be his sherpa, McCarthy felt fully equipped to help. Matt and Bill Arnett and Mary McCarthy journeyed to Selma in the Arnetts' decrepit white minivan—front bumper now partially held together with chewing gum.

"Bill just wanted to see *everybody's* quilts. Whatever house we went to, Bill would look through stacks of quilts and select what he liked best. Then he would think about it a little and give the woman a number—a dollar amount—and the woman's eyes would pop. 'You gonna pay me that for these old raggly quilts?' the women would say. We went to lots and lots of houses, and by the time we left the white van was chock full of quilts, piled up so high and deep they were stuffed between the driver and passenger seats," Mary McCarthy remembers.

"Here was a critically important community that for reasons of fate, isolation, history, developed within itself these extraordinary visual art traditions that had nothing to do with mainstream white art or mainstream American quilts. I sensed from the start that this artwork was very important," Arnett says. "But I had no idea where it was going to lead. I mean it took me years to put all the pieces together and figure it out. It wasn't something I walked into and said, 'Hey, here's a paradigm shift, and I'm gonna jump in and control it, corner the market on it,' all that shit. No way. This woman from the *New York Times* said to me recently, 'You cornered the market on Gee's Bend quilts!' I said, 'Lady, *there was no and is no market* for Gee's Bend quilts!' And she says, 'Well, what would you call it? If you

bought every good quilt in Gee's Bend?' I said, 'Every good quilt in Gee's Bend means I went to twenty-eight houses and bought the best of what I saw at a time that nobody else on earth wanted these things, and I had no idea there would ever be any interest in them.'"

McCarthy and the Arnetts revisited Gee's Bend several weeks later. And then again. And then once a month. Once a month for six months straight. They went back so often that Gee's Benders felt like they were just part of the community. "Matt Arnett act like he's race of our color," says Mary Lee Bendolph, in whose home the Arnetts and Mary McCarthy would stay when they visited the Bend. "Matt just going from room to room like he's livin' here—friendly and warm. We could feel the love they had for us," Bendolph says.

"At first, they thought he was just another crazy white man," Mary McCarthy says, referring to Bill Arnett. "But then a banker friend of mine across the river in Camden said, 'There's an awful lot of quilt money coming in to the bank.' Bill must have put fifty thousand dollars into the community by that point."

In addition to putting in money, Arnett and his sons were putting in research time. They explored Library of Congress materials on Gee's Bend, including the Rothstein photographs. They scoured articles and books. They talked to quilters. They talked amongst themselves and wondered, "How is it that these gentle women came to make quilts that look like edgy contemporary art?" How is it that their art-in-fabric tied together so clearly with the aesthetics of Thornton Dial and Lonnie Holley and the other artists of *Souls Grown Deep*? And, why, after all this time had no one brought this material to the world in the way it deserved: not as rags to be displayed as quaint folk objects, not as artifacts of a lost civilization, not as commercial items to be sold at Sears, but rather as sublime art, as art that belted out tunes like a scatting jazz vocalist?

"Yeah, I've only interviewed one hundred women that talked about this," says Arnett, as if to imply, "Of course, it is about music, stupid." "Yeah. They can visualize where they're going when they

make the quilts. It's like jazz. This has been said often. I don't like the comparison because jazz is jazz and quilts are quilts, but if you have to have a parallel, some kind of analogy, you might as well use jazz. You have a theme and the musician doesn't know when he plays that theme where he's going to take it. I mean that's the beauty of jazz. The operative word that's overused is improvisation. That is the operative concept in the quilts, too."

———————

If ministers were the mouthpieces for Gee's Bend's churches, and the women stocked their choirs, Arnett was the evangelist for their quilts.

"I call him a genius," says Reverend Clinton Pettway.

Arnett puts it this way: "Alabama is America's answer to Tuscany!" and he put it to anyone who would lend him an ear. He told this to Peter Marzio in no uncertain terms.

"Arnett is a fanatic in the best sense of the term," Peter Marzio says. "He seems to be obsessed or possessed but very intelligent and truly selfless." By the 1990s Peter Marzio had a cause of his own. In 1982 the floundering Museum of Fine Arts, Houston lured "handsome and well-spoken" Marzio away from the Corcoran with a salary and perks that in 2000 ranked him at the top of a list of the best-compensated museum directors in the United States. Fifteen years after his Houston arrival *Texas Monthly* magazine featured Marzio in their list of twenty of "the most impressive, intriguing, and influential Texans." But by then Marzio's luminosity extended beyond Texas' lone star. "Any museum looking for a new director wants a Peter Marzio," said Ned Rifkin in 2003 in a conversation with *USA Today*. In his twenty years as director, Marzio quadrupled museum attendance and transformed the Museum of Fine Arts, Houston from the nation's thirtieth largest museum with an endowment of $25 million to the nation's sixth-largest museum with a $425 million endowment that continues to grow. Peter Marzio was someone to know.

"Peter Marzio is the most secure museum director in the history of the world," explains Paul Arnett. And Marzio, solidly situated at the Museum of Fine Arts, Houston, was ready to take the next step: opening the museum's doors to a wider audience. He wanted the Houston museum to tell "a much broader story of creativity" in the same way that the Corcoran did with its *Black Folk Art in America* show. Bill Arnett may have also been thinking about the *Black Folk Art* show when he decided to share the work he had been doing on the quilts with Marzio's former curators John Beardsley and Jane Livingston, the instigators of the seminal Corcoran show.

"After Jane and John saw the photographs of the Gee's Bend quilts, John Beardsley wrote a letter to Peter Marzio saying that Marzio really needed to come to Atlanta and see the quilts because they were phenomenal. So Peter agreed to come," remembers Paul Arnett. The Arnetts converted a portion of their warehouse into a viewing area, and they digitized images of the quilts so the art could be seen easily on a computer screen.

"Peter started looking at the pictures, and it was like quilt, quilt, quilt, quilt flashing on the screen in this dark room with just the computer on," Paul Arnett recalls. "Then suddenly nobody knows where Peter has gone. He's not looking at the quilts anymore. We were like, 'Well, that didn't go too well.' So we all just sat there and watched him for a couple minutes. And Peter is just writing stuff down. He hadn't said a word. He came back, and we'd already turned off the computer. He put down his little book, and in it he'd designed an entire exhibition for the quilts. He was like, 'Okay, I want to do the show!'"

"The first time I visited Atlanta to see the quilts I couldn't believe it," Marzio shares. "The quilts were fantastic." And if Peter Marzio was impressed with the "masterpieces" made in Gee's Bend, the Arnetts were impressed with Marzio. They, like many, admired his candor, his confidence, and his conviction to embrace diverse art.

"I admired Peter Marzio," says Paul Arnett. "He was not interested in the quilts or in Dial or in anything like that simply because he

wanted to be a friend to the black man or just because he wanted to democratize the art world as an end in itself. He was interested in the quilts because he thought that what the women created was at the highest level of art. That's his idealism."

But when it came to finding other directors who matched Marzio's enthusiasm and ideal, the art world felt like a black hole. As Peter Marzio tried to encourage other museums across the country to mount the Gee's Bend quilt show after its Houston opening, he encountered a cold dark void.

"It was hard to get other museums to take the show," says Marzio. "That's the way it was with the *Black Folk Art in America* show. The other museum directors just didn't think it was art. This kind of art is threatening to the academy, the traditional art infrastructure. It throws up to them that the creative world can take many routes— outside of the main channels they control. The people of my generation, who were so antiestablishment, are more reactive and defensive culturally now than the nineteenth-century academy was to the advent of modern art. This attitude is more dangerous now than it was in the nineteenth century because today we *think* we are more liberal. It is Orwellian," Marzio cautions, with frustration leaking clearly through his words. Because, instead of Orwell's Winston Smith turning away from a fictional 1984 society, this time it is the art world turning the corner on a new century with Doublethink as its official mode of reasoning.

———————

Max Anderson's career turned upward rapidly following his exit from the Carlos Museum of Art at Emory, and it was that upturn that turned the corner for *The Quilts of Gee's Bend*. Anderson left the Carlos Museum to become director of the Art Gallery of Ontario. Three years later he moved again, this time to New York City in the fall of 1998 for a job of enormous prestige. He was hired to lead the

Whitney Museum with a directorship named after the Houston phi-lanthropist Alice Pratt Brown. Expectations were high for the young, well-bred Anderson. But by the time the Gee's Bend quilt team approached the charming Whitney director, his reputation was in need of repair. Whereas under prior leadership, the Whitney Museum had gained a reputation for shows that were "aggressively hip, edgy fashionista," Anderson's first Biennial exhibition in 2000 was panned by critics as "the most uncontroversial in years" and garnered review titles like "Whitney on Prozac." Anderson, who prided himself for being a risk taker, was scorned for his caution. If hanging the bed coverings of black Alabama women next to a painting by Edward Hopper was "threatening," then Anderson was up for the call.

"Peter called me after he had seen the quilts and was totally wiped out," says Anderson. "He asked me if I wanted to co-organize." Anderson, perhaps looking for a way to rebound from his Biennial disaster, was ready to take a gamble. "We [museum directors] are not there to validate the art market's hunches," Max Anderson declares as he explains that it was the Whitney's role to take risks on new talent, to circumvent critics and dealers, and to connect directly with artists and the people who go to see their art. "We're there to roll the dice on artists whom we believe in." By saying yes to hosting the Gee's Bend quilt exhibit, Max Anderson definitively rolled the dice.

The quilts would leave Gee's Bend to be displayed for the first time in the fall of 2002, but this time they wouldn't be carted alone in bags and boxes. They would be delicately wheeled away as "priceless" artis-tic masterworks with the Arnetts and eighty Gee's Benders following proudly behind. The quiltmakers had painstakingly prepared for the trip—picking their best Sunday dresses, curling their hair, packing their Samsonite luggage, undoing their curlers. Matt Arnett was like an attentive son, loading their bags into the bus storage hold. Heads

down, hands clasped, the women prayed together before boarding the bus. Sitting next to the quilters were Lonnie Holley and Thornton Dial.

In the late 1990s, the Arnetts warned Thornton Dial and Lonnie Holley that Gee's Bend would be taking up an increasing amount of time for the Tinwood team. "This project is going to be for the greater benefit of everybody. This project is going to enable millions of people to develop an understanding of what you're doing. We have to use the tools that are put in our hands," Paul Arnett counseled the artists. "We do have a bigger vision for how it all fits together, and we're not abandoning you." Paul Arnett sat down with Max Anderson to discuss the quilt show and provided the same forewarning. "We are going to need an entire whole floor of your museum for Gee's Bend," Paul Arnett told him.

On behalf of the quilters of Gee's Bend, the Arnetts saw a chance to kick the art world's door down, and they put colossal energy into the project. In addition to planning the exhibition itself, they produced a documentary video to be shown alongside. They cut a CD, too, of the women and their songs to waft through the museum galleries. They published two books about Gee's Bend, each one rivaling *Souls Grown Deep* in gravitas and beauty.

Instead of fighting for more than their fair share of the Arnetts' time, Thornton Dial and Lonnie Holley embraced the Arnetts' work with the quilters of Gee's Bend. Even if the Arnetts' promise of long-term benefit didn't lend enough weight, the Bend itself offered a comfort of its own.

"The life of the spirit was just there," says Dial as he recalls his time in Gee Bend. "It carried me back to the farming days when I was knowing something about farming. I stayed on a farm until I was thirteen years old." For Thornton Dial, farm-born in Emelle, Alabama, the land beyond the notch of Gee's Bend felt like coming home. On the September night before the Gee's Bend caravan left for the Houston opening, Thornton Dial and his son Little Buck stayed

with Mary Lee Bendolph. Perhaps it was Mrs. Bendolph's "smile that makes men trip over themselves in church" that charmed Thornton Dial. Or maybe it was her artistry that wooed him, but likely it was her heart—hers and those of the other Gee's Bend women who would affect Dial and Lonnie Holley for years to come. For Holley, in particular, Bendolph and her friends were like the nurturing mothers he never knew. The next morning, in September 2002, Dial and Holley and the Bend entourage, with their cameras and church clothes firmly packed, rode up County Road 29 and then down the seam line out of Alabama on a bus.

"Oohh, gracious, I'm livin' in style," Mary Lee Bendolph cooed as she took account of the Hilton Hotel in Houston where she and the other Benders stayed. She and several other women shared a suite with living room, bedroom, two bathrooms, three phones, and a wet bar, so there was plenty of space to luxuriate. "One time I had breakfast in my room!" remarked Bendolph in amazement. "I wrote a note and put it on the door and they brought it up. But then I was sorry I did, 'cause it cost too much to do," she laughed. There were more surprises in store for Bendolph and friends. Seventy of the best quilts from fifty-four of the Gee's Bend quilters graced the pristine walls of the largest art museum in the Southwest. "When we were in Gee's Bend and the Arnetts were calling the quilts art, I said I didn't see where no art was," Bendolph continued. "But in the museum all those old raggly quilts look soooo good that we said to the Arnetts, 'Y'all knew what you was talkin' about.'" The citizens of Houston thought so too. "I felt so good. I had the happiest time I had in my life to see our quilts hanging on the wall, and peoples just praising our quilts, and everybody's eyes full of water," quilter Arlonzia Pettway told PBS *NewsHour*'s Jeffrey Brown in a 2003 interview. "And I didn't know what was going on. I really didn't know what was going on. White peoples was crying, and black peoples was crying, and everyone was crying. And I had such a good time and I enjoyed myself so much, I had to ask myself a question. I said, 'Am I dead and in heaven?'"

The ascension of Gee's Bend had just begun. The exhibition closed in Houston on November 10, 2002, only to open a mere eleven days later at the Whitney Museum in New York. That's when the quilts of Gee's Bend morphed from raggly bedspreads into wall-mounted art and then beyond: into flying patchworks of color levitating toward the heavens. Crowds wrapped around Seventy-fifth Street and Madison Avenue waiting for a glimpse of the magic cloth. Cynical art critics melted like ice cream in summer for the Gee's Bend women and their creations.

One November morning, just eight days after the Whitney opening, Bill Arnett opened the *New York Times* to find nearly a full-page article lauding *The Quilts of Gee's Bend*. Arnett had suspected the *Times'* art critic Michael Kimmelman of being one of archenemy Ned Rifkin's minion since the critic once wrote that Thornton Dial was "an overrated folk artist." But on this day Kimmelman's review of the quilt show nearly led Arnett to grant a formal pardon for the critic who called *The Quilts of Gee's Bend* "the most ebullient exhibition of the New York art season." He went on to gush, "The results, not incidentally, turn out to be some of the most miraculous works of modern art America has produced. Imagine Matisse and Klee (if you think I'm wildly exaggerating, see the show) arising not from rarefied Europe, but from the caramel soil of the rural South in the form of women, descendants of slaves when Gee's Bend was a plantation."

Before long, the quilt show had made news across the nation with articles in everything from *Newsweek* and *House and Garden* to *Artforum* and *The Economist*. The show's curator, Alvia Wardlaw, was featured on National Public Radio, and some of the women were guests of Martha Stewart on her television program. The incredible reviews enabled Peter Marzio to finally get attention from other museums. He quickly booked the show in Mobile, Alabama. Then Milwaukee. Then the Corcoran wanted it. And Cleveland and Norfolk and Memphis and Boston.

The women traveled to the launch of each exhibition as guests of the host museum and, though the institutions would surely have paid the

airfare, the quilters chose to ride by bus as a group to every opening-night soiree. Matt Arnett, Mary McCarthy, and Lonnie Holley accompanied the women on most trips, with Holley toting a suitcase full of art supplies to keep busy on the ride. He carved his sandstone or bent copper wire into all manner of objects. During one road trip, Holley shaped bracelets and rings for each of the quilters, who placed them on their left arms in honor of the Sandman and his bangle-draped left limb.

Fanfare accompanied the Gee's Bend women wherever they traveled. Nearly 650 people attended the opening event at the Mobile Museum of Art, including dignitaries like Governor Bob Riley and Albert Head, executive director for the Alabama State Council on the Arts. They named the quilters honorary citizens of Mobile, Alabama. In Washington, D.C., for the Corcoran's display of *The Quilts of Gee's Bend*, First Lady Laura Bush visited the women and took in the exhibition. In Milwaukee, the women took the stage at a black-tie gala while museum staff compared the quilters' work to modern art masters Barnett Newman and Josef Albers. The all-white audience listened, hushed. Accolades complete, the women stepped to center stage and wowed the packed room with sweet spiritual sounds. "Somebody Knockin' at Your Door" rang out against the stark contemporary hall, shaking it like an earthquake at a revival meeting.

Not everyone was enthused by *The Quilts of Gee's Bend*. Ten years after *60 Minutes'* "Tin Man" episode, rumors of exploitation followed Bill Arnett wherever he went. Georgine Clarke, visual arts program manager for the Alabama Council on the Arts, is someone that Bill Arnett holds in contempt, and the feeling appears mutual. Clarke says she bought $350 worth of Gee's Bend merchandise when she saw the exhibition at the Corcoran in D.C. "I have seen no signs of the money going into Gee's Bend," she notes, insinuating that in her view Bill Arnett is up to his old exploitive tricks. "I'm not sure yet whether or not I have time to take up that cause," Clarke points out.

In *Artforum's* December 2003 issue, Studio Museum's Thelma Golden wrote a scathing commentary about *The Quilts of Gee's Bend*:

We all know the quilts are brilliant and beautiful. I just wish the quilters were making a little more money for all their brilliance! I like the old black ladies. My mother is an old black lady. I hope to become an old black lady. I just hated the exhibition, which, with its shockingly politically correct tone, under the transparent cover of high/low intervention and demolished media categories, was the most culturally repugnant, retrograde moment I have experienced, perhaps in my entire professional life.

Golden's accusations evoked a rebuttal in a letter to the editor of *Artforum*, but it did not come from Bill Arnett. Rennie Young Miller of Boykin, Alabama, who had been chosen by her peers to lead the Gee's Bend Quilters Collective, which was established with full encouragement from the Arnetts, instead wrote the missive. Her response to Golden, printed in the March 2004 issue of *Artforum*, defended the show, the art, and the Arnetts:

The "Quilts of Gee's Bend" exhibition project has transformed our community. It has brought hope and renewal to dozens of African-American women artists here. We have been treated with dignity and respect for the first time in our lives. Thanks to the exhibition, we now have a stake in our future as artists. Earlier this year, the women quilters of Gee's Bend—every able-bodied quilter in the exhibition—founded the Gee's Bend Quilters Collective. We own the Collective, which establishes prices, creates inventories, and handles sales, marketing, and accounting. Individual quilters receive half the proceeds from the sale of their quilts, and above that, we pay dividends to all our members.

She went on to write of Thelma Golden:

She says she loves our quilts—maybe that makes them good enough for her Harlem museum. But she never says what she would have

done differently than the organizers at the Whitney, and she never gives any specific examples of what she thinks was truly wrong with the show, just that it was "transparent" and somehow too painful to her. She hopes it will be the last exhibition of its kind. Should we put our quilts back in the closet now, Ms. Golden?

Bill Arnett could not let the criticism go. It plagued him like a hangnail that just wouldn't pull off. Arnett and his sons compiled dozens of letters of support written by the quilters and citizens of Gee's Bend on behalf of the Arnetts addressed "to whom it may concern" and arranged in a spiral-bound book with an equally anonymous cover for an anonymous audience. But it was not enough. His enjoyment of the Gee's Bend victory remained occasional and fleeting, constantly interrupted by anger at his perceived persecutors.

Arnett cogitated. He wondered when this nonsense would stop. With feigned patience, he explained to whoever would listen that his efforts have *brought* wealth to town, *not* taken wealth away. "There's never been but one real way that the people of Gee's Bend made money. The staple of the Gee's Bend community is quilts," Arnett says. "We brought, gosh it ain't even worth saying, but we brought all of the money that's come to Gee's Bend in the last 180 years other than wages such as they were. They didn't get wages. The original cotton pickers got whatever they got. There's never been money to come into Gee's Bend. There are no jobs in Gee's Bend. There have never been jobs in Gee's Bend. There is never a paycheck written by someone in Gee's Bend to another person in Gee's Bend ever. A few people that could may have worked across the river in Camden. You know how long it takes them to get across the river? They have to drive sixty miles around the river because there's no way to get across. They feed themselves with welfare checks. Gee's Bend has been a welfare state forever until we got there, and it made it more or less self-sufficient."

Arnett's rant shifts gears and drifts back to conspiracy. He says, "Gee's Bend would have gotten shot down if *they* had known about

it ahead of time," Arnett insists. "Are you kidding? If Ned Rifkin and all those people had known, if that team had known I was cooking up a quilt show that was going to change history, it never would have happened. Only way it happened was I finally got smart enough to keep my fucking mouth shut. I'm telling you. That should be a lesson to me. It isn't 'cause I still yap and bitch and shout. I can't help it. I can't help it."

––––––––––

Many great artists claim a muse. In the quilters of Gee's Bend, Thornton Dial could claim fifty-four of them. He began a series of paintings in 2003 dealing with Gee's Bend and the women and their quilts and the social conditions surrounding them. Wandering through Bill Arnett's mammoth art warehouse with a group of museum curators, Arnett waves his hand across five such paintings by Dial. They are gigantic patchworks of pigment. "This one is called *The River Not Crossed*. This is about the ferryboat that didn't get across the river to Gee's Bend 'cause the white people in Camden stopped it," Arnett says. "That one over there looks like a Gee's Bend quilt. It's called *Don't Forget about Mrs. Bendolph*. Dial made that one in honor of Mary Lee Bendolph," says Arnett, pointing the bright beam of an industrial lamp on the piece so the group can get a better look.

Dial and Little Buck have stayed with Mary Lee Bendolph on several occasions—enough times that, in thanks for her hospitality, the Dials sent Mrs. Bendolph a gift. A metal swing from the Dial Metal Patterns' Shade Comfort line rocks in front of her small clapboard house. She, in turn, has twice visited the Dials at their home, and she sends scraps of cloth that can't be used in her quilts for Dial to transform into art materials for his assemblages.

On the day of Michael Kimmelman's rave review in the *New York Times*, Bill Arnett visited Dial at his home on the outskirts of

Bessemer. Clara Mae's Thanksgiving leftovers simmered on the stove. Arnett planted the newspaper in front of Dial as they convened around the kitchen table. He slapped the page proudly.

"Look at that front page of the art section. Quilts," Arnett says.

"That big old picture is one of those quilts from Gee's Bend," Arnett continues, checking for Dial's reaction. Nothing yet.

"This it here?" Dial asks pointing to the paper.

"Yeah. It's about two more pictures in black-and-white, but that's the main one. It's a long article," Arnett says. "It says, 'The results of this artwork turn out to be some of the most miraculous works of modern art America has produced.' Like it's a miracle America produced this art! Look," Arnett insists. Dial looks.

"That's beautiful, man," Dial says.

"You remember Arlonzia Pettway?" Arnett asks Dial. "There's a quilt in the Gee's Bend show that Arlonzia's mother made about sixty years ago. When her husband died she took his old dirty clothes and cut them up and made a quilt to honor him. This was in 1941 or '42. So at the exhibition some woman comes up to Arlonzia and asks, 'Are you sorry you sold this quilt?' and Arlonzia says, 'If I hadn't sold it to Bill Arnett it would have ended up getting torn up and thrown away, and now it's up on a wall in a museum and we're all proud to be able to come see it.'"

"That was great. That was really great," Dial says.

"They were trying to get Arlonzia to say, 'Yeah, I'm really sorry I sold that, and I wish I had it back.' They're trying to play that shit up," Arnett complains.

"It mean so much," Dial responds. He's still focused on Arlonzia's mother wrapping herself in a quilt made of her dead husband's clothes. "That what I was telling you about that," Dial continues. "History is good. That's history."

Chapter 16

GRAVEYARD
TRAVELER

WALK THROUGH THE STAINLESS STEEL DOORS OF JANE FONDA'S ATLANTA loft and you enter a virtual vagina. Fonda's foyer was designed with undulating curves that call to mind a woman's private parts. Walking into Fonda's loft one evening, a visitor wondered aloud about the color of the walls. Were they peach colored? Pink? Salmon? What was that color? Bill Arnett responded, "I don't know. I've never been this deep inside of one before."

Fonda is a vagina warrior. She has said, "If penises could do what vaginas could do, they'd be on postage stamps. There would be a twelve-foot one embronzed at the rotunda in Washington. Vaginas are just absolutely extraordinary." One of the likely reasons that Fonda is fascinated with Thornton Dial is that he is a "vagina-friendly" artist. Of all the art in Fonda's vast loft, nearly every piece is by Dial, and most are on the theme of women.

The Oscar-winning fitness-guru-cum-political-activist moved to Atlanta in 1991 following her marriage to media mogul Ted Turner. At the time, she was refashioning herself as a full-time philanthropist, concentrating on the arts and African American causes. Around 1998, Paul Arnett's wife, Jennifer, was helping to write a grant proposal for the Turner Foundation when Fonda happened to ask what

her husband did for a living. Jennifer's reluctant response, "Art historian," caught Fonda's attention.

Within a month, Fonda was invited to Bill Arnett's unkempt manse. "You had to suck it in to get in the door," Fonda later recalls. "Their home was used as a warehouse for art, and it was so jammed that it was hard to stand back and see anything. It was packed with pieces by this seventy-two-year-old illiterate black man, some of which were probably ten feet long and a foot or more thick." That man was Thornton Dial. Fonda was intrigued by Dial's art, and she was equally smitten with Arnett. "Bill described Dial's work with such sensitivity and detail. You can really disappear into a Dial work, and Bill did," Fonda says. "He was a scruffy genius, radical, generous, verbose, passionate, and deeply knowledgeable and deeply caring. On that day I said to him, 'Why didn't I ever have a husband who could describe a work of art the way you do?'"

A year later, when Arnett moved his collection to a football-field-size warehouse near downtown Atlanta, Fonda paid a visit. She came first with her children and then with her interior decorator. The warehouse offered plenty of room to view Arnett's collection, so Fonda was overwhelmed not only by Arnett this time, but also by the vast fields of art. "It started to get under my skin," she said. "I found it so moving that these artists who had such unbelievably difficult lives did work that was so empathic, hopeful, patriotic, and spiritual. You would imagine that their work would be laced with rage, but it isn't. These artists pick up objects that the rest of us throw away and give them a second chance. In a way, the materials give these *artists* a second chance.

"The works by Dial were really well displayed, and I swear to God it was the first time I really got it. When I could stand back and see the full paintings, it just took my breath away," Fonda says. She was especially drawn to Dial's treatment of women as subjects in his art. "He made works about how women have to disguise their innate power in order to pass," she recalls. "They came off the wall and kind of grabbed me by the throat." Then and there, Fonda decided to fill

her loft apartment and the offices of her nonprofit organization with works by Thornton Dial.

By early 2001, Jane Fonda had agreed to invest $1 million in Arnett's Tinwood publishing business. She had yet to meet any of the artists in person, though. So Arnett decided that something must be done. The answer was clear: an Alabama road trip.

For weeks, Fonda and Arnett brainstormed about who else would join the excursion. To begin with, there was family. As the oldest son and the art historian of the Arnett clan, Bill's son Paul was the first pick. Arnett's son Matt was next, because he could coordinate the trip. Bill's youngest son, Tom, was at the University of Texas and wanted to be a documentary filmmaker, so he was invited for the ride.

Fonda weighed in with her own family choices. Jane wanted her daughter Vanessa Vadim to come. Vadim's toddler son, Malcolm, joined the merry band. And Jane wanted her son Troy, her offspring with ex-husband Tom Hayden, to be there.

Arnett and Fonda agreed that Peter Marzio, now executive director of the Museum of Fine Arts, Houston, should be a member of the crew. Since Marzio was coming, it made sense to invite the Gee's Bend exhibition curators. That put Jane Livingston and John Beardsley on the list. Then there was Larry Rinder, curator of contemporary art at the Whitney Museum of American Art, who was considering hosting the Gee's Bend exhibition after its run in Houston.

Arnett's friend Amiri Baraka (aka Leroi Jones) was invited to come along. Baraka was a writer and militant civil rights activist in the 1960s who, after the Newark race riot in 1967, penned poems like this: "We must make our own world, man, our own world, and we cannot do this unless the white man is dead." Baraka had written essays for *Thornton Dial: Image of the Tiger* and Arnett's *Souls Grown Deep* books, and he was a vocal champion of artists like Dial and Holley.

Fonda invited documentary filmmaker Carol Cassidy. Cassidy hoped to make a series of films about Arnett's artists and would record the Alabama trip. As backup, Cassidy invited a friend of hers,

Becky Smith. Smith was on the faculty of the UCLA film school, and would keep the camera rolling on this tour.

Another invitee of the Arnetts was Bob Land, a freelance production editor working with the family since the mid-1990s on the *Souls Grown Deep* books and ultimately on books about the quilts as well. Finally there was Matt Arnett's friend, Lynn Sledge. Sledge was a writer from Mobile, Alabama, whose husband served as a book critic for the *Mobile Register*, and she was working with him on a review of *Souls Grown Deep*. That was enough to qualify her, in Fonda's view, as a journalist. Fonda didn't want any journalists along for the ride, so Sledge was left to follow behind in her own car.

Nearly twenty people would begin the journey, all in support of Jane Fonda's folk art education. More would join the faculty as Fonda progressed through Alabama's interior.

To seat the battalion, Matt Arnett chartered a streamliner that could have passed as Willie Nelson's tour bus: a gleaming marine-blue luxury coach with plush seats and mirrors and retro-colored fabric encased in chrome. "It was like a floating living room," Jane Fonda laughs, "with bubbles and plastic tubing." There was a refrigerator and wet bar, a restroom, and a lounge in the rear. In early May 2001 the bus left Atlanta, full with Fonda's merry pranksters, ready to roll down the dusty red-clay roads of middle Alabama.

Forty years earlier, on Mother's Day 1961, a Greyhound bus traveled the same route from Atlanta. A dozen or so whites and blacks, mostly college students, were on board to test the federal law against segregation on interstate transit. They sat defiantly—sometimes together, sometimes with whites in the back of the bus and blacks in the front—refusing to move despite constant harassment. As the first bus pulled into Anniston, Alabama, an angry mob slashed the tires. The driver kept his foot on the gas, but the welcoming committee from

the Anniston station followed. When the bus's tires went flat not far out of town, the driver pulled the vehicle to the side of the road, jumped out and ran. The crowd that was following surrounded the bus, trapping the passengers inside. Someone tossed a firebomb inside the bus, and it burst into flames as the gas tank blew and the mob moved back. The Freedom Riders saw their chance to escape, but as they stumbled out of the burning bus, the mob surged forward again waving lead pipes and baseball bats. One rider, a former college professor, suffered permanent brain damage.

Jane Fonda's bus also made its first stop in Anniston. But as much as they may have felt like modern-day Freedom Riders, Fonda's gang spent the night at the Victoria Inn—a gracious nineteenth-century southern home turned bed-and-breakfast—rather than the Anniston hospital.

In the morning, the crew washed, filled their bellies, and cruised to Lonnie Holley's house in Harpersville. The raw materials of self-taught artistry lay scattered like toys across a child's playroom—dumpster relics waiting to be shaped into objects of transcendent meaning: a crumpled lounge chair, a tattered rubber hose, some bent aluminum siding, a toddler's safety gate, a street sign. Abandoned vehicles decayed in the yard.

And in the midst of it was Holley, sporting a black baseball cap encrusted in buttons and pins. A yellow- and blue-striped short-sleeved shirt draped his lean frame. Wandering around his yard, tilling his artifacts, Holley seemed at one moment to be one of those artifacts and at another to be a bumblebee flitting through the refuse.

Lonnie Holley and Jane Fonda squatted on the ground. If Fonda was on this trip to learn about African American vernacular art, she was now at the feet of the senior professor of folk. The crowd looked on. Holley described as he built, with his fingers in constant movement and arms sweeping gestures that rattled his bracelets in the wind and painted images in the air. He caressed a sandlike stone as he bent over and carved it into shape, sensually tracing curves with his hand. Holley spoke in a storyteller's manner. "I gone come down the side of the nose and bring

it in real good," he sang as he scraped a razor alongside the stone face. "This goin' be a beautiful piece. You have to thank God for this kind of ability and talent," Holley said of himself. And the group agreed. By the time the caravan was ready to leave, Jane Fonda and her pilgrims were completely in the grip of Holley's spell. Fonda asked him to ride the bus for the rest of the trip, and without delay he climbed aboard.

Nassau Avenue is a residential street just off of Martin Luther King Drive near downtown Birmingham. As the deluxe bus wheeled up Nassau, neighbors took notice. They peeked through Venetian blinds, opened screen doors, and came out onto their front stoops. Cautiously, a few at a time, they walked up the street to see why this strange craft had landed in their world. Soon, a large crowd surrounded the bus and moved toward the chain-link fence that protected Joe and Hilda Minter's sculpture garden.

Joe and Hilda Minter's place popped up like a visual jack-in-the-box at the end of a sloping road lined with modest working-class homes. It was an ocean-blue shanty overlooking a large cemetery. The Minter's sprawling yard was cluttered with found-object assemblages. The entire collection paid tribute to the history of Africans in America. Joe was sixty years old with a wiry, gray-black beard and hair stuffed under a Panama hat and pinned back by oversized Foster Grants.

He had been building this garden since 1989, ten years after his furniture-making career ended due to a combined layoff and work-related eye injury. Minter saw his garden as a living work of art, a history book in three dimensions. The sculptures were crafted from whatever he could scrape up at the flea market or the junkyard: car parts, abandoned furniture, chains, blenders, roofing supplies. Despite his scrap-metal garden and luminescent house, Joe Minter would often lament that it was "just like I'm invisible here." He may have been unnoticed by Birmingham at large, but not by his neighbors. They thought he was a crackpot—that is, until the bus showed up.

"When the bus come up, didn't nobody know what was going on. I didn't tell nobody, so when the bus come up everybody started com-

ing out on the porch. They said a bus got lost and come up here," Hilda Minter would later reminisce.

Then word spread that a movie star was there to visit Joe and his wife Hilda. Was it Shirley MacLaine? Cher? No, it was Jane Fonda and a whole bunch of artist people. The neighbors started to wonder if maybe there was something to all that stuff in Joe's yard after all.

"See that? That the Edmund Pettus Bridge in Selma," Joe told the crowd while he pointed to a sculpture.

"They called it 'Bloody Sunday.' That's a whole story right there that you can tell. Tell you how the six hundred demonstrators were beat back," Joe said.

Joe Minter's bridge was built as a symbolic replica of the one in Selma and was constructed out of wood planks. As the group walked over Minter's bridge from one side, they met the righteous, haunting gaze of a half-dozen African warriors with red and yellow masks, scrap-wood bodies, and armor made of chrome hubcaps. With metal crutches and ski poles for arms, the soldiers reached for the heavens in either a plea for mercy or a cry for revenge.

Nearby was a piece that Joe told the group was *Two Buses in One: The Freedom Riders and the Bus Boycott*. It stood on a corrugated metal base with an actual bus bumper and steering wheel and outfitted with a rusted iron seat from an old tractor. The bumper held two painted license plates. One read, "Heart of Dixie, Alabama '61." The year of the Freedom Rides.

While Arnett, Fonda, and their crew marched through civil rights history in Joe Minter's backyard and while the neighbors were scratching their heads, the police arrived. An officer flexed his biceps, adjusted his mirrored sunglasses, and approached Paul Arnett.

"What's going on around here? Anybody in there doing anything the homeowner objects to?" the cop asked.

"No, sir. The Minters are friends of ours. We're just visiting," Paul Arnett replied.

But the officer didn't hear the response. He was busy looking over Paul's shoulder, trying to catch a glimpse of Jane Fonda.

Fonda's magic bus drove across Birmingham to McCalla on the outskirts of Bessemer. It rolled through the metal security gate at the entrance to the Dial compound and up the wooded hillside property to a roundabout in front of Thornton Dial's gray wood-and-stone contemporary house. Hilda and Joe Minter were now part of the entourage.

The entire extended Dial family was there. Thornton and Clara Mae Dial shook hands with the visitors, seemingly unaffected by the power and celebrity in their midst. But Jane Fonda was affected dramatically. She cried.

Peter Marzio shook Thornton Dial's hand, made polite talk. But his attention was riveted by what he saw in the distance where a black steel mass rose up on one end and sloped back down on the other, an enormous semicircular sculpture. Marzio approached the sculpture and stopped, silent and alone. He cut a dashing figure, tall and firm, sporting a tan blazer, brown slacks, white shirt, and a beige tie. His tinted shades and square jaw gave him movie-star polish. He gazed at the sculpture. Abstract cars rolled alongside it. Metal figures danced along the top of it. A tiger stalked. Marzio turned away to walk by himself down a path alongside the driveway.

The Arnetts looked at each other, then someone ran to catch up with Marzio and bring him back to the group. "That thing right there is a fucking masterpiece!" Marzio repeated, over and over again, as he walked back toward the sculpture. "I want to buy it for my museum. I think this," he said pointing to Dial, "is one of the greatest artists in the world in the twentieth century."

In his spiral-bound notepad, Marzio sketched Dial's sculpture that was made in honor of the heroes of "Bloody Sunday." Dial simply called it *The Bridge*. As Marzio measured the dimensions, Fonda came over. By contrast, she was dressed for an Earth Day Summit. Her short-cropped hair stuck out from beneath an orange-brimmed Gee's Bend baseball cap. She wore a patterned blue blouse untucked

and hanging over a black T-shirt, small dangly earrings spinning from her earlobes.

She approached Marzio gingerly, "Now are you thinking this would become a part of your permanent collection?"

"That would be the idea," Marzio said. "It deserves a really great location, you know?"

"Yeah, yeah," said Fonda. "I can imagine conservators giving you a fit, saying you would spend a fortune keeping it up."

"So what?" replied Marzio. "It's a goddamn masterpiece. It's so coherent, so upbeat, so promising!" Marzio started laughing. Admiring. "Think of what he's given us."

Fonda turned the conversation back to Dial. He showed her the seat that he made from Dial Metal Patterns' material in honor of Rosa Parks. It was an iron bus bench. "This here is where she sat," he said with "she" meaning the black seamstress who, in 1955, galvanized the civil rights movement by refusing to give up her bus seat for a white man. "I see you, I see a woman. I see that man, I see him as a man. White, black, whatever, a man's just a man. That's the way I see life," he told Fonda.

Fonda asked Dial to get on the bus and take the rest of the trip with the group. Reluctant by nature, he was so swept up in the excitement of the day that he heard himself say yes before he could think of reasons to stay home. He got on board, donning a Gee's Bend cap, a blue work shirt buttoned to the top, and an uneasy smile.

———————

Jane Fonda was hostess and field-trip chaperone. She tried her best not to dominate, but rather to facilitate the dialogue. She would ask questions, probe, and listen, and in addition to inviting artists to join the entourage Fonda encouraged the group to bring other living things on board. Things like a duckling, a baby quail, and a small yellow chick that they picked up along the way. Someone wanted to get

a pig, but the group put a stop to that. Fonda rode for a while with the baby duckling sitting on her shoulder. She told a story of the time as a child when she put a chick in her mouth to hide it.

Lonnie Holley was the entertainment coordinator. He traveled with a sack of art supplies. He also used anything else he could find: pencils, crayons, paper, yarn, and wire. When the bus stopped, he scavenged the ground, collected objects from the side of the road, and wove them into makeshift masterpieces. He picked up a rock, painted it, and presented it to Jane.

At times, ten conversations took place around Holley as the bus rolled along. Arnett could be heard telling stories of the people who stood in his way. But Holley was oblivious. Half-glasses dangled from his neck—reading spectacles with a librarian's chain. Holley reached into his bag and pulled out a roll of heavy yarn and some rags. He cut off pieces and passed them out to the group.

"Look around," he said. "Use what you see. Create a piece of art that speaks from your heart. Use the string, use the paper, the cloth, the fabrics, whatever. Then we will tie all the strings together. We goin' make something very beautiful."

Jane Fonda completed her string art project and handed it to Lonnie to tie together with the others. "This is a vagina," she said.

The travelers had been invited to a revival service at the Pleasant Grove Baptist Church in Gee's Bend, but while the citizens of the Bend were fond of the Arnetts and welcomed the visitors, the minister of Pleasant Grove held a contrary view. Scheduled to make a simple welcome, five minutes at most, the minister launched into a tirade. He rocked back and forth as he bellowed: a big man with a big ruby ring, a white collarless shirt buttoned to the top, a dark jacket, and tinted glasses. The crowd sat motionless in the pews while he lifted his angry voice, "Beware the outsiders who come to

exploit you. Beware the city people who are going to film us so they can say, 'Oh look at these poor dumb country folk,' present us in a bad light, and then forget us." He shook his ruby-ringed finger at Bill Arnett. "You people are here under false pretenses. This is not just about quilts. We're not a bunch of unsophisticated black folk. Don't take me for a fool."

The room was quiet. Not even an usher stirred. Then Lonnie Holley's seat creaked. Holley stood up, addressed the crowd. "My name is Lonnie Bradley Holley, African American artist from Birmingham, and I am very glad to be here," he said. Holley looked past the faces of the Gee's Bend residents, past the choir, the deacon and deaconess board, past all of the people he traveled with that day, directly into the minister's eyes. "With all due respect, you better be looking at *your own* pretenses. You drive up here in your gold Cadillac with your big jewelry and big talk, and you put down these people I'm with. I think you need to think about jealousy and animosity around here. These people are good people. Best people I know. They've done more for me and other artists than anyone I know, black or white." Women in their seats crossed their legs, waved fans.

Then Joe Minter stood to testify, "If not for Bill Arnett, I never never would have been appreciated."

The minister listened, tightening. He wrote down Holley and Minter's names as they got up to speak—his own blacklist.

The hushed audience wondered what was next. Slowly but deliberately, Thornton Dial stood up—a man reticent in front of his own family members, no less a crowd of strangers. He faced the congregation and said, "I just want to say that I'm Thornton Dial. I'm an artist too, and I want to thank you for having me here." Then he turned to the minister, his head high, his back straight, and said, "Mr. Arnett, he a trailblazer. We been on this trail fifteen years, me and him. I love him for what he's done. He's the cause of all this here. Mr. Arnett and his friends are the finest people. He's got all the blessings from me. That's all." And then Thornton Dial sat back down.

The front doors of the Pleasant Grove Baptist Church look out onto a long dusty road that climbs a hill and then disappears down the other side. Not fifteen minutes after the service ended, pairs of Gee's Bend women walked slowly over that hill and toward the church, carrying dishes of home-cooked roast and yams and corn and cornbread and biscuits and gravy. When they arrived they sang gospel songs that rang out over the murmur of voices. In time—over the sound of tongues and lips licking fingers and utensils hitting plates— laughter emerged. Everyone except the minister enjoyed the feast.

———————

Selma, Alabama, hit the national radar on March 7, 1965. Then-Governor George Wallace positioned state troopers along the Edmund Pettus Bridge in Selma to help "protect" the crowd. County Sheriff Jim Clark had his policemen out on horseback in support of the troopers.

John Lewis, a twenty-five-year-old sharecropper's son and one of the original Freedom Riders, led the demonstrators across the bridge that fateful Sunday in search of more equitable voting rights for blacks. Civil rights activists had for years been waging an unsuccessful effort to register black voters in the Selma area. After an aborted demonstration ended in the violent death of one protester, some six hundred voting rights demonstrators planned to march from Selma to Montgomery to gain attention for their struggle. But as the marchers came across the bridge, they were met violently by troops who lunged at the demonstrators with nightsticks, bullwhips, and tear gas. The horses trampled some protesters, and others went down in the gaseous air. Sixty-five people were wounded, including seventeen people packed in ambulances to the local hospital.

Now a U.S. congressman from Georgia, Lewis told a *Life* magazine reporter years later, "On that day we thought that we would be arrested and jailed. We had no idea that we would be beat. I remem-

ber we left that little church, Brown Chapel, walked through the streets of Selma, got to the foot of the bridge. We were walking in twos when we came over the apex of the bridge and saw a sea of blue. It was the Alabama state troopers."

Two weeks later, on March 21, 1965, Dr. Martin Luther King Jr. and his supporters successfully marched across the bridge, down Highway 80 and through to Montgomery, where they held a rally on the steps of the Alabama State Capitol. By the time they reached Montgomery, twenty-five thousand marchers had joined Dr. King. Not long after, in August 1965, Congress passed the Voting Rights Act.

For these reasons the Edmund Pettus Bridge was the main Selma attraction for Jane Fonda's guests. Holley, Minter, and Dial had all created art in memory of Bloody Sunday, but none had ever seen the bridge.

The night the bus drove into Selma, the party stayed at the St. James Hotel. The St. James, which opened in 1837, was occupied by Union troops during the Civil War. Benjamin Sterling Turner, who later became the first African American to serve in the U.S. Congress, then managed the hotel. Perched on the banks of the Alabama River, the stately southern residence overlooked the Edmund Pettus Bridge.

Joe Minter stood at the base of the bridge the next morning as the group emerged from the St. James. He held a five-foot-long staff topped with bells for the hike across the arching span. "As I stand here, I could feel the pressure the people must have felt. They had it in they hearts that they were gonna throw away their shackles. Me and my children, we not gonna suffer no more," Joe preached. "Sunday morning the most segregated hour in the world—people all in they separate churches. But we back here together."

Thornton Dial struggled to field a barrage of questions that poured at him despite Minter's ongoing sermon and shifted awkwardly at Joe Minter's side.

"Did you sleep good, Mr. Dial?" someone asked.

"Mr. Dial, what do you make of all this?" queried another.

"Have you ever been here before, Mr. Dial?" one wondered.

"Mr. Dial, what significance does this bridge have for you?" they persisted.

Dial strained to match Minter's tone.

"Great memories of Martin Luther King and marches," he replied. "I didn't take part, but I heard so much about it." Dial's tank-top T-shirt peered through his pressed white dress shirt.

But it was Lonnie Holley who took the first steps toward the bridge. Holley walked, leaned down, picked up trash, scavenged for art supplies, while Minter preached.

"God is the ultimate recycler," Minter said.

Then the three men moved up the bridge together. Holley removed his sandals and strolled barefoot. They were approaching sacred ground. Halfway up the sloping expanse, Holley spotted a plank across the road, a solid board like that was a healthy catch. He excused himself, said, "I'm gonna break the law for just a minute now." He jumped barefoot into the street, dodging oncoming traffic. While Joe Minter egged him on, "Get that board. He gonna *get* that board! Testify to it. Tell 'em." At a sprinter's pace, Holley hot-footed across the four-lane road, grabbed the board, swung around, and tore back across the street like a high stepper in the Tuskegee marching band.

Cars swished past the men. They walked carefree under the high steel arch. This bridge was theirs.

Chapter 17

THE BRIDGE

"IT'S HARD TO CROSS THE BRIDGE, AND YET ALL THEM ARE FREE through the bridge," Dial said, thinking back about the Edmund Pettus Bridge. Bridges, activists, and conflict seem to go together. Abortion-rights activists have marched across the Brooklyn Bridge, forest activists have scaled the Golden Gate Bridge in San Francisco, and antiwar activists have stopped morning traffic across the Evergreen Point Floating Bridge in Seattle. Twenty years after leading a group of activists into conflict on Selma's famed bridge, John Lewis was helping a group of in-town neighborhoods in Atlanta fight against bridges and roads that threatened their existence. Eventually, the battle would suck Thornton Dial into its vortex, presenting both opportunity and obstacle. Critic Jerry Cullum once called it "a case of well-meaning incompetence meets paranoia."

Well-meaning incompetence began in the neighborhoods east of Atlanta's central business district. Downtown Atlanta is buttressed by a series of its original garden suburbs, where charming antique homes sprout like ornaments in a restoration architect's window box: Morningside, Ansley Park, Candler Park, Druid Hills, and others fan out from Atlanta's center. Atlanta's first planned community, Inman Park, may not be the largest or most prominent of these neighborhoods, but it is arguably the most activist and most proud.

Inman Park residents characterize their little community as "SmallTown DownTown," and they celebrate their own eclectic charm each spring with a festival and parade. The parade meanders through Inman Park's streets past throngs of onlookers, Birkenstocks and baggies side by side with Weejun loafers and khakis. The procession itself is like flipping the TV channel between MTV and the Disney Channel. The marching Atlanta fire department representatives are not far from marching members of a lesbian garden club trotting along not far from perky Girl Scouts who are not far from scantily clad gothlike characters alongside Hare Krishnas marching near face-painted kids. Though the residents are diverse, there is a sense of camaraderie and sameness in Inman Park. This collective spirit developed through the shared experience of waging and winning a civic war.

Built in the late 1800s, Inman Park was conceived as a little bit of paradise located just next to the city. In the years immediately after this paradise was founded, Inman Park sported two idyllic parks, a trolley line, broad winding streets, and grand Victorian homes radiating around Coca-Cola founder Asa Candler's first mansion, Callan Castle. But by the 1960s Inman Park was a ruin of its former self: One of its two lakes was clogged with slop and then drained dry; homes were turned into flophouses; weeds overtook grass; kudzu choked the trees; clunker cars lay abandoned by the curb.

In 1961 the Georgia State Highway Department acquired hundreds of homes in Inman Park and the surrounding area in order to demolish them. The highwaymen planned to make way for an east-west corridor called the Stone Mountain Tollway running through Inman Park and past Druid Hills out to the gigantic granite rock known as Stone Mountain. Another north-south connector—the proposed Interstate 485—was to intersect the east-west road near the outskirts of Inman Park. The Inman Park intersection was to create a second version of Spaghetti Junction, infamous as a Gordian knot of looping roads and overpasses twisting around each other like a large plate of pasta and dominating northeastern Atlanta's traffic flow.

THE LAST FOLK HERO

But the government-acquired property lay fallow and continued to decay until a crop of urban pioneers reclaimed some of Inman Park's old homes. In 1971, these gentrifiers formed Inman Park Restoration, Inc. to preserve the historic district. Within two years they succeeded in getting Inman Park listed on the National Register of Historic Places. In response to the road plans, loosely affiliated groups like Inman Park Restoration started to make their voices heard, and by 1975 old plans for both highways and the resulting junction were tanked. By 1982 new highway plans were in place, in part to accommodate traffic to the Carter Presidential Library which was planned near the spot where Spaghetti Junction South was once to go, along the edge of Inman Park. The newly conceived Presidential Parkway would cut through many of the garden suburbs, dividing neighborhoods and devouring land from parks and homes. Enraged, the loosely coupled neighborhoods banded formally together under the anti-parkway umbrella group, CAUTION: Citizens Against Unnecessary Thoroughfares In Older Neighborhoods. Thus began a brutal ten-year war between Inman Park together with its CAUTION brethren against Georgia's Department of Transportation and any politician supporting the proposed road.

Battle tactics ranged from political wrangling to lawsuits to restraining orders and injunctions and even an appeal to the U.S. Supreme Court. The most memorable skirmishes were led by the "Roadbuster" militia, a group of civil disobedients who chained themselves to trees. Among the politicians standing firmly with CAUTION was John Lewis who was, at the time, an Atlanta City councilman. "I'm for the neighborhoods," Lewis persistently told politicians on the opposite side of the struggle.

By the summer of 1991, both sides of the fight were worn out and agreed to find a compromise. After fifty hours of mediation, the sides finally hammered out an agreement. The solution was Freedom Parkway—a strip of road whose main artery runs from the downtown Atlanta highways like a two-mile driveway up to the Carter Presidential Center. Freedom Parkway was to be buffered along each

side by strips of grass and paved trails constituting the 207-acre Freedom Park—a long and, in places, narrow park that came along with the compromise. Two years later, CAUTION changed its name to Freedom Park Conservancy (FPC) and began a mission to develop and preserve the Park.

Ruth Wall was a middle-aged, plain-talking sometimes-real-estate-agent who had been an active member of the CAUTION fight. She had a penchant for local politics and could chew a man to shreds or smooth him over like a syrupy sweet southern queen.

At a July 4, 1996, neighborhood party at one of the CAUTION leaders' homes, Wall and other Freedom Parkers were discussing what to do with a small triangle of land just in front of the Carter Center. Wall spotted John Lewis, by then a U.S. congressman, across the room and immediately knew the answer. She approached Lewis and told him, "We want to put up a sculpture in tribute to you on that triangle. You decide on the artist." Three months later, Lewis told the Freedom Park Conservancy that the artist he wanted to create the sculpture was Thornton Dial.

In December that year, Ruth Wall and fellow Conservancy member Eileen Brown traveled to Bessemer to meet with Bill Arnett and Thornton Dial. Wall said she thought she could raise fifty thousand dollars to pay Dial for a sculpture honoring John Lewis. They hoped to have a sculpture in place by fall 1997. They wanted it to be forty feet long—an enormous piece, the biggest Dial had ever done. Fifty thousand dollars was a pittance relative to what Dial would normally have received for a massive sculpture of this kind, Arnett believed— short of his market value by a factor of ten. But Dial revered John Lewis and knew his history. With five kids and a factory job Dial felt he stayed on the sidelines during the civil rights movement of the 1950s and 1960s. Now, he told Arnett with the building of the bridge, "I can be *in* the civil rights movement."

Dial had already been thinking about the project and described his idea to create a sculptural bridge resembling the Edmund Pettus

Bridge. The group discussed showcasing the concepts of neighbor-hood rights and civil rights. A past-to-future theme emerged that would reflect Lewis's growth from rural past to urban present. Not long into the conversation, Wall and Brown asked Arnett to step aside from the ongoing relationship.

"They claimed that they needed to make constant visits to Dial to get updates on the progress, and they didn't want to have to call me up and go at my convenience," Arnett says. "Ruth Wall said to me, 'You know we're going to take a lot of people over there. We're rais-ing money. We're going to have to take funding people over and we're going to have to take people from the landscape architects and we're going to need to be dealing with Dial a lot,' and she even said to me, 'You know you can trust us. After all, we're working with John Lewis.'" By all accounts, Arnett was agreeable. "You pay and work with Dial directly," he told them. The deal between Dial and the Conservancy went forward on a handshake.

The Dial commission wasn't the only Freedom Park Conservancy deal struck on a verbal agreement. Permission to use the triangular plot across from the Carter Center on which the sculpture would rest was never documented. Soon after Wall returned from Bessemer, she learned that the triangle was no longer available for use. The Department of Transportation assured Wall and her colleagues that they had a better spot for the Dial sculpture. The new site was signif-icantly larger than the old one. It would be called John Lewis Plaza and, because of its size, the land also came with the requirement that Freedom Park Conservancy raise five hundred thousand to one mil-lion dollars to build and maintain it. To get the money, Wall and her colleagues decided to apply for a federally funded Transportation Enhancement Activity grant. Known as a T.E.A. grant, none had ever been issued in Georgia for an art-related project before.

Arnett remembers, "Ruth Wall called to tell me that she had bad news. That maybe the Dial piece could not go on the property in front of the Carter Library. I said 'Why?' She said people at Emory

University told Jimmy Carter that Mr. Dial's work was pornographic and that they had a lot of complaints about it during the Olympics and that it wasn't suitable for public display." Someone from Carter's office called the Department of Transportation and complained. The Carter Center, says Wall, didn't want *The Bridge* on their front yard.

The new site was well out of view from the Carter Center. John Lewis Plaza was to grace the entrance of Freedom Park on the corner of Freedom Parkway and Ponce de Leon Avenue: a bustling thoroughfare and host to an eclectic nightlife scene. Less than a block away from the newly proposed John Lewis Plaza, for instance, was the Clermont Lounge, Atlanta's oldest strip club, once described by a local newsweekly as "a dingy bar/disco in the basement of a rooming house with low, claustrophobia-inducing ceilings, filthy décor, and restrooms that your urine actually cleans." The Clermont's main attraction was Blondie, a hefty middle-aged African American stripper with dyed-blonde hair who, for tips, recited self-styled poetry and crushed empty beer cans between her mammoth breasts.

Despite the change of venue, Thornton Dial took his *Bridge* to heart. "It was the Selma bridge. Where the peoples got killed trying to vote for freedom." He says, "That's what I made *The Bridge* for."

The sixty-eight-year-old Dial worked ceaselessly on the piece, hauling huge metal girders from the Dial Metal Patterns factory to his yard and assembling them into a massive sculpture, cutting metal and rubber and shaping and inventing a lyrical three-dimensional landscape that connected John Lewis's past and future lives. Dial stayed in his yard welding and spray-painting through the dripping heat of Alabama summer; through the gray cold fall and bitter winter until he finished *The Bridge* in mid-1997, just ahead of what he believed to be his June deadline.

Then he collapsed.

"They called me up. I went over there in the middle of the night, and the doctor at the hospital told me they did not expect Dial to live more than another day or two," Arnett remembers. "It was touch and go."

Thornton Dial was hospitalized for liver damage and other internal organ failure. Doctors were uncertain about his ability to survive.

"What do I know about it?" asks Arnett rhetorically. "I know that it was from overwork."

"Look around you," says Thornton Dial. "Count up all the leaves on trees, all the pieces of grass. Then count up all the people ever lived and died. It'll be all the same. Life back into life," Dial says. He believed in his own renewal too, but as Thornton Dial lay recovering in his king-size bed, his completed *Bridge* and all its recycled parts lay fallow under the shade comfort trees outside his bedroom window.

In late spring 1997, not too long after Dial returned home from the hospital, John Beardsley was busy curating an exhibition for the Spoleto Arts Festival in Charleston, South Carolina. The exhibition concept, *Human/Nature: Art and Landscape in Charleston and the Low Country*, required selected artists to tour Charleston and make art that responded to what they saw. Beardsley invited Thornton Dial.

First, Beardsley drove Thornton Dial from Alabama to Folly Beach, just fifteen minutes outside Charleston. Folly's white beach and surf are watched over by the Morris Island Lighthouse, a classic red- and white-striped cylinder that has stood since 1876. Thornton Dial saw the majestic light tower and the rhythmic waves. He saw the soft sand and began to chuckle until his chuckle grew into a full-tilt laugh. It was the first time that Thornton Dial had ever stood at the ocean's edge.

Beardsley drove Dial to the southwest edge of Charleston Harbor where fifty-four acres of antebellum history lived in the form of McLeod Plantation. Two majestic allées of moss-drenched Live Oaks framed a row of whitewashed slave cabins. Dial stopped before them, grabbed a clump of the stringy moss in his hands and draped it over his face and ears like a long white beard. Then he laughed again.

In Charleston, Beardsley introduced Dial to Spoleto artist Philip Simmons, an eighty-five-year-old blacksmith who was one of the most revered craftsmen in South Carolina. Simmons's elaborate iron

gates—some two hundred of them—decorated gardens throughout Charleston. One of these, with the image of a snake slithering through it, is said to be the first in the city with an animal motif. Thornton Dial felt a kinship with the man known as "the Gatekeeper." He admired Simmons's facility with hot metal—his ability to bend the coarse molten iron to his will and to shape curling leaves and flowers and other soft organic lives—and as Dial saw the beauty he saw the commensurate irony. *Here is Philip Simmons, a black man, and he has spent a lifetime making iron fences for white people to help them keep black people out of their yards*, Dial thought.

As Dial sat with Philip Simmons in the elder craftsman's workshop, both men started hammering on solid black anvil, a call-and-response with hammers on iron. Dial had heard the call of death, and his response was to create.

Back in Alabama, Dial invented a new way to develop assemblages so as not to tax his still-rejuvenating body. He began to use cloth that was light enough for him to manipulate and affix to the heavy wooden boards on which he previously hung metal, carpets, and cut wood. His first effort resembled an enormous red giant that looked like a cross between a blood-soaked rag and a cluster of holly sprigs. *Construction of the Victory*, he called it: his ode to victory over death.

The Freedom Park Conservancy (FPC) held its first fundraiser for *The Bridge* on March 21, 1998. The event attracted local dignitaries like Bill Campbell, mayor of Atlanta and Inman Park resident, as well as two hundred or so other guests. Thornton and Clara Mae Dial and their children attended. The cover of a brochure for the event showed John Lewis and Thornton Dial in an embrace under the words "Two Living Legends" and, at the bottom, the words "Help Us Build a Bridge." The party raised ninety-five hundred dollars, and Ruth Wall gave Dial a check for five thousand dollars that evening—the first

payment made on the artwork that still lay dormant in Dial's yard. Another three-thousand-dollar check would follow in November 1998, but it would be three years before another payment would be delivered to Thornton Dial.

Through the end of the 1990s and into the new millennium, Thornton Dial occasionally tended to the black metal arch in his backyard. He repainted it. He tweaked it. He wondered where the rest of his fifty thousand dollars was. He wondered why no one came to get the completed sculpture.

By 2001, project cost for the John Lewis Plaza had soared. The Conservancy managed to pay Thornton Dial another twenty thousand dollars in January of that year. Eileen Brown, Ruth Wall's friend and FPC colleague, delivered the check and, along with it, a small document which she asked Thornton Dial to sign acknowledging receipt of all payments to date, which still fell twelve thousand dollars short of complete compensation for Dial's work commissioned five years prior. Presumably, the Conservancy had to be careful with their payments to Dial since so much money was going to other aspects of the project. The Conservancy hired a well-respected engineering firm, Edall, to build the rectilinear pedestal that would support *The Bridge* and to design the surrounding landscape to complement the art. Edall did not come cheap. They hired a professional lighting designer to spotlight the piece at night. No small expense there. A top-flight public art consultant and installer, Patricia Kerlin, was retained to consult on the art's transport and installation. Kerlin had consulted for the Atlanta Olympic Games in 1996 for the creation of a Folk Art Park near downtown that included a work from Lonnie Holley.

Just a month after the Arnett-Fonda bus ride, in June 2001, an article about *The Bridge* appeared in Atlanta's weekly alternative newspaper, *Creative Loafing*, quoting Ruth Wall extensively:

"We really need to get more money from the DOT," says conservancy member Ruth Wall. "It's like trying to nudge a huge elephant."

While securing private dollars is tough, getting federal money means waiting. The money to build the base and do the landscaping for the Dial sculpture, about $200,000, came in the form of a federal transportation grant. "It's taken us four years," says Wall, who oversees the sculpture project. "The process was like asking for a $50 million bridge. . . . It's going to put Atlanta on the map," Wall says of the Dial sculpture. "On the open market, it would bring $750,000 to $1 million."

Arnett saw the article and seethed. *They're bragging that the sculpture is worth a million bucks*, he thought, *but they're only paying Dial fifty thousand dollars, and five years after he's finished they haven't even come up with that!* On the bus trip through Alabama, it was *The Bridge* that Peter Marzio saw and said he wanted to purchase and showcase in his Houston museum. *If Wall isn't going to pay Dial for his work and take the piece*, thought Arnett, *why not sell it to Houston instead?*

Since commissioning *The Bridge*, Ruth Wall had made the two-hour trip west from Atlanta to Thornton Dial's home on a regular basis to check on its progress. Eileen Brown often accompanied Wall on her excursions, as did art consultant Patricia Kerlin. They made jovial chit-chat with Thornton Dial as he worked and toured them through his property. Ruth Wall felt free to call him "Thornton." Whenever they arrived they hugged Thornton hello. During one such jolly encounter, the Conservancy ladies ogled a small black assemblage that Dial created and which rested not too far from *The Bridge*. "Now is this part of *The Bridge*?" Wall asked Thornton Dial. Whether or not Dial responded that the piece was of the initial *Bridge* concept is not clear, but in time the admired art and several other pieces that caught Wall's eye began to surround *The Bridge*. A black VW Beetle–like car made of metal, wood, and epoxy with a cartoonish driver at the wheel seemed to fit the notion of *The Bridge*, and it was pushed nearby. A black metal object resembling tall crops sprouting from the earth also seemed to fit the notion of John Lewis's rural beginnings, so it was

added to *The Bridge*. Then a black fish shape showed up, and last a black mule—with the bodies of both animals composed of cut car tires. A tree and a human shape were also annexed.

"I would come over to Dial's, and I would see a piece of art that didn't go with *The Bridge* leaning against the sculpture or sitting in front of it," Bill Arnett remembers. "I would ask Dial, 'What's this doing here?' He would say, 'Oh, those women want to get that piece so they put it over here.' So I would call them and say, 'What is this about all these additional pieces of sculpture? Are you going to pay Dial for those extra pieces?' Ruth Wall would say, 'Oh no, Mr. Dial wants to give them to us.' I said, 'Ruth, how could Mr. Dial possibly want to *give* you pieces that don't go with *The Bridge*? That don't make sense. *The Bridge* has a concept. It's a piece of art, for God's sake. You can't take something like a statue of Michael Jordan and stick it next to the bridge holding a basketball.' But that's what they did."

Arnett claims he told Ruth Wall that Dial didn't hear very well and probably didn't understand that she wasn't planning to pay for the extra art pieces. "I could almost reconstruct it verbatim hearing them and hearing him," says Arnett. "Oh! Mr. Dial, that's a beautiful piece! I'd love to get that piece to go in Atlanta. Is that available? Can we have it?" continues Arnett imitating Wall's syrupy drawl.

"Excuse me for cutting across, but they asked me for *The Bridge*," insists Thornton Dial who has been listening to Arnett recount the story. "Well, that's what they asked me. That's *all* they asked for."

"But how did they end up with all of those other things?" Arnett queries.

"They wanted it and they placed it into . . . ," Dial begins.

"Did you ever give them pieces of art 'cause they said, 'We want them'?" Arnett interrogates.

"No," says Dial. "They placed them in there like they wanted them. Well, a lot of stuff was placed in there they wanted to go with *The Bridge*."

Arnett says, "We got into a real fight, and Ruth Wall said to me eventually, 'Bill, butt out. Butt out. You're not a part of this anymore. It's between us and Mr. Dial,' and then I suddenly thought: *Ding! That's why they want me out of the way. So they can just run roughshod over him like everybody else tries to do.*"

Dial, however, wondered why after all this time and haggling over additional pieces, the Conservancy Ladies still had not come to get the massive sculpture that occupied his yard. "So I look at the ways of the law. I look at the law of the land. I mostly have to look at what happened to black peoples," says Thornton Dial. "And how people feel about one another. If I can let something sit here, well, I might as well be in slavery because, hey man, you just treat me like you want to treat me. That's the way I felt about it, because they supposed to get *The Bridge* when they told me. You supposed to pick it up when you say you goin' do it."

For Dial, Arnett, and the Freedom Park Conservancy, mounting tensions came to a head on November 15, 2001, with a letter from Patricia Kerlin seeking clarification on uncertain issues regarding *The Bridge* project. She had previously discussed with Dial how *The Bridge* itself would be positioned on the site and installed. She wanted Dial's official sign-off on the plan. Kerlin was uncertain about what the sculpture actually included. Were the four little sculptures a part of the deal or not? She says, "We weren't completely clear really how many pieces we were getting. Even though he had offered the pieces, we needed to be sure that's what we were getting." Last, Kerlin had grown concerned about vandalism of the sculpture once installed. Kerlin says she had talked with Dial about building a fence around *The Bridge*. She needed to know if Dial wanted to design and develop the fence himself. "He had agreed to do the fence, but his manner is such that he seems very agreeable on everything, and I just wanted to be clear that he *really* wanted to do the fence," Kerlin says. On November 15, Kerlin sent a letter to Dial outlining these issues, describing the general shape of the fence she hoped for, and asking him to provide a price that he would charge to build it.

Kerlin called the Dials to follow up, as did Wall, but they got no response. Instead, Kerlin got a call from Bill Arnett. He asked about the current state of the project. He wondered aloud if the whole John Lewis Plaza project wasn't going to be aborted. He had heard constantly about the trouble the Conservancy had in raising funds. He commented that Dial hadn't been fully paid, so he imagined this lack of funds must be true. He asked for all documentation regarding the project. He inquired about the installation schedule. He wondered if the Conservancy at least planned to slow the project down.

Within a week of Bill Arnett's call to Patricia Kerlin, the Conservancy received a letter from Donna Howell, who was serving as counsel for Thornton Dial, responding to Kerlin's November letter. Howell said she found it "insulting that you are instructing Dial to do a fence for free since you haven't yet paid him fully for *The Bridge*." Al Caproni, the FPC's own attorney, sent back an apologetic, ameliorating letter in response. Howell then faxed a brief memo asking Freedom Park Conservancy to cease all work on the Plaza until they heard from her. "Mr. Dial and I have several matters to discuss regarding the sculpture," Howell wrote. "We will get back to you as soon as possible."

Caproni told contractors to stop work on the Plaza until all could be clarified, they hoped, in a March meeting with all parties in Congressman John Lewis's office.

Standing before the Lincoln Memorial during the 1963 March on Washington, John Lewis told an assembly of 250,000 civil rights activists, "To those who have said, 'Be patient and wait,' we must say that, 'Patience is a dirty and nasty word.'" Sitting in his downtown Atlanta office nearly forty years later, Congressman Lewis's patience was tested again.

"You've been rude and you've moved the location of *The Bridge* and you've taken pieces from Dial and claimed they're part of *The Bridge* and you haven't paid for it and you forged a contract and you leaked information to Cathy Fox at the *Atlanta Journal-Constitution*!" Bill Arnett spat at Ruth Wall and her Freedom Park colleagues in a

cacophonous tirade. He explained to John Lewis how the problems with Freedom Park were tied to his own battles with the High Museum and with Emory and an entire ten-year conspiracy to tear down Thornton Dial and black folk art. He then turned back to Ruth Wall and said, "I can't let you sit here, lie to Dial, squeeze him and exploit him for five years. You're disqualified from ownership! And so now you can't have the piece. Over my dead body you're getting it! We are selling *The Bridge* to another party that Jane Fonda brought in. We will give you the thirty-eight thousand dollars back, and Dial will do another piece for you instead."

"It was devastating—like an arrow in my heart," Ruth Wall claims in a soft southern tone. And, then harshly, "But what do we know? We are just the dumb-ass citizens."

John Lewis ended the contentious meeting by asking for a two-week "cooling-off" period so that each side could gain perspective and resolve the issue. The parties agreed.

"Then beginning right away, first thing Monday, we and friends and supporters of my husband started getting phone calls from an Atlanta attorney named Jeffrey Evans," Clara Dial claims. "They decided to attack us right away. They had brought in a lawyer who was doing anything he could think of to try to scare us and our friends. He was talking a lot about how our reputations were going to be destroyed," says Clara Dial.

Jane Fonda might be a point of leverage, the Freedom Park Conservancy team presumed. They marshaled powerful friends to contact her, hoping she would intervene with Arnett and Dial on the Conservancy's side. Camille Love, executive director of the Atlanta Bureau of Cultural Affairs, called Fonda asking for her help. Fonda asked to be kept out of the matter. Shortly after, Love resigned from the board of one of Fonda's charities. Georgia State Representative Nan Grogan Orrock called Fonda asking for her help. Again, Fonda declined. Evans, the Conservancy's attorney, called Fonda twice hoping to persuade her. His voice mail message

ended, "Last thing we want this to do is turn this into negative publicity and a negative experience for all those involved." Meaning that Fonda, as a business partner of Bill Arnett, might be dragged into the mud too unless she helped.

Two weeks later, Cathy Fox authored another article for the *Atlanta Journal-Constitution* entitled "Unfinished Homage: An Atlanta Group's Plan to Honor John Lewis." She wrote: "What began as a grass-roots goodwill gesture has devolved into a standoff."

"Cathy Fox got in it, and it then became like a cause célèbre," says Arnett. "It was like the City of Atlanta and all good, right-thinking people versus Bill the exploiter and Dial the stupid, illiterate dupe of Bill the exploiter, and then they started trying to make a national story of it, which they succeeded in doing." In the summer 2002 edition of the national publication *ArtNews*, Jerry Cullum posted a column in the magazine's National News section entitled, "Commission Impossible" about *The Bridge* standoff.

Kara Land, president of Freedom Park Conservancy, wrote to Dial's attorney Donna Howell a week after the Fox article appeared. "Under your proposal for a new contract between the parties, FPC gains nothing and forfeits much. In short, your proposal amounts to an effort to provide us with a 'knock off' of the sculpture that FPC commissioned and for which it substantially paid Mr. Dial," she complained. And, she added, "The FPC demands that Mr. Dial fully and specifically perform his contractual obligations to FPC immediately." Shortly after that, Land sent a check by Federal Express to Thornton Dial for the final twelve thousand dollars owed on *The Bridge*.

Howell returned fire with a letter to Land, stating, "Let me make clear to you that because of this five-year history of unethical behavior toward Mr. Dial by Freedom Park Conservancy, 'The Bridge' will not be sold to Freedom Park. I am sure I need not remind you that it was FPC's failure to provide Mr. Dial with a legal contract that has precipitated this controversy. FPC has no legal right to 'The Bridge'

and unless legal action is initiated by you within the next 10 days we will assume FPC concurs and thus effectively waives any and all purported claims FPC may have against Mr. Dial and 'The Bridge.'" The twelve-thousand-dollar check was returned, marked "void."

"At that point, we were left with no choice but to sue," says Ruth Wall.

The courthouse in Bessemer, Alabama, stands at the center of the town's history: around the corner from Debardeleben Park, down the street from the old Southern Railway Depot, and a quick drive from the vacant and decaying Pullman-Standard plant. Thornton Dial had passed the courthouse many times in his life, but never before did he have to defend himself in one of its rooms.

"My husband grew up in a time when black people learned the first lesson of surviving, which is to stay out of white people's way," says Clara Mae Dial, remembering her husband's visit to the courthouse. "He always said it's better if a white man doesn't even know your name."

But at the time, the Dials were not worried. "Our lawyer, Donna Howell, came to Bessemer to go over the FPC case with us," says Clara Mae Dial. "She said we didn't need to worry about it at all. Her words were, 'Their suit is without merit.'"

Confident that the case could be easily won, Donna Howell sought a postponement of the February 2003 court date so that she could travel with her son to visit colleges during his high school spring break. With vacation plans already in motion, on February 17 Donna Howell learned that although the judge had considered postponing the hearing from February 18 to February 28, no further postponement was actually granted. Howell asked her assistant to phone Paul Arnett with the bad news and notify him that she would not be present for the court hearing the next morning. "Later that night, when the Arnetts called us with news about Mrs. Howell, we asked them to come with us to court and help if they could," says Clara Mae Dial. "By the time Paul reached Bill it was almost ten o'clock, and none of

us knew any lawyer we could ask to be in a Bessemer court the next morning. Bill and Matt Arnett drove over to Bessemer to meet us."

The Freedom Park Conservancy team drove over to Bessemer, too. Though the Arnetts and Dials arrived at the courthouse lawyer-less, Ruth Wall and the FPC team came equipped with at least four barristers. Attorney Al Caproni was there as a plaintiff. Lawyer Jeffrey Evans came to lead the legal charge for Freedom Park. FPC also hired Alabama counsel Raymond Johnson Jr. If that weren't enough, tagging along with the FPC team was Traylor-Shannon lawsuit attorney William Gignilliat III.

Thornton Dial entered the courtroom along with Clara Mae, who at that time was wheelchair-bound, and beside them were Mattie Dial and Bill and Matt Arnett. Jeffrey Evans called the Dials over in front of Judge Dan King's bench. "I didn't know if they were lawyers or what they was. They said the lady—Mrs. Wall—was gonna get *The Bridge* either way I go into it. Say either way I go they gone get *The Bridge*," Dial recalls. Bill and Matt Arnett saw the discussion and quickly moved to Dial's aid but Evans intercepted.

"You just stay out of this. Are you party to the lawsuit?" Evans asked.

"No," the Arnetts answered.

"Are you legal counsel?" Evans queried.

"No, but the Dials couldn't get legal counsel on short notice," the Arnetts tried to reply.

"They pushed the Arnetts out of the courtroom and wouldn't let them say anything. I don't know nothing about art business. Bill take care of things for me. So that's all I had there. I didn't have nobody there but Bill to talk for me and they wouldn't let Bill and them say nothing. I was stuck," Dial says. "I was stuck right there with them."

The Dials and the Freedom Park representatives moved to a separate room to caucus.

"Ruth Wall was crying," Clara Mae Dial remembers. "And said she just wanted to see John Lewis honored and us get paid, and not see us suffer anymore or have to pay out a lot of damages. It seemed

to us it was agree [to quickly settle with the opposing side] or lose everything we have."

To avoid confusion, for posterity, for whoever would listen, Bill Arnett transcribed a statement from Clara Mae Dial about the events in the courtroom that day. "My husband was so afraid of this situation," Clara Mae says in the statement, "because he said to me and Mattie that a black man without a lawyer that goes against the judge in the courthouse is asking to get himself killed."

Whatever happened, when it was over, Freedom Park Conservancy had agreed to complete its payment to Thornton Dial of the remaining portion of its initial fifty-thousand-dollar commission plus an additional twenty thousand dollars for *The Bridge*, and Dial agreed to turn the sculpture over to the FPC. Bill Arnett was appalled. "Arnett got upset and stormed off in a snit," Ruth Wall recalls. "Me and Thornton hugged. We helped Clara to the car."

This, however, wasn't the last the Bessemer court would hear from Bill Arnett and Thornton Dial.

———

"It wasn't a trial in the courthouse," Bill Arnett charged shortly after the hearing. "It was a kangaroo court that the judge had almost nothing to do with. It was carefully orchestrated. It wasn't a meeting. It was a nothing. It was a big con of Dial," Arnett says in full conspiracy mode. "I'm gonna fight the shit out of them. I know I'm goin' to win. I don't give a shit what the judge says. This whole thing was a scam!"

Clara Mae chimes in, "Not in Atlanta. Not *The Bridge*. I don't want them to have it. I would rather send it anywhere than for it to go to Atlanta. 'Cause they done so dirty. They treated us like we was little ignorant children and didn't know no better."

Arnett joked about hiding *The Bridge* in the woods of Bessemer, but instead he pursued a more direct action. Arnett hired a Bessemer attorney, Bill Thomason, to work with Dial to reverse the court deci-

sion. "Bill Thomason, he's a union lawyer," Arnett said at the time. "He's a liberal who's like tenth-generation cracker. He's a real anomaly, but he's a good man. He told me on the telephone, 'I am pissed.' When I first told him my story, I mean when I tell my story to anybody they don't believe it. Now he does. He says, 'I am pissed. I am pissed about this.' He met with the other side's lawyer. He had a deposition of the other side's lawyers, and they wouldn't answer a single question. He got pissed. He says, 'I see now what this is about and I'm pissed. Don't worry about further legal fees at this time,' he says. 'I'm gonna take care of it.' So I don't know what that means. He's like I am. I mean he's in it now. He sees it, and when you see something like this and you get annoyed by it, you want to fight it even if you ain't getting paid to fight it. I can't pay him." Thomason filed a motion for a hearing to set Judge King's order aside, claiming that the settlement was the result of improper coercion and undue influence on Thornton Dial.

"The hearing was set at 8:30 a.m. in Bessemer, but no one showed up but us," Freedom Park's Al Caproni recalls. "Judge King said, 'Well, no one's here; what did I do? I don't remember doing anything fraudulent.' He stood by the prior court agreement. But they were still not delivering the art," says Caproni. On November 12, 2003, Judge King ordered Thornton Dial to turn over *The Bridge* immediately. A crew from Freedom Park Conservancy drove down to Bessemer five days later to accept delivery.

Thornton Dial did not want anyone from Freedom Park Conservancy on his McCalla property, so a neutral site was selected: an abandoned freight depot that Bill Thomason had once considered converting to a museum honoring Thornton Dial.

"We showed up at the appointed hour with two twenty-four-foot-long Ryder trucks with a forklift on a flatbed truck and us in a car. But no one was there," Ruth Wall says. The Freedom Park crew called Bill Thomason. They asked, "Are we going to have to go back to court?" Thomason made some calls. A new rendezvous point was

chosen: a church down the road from Dial's compound. The sculpture was there. Patricia Kerlin was there to secure the sculpture and make sure it was delivered safely to storage. Freedom Park attorney Jeffrey Evans was there with video camera rolling. Matt Arnett and Vanessa Vadim, too, had a video camera taping Evans taping them. *The Bridge* was split into two halves—past and future—and loaded on separate Ryder trucks. Two hours later it was done. Two hours more and *The Bridge* was in Atlanta. "We're really ecstatic," Ruth Wall told *Atlanta Journal-Constitution* art critic Catherine Fox. "It is so fantastic. I just cried."

But Ruth Wall had another reason to cry. The four Dial art pieces that she wanted so badly to have included with the sculpture did not get picked up along with *The Bridge* itself. "I don't know anything about that," Matt Arnett had told Wall when she asked of their whereabouts during *The Bridge* handoff. The Board of the Freedom Park Conservancy was unhappy too. They expected those pieces to be included. Ruth Wall suggested they try to reconcile for the additional art. She called Clara Mae Dial in February 2004 to discuss the situation.

"Hey, how you doin'?" Wall drawled to Mrs. Dial.

"Not so well," Clara Mae said. "I've been in the hospital—not that well. . . . You owe us twenty thousand dollars. When are you going to get that to us?"

"Well. Remember the judge gave us a year to raise the money," Wall said. "Then we still need to get the four pieces," she added.

"Ruth, remember that was not part of the deal," Clara Mae objected.

"I think it was," said Wall.

"Buck said that's additional," said Clara Mae.

"How much more?"

"I don't know, I'll check with Buck and call you back," Clara Mae said and hung up the phone.

Wall immediately called Al Caproni. "Let's see if we can get the twenty thousand dollars from the FPC board and go to McCalla this weekend and pick up the pieces," she said. The Freedom Park

Conservancy Board quickly approved and issued a check for twenty thousand dollars payable to Thornton Dial. Wall then called Clara Mae Dial and said, "I have your twenty-thousand-dollar check, but I need those four pieces." Again, Clara Mae said she would have to confer with her husband.

"I waited, got depressed about it. I sat there thinking when I die, they'll throw my dead body on top of *The Bridge* and spray-paint me black," Wall says. At 10:00 p.m. that night Wall was awakened by Clara Mae's phone call. "Buck says OK, you can come over and have the four pieces," Wall recalls Mrs. Dial telling her. That weekend, Wall drove to McCalla to pick up her four sculptural add-ons. Thornton Dial told her, "Bill won't be happy about this."

"Well, don't tell him," Ruth Wall replied.

In the summer of 2005, *The Bridge* remained in an undisclosed warehouse. The four pieces? They sat under a wooden deck looking out onto a rustic but neatly kept flower garden where blossoms adorn a gray picket fence. They lay next to a barbecue grill, some lawn furniture, citronella candles, party candles, bug spray, in the confines of Ruth Wall's Inman Park backyard.

MEAT MARKET

THE WAREHOUSE | The futures of Bill Arnett, Thornton Dial, and Lonnie Holley; of their art legacies; perhaps of the whole art genre they represent ebb and flow in the Arnetts' colossal warehouse tucked unobtrusively away in an industrial section on the edge of Atlanta. It is within this chaotic, overstuffed, fifty-thousand-square-foot-plus repository that curators, scholars, patrons, curiosity seekers, journalists, buyers and sellers, friends and enemies, influence the fate of art and artists represented there.

Within any arts subculture, there are restricted places where tastemakers gather to pass their judgments. They may hold court in the backroom of a SoHo gallery or in the curators' offices at the Museum of Modern Art or in the faculty lounge at Julliard or behind a talent agent's desk at the William Morris Agency or in an editorial meeting at Simon & Schuster, or an endless list of similar judicial-like chambers. This place, the Arnett warehouse, bears little resemblance to sophisticated arts enclaves. It is dingy, dark, and without air conditioning in the blazing summer (nor heat in the toe-numbing winter). Once someone stole the air-conditioning coils from the warehouse roof and hocked the copper content. Now the coolest place in the joint is the ceramic-tiled men's room. Look up. Water damage is evident in

the low drop ceiling. Look down, and buckets are strategically posi-
tioned on the concrete floor to catch the persistent drips. Some of the
Arnetts' collection is tilted up against the wall or strewn across the
ground; some of it does appear to be made out of rusted tin and rotten
wood or, at best, a bunch of stuff ready for the Salvation Army's pickup
bin. Most of what can be seen, though, stops warehouse wanderers
dead in their tracks. Even in the musty dimness, the art radiates a
power and message, a color and vibrancy that are at the same time
damning and exuberant; emasculating and empowering. Any
tastemaker stepping into this courtroom has their work cut out for
them. It is enough just to get one's mental balance in Arnett's archive
of art, no less make aesthetic decisions. But tough curatorial choices
are exactly what are required of the elite crew that assembles in the
Arnett warehouse during the blood-hot summer of 2003. Their mission:
determine which artworks by Thornton Dial are great and worthy
and which are not.

They are planning a 2005 retrospective of Thornton Dial's art
that, they hope, will at least rival the success of *The Quilts of Gee's
Bend* exhibition. They need it to be a blockbuster. Peter Marzio, Jane
Livingston, John Beardsley—the original squad that, in 1982,
mounted *Black Folk Art in America* at the Corcoran and, in 2002,
launched *The Quilts of Gee's Bend*—make up the core of the curator-
ial team, that is, besides the Arnetts. Bill Arnett is there. Paul, Matt,
and Harry Arnett are there too. David Gordon, director of the
Milwaukee Art Museum, is in the house as well. Gordon is a former
Economist magazine editor turned museum-man. His museum
recently hosted *The Quilts of Gee's Bend* and, for the moment,
Gordon is on Bill Arnett's "friend" list.

Bill Arnett has another list in hand on this particular day. It is a
long list of Thornton Dial art pieces that the curatorial team will eval-
uate. Arnett has developed the list into a rating sheet. The experts
move from piece to piece in the warehouse and grade each of Dial's
art creations on a scale from A to C. Actually, Arnett proclaims early

on, there will be no C's. Thornton Dial has never produced such a thing, he jokes.

Judgment Day begins. *Raggly Flag*—an old box spring that Dial has tilted on its side and painted and laced into a Sealy Posturepedic American Flag of sorts—receives mixed grades. For instance, David Gordon gives it an "A"; Marzio gives it a "B+." They move on. *Meat* and *Meat Market* both receive high marks. These sister pieces are gory red shocks of paint and cloth, in memory of the bodies and blood of Negroes for sale during slave trade days. Another work, in which Dial has encased a dead rooster, provides pause. Still, in this crowd Dial's art rarely receives a grade less than a "B" from any individual, and collectively most works average an "A" or better. Bill Arnett does not get upset about less-than-perfect grades. He is jubilant that such erudite guests are here with the same ultimate goal: to praise Dial, not to bury him.

Besides, Bill Arnett sees clearly that these people "get it." The curators are serious and professional. They are respectful of him and praiseful of Dial. When Arnett starts yabbering about conspiracies, these professionals ignore it. They don't agree. They don't disagree. They say nothing and avoid eye contact.

The group gathers in a room stacked with old quilts (which serve, in part, as seating) to look through box after box full of Dial drawings. Out the pieces come, one by one. Bill Arnett commentates in his role as master of ceremonies and Paul Arnett plays Vanna White. Neither Bill nor Paul Arnett is the center of attention, however. By now, it is clear that Peter Marzio is the alpha male of the crowd. Before responding, the other curators eyeball Marzio for his reaction and measure their responses accordingly.

Marzio sees a simple line drawing entitled *Woman with Green Eye Shadow*. He smacks his forehead in disbelief. "Ughh!" he groans in orgasmic pleasure. "Oh, Jesus Christ almighty," he grunts. It is like the Meg Ryan orgasm scene in *When Harry Met Sally*, but with Marzio not Meg. "I mean Gorky! Come on!" he shouts. The cumulative effect

of two hundred Thornton Dial drawings paraded in rapid fashion is hypnotic, exhausting, overwhelming.

Up pops a drawing of a woman with three vaginas. "One thing is certain; Jane Fonda would like these drawings," someone cracks. David Gordon gives a more sober assessment. He says, "It is like looking at the whole of modern art. I see Chagall, Picasso, Leger, Matisse, all of it." Now you're talking. These people, Bill Arnett likes!

PAPERS | It is mid-day, too hot, and everyone is famished. The group piles into cars and rides a few blocks from the warehouse to Commune, an ultra-hip subterranean restaurant featuring long thin tables, long thin breadsticks, and long thin waiters and waitresses dressed in fashionable black. Fizzy water is poured from sculptural bottles (long and thin). Tuna tartare is passed. The conversation turns from menus to art and then to art *business*.

The curators press Bill Arnett for details on his economic arrangements with artists. Harry Arnett, six months prior, left his job at an elite strategy consultancy to work at Tinwood for no pay. His job responsibilities now include jumping into discussions such as this and keeping his father away from the fire. "We've provided millions of dollars to these artists. We've taken a percentage and returned the majority," Harry vouches. He tries to answer as briefly as possible and move the conversation in a different direction. But even Harry cannot control Bill.

"What specific agreements are in place?" someone asks.

"Dial has an agreement from me that I gave him in 1987, but he's lost it. He has the paper from me selling him the house for one dollar. But he lost that too," Bill Arnett says.

No one is satisfied—least of all David Gordon. "Are you a dealer or a collector or what? It is not clear," Gordon shoots at Bill Arnett.

"No, it is not clear," Bill answers flatly.

Harry tries to save him again. "We've got two lawyers in Birmingham and two in Atlanta working on structuring what happens with the art in a way that will benefit the artists," Harry offers.

But now Bill goes into a tirade. He has had enough of this interrogation. He has done too much for his artists, for their art, for the whole genre, for the whole goddamn history of art; too much to take this crap. Peter, Jane, and John go silent and glaze over. They poke at their meals. Only David Gordon, a relative newcomer, plays along. Harry describes the Tinwood Alliance—a foundation formed to funnel revenues from *The Quilts of Gee's Bend* exhibition and ancillary products back to the quiltmakers. Harry says he has used other respected artist foundations as the model for Tinwood Alliance. But it turns out that two of the Tinwood Alliance trustees are buddies of Harry, and to the curators this trustee situation smells like conflict of interest. "The arrangement is too gray," Marzio says. Jane Livingston concurs, "What you are trying to set up is really murky, Harry. They'll sue you in a minute," though who will sue and over what are unclear.

David Gordon pushes further. He must know the Arnetts' *real* financial situation so that he can fend off their critics. He pleads.

"In the past, sometimes we took 100 percent and sometimes we gave 100 percent away," Harry says, trying to explain the loose family-like arrangement the Arnetts have had with their artist friends.

"You need documentation," Marzio says.

Livingston brainstorms, "It is important to get everything organized professionally. Maybe you do it under a nonprofit status, but you need to spell out your purpose very clearly."

Gordon urges, "Just start with a desktop-published brochure that describes the history of your efforts and of the artists. It is a great history."

Marzio finishes, "It is such an American story too."

"We owe $2 million and have four hundred thousand dollars in assets," Bill Arnett surrenders. "That's where we are. We borrowed $2 million to keep *Souls Grown Deep* alive. We pay more in interest than we bring in each month. In the last ten years we've sold art to hardly anyone: Jane Fonda and the Houston museum and sometimes to a few others. Financially, we're down the drain, and we have been

since *60 Minutes*. The Whitney paid zero for the Gee's Bend show, while we spent twenty thousand making it happen. The Whitney made over $2 million. We lost $2 million."

It all comes out of Bill Arnett's mouth fast, and no one completely follows the story outside of the Arnett family members at the table.

"Which entity of yours owes the money?" Gordon asks.

"The entity called Bill-fucking-Arnett," says Bill Arnett.

BILL ARNETT | Bill Arnett does not spend all of his time in the warehouse. He is often at home, in his corduroy recliner in front of the television or with a pad and pen and books. He is in his mid-sixties now, with disheveled black hair, a scraggly beard-goatee, puffy eyes behind inadvertently oversized glasses, black square-toe shoes, khakis and a "Gee's Bend" dungaree shirt hung loosely and untucked over his distended belly. Arnett is recovering from a multitude of illnesses, primarily diverticular disease in which small inflamed pouches bulge from weak spots in Arnett's colon. Arnett's diabetes is a continuous complicating factor. Refreshments during his time in the recliner include insulin injections followed by Diet Minute Maid Lemonade served in a plastic Big Gulp cup. The main course is a fiber-filled concoction of seeds and wilderness roughage created for Arnett on the spot by Bill's brother Robert, who is in town to lecture to Emory students about his vast knowledge of India. Later, after brother Robert is deep in another room of the house, Judy Arnett quietly takes the seed bowl away and in its stead she places a tray on Bill's lap loaded with a thick roast beef sandwich on a fresh Kaiser roll and a bottle of Diet Dr. Chek from Sam's Club. Nearby, Arnett's halitosis-plagued Labrador retriever Little Girl curls up beside an old wooden chair on which rests a handwritten sign, "Do not sit here, chair is broken." Balls of Little Girl's shedding hair roll across the kitchen floor like tumbleweeds. Lights hang out of their recessed cans in the ceiling and provide erratic, if any, light.

Arnett is on the phone talking with Thornton Dial. "Hey, Boss!" he says to Dial. And, "Hey Uncle!" Dial's studio is overflowing. Arnett will send John Ricker to McCalla to load pieces and bring them back to the Atlanta warehouse for safekeeping. As quickly as Arnett hangs up from Dial's call, the phone rings again. This time it is a call from New Haven, Connecticut. The caller is the daughter of a former slave whose quilts Bill has showcased in the Gee's Bend exhibition. He invites the ancient woman to the Whitney show. He hangs up, and now there is a knock at the door. It is the warehouse landlord, and he has made a special drive out to Arnett's home to collect two hundred thousand dollars–plus in excessively tardy rent. Judy cuts a check for him, but it is a tiny portion of the amount due. Big things are happening, Bill assures the property owner. There will be more money soon, he promises.

But a year later the landlord is tired of excuses. Also, the area around his warehouse is in high demand by speculators who want to tear it down to erect loft apartments and chic mixed-use properties. The landlord wants Arnett out for good. Lawyers descend. Dollars owed with penalties, according to Arnett, are pumped up to four hundred thousand dollars. Arnett must sign a document saying the landlord could get a court order to take over the art collection as collateral. He is backed into a corner, and so he signs. The lawyers make a few calls around Atlanta to individuals they know who may be interested in art like Arnett's. They want to see how much cash could be recovered for the landlord by selling off the Arnett collection. "I would never let it happen. I would get an arsenal of weapons and make it into a Waco. I wouldn't shoot at U.S. marshals, I would just blow the others away and plead temporary insanity," Arnett spits out.

"The reasonable man adapts himself to the world; the unreasonable one persists in trying to adapt the world to himself. Therefore all

progress depends on the unreasonable man," wrote George Bernard Shaw in 1903.

More than one hundred years later, sitting on a beat-up sofa in his Atlanta warehouse, Bill Arnett is asked what relevance this quote has to him. "Shaw wasn't talking about me. . . . I never met the man," he replies.

"If God put a gun to my head and said you've got to answer the following question truthfully and you've got to be right, and he asked, 'Is African American vernacular art the most important thing that's ever happened in American art?'" Arnett says, pointing a cocked finger at his head in a pantomime of blowing his brains out, "I'd say, absolutely it is the most important thing. I wouldn't even have any fear I'm gonna hear an explosion. I mean that. It's just my opinion. I may be wrong. . . . I may not be wrong. . . . I'm *not* wrong," he says.

"What's important about it to me? Why do I think I'm doing all this?" Arnett asks. Then he answers himself: "My detractors, they will say, "Bill is just a narcissist; he's self-absorbed; he's doing this for himself; he's gonna make a lot of money off this down the road; or leave it to his children . . . and they start ascribing motives to me that I don't recognize. Every person that has ever done anything and has had to work his ass off to do it is obsessive and compulsive. If you're not, then how you gonna get anything done, especially if what you're trying to do is push uphill? What am I doing? What I'm trying to do is just simply correct a history that is incorrect . . . period . . . end of story. That it happens to have racial overtones makes it all that much sweeter. Because prejudice—and that's prejudice against blacks, prejudice against Jews, prejudice against white Anglo-Saxon Protestants—is a heinous thing. It's what keeps the human race from being superior to dogs. I mean, I have a much higher regard for dogs. My favorite breed is Labrador retriever. Labrador retrievers are much finer mammals than humans are. They can't do as many things, but they got more sympathy and more class and more loyalty, you know. That's how I feel. Take the average human and the average dog, and I'll take the dog any day."

PETER MARZIO | Peter Marzio and Bill Arnett are no longer friends. The estrangement can be traced back to the meeting in Fonda's loft as a curatorial discussion digressed from art to art business, and then to Arnett's business. That evening, Peter Marzio was articulating his plans for the Arnett Collection once it was all relocated from the Arnett's Atlanta warehouse to a well-equipped one in Houston under the control of Marzio's museum.

"Our long-term goal has been to get the whole collection and a new building to go with it. The collection would have its own section *and* we would integrate it through the existing contemporary collection. I still think this is an inspiring and worthy approach. We could build a whole institute around documenting this art," Marzio explained. Big vision. So far, so good. Then the direction changed.

"My position is now as fragile as yours in terms of wanting to achieve something like this but having limited resources," Marzio said to Arnett. Instead of everything happening in one big move, Marzio suggested taking the Arnett Collection a bit at a time—per project. "I can afford the one-hundred-thousand-dollars-per-year, air-conditioned, well-lit warehouse space and a photographer to document everything and all the other stuff involved in making this happen all at once. The big nut is the purchase of the hard core of your collection. We could take it slowly and, in the meantime, you spin off and sell whatever art you don't intend to be in the institute we create," he said.

Bill Arnett was visibly taken aback. He believed Marzio had committed to taking the whole collection, not piecemeal over time.

"He tried to pull off a coup," Arnett says. "He was trying to get the collection for a song. It is not Peter. It is human nature," says Arnett, building steam. "That's the way corporate executives act, and he's like the CEO of a big corporation. For guys like Marzio, their pleasure comes in the game."

Months later, with the warehouse landlord still threatening to seize the Arnett Collection, the Museum of Fine Arts, Houston sent

an art moving truck—an eighteen-wheeler—to the Arnetts' storage facility to begin moving art to Houston. The long-haul driver was instructed by the museum only to take certain pieces back with him, not the entire collection. Bill Arnett was livid—the deal for the Arnett Collection would be all or nothing—and he sent the truck back to Houston as empty as it arrived.

"Marzio says I bite the hand that feeds me. I say that I feed the hand that bites me," Arnett says.

THE NEXT SHOW | No matter the widening rift between Bill Arnett and Peter Marzio, the Thornton Dial retrospective will take place in Houston as planned. Almost as planned, anyway. Instead of the show being a survey of Thornton Dial's entire body of art, the curators decide to target a less daunting though still massively ambitious project: displaying a selection of the best works created by Thornton Dial since the year 2000. They title the exhibition, *Thornton Dial in the 21st Century*. Opening in Fall 2005, the show would still include hundreds of pieces—paintings, drawings, assemblages, sculptures—taking up an enormous amount of territory in the brightly lit, ultra-contemporary Audrey Jones Beck Building at the Museum of Fine Arts, Houston. In a May 2005 press release announcing the exhibition, Peter Marzio declared, "Thornton Dial, Sr., is one of the great artist-storytellers of our time. Like the photojournalists of the 1930s, who documented the human toll of the Great Depression, or painters such as Jacob Lawrence, who witnessed the great migrations of African-Americans from the farms to the cities in the 1940s, Thornton Dial chronicles today's world, expressing the basic truths of modern life, from the perspective of a life spent in the deep South. He is a self-taught genius whose vision is that of a prophet or shaman."

JANE LIVINGSTON | Jane Livingston was listed in the press announcement as the curator for Dial's Houston show, along with

the museum's Alvia Wardlaw. Bill Arnett was described as providing assistance to the effort. "Many people had opinions about what should be included, but we needed one chief curator and Jane is it. She has the final say . . . which of course Bill will fight," said Peter Marzio just before the announcement. Livingston likes Bill Arnett, loves Thornton Dial and his art, but she has her work cut out for her. She is a tall, thin, serious woman with short gray hair; often clad in blue jeans and a light cotton shirt, she has a casual, approachable manner. "I've known Bill a long time, and he works in his own way," she says. "In putting on the Dial show I've got to assert my vision in the face of the whirlwind that is Bill Arnett."

PAUL ARNETT | Paul Arnett has his work cut out as well. He has the managing editor role for the book that will accompany the Dial exhibition. He has to wrangle his father as well as a host of other writers. Paul has worked with and edited some of the contributing essayists before. Tom McEvilley will provide his insights on Thornton Dial and his work. Amiri Baraka will share his thoughts too. But there will be new participants in the Tinwood venture this time, and Paul's work will be more challenging as he edits a broad array of writing styles and personalities and figures out how to blend the words and Dial's images into a cohesive whole. Among the contributors with whom Paul Arnett has never before worked is one with whom he, Bill Arnett, Jane Livingston, John Beardsley, and Peter Marzio must have assumed they would never in their life work. His name is Eugene Metcalf.

EUGENE METCALF | Eugene Metcalf serves as professor of interdisciplinary studies, Miami University, Oxford, Ohio. In 1982, Metcalf penned the most controversial of the *Black Folk Art in America* reviews, in which he essentially labeled the Corcoran show as racist and, as a result, slammed Jane, John, and Peter in the process. As for Paul and Bill Arnett, they had for years believed Metcalf was one of the conspirators against them. Making matters worse, he married Joanne Cubbs—

the first curator of folk art at the High Museum appointed by Ned Rifkin. Now, Cubbs too will contribute to the Dial book.

Metcalf is ebullient in his discussions about Thornton Dial and Lonnie Holley and about the whole of African American vernacular art. Having reformed his viewpoint since the 1980s, Metcalf now believes this art genre is exceptionally important and, therefore, it is critical for him to study it and issue his scholarly views on the field. "I have cleared my plate of other projects," he says. "I plan to devote years to this art."

JANE FONDA | There is a crowd gathering at Jane Fonda's loft apartment just off of Freedom Parkway in Atlanta, but Fonda is not at home. She is holed up in her New Mexico ranch where she labors away at her memoirs. Matt Arnett has run of the place since he and Fonda's daughter, Vanessa Vadim, now have a baby together. Matt escorts a curatorial group through the dimly lit, concrete hallway leading up to Fonda's place. Outside her doors, the cold industrial styling of the building melts away. Antique dressers buttress either side of her stainless steel front doors, and a tan Japanese mat lies in front of the entrance. The visitors pass through Fonda's vaginal foyer and into a bright and beautiful contemporary home. A multi-panel, multicolored Andy Warhol print series of Jane peers down at the gang. A half-dozen Janes stare out, mounted high on the wall, looking at the group as they look back at her and through her lair. Before leaving, the group will tour the entire loft; checking out everything from Fonda's shoe closet to pictures of her family on the shelf in her bedroom. One is of her mother, who committed suicide early in Fonda's life. Others are of her children. In fact, signs of her kids and grandkids are everywhere in the loft. A picture of Jane and her father Henry taken during the filming of *On Golden Pond* is proudly displayed.

Over the years, Jane has gone from "Henry's daughter" to lust kitten known as "Barbarella" to traitorous villain known as "Hanoi Jane" to movie star to aerobics guru to media mogul's wife to good

citizen and back to movie star again. Some things have stayed more constant. Though Fonda divorced Ted Turner in 2001, she stayed committed to other men in her life, notably Lonnie Holley and Thornton Dial.

In December 2001, the American Folk Art Museum opened a new $35 million building at 45 West Fifty-third Street in Manhattan. To commemorate the opening, Fonda donated a massive Dial painting entitled *Man Rode Past His Barn to Another Day*. She has been loyal to the women of Gee's Bend as well. On a recent Easter Sunday, Fonda traveled to the quilting enclave, dressed as the Easter Bunny, and hopped around to the delight of children and adults alike.

Fonda also remains on the side of Bill Arnett, though her initial infatuation with his creative passion has long faded. Frustrated by Bill's ongoing claims of unseen enemies, Jane Fonda commissioned Nancy Raabe, the former Birmingham reporter (who has since moved to Columbus, Ohio, and traded in her reporter's pad to become a part-time Lutheran minister) to investigate corruption in the folk art world and, ostensibly, to clear Bill Arnett's name. "Jane wanted to put to rest all these rumors that float around about Bill. She asked if I would write ten thousand words to set the record straight. It is supposed to be a piece that disputes the things said about Bill," Raabe says. "The idea is that Jane would send the article out to the ten thousand people on her mailing list. When someone attacks her for being involved with Bill Arnett, she would like to pull out a pamphlet and say, 'Read this, and if you have any more questions, call me.'"

But after visits to some Arnett antagonists in New York and Atlanta, Raabe put the project on slow boil. "No one is willing to talk," Raabe offers. "They pretend to know a lot, but when it comes down to it they really don't," she says.

Jane Fonda's own writing efforts emerge more easily. In the spring of 2005, Jane Fonda released her first film in fifteen years, *Monster in Law*, and at the same time, she issued her memoirs, *My Life So Far*.

Vanessa Vadim naturally figures prominently in her mother's book. Vanessa's daughter, Viva, is mentioned too. But Viva's father, Matt Arnett, can be found nowhere in the text (save for a tiny photo credit), nor is the baby's grandfather, Bill Arnett, mentioned.

MORLEY SAFER | Like Bill Arnett, *60 Minutes* correspondent Morley Safer is a fan of dogs, though whereas Arnett favors Labradors, Safer has a golden retriever by the name of Dora. Fondness for canines is where the common bond between Safer and Arnett ceases. Morley Safer is not a fan of Bill Arnett, though he won't condemn him either. "He brought the work of people like Charlie Lucas and Thornton Dial to a much wider world. It's a tough one. With many real scoundrels it's easy to condemn them. You can't do that so easily with Bill Arnett," Safer says.

Though Safer has reportedly considered doing update stories on Arnett and folk art, none have hit the air so far. However, Safer still consistently creates stories about the art world. He has done profiles of artists as diverse as devout Christian sentimentalist painter Thomas Kinkade, and the conceptual artist team of Christo and Jeanne-Claude. But Safer's "Yes, But Is It Art" reputation as a cultural cretin still haunts him. In 1998, the Museum of Modern Art refused Safer's request to film a segment about the MOMA's Jackson Pollock retrospective. MOMA director Glenn Lowry's rationale for rejecting Safer's offer: Safer's art reports are "drive-by shootings," he said.

JEFFREY FAGER | Jeffrey Fager left *60 Minutes* in 1994 to join the *CBS Evening News* as a senior broadcast producer and, after two years in that gig, he became executive producer where he stayed until he was tapped in July 1998 to launch *60 Minutes II* as that show's executive producer. In his six years running *II*, Fager and the show were victorious. In June 2004 Fager replaced Don Hewitt, the series' storied founder.

In just over ten years, Fager had moved from working on "Tin Man" to becoming the Wizard. But, on September 8, 2004, the curtain would be pulled back. That evening Dan Rather appeared on *60 Minutes II* to report that President George W. Bush received special treatment during the Vietnam War with a safe assignment at home in the Texas Air National Guard. There, according to Rather's research, Bush shirked his duties. Not too long after the segment aired, Rather's conclusions were found to be based on questionable research. The ensuing controversy led to Rather's retirement from the *CBS Evening News*, but he remains as a correspondent for *60 Minutes*. In September 2005, *60 Minutes II* was cancelled.

CHARLIE LUCAS | Charlie Lucas will no longer speak publicly about his interactions with Jeff Fager or Morley Safer or Bill Arnett or Mark Kennedy or about any aspect of his role in *60 Minutes'* "Tin Man" segment. "I'm under a gag order. I'm gagging myself," he says. "I don't want to get back into all that." The only thing Lucas will confirm is that, today, "If I make a dollar at least I know where it goes." Still, arts entrepreneurs continuously approach Lucas about representing his work. One is a young erstwhile musician from Selma now living in Brooklyn, New York, who has opened a Charlie Lucas art gallery in the third floor of his brownstone. Though the young man sees himself as Lucas's right hand—his business manager, his agent, his dealer, even his Web designer—Lucas hedges his bets. He will no longer rely on one source of promotion. Marcia Weber still sells Lucas's art at her Montgomery gallery. Southern Hub, an Internet coffeehouse and art gallery across from the civil rights museum in Selma, also reps the Tin Man. Collectors can even view Lucas's art at his very own Web site that contains a link to a place where you can buy his creations online.

Lucas has moved from his farm in Pink Lily, Alabama, to Selma in order to live next to Kathryn Windham Tucker, an elderly southern storyteller who frequently weaves her yarns on National Public

Radio's *All Things Considered* and at storytelling festivals around the country. She keeps a close watch on Lucas and the sculpture garden in his backyard. Pull into or out of Lucas's driveway on a day he is away, and Ms. Tucker is likely to shuffle out her back door—hunched over, white hair puffed out, raggedy bathrobe still on—to ensure that no precious items have been swiped from the Tin Man.

Bill Arnett believes that she is out to get him. He has heard that she has been in contact with a reporter from *Time* magazine and is encouraging the journalist to dig for negative influences Arnett may be having in Gee's Bend. Arnett bristles at the name Kathryn Windham Tucker as readily as he does at Charlie Lucas. "She is a storyteller. She tells ghost stories. . . . Most of her stories are autobiographical," Arnett deadpans.

In late 2004, *60 Minutes* considered doing an update on the "Tin Man" episode from over ten years earlier. A cub reporter contacted Charlie Lucas but found that not enough had changed in his situation; there wasn't enough current "dirt" to warrant an update segment. Lucas keeps busy, and things are pretty good. He is learning to read. He and his art are in moderate demand. The Rosa Parks Library and Museum in Montgomery has had a one-man Charlie Lucas show on display entitled *In the Belly of the Ship*. He is invited as an annual special guest and exhibitor at Alabama's Kentuck festival.

Lucas is also a regular exhibitor at Atlanta's Folk Fest—the world's largest folk art show and sale—where he is found one Saturday in August manning his own booth. He is clad in jeans, black baseball cap, and black T-shirt.

"How much is that?" asks a pale middle-aged man pushing his toddler in a stroller through Lucas's setup at the North Atlanta Trade Center where Folk Fest is held each year. The man is pointing at a set of rusty auto and bike parts—wheels and mufflers and nuts and bolts—shaped to resemble a man of sorts.

"That piece, three hundred dollars. But we'll make you a deal," Lucas says. Then, sensing the prospective buyer's reluctance, Lucas shifts into selling mode, whipping out his visionary banter.

"That a piece of art about Moses' power with the staff. He raises his staff and calms Pharaoh," says Lucas with one eye on the man and another on the man's child who has now escaped the stroller and is tenuously waddling around the booth. Lucas proceeds, "The wheel right there symbolizes my great-granddaddy who was a wagon wheel maker, and you know how the wheel keeps turning, life keeps turning." He goes on like this for five minutes. "This art's my life. My art is out there representing me," Lucas says in one breath, showing how authentic he is. Then in another breath he swings back to sales mode. "Believe me," he says, "you getting top-quality stuff here."

BESSIE HARVEY | Bessie Harvey cannot be found at Folk Fest. She cannot be found at Kentuck. She cannot be found anywhere. Bessie Harvey passed away in 1994, less than a year after the *60 Minutes* "Tin Man" episode aired. Her legacy lives on in the haunting root sculptures she has left behind, some of which remain in the Arnett Collection. Though Arnett and others agree that he and Bessie Harvey had reconciled prior to her death, there are still others who like to keep their feud alive.

RUMORS | During the fall semester of 2000, an undergraduate at the University of Oregon in response to an Art and Human Values class assignment created a satirical Web site entitled "Eat This Zine" in which he poked directly at the Harvey/Arnett conflict. In a page seemingly out of *The DaVinci Code*, the site's author places Bill Arnett as a low-ranking member of the Freemasons.

"Bill Arnett has spent the better part of his life fulfilling the Freemason's mission to keep certain outsider artists disadvantaged," the student's site reveals. "While at first it appears that he is actually helping the artists gain exposure, in actuality he steals works and offers crooked contracts to keep the artists poor. He hordes art work in his house away from the public's eyes and there is no telling how many pieces have been lost as a result of his systematic destruction of

the pieces." When it comes to Arnett's relationship with Bessie Harvey, the undergrad offers his presumably fictional opinion that "it seems plausible that Harvey did put a hex on Arnett." Then he continues. "One thing is known for sure: the punishment for harming a member of the Freemasons organization is severe, and Harvey's death was no coincidence."

When contacted about the lampooning Web site, the author claims a pseudonym and the need for anonymity. "I can't offer you much more comment," he says, "for fear of my safety."

FOLK ART | In many ways, the folk art field increasingly leaves itself open to teasing. Today, you can buy a Bill Traylor–design necktie over the Internet or order a piece of art from the now-deceased Howard Finster through the 800-number his family has arranged. As *The Quilts of Gee's Bend* exhibition tours the country it is accompanied by Gee's Bend quilt postcards, scarves, coffee mugs, and other replicas of American authenticity that are manufactured overseas. Through Tinwood, the Arnetts have inked a deal with former swimsuit-model-turned-fashion-entrepreneur Kathy Ireland to sell Gee's Bend–inspired products through stores like Kmart. The Arnetts plan to donate proceeds from the sale of Gee's Bend/Ireland products to the Gee's Bend Foundation, which will help develop a new arts center for Gee's Bend. Even the Arnetts' well-intentioned efforts leave room to be painted by cynics as another act of cynicism: white men teaming with a statuesque white fashion queen to market the wares of poor black women.

Pointing a mocking finger back at the field's commercialism, art professor Beauvais Lyons at the University of Tennessee has developed an entire fictional exhibition of folk art, *The George and Helen Spelvin Folk Art Collection*, which has traveled on a tour of U.S. cities. The pretend collection of outsider art by "imaginary folk artists" and owned by the fictitious middle-class white Spelvins includes velvet paintings, face jugs, painted records, and other mock creations.

Magazines, too, are jumping on the mockery bandwagon. In the summer of 2004, *ReadyMade* magazine printed an article on folk art with the stinging title, "You Too Can Be an Outsider Artist: Career Counseling for Losers." In it, the author indicates that if you are talentless but have ready access to "scissors, paper, pen, glue stick, ink pad—and a few items from around the house," you are on your way to outsider art fame. She offers tips on how to get started such as: "Draw a stick figure with tears falling down its face" and "Make squiggles that look like genitals" and "Gather several items from around the house and glue them to the page. Bonus points for including objects that make people squirm (your mother's underwear, strands of hair)."

It seems that, despite (or, the enemies argue, because of) the best efforts of Bill Arnett and others, the self-taught art world still struggles to gain respect.

MAXWELL ANDERSON | Maxwell Anderson spent three years after leaving Atlanta in Toronto as director of the Art Gallery of Ontario. Then, in mid-1998, Maxwell Anderson was recruited to become the new director of the Whitney Museum in New York. Catherine Fox printed an article in the *Atlanta Journal-Constitution* saying, "Frankly, I was flabbergasted when the Whitney Museum of American Art announced last week that Maxwell Anderson would be its new director." She implied that Anderson was vastly underqualified to assume the role. "But, upon reflection, it makes sense," she wrote. "The role of museum director has shifted dramatically over the years. Now, scholarly occupations are way down the list of priorities, superseded by fund-raising and schmoozing." As proof of Anderson's schmoozing skill, Fox wrote that he was "the only one in town who managed to develop a friendship with collector Bill Arnett." Arnett struck back in a letter to the editor, "Although Fox and I don't attend the same dinner parties, and although no one would ever claim that Fox has tried to develop any friendship with

me, I was nevertheless flabbergasted to learn in the Sunday paper that she's concluded I'm a social leper," he said.

Regardless of the lingering doubts in Atlanta and the initial ones in New York, Maxwell Anderson ultimately found some success at the Whitney. "This bad guy from beyond, a suave art historian, no less—let's call him Mad Max—came galloping into town, stormed the fortress, routed the rightful occupants, and hijacked the Biennial. Even more unforgivable, he reinvented it in the image of the show we always wished it was," Kim Levin said of Maxwell Anderson in the *Village Voice*. One of the artists that Anderson featured in the 2000 Biennial as indicative of the best working artists of the period: Thornton Dial.

The Quilts of Gee's Bend was another fortress-storming event at the Whitney Museum and for the New York art scene overall, and its New York exposure was due to Anderson. "The most ebullient exhibition of the New York art season has arrived at the Whitney Museum in the unlikely guise of a show of hand-stitched quilts from Gee's Bend, Alabama," gushed Michael Kimmelman of *The New York Times*. Record crowds surrounded the Whitney waiting to see Boykin's beauties. But, while many critics and audiences raved, the board of the Whitney Museum was less enthusiastic about Anderson's doings. Mounting a show of quilts by a bunch of unknown old ladies was just one of the points of artistic difference that led to what Anderson calls "epochal discomfort" between him and the board. The Whitney board of trustees, according to Anderson, preferred the museum to show artists that were already known and proven. "Gee's Bend didn't map to any notions the board felt were important. It didn't map to the commercial paradigm," Anderson says. "About six months before the Gee's Bend show launched at the Whitney, I was asked by the trustees if it was too late to cancel." In September 2003, the Whitney board and Maxwell Anderson agreed that it was time to part ways.

"What's next for me?" Anderson rhetorically asked at the time. "I am having so many interesting conversations, but I can't predict it.

I'm sure that I won't be directing an art museum in the near future. I think I will probably patch together a different type of career."

Currently, Anderson is a principal with AEA Consulting, a professional service firm serving cultural organizations. He is also a research affiliate of Princeton University's Center for Arts and Cultural Policy Studies at the Woodrow Wilson School of Public and International Affairs.

NED RIFKIN | Ned Rifkin would rather not mention Bill Arnett. "I just have no time or energy for someone who is so self-serving," he snaps. The Menil Collection in Houston needed someone to serve as director over its fifteen-thousand-piece collection of art from the Stone Age until modern times. They picked Rifkin, who arrived at the Texas museum in February 2000 in the hopes that he could carry on the founders' legacy and lift it to a new level, but Rifkin stepped into a political hornet's nest. A group of trustees were divided on strategic vision, and as a result, many of Rifkin's efforts at organizational advancement were rebuffed. One year after his arrival in Houston, the *New York Times* ran a story about the mounting Menil conflict, indicating that certain individuals close to Dominique de Menil believed "crassly commercial influences were intruding too insistently on the museum she left behind." Some of the Menil's supporters were also concerned about Rifkin's affiliation with the disgraced Enron Corporation, where he participated on the company's art committee.

Rifkin resigned from the Menil Collection and returned to his career roots, traveling back to Washington, D.C., to serve as the director of the Hirshhorn Museum and Sculpture Garden at the Smithsonian Institution in February 2002. This was a museum that fit Rifkin perfectly—the nation's museum, totally dedicated to sophisticated modern and contemporary art—centered in the power capital of the world. Rifkin found new energy at the Hirshhorn, and even the most finicky art critics noted his efforts. In August 2003 *New York Times* arts writer Roberta Smith reported on the

Hirshhorn's *Gyroscope*, a freshly mounted exhibition of its permanent collection. She called it a "meticulously considered installation," noted that it was "masterminded by Ned Rifkin," and proclaimed that, "A fresh wind with knots in the double digits seems to have blown through the carousel of the Hirshhorn."

By January 2004, the heads of the Smithsonian Institution were so impressed with Ned Rifkin that they named him under-secretary for art in addition to his role as director of the Hirshhorn Museum and Sculpture Garden, meaning that Rifkin would not only run the Hirshhorn, he would also oversee every art museum affiliated with the Smithsonian: the Freer Gallery of Art and the Arthur M. Sackler Gallery, which together form the national museum of Asian art; the National Museum of African Art; the National Portrait Gallery; Archives of American Art; Cooper-Hewitt National Design Museum; Smithsonian American Art Museum; and Renwick Gallery. By mid-2005, Ned Rifkin had become one of the most powerful men in the art world.

JIMMY ALLEN | Before exiting Atlanta, Ned Rifkin had enlisted several allies to help build the High Museum's folk art collection, anything to create a buffer between the museum and Bill Arnett. One of these allies was Jimmy Allen, who had been successfully "picking" antiques and folk art since the mid-1970s. Allen is one of the few who has accused Arnett directly to his face of exploiting artists. Once, after a High Museum symposium on folk art, Allen was so direct about Arnett's exploits that Arnett had to hold himself back from slugging the picker in the jaw.

In 1994, as Reverend Howard Finster progressed in age and his outdoor garden of art progressively deteriorated from exposure to the elements, the "Man of Visions" envisioned that he'd better sell off a chunk of his yard while the getting was good. Somehow, Jimmy Allen showed up at just the right time and bought up much of the reverend's garden. He then immediately flipped the collection to the High Museum for a tidy profit.

In 2000, the same year he won the Pulitzer for his article about Mary Lee Bendolph and Gee's Bend, *Los Angeles Times* writer J. R. Moehringer penned a feature for his newspaper about Jimmy Allen. In addition to skulking around the rural South for antiques that he could arbitrage, Allen has spent years collecting photographs and postcards that chronicled another remnant of the South's history: lynching. He compiled 145 photos from his collection into a book entitled *Without Sanctuary* and put 68 of the images on display in an exhibition by the same name. By the time of Moehringer's article, Allen had sold twenty-eight thousand copies of the lynching pictorial book at sixty dollars per copy, and the item had even spent time on the Amazon.com bestseller list. Crowds lined at venues across the United States to see the disturbing exhibition. Allen had stimulated a new dialogue about the meaning of the horrific act that was so commonplace through much of the America's history.

But not everyone saw Allen's *Without Sanctuary* as motivated by the picker's selfless desire to educate. Moehringer quotes African American scholars and historians in his article who imagined a different side of Allen. "He's not a saint," one of those quoted said. "I know why he did it. He did it because he's a dealer." Another said of Allen, "To commercialize the suffering of black people is to do the ultimate disservice to black people." What right, they asked, did a white man have to do this?

Jimmy Allen was hurt by these accusations. He was stunned that anyone would question his integrity. After all, he had been trying to help, not hurt. And the likelihood that he would see any profit from the enterprise—sixty-dollar book or not—was remote. Bill Arnett may have been glad that he never socked Jimmy Allen in the jaw. This form of ironic turnabout was much sweeter revenge.

THE HIGH MUSEUM OF ART, ATLANTA, AND BILL ARNETT | The Woodruff Arts Center has embarked on a $130 million expansion program, including the addition of 177,000 square

feet for the High Museum of Art. Bill Arnett and his sons have hit it off (for the moment) with the new curator of folk art at the High Museum, Susan Crawley, and the High has even agreed to be the last stop on the Gee's Bend exhibition tour. In the spring of 2005, for the first time in a decade, officials and major patrons of the High Museum visited Bill Arnett at his warehouse.

Despite this mild progress, Bill Arnett continuously claims to be moving away from Atlanta at any moment. For a while Arnett planned to evacuate to Houston until that relationship tanked. Then it was Birmingham, Cleveland, Boston, Dallas, or wherever else someone of substance in the art world began to show some appreciation for Arnett, his artists, and his mission. In recent years, that appreciation has become more frequent and visible. Tinwood's books have helped. The *Souls Grown Deep* volumes and *The Quilts of Gee's Bend* books have won various awards from credible organizations. When Arnett is asked to speak outside of Atlanta, his audiences receive him with great praise.

But in Atlanta, local art world participants will rarely comment about Bill Arnett on the record at all, much less with words of appreciation. Off the record, they begrudgingly admit to Arnett's impact on the world of folk art and its artists. They concede that artists like Thornton Dial and Joe Minter and Lonnie Holley and the women of Gee's Bend have received far more publicity than they otherwise would have because of Arnett's tireless promotion. They admit that, by recruiting serious supporters like Amiri Baraka, Tom McEvilley, Maude Wahlman, and others, Arnett has advanced the folk art field. They may even say that the *Souls Grown Deep* publications and other contributions from Tinwood Books are the most important works in the field of African American self-taught art and, perhaps, of all self-taught art—that their approach is scholarly and serious and not self-promoting, and that in these books Arnett treats the artists with the profound dignity that they deserve.

Yes, behind the scenes in Atlanta, even Bill Arnett's enemies will grunt that he has done some good, but none of Arnett's alleged villains

will go on record saying so. And even Arnett's supporters remain fearful to testify on his behalf, fearing retribution from his detractors or from him directly should they compose their praise imperfectly.

Atlanta has been a tough place for Bill Arnett. Still, no matter how much he talks about leaving the city, he has yet to pack the first bag.

RONALD LOCKETT | Ronald Lockett was just twenty-two years old when Thornton Dial began his official art career. Lockett had graduated from high school four years prior but never landed a steady job and still lived in his mother's home. Betty Lockett was a frail woman, not much of a role model. She had reportedly suffered two nervous breakdowns by the time Ronald had grown to manhood, and she was reclusive, perhaps agoraphobic. Ronald was physically slight and almost feminine in appearance compared with the sturdy, steel-working men that generally composed the Pipe Shop manhood. He was painfully shy and went mostly unnoticed. As his teen years passed, he grew intensely introspective. Paul Arnett remembers Ronald as "depressive, at times enervated, and intensely self-analytical." One thing kept Ronald Lockett going. He had always wanted to be an artist.

With his mother housebound and his father prone to violent outbursts, Lockett spent as much time as he could in the presence of Thornton and Clara Dial. They were his surrogate parents. He learned about making things from watching Dial. He learned how to paint by watching PBS television's Bob Ross. Ross's world was an ever-joyous and beautiful one. On his television program he told viewers, "We want happy paintings, happy paintings. If you want sad things, watch the news." Lockett had a knack for painting "happy little clouds" and "happy little creatures," but when he left the hypnotic glow of the television, Lockett's landscapes morphed into a hybrid of Bob Ross critters scurrying across the apocalypse.

Bill Arnett wasn't sure about Lockett and his art. Perhaps Arnett thought him too unstable. Perhaps the Bob Ross touches left Arnett cold. Judy Arnett, however, had a warm spot for Ronald Lockett. She

encouraged him, and he called her "Mama." With this small nudge, Lockett redoubled his efforts to become an artist and to prove his talent to Arnett. Thornton Dial remembers, "He told me, 'I'm going back to school for art.' I said, 'Man, you don't need to go back to school for no art.' I said, 'You can make art yourself.' So he would have went back to school but Mr. Arnett accept him and when he accept him, Mr. Arnett went to give Ronald a little something, some money, for what he did. Mr. Arnett really didn't want Ronald but he took him on after Judy told him. She said, 'Try him, Bill.'"

"We got him into making art," Bill Arnett recalls. "His whole life changed. He started traveling to New York and different places, and people started coming to him and he loved it. He loved it. Then he got into drinking and drugs and women and maybe other things. I really don't know. He never let on. People started going to him regularly and telling him how he was the best artist of them all and how I was mistreating him and they were bringing him whiskey and he would be drinking. He just turned to shit as an artist." But there may have been something else haunting and debilitating Lockett besides his penchant for drink. In 1994, he learned that he had been infected with HIV.

"He called here essentially every night," Arnett says. "He's drunk every night, he's calling and saying, 'Mr. Arnett, I just wanted to tell you if it wasn't for you and Mrs. Arnett I wouldn't be nothing. I would be nobody.' I mean it was sad. I couldn't deal with it. When I just couldn't talk to him anymore I'd put him on with Judy. So I would let Judy get on the phone. She would talk all night with him."

Ronald Lockett died of AIDS-related pneumonia in 1998.

LONNIE HOLLEY | The Birmingham Museum of Art's multi-level sculpture garden is home to a select assortment of plants—dogwoods, azaleas, magnolias, boxwoods—and an even more select display of three-dimensional art by internationally known artists like Fernando Botero and August Rodin. In the summer of 2003, a

unique visitor inhabits the lowest level of the garden—the sunken, gravel-floored outdoor gallery space. The guest is Lonnie Bradley Holley. Despite the sweltering heat in the garden, Holley feels a calm that comes only from long-overdue recognition. "Jesus himself testified that a prophet has no honor in his own country," Lonnie Holley once said, quoting scripture but referring to his own treatment in Birmingham. After Holley has spent nearly twenty-five years creating art in his hometown, the Magic City's leading art institution finally honored Holley with two major events showcasing his talents. For the first event, titled *Perspectives 8: Lonnie Holley*, the artist filled the Lower Gallery of the Birmingham Museum's sculpture garden with the contents of a dumpster hauled from a junkyard. He shaped the material to his will and transformed the pit into a recycled wonderland.

"We waste so much. Can we really, really look at what we're wasting?" Lonnie Holley said one day while *Perspectives 8* was still in process. "This is really a project to kind of teach about reusing things from the elder part of Birmingham because Birmingham been an industrial city and the conversation is all about the industrialism from the beginning to the very, very end, but it's not the end. I think what we're doing is a technical transition: coming out of the industrial to technical. If we just look at the materials that we have mined, materials in the sense of having power to go the next level," Holley said.

"The next level is actually where I'm trying to take them to down here. You got to come and look down on the pit. The pit, it's almost like Shadrach, Meshach, and Abednego going down in the pit and the Spirit being down in the pit," Holley said. "This is biblical," he added. Holley is right. In the book of Daniel, an angry King Nebuchadnezzar tosses Shadrach, Meshach, and Abednego into a pit of fire. "Then Nebuchadnezzar came near to the mouth of the burning fiery furnace, and spake, and said, Shadrach, Meshach, and Abednego, ye servants of the most high God, come forth, and come hither. Then Shadrach, Meshach, and Abednego came forth of the midst of the fire," Daniel notes. A miraculous survival, like Holley's

own. He pays honor to the miracle that got him here. He pays honor to his ancestors who paved the way. Birmingham was built on the backs of men sent into fiery iron and steel furnaces, and Holley believes that he is paying homage to them by taking their discarded creations and giving that refuse another life. "Yeah, but this is biblical," Holley repeats. "So we're talking about three humans being in the pit and then the Spirit in the midst. So this is the same thing. The materials. The materials is in the sculpture pit, but the spirit of the maker is in the midst."

While *Perspectives 8* was still in Birmingham, Alabama, installed in the museum's outdoor Lower Gallery, another demonstration of Holley's prowess opened across the Atlantic Ocean, mounted inside the Ikon Gallery located in an old school building in Birmingham, England. *Do we think too much? I don't think we can ever stop: Lonnie Holley, A Twenty-Five-Year Survey* was the first retrospective of Holley's work and the first solo Holley show to take place outside the United States. The exhibition attempted to show the full span and scope of Holley's career—from his early sandstone works like *The Mystery of the White in Me* (an image carved in two tones, black and white) done in 1983 to his more current assemblages like *The Pointer Pointing the Way of Life on Earth* (in which the pointing arm of a black lawn jockey is adorned with roots and chains) completed in 1997. After a two-month run in England, *Do we think too much?* returned to the Birmingham Museum of Art (which has cosponsored the exhibition) for a four-month stint.

Art in America, one of the premier magazines that chronicle the national art scene, devoted a feature article in its May 2004 issue to Lonnie Holley's two exhibitions. "Last summer in the walled garden of the Birmingham Museum of Art, Lonnie Holley turned a dumpster full of junk into dozens of striking sculptures," wrote journalist Raphael Rubinstein. "Let's hope that in the wake of this exhibition and a survey show — at Ikon Gallery in Birmingham, England, and scheduled to come to Birmingham, Ala., his work, which is too often

restricted to the ambience of vernacular or Outsider art, will become more widely seen." With Rubinstein's well-wishes, *Do we think too much?* arrived at the Birmingham Museum of Art during the fall of 2004 to Lonnie Bradley Holley's great hopes.

As part of these dual Lonnie Holley events, the two Birmingham art institutions published a seventy-eight-page full-color catalog covering the sculpture pit installation and the retrospective. It is the first time an art publication is solely devoted to the work of Holley. Add to that honor a documentary film about Holley that would premiere at the opening of his retrospective in Birmingham, Alabama. The film, entitled *The Sandman's Garden*, tracks the artist's development of the *Perspectives 8* sculptural environment in the Lower Gallery.

On a Thursday evening in mid-October 2004, the Birmingham Museum of Art hosted an opening soiree for Lonnie Holley's retrospective show. On the ground level of the museum, a crowd took its place in a darkened room, and the film *The Sandman's Garden* played to start the evening's festivities. Lonnie appears, larger than life. Unlike his days watching the drive-in from the McElroy's rooftop, this time he is the star projected on the movie screen. In addition to the wide array of Holley's art shown, Holley has virtually written the documentary's musical score. Throughout the film, he can be seen and heard playing an electronic keyboard and singing along with improvised lyrics and a soulful voice as he bobs to and fro with dark sunglasses like a young Ray Charles. David Moos—the Birmingham Museum curator who orchestrated both *Perspectives 8* and *Do we think too much?*—is also given ample airtime on the film. Larry Crenshaw, a fifty-something with thinning gray hair and the easy, relaxed manner of a country squire, is also a regular commentator on the screen.

With the film completed, after Holley took his bows and the audience finished applauding, the auditorium crowd headed upstairs to the open hall outside the museum's cafeteria where a feast has begun. The décor is harvest theme: orange and brown and maroon southwestern-

patterned tablecloths, orange carnations, bundled branches tied with cornhusks. There is merlot and chardonnay and Bud Light and cut fruit and cheese and hummus and other earthy munchies for the hungry art lovers. Then the entertainment begins. First, a belly dancer swivels her tummy around the room as her black and silver tassels jiggle with her bosom. Next, a group of African dancers grace the floor to the beat of a nearby bongo drummer. The patrons are stirring, mingling, knocking back booze, lining up for the buffet.

Almost no one steps away from the festivities to walk upstairs to the top floor of the museum where twenty-five years of Lonnie Holley's art is waiting to be seen. Up there, the shimmering black and tan of Holley's sandstone faces look out on the empty room, serene, sublime, and haunting. Their spirits escape the gallery and float down the shiny museum corridors to the other side of the building where two-thousand-year-old fired clay Mexican masks, Nigerian carvings, and Native American totems hear the call and echo back. The sandstone calls out again, and this time, from elsewhere, a Madonna and child—fifteenth-century, Tuscan—feel entitled to join the aesthetic chanting. And again Holley's silicon faces sing. This time, the response comes from a black-and-white Walker Evans photo of a rundown shack in Depression-era Alabama plastered with advertisements for Coca-Cola and Grove's Chill Tonic and Bromo Quinine.

Not a human soul is in the hallway to intercept the exchange. And then a group of middle-aged women appear. They are plump, white, southern, and curious. They walk around the Holley exhibition in confusion and ask, "Where is the art?" They see *Cold Tittie Mama*—Holley's industrial-age metallic mother—and blanch at the title. They see wood, sawdust, patchwork quilts, bent wire, rags, and—to them—junk. The women approach a painting that Holley has named *Caught Up in the Spirit*. They like the title, got a bit of the Lord in that one. The museum describes the work as "a joyous and colorful painting paying homage to divine inspiration and the process of artistic creation."

For a moment, it appears, these Junior League castoffs may be won over.

"That's not bad," one says.

"Where would you hang something like that?" her friend asks.

Pause. Scratching of the head. And then a firm answer before moving on: "You wouldn't."

Lonnie Holley does not see or hear the women in his museum galleries. He is elsewhere. He is the man of the evening. He is Vulcan, the god who was once crippled and outcast but through his work showed his heart. He is Birmingham's Ole Luk Oie, the Sandman, the weaver of dreams, capable of traveling in more than one world. Soon he will hop a bus with a different bunch of ladies, ladies who appreciate him fully. Ladies who share his love of beauty in old materials, though their medium is fabric: quilts. As he rides next to his newfound Gee's Bend mothers, Lonnie will reach into his bag and perhaps bring out pens, pencils, or maybe even sandstone. He will accompany the women to their quilt show openings, sprinkling dust as he cheers them on. He will participate alongside them in educational programs to help children create art. And for the women and the children and anyone else in listening range, Holley will tell his tales so that they may see what he sees: the beauty in everything.

METAL, MONEY, AND IRON | The film about Lonnie Holley entitled *The Sandman's Garden* is the creation of Arthur Crenshaw. Arthur Crenshaw's father, Larry, has dedicated a significant amount of personal energy to the advancement of Lonnie Holley and his art. He has helped to fund Arthur's film about Holley. He helped ensure that Holley stayed on track in his efforts with the two exhibitions, traveling with him to England. Arthur's mother, Cathy Sloss Crenshaw, can also provide extraordinary financial resources to support Lonnie Holley's artistic endeavors. Like Holley, Mrs. Crenshaw is highly focused on recycling in a different sense. Her expertise is urban renewal—facilitating the lives of cities, especially of Birmingham.

Cathy Sloss Crenshaw spends her days as president and CEO of the Sloss Real Estate Group, a company that redevelops old buildings in Birmingham into thriving mixed-use properties.

Her role makes sense because it was, in fact, the same Sloss family that initially drove the building of the Magic City in the late 1800s as a partner of Bessemer's founding father, Henry Fairchild Debardeleben, in the Pratt Coke and Coal Company. The Sloss family also had their own massive blast furnaces for the production of iron. Today, Sloss Furnaces is open to public view. The old blast furnaces now give shelter to workshops, exhibitions, conferences, studio facilities, and children's programs to encourage the creation of metal sculpture through Sloss's metal art program. On its Web site, Sloss Furnaces bills itself as "a museum of industry which speaks to the contributions of the working men who labored there. With its massive furnaces, web of pipes, and tall smokestacks, it offers us a glimpse into the great industrial past of the South and our nation." Briefly, only in three sentences to be exact, is it mentioned that much of that industrial empire was built with black convict laborer's hands.

THORNTON DIAL | Thornton Dial attends a gala event at the Fox Theater in Atlanta—a restored 1920s Shriners' temple turned movie house. Former Atlanta Mayor and UN Ambassador Andrew Young is on hand; other notables, too. A stunning young African American woman named Precious who is overwhelmingly perky escorts Thornton Dial into the Fox's grand ballroom. Dial is clad in suit and tie and is not so perky. A frizzy-haired photographer with the finesse of a blowtorch stalks him. Dial shakes hands with one big dog after another, whoever Precious can wrangle, while the photographer is in pursuit. She shoots pictures and auto-advance rapid fire click-click-clicks sound against Dial's skull like water torture. He looks down, doesn't say much. "You need to open your eyes," the photographer shouts to him in a grating nasal Long Island screech. "Your eyes are closed in all these pictures. Come on. I need one more!" Dial shoves

his hands deeper into his pockets. He cooperates but cringes. He wants to go home.

Home is not providing much relief these days. Clara Mae's health has deteriorated. She is hanging on, but it doesn't look good. Dial needs her help, and she can't provide it the way she once could, if she can help at all. He needs Clara's help with the taxes, with the Internal Revenue Service that has been after him for over ten years for apparently more than two hundred thousand dollars. The Dial twenty-acre homestead in McCalla, Alabama, is still owned by Bill Arnett, and the Dials have been living there rent free since its purchase; this housing benefit, according to the IRS, is akin to income for which Dial must pay tax. "He has a huge IRS penalty because of what they thought he was getting: $250,000 in free rent," explains Harry Arnett. "I don't know how it happened, but you should know that Ned Rifkin is on the art advisory board of the IRS," Harry feels compelled to add.

This is a tough time also in America, and Thornton Dial records the country's biggest challenges in vivid color on massive canvases. After the contested 2000 election put George W. Bush in the White House, Thornton Dial commemorated, in paint and organic materials, the electoral bungling and its end result. The primary ingredient in this piece is okra, a common ingredient in southern cooking and the slimiest of vegetables. Believing that George W. slid into the presidency in suspicious fashion, Thornton Dial named the painting for both the questionable event and the okra's consistency. He calls it *Business on the Slippery Side.*

Less than a month after the tragedy of September 11, 2001, Thornton Dial visited Ground Zero in lower Manhattan. When he returned to Alabama he produced a powerful series of paintings about the experience. *Reaching Out with Love and Fear* is one result in which a tiger, a man, and a hippo touch each other across a smoky background of destruction.

Despite it all, Thornton Dial's still deeply believes in the promise of freedom, the American promise. "I have seen the Negro next to the

mule, used like a farm animal. I seen cruel things like that," Dial remembers. "A grown man should have not been handicapped that way. He should be able to fight for his freedom to say, 'Yes, I will do because I want to do.' Black folks know what they got to do to live, and they will do it, they will work hard as they know how, as hard as the next man, by the sweat of their own brow. They want to have their own strategy for working, to use their own energy and spirit the way it come to them to do it, not to do something because someone else make you do it. That's freedom. My art is the evidence of my freedom. . . . All my pictures mostly be about freedom, somehow," Dial says.

The Freedom Park Conservancy finally scheduled a date for the unveiling of Dial's tribute to John Lewis, *The Bridge*, though it is unlikely that Thornton Dial would show up for the event. His statement has already been made, and he has moved on to other projects. Like getting ready for his retrospective show in Houston, or collaborating with freedom fighter Nelson Mandela on a series of lithograph drawings that honor struggle and victory. "We pledge ourselves to liberate all our people from the continuing bondage of poverty, deprivation, suffering, gender, and other discrimination. Never, never, and never again shall it be that this beautiful land will again experience the oppression of one by another. . . . The sun shall never set on so glorious a human achievement," Nelson Mandela has said. Thornton Dial seconds that.

Thornton Dial works in clusters—in fits and starts—with surging high points that tumble back to earth with a crash. Then, when the energy wave returns, he finishes the works, usually several pieces evolving at once. Though he would be seventy-seven years old when his retrospective launches in Houston, Thornton Dial's creative surges are getting stronger. "Every time I go to see Dial I can't believe how much is going on," says Jane Livingston. "He is so physically slight, but so ambitious. Now that Dial feels the reality of the upcoming show, he is energized," Livingston says. There are many cases of

artists who flourish early but can't sustain the effort. Dial, Livingston says, keeps getting better.

———————

Clara Mae Dial died on August 11, 2005.

Several days later, Bill Arnett answers his cell phone from the deck of a deep-sea fishing boat motoring in the Atlantic Ocean off the Georgia coast. He tells the caller that the Cloister on Sea Island has invited him and several of the women of Gee's Bend to visit. The site of the G8 Summit in 2004, Sea Island and the Cloister are better known by southern Jews and African Americans as formerly restricted environments where "No Dogs, No Jews" signs once hung from the elegant walls and the only blacks on the property were most likely to be found trimming hedges or carrying bags. On this summer day in 2005, the now–politically correct facility has given its invited guests— a southern Jew and a bunch of geriatric African American women— full use of a fishing vessel to plumb the depths of the salty seas.

As Arnett talks to his caller, he occasionally breaks away from wireless dialogue to shout things like, "Mary Lee, you got it! That must be an eighty-pound stingray you caught! Wow!"

And, then, turning back to his mobile conversation, Arnett's caller discusses the fact that Ruth Wall has been making phone calls to any-one who might have influence with the Dials and Arnetts in hope of luring Thornton Dial to Atlanta. She is desperate to get Dial to attend the unveiling of *The Bridge* on September 9. She says that she secured an allocation of fifteen thousand to twenty thousand dollars from the Department of Transportation budget for the John Lewis Plaza project to give to Dial if he shows up. They'll be able to justify the payment as "supervising the installation" of *The Bridge*. Wall says she called the Dial house a few days ago and someone answered. She asked for Mrs. Dial. "How's Mrs. Dial?" she said in her syrupy way. They hung up.

Bill Arnett snaps out heated instructions to his caller, "You tell Ruth Wall that there's no fucking way Dial is going to that opening. First of all he's in mourning, for God's sake! Second, you tell Ruth that Mrs. Dial would never have let him go." Then Arnett takes a break again to observe the action on deck. More fish and stingrays are caught and flopping on the deck. A shark breaks loose from the fishing line. Groans of disappointment and laughter mingle in the sea spray. Arnett puts the cell phone to his ear again and speaks this time in a calm, matter-of-fact tone, "About the money. Tell Ruth Wall to take the check from the D.O.T. and put it in an envelope." Long pause, his tone still light and friendly. "Then, tell her to cover the envelope in Vaseline, fold it up, bend over, and shove it up her own ass."

Thornton Dial's epic sculpture *The Bridge* was unveiled in Atlanta's Freedom Park on September 9, 2005. A high school band serenaded local dignitaries who gave long, glowing speeches as the crowd melted in the noonday sun. Ruth Wall was there. So was John Lewis. Former Atlanta Mayor and UN Ambassador Andrew Young was there. So was current Atlanta Mayor Shirley Franklin. "Thornton Dial and John Lewis are side-by-side soldiers in the ongoing struggle for human rights," they said. Applause. "Two heroes," they said. Louder applause. A massive black tarpaulin was yanked off the forty-two-foot-long black sculpture which now included the four disputed pieces Ruth Wall had stashed in her backyard. The audience cheered! No members of the Arnett or Dial families were in attendance.

Just two weeks before *The Bridge* dedication, Hurricane Katrina struck New Orleans and nearby environs with devastating rains and winds topping 140 miles per hour. The Gulf Coast lay in ruins, partially submerged. Frantic evacuees jammed highways heading to the closest big city that could accommodate them: Houston, Texas. By September 21, 2005, the Katrina traffic to Houston had subsided

enough for Thornton Dial, Bill Arnett, and their families along with
Lonnie Holley, Mary Lee Bendolph, and several of her quilting companions from Gee's Bend to travel by bus from McCalla, Alabama, to
Houston in time for the opening of *Thornton Dial in the 21st Century*.
Only trouble was, Hurricane Rita had arrived just in time too, forcing the Arnett bus to turn heel upon arrival and return home in
bumper-to-bumper traffic, stretching a tolerable twelve-hour drive in
to a torturous thirty-hour one. Museum closed. All events cancelled.
Houston evacuated.

If art could flee its home, the Chagalls, Miros, Picassos, Matisses,
Degas, Monets, and their surrounding framed friends on the second
floor of the Audrey Jones Beck Building at the Museum of Fine Arts,
Houston might also have jumped in an SUV and hightailed it inland,
their desire to escape caused not by the hurricane outside but by the
artistic weather front brewing downstairs. Muscling its way through
six separate gallery areas on the first floor were an army of Thornton
Dial paintings, drawings, and sculptures that pulsated furiously off
the shiny wooden floors and pristine white walls. The refined art
upstairs had never experienced neighbors like this. This art did not
look like they did, not even the most contemporary of the second-
floor works. To them Dial's art was renegade, dangerous . . . subversive. "Good God, don't let that *ordure*, that *fumier* move upstairs with
us!" the French landscapes might have sneered, covering their blatant
fear with a varnish of disdain. Even in the evacuated museum spaces,
Thornton Dial's works grabbed at the air—painting and sculpture
melded together like raucous, half-breed troublemakers moved in next
door. There was no call and-response down the halls of this museum.
There was only attack and cower. The white marble sculptures down
the hall heard the moaning and laughing and suffering and celebrating mixing together in Dial's galleries, and they turned to each other
and shrugged, with a look of "gotta get outta here" in their carefully
carved eyes. Whatever it was in those other galleries, it spoke a different language and certainly not a fluid romance one that tumbled off

the tongue like a sonnet, but rather one that spat out like venom. Made of everything from cow bones to crockery shards, from okra to stuffed animals, it was heavy and half the time looked like five paintings layered on top of each other with jagged edges lashing out. Even the titles were menacing: *The Blood of Hard Times, Valley Creek Disaster Area, Shacktown, Looking for the Taliban, Ground Zero: Nighttime All Over the World.* Rumor spread among the still-life paintings that some of the Dial pieces, one called *Setting the Table* and others that carried the words "Strange Fruit" in their titles, were at least based on an Academy-approved mid-1800s American still life. While these Dial paintings would never be up to European standards, the still life works upstairs agreed, perhaps the artist's attempt at an appropriate topic indicated some common ground? But then another rumor spread, started by the manic-depressive portrait *Suicide of Lucretia.* Lucretia said that "Strange Fruit" had been the title of a Billie Holiday song about lynching. The song "Strange Fruit," Lucretia told the portraits hanging near her, had lyrics about "Black bodies swinging in the southern breeze/Strange fruit hanging from the poplar trees." All hope was lost, the entire second floor agreed. If only they could jump off the walls, into a car, and onto the freeway. Perhaps the Dallas Museum of Art would give them shelter from the impending storm.

On October 14, 2005, a Southern Stages coach stocked with candy and colas and Dials, Arnetts, and Pettways pulled up in front of the museum in Houston. Bartenders and jazz musicians, wealthy patrons and curious museum members greeted the bus travelers as they entered. A documentary film crew from Alabama Public Television that had been tracking Thornton Dial for over a year dogged him as he walked slowly, smiling, through the galleries. The artist wore a maroon suit, white shirt, and black tie. He moved easily, betraying no discomfort, if he felt any, at the gushing attention and praise. Mattie, Richard, Dan, and Little Buck stood close by his side. Bill Arnett was nearby as well, clad in a charcoal-gray pinstripe suit, dress shirt, and tie. Everyone looked at ease, pleased. On his way

from gallery to gallery, strolling past a bronze statue of Hercules carrying the world on his shoulders, Thornton Dial too made it look like he had done this all before.

———————

Standing at a distance from Dial and Arnett, in another part of the sprawling exhibition, Peter Marzio looked less certain and less at ease than the rest. He had been surprised at how magnificently the show turned out. He knew it would be good, but having only seen Dial's art in the dark confines of the Arnetts' warehouse it was hard for him to know for sure. He recently told Bill Arnett as much, though it was still too late for Peter Marzio. Marzio was already on the Enemies List. But it was not Arnett's acceptance of him that worried Marzio as he stood among the gallery guests. It was the public's acceptance of the art of Thornton Dial that had him concerned. "I don't know," he says, looking around at the museum members who wander the exhibit. "I think it is just hard for people to get it. Oh, they'll tell me they like it and they'll be polite, but they won't say what they really think," he says. "Because of my background being involved in the civil rights movement and my history of doing shows that break the race boundaries, a lot of people may dismiss this. They'll say, 'Oh, that's just Peter indulging himself. Let him get it out of his system,'" Marzio says. "People coming into a room full of Dial's work is like having them go into a room where others speak a different language they've never heard before. It sounds like jumble to them, so they immediately cast it off as unworthy," he adds.

Language is, in fact, at the heart of the problem faced by Peter Marzio. Some believe that in the world of art intellectualism, worthiness is no longer about the image as much as it is about the words used to describe the image. "Frankly, these days, without a theory to go with it, I can't see a painting," wrote Tom Wolfe in his satire of avant-garde art and art-world tastemakers, *The Painted Word*. Theory

and words matter to the world that Peter Marzio must convince. Marzio hasn't yet found the words. He would go to New York one week after the opening of Dial's Houston show and give a press conference about *Thornton Dial in the 21st Century*. He would project images of Dial's work onto a screen for an audience of art writers for the world's leading publications, but looking at Dial's art on a screen is no match for the real thing—and even the real thing may not win the critics over if they can't look long enough and in the right way. Looking at Thornton Dial's art carries the same risk, for instance, as staring at the sun too long. It is beautiful and powerful and at the same time so strong, so intense that you fear it may burn out your retinas—or your soul. Without the right words, the audience and critics may turn away too soon. In New York, as on this exhibition opening night, Marzio would try to weave a story that may or may not move those listening to praise Dial. Peter Marzio is skeptical of his ability to succeed at this.

Not twenty feet away from Peter Marzio that evening stood a fifty-something woman with short silver hair and glasses. She is in the room dedicated to Dial's art about the September 11, 2001, tragedy. "Struggle and survival," she says. She has never seen Thornton Dial's art before, but has been immediately moved by it. "This exhibition is so timely given what the hurricane in New Orleans is revealing about the struggle and suffering that had been going on there without prior notice. We live in a throwaway society. This art speaks to that," she says. Perhaps someone *will get* Dial's work after all. But, then again, not twenty feet away from her, *others* walk around the gallery in a daze, clustered, whispering among themselves. The words "interesting" and "different" are mumbled, but not in a flattering way. The words are stretched out to emphasize the speaker's confusion, uncertainty. Should they like this stuff, or shouldn't they? The most that can be mustered is a noncommittal, "I can't really comment on it right now. Overwhelmed. That's the most I can say. I may need some time to think about it."

Upstairs, a VIP reception and seated dinner in the Sarah Campbell Blaffer Foundation Gallery begins in honor of Thornton Dial. Mary Lee Bendolph and Arlonzia Pettway of Gee's Bend kick off the evening by singing a gospel tune. Mrs. Pettway believes they are to sing "Don't Want Nobody to Praise Me When I'm Gone," which is Thornton Dial's favorite. But Mary Lee Bendolph, wearing her best black dress, white lace collar, and pearl necklace and earrings, waves that tune off like an embarrassed schoolgirl. She doesn't want to seem too forward. "Because they've been trying to fix those two up," Mary McCarthy whispers, "those two" being the widow Bendolph and the widower Dial. Instead, the Bendolph-Pettway duet belts out "I'm Going Home" in gorgeous a cappella voices that get the crowd swaying and clapping along. Later, Mary Lee Bendolph will roam from table to table collecting all the blue silk ribbons used to hold the dinner napkins. Soon after arriving back in Gee's Bend, she will make them into a quilt honoring the occasion.

Bill Arnett introduces Thornton Dial, who walks to the podium during a standing ovation. "I really appreciate Mr. Arnett. He a good man," Dial starts off. "He did a wonderful job for us. I didn't really know too many white people before Mr. Arnett, and I was scared of them," Dial goes on. Then he retells the story of his first encounter with Bill Arnett and the "Sandman" and how they were his saving graces. How, before they came, things were so bad but the spirit of his dead daughter Patricia had come to him and told him not to worry, that things are going to be okay. How Bill Arnett was Patricia's prophecy come true. Like a seasoned raconteur, Thornton Dial has the crowd in his grasp; when he finishes they give him another standing ovation.

As the museum celebration draws to an end, Matt Arnett, looking handsome and bohemian, hair moussed, wisp of a goatee sprouting, orchestrates the logistics of the bus ride to the hotel. He is like a charming steward making sure everyone is comfortable and safe and happy. Tomorrow he will escort Mary Lee Bendolph and several

other Gee's Bend quilters to Vancouver for a quilting workshop. They will leave at 6:00 a.m., and he wants to make sure everyone gets the rest they need. In the dark of the bus interior, exhaustion mingles with excitement. "My art ain't in it. It's not my show. It's not my show, but I enjoyed it just as if it was!" Mary Lee Bendolph laughs. Then she starts singing. "Everybody say, A-A-men, A-A-men, A-A-men, Amen, Amen," she belts out. Everyone on board sings too. And, then, after the Dials have boarded the bus, with the lights of Houston whizzing past sporadically lighting up the dark coach cabin, Mary Lee leans over to Mary McCarthy sitting one row in front of her and whispers. If she sings it, will Mary McCarthy start? Mary Lee doesn't want to be the instigator. Wouldn't look right. Mary McCarthy agrees and begins the song. The rest of the passengers sing and clap. Mary Lee Bendolph joins in right away, her voice rising above all others. "I don't *want* nobody to praise me when I'm gone, I don't want *nobody* to praise me when I'm gone, I don't want nobody to *praise* me when I'm gone, Give me my flowers while I yet live, while I yet live," they sing. Somewhere in the dark back of the bus, Thornton Dial smiles, rocks his head slightly to the beat and sings along.

––––––––

"Thornton Dial lives here," says the woman who works at the Bessemer, Alabama, Hall of History. "He's probably the foremost folk artist. Thornton Dial's work sells for hundreds of thousands. I mean, the man is a multimillionaire several times over, but you still see him around town pushing a shopping cart that he snitched from Wal-Mart loading up odds and ends to make his art. Oh, he's famous," she says, and then stares off down the tracks that ride into and out of Bessemer. "He's just a different one, that Thornton Dial."

SOURCES

BOOKS

Abrams, Ann Uhry. *Explosion at Orly: The Disaster That Transformed Atlanta.* Atlanta: Avion Press, 2002.

Agee, James, and Walker Evans. *Let Us Now Praise Famous Men.* Boston: Houghton Mifflin, 1941.

Allen, James. *Without Sanctuary: Lynching Photography in America.* Santa Fe, NM: Twin Palms Publishers, 2003.

Ardery, Julie. *The Temptation: Edgar Tolson and the Genesis of Twentieth-Century Folk Art.* Chapel Hill: University of North Carolina Press, 1998.

Arnett, Paul, and William Arnett, eds. *Souls Grown Deep: African American Vernacular Art of the South, Volume 1: The Tree Gave the Dove a Leaf.* Atlanta and New York: Tinwood Books in association with the Schomburg Center for Research in Black Culture, the New York Public Library, 2000.

———. *Souls Grown Deep: African American Vernacular Art of the South, Volume 2: Once That River Starts to Flow.* Atlanta: Tinwood Books, 2001.

———. *Gee's Bend: The Women and Their Quilts.* Atlanta: Tinwood Books in conjunction with the Museum of Fine Arts, Houston, 2002.

Arnett, Robert. *India Unveiled.* Columbus, GA: Atman Press, 1999.

Barefield, Marilyn Davis. *Bessemer, Yesterday and Today 1887–1888.* Birmingham, AL: Southern University Press, 1986.

Barrett, Terry. *Criticizing Art: Understanding the Contemporary.* New York: McGraw-Hill, 2000.

Benhamou-Huet, Judith. *The Worth of Art: Pricing the Priceless.* New York: Assouline Publishing, 2001.

Blum, David. *Tick . . . Tick . . . Tick . . . : The Long Life & Turbulent Times of 60 Minutes.* New York: HarperCollins, 2004.

Bunnen, Lucinda, and Frankie Coxe. *Movers and Shakers in Georgia: The Power Elite of the New South—the Dynamic, Creative, Influential People in Georgia Who Make Things Happen.* New York: Simon & Schuster, 1978.

Callahan, Nancy. *The Freedom Quilting Bee.* Tuscaloosa: University of Alabama Press, 1987.

De Coppet, Laura, and Alan Jones. *The Art Dealers: The Powers Behind the Scene Tell How the Art World Really Works.* New York: Cooper Square Press, 2002.

Du Bois, W. E. B. *The Souls of Black Folk.* Chicago: A. C. McClurg & Co., 1903; repr., New York: Vintage Books/Library of America, 1990.

Fairchild, Ken. *Sunday Showdowns with 60 Minutes: 15 Years of Dueling America's Most Feared TV News Magazine—and Winning.* Dallas: Arena Publishing, 1998.

Fine, Gary Alan. *Everyday Genius: Self-Taught Art and the Culture of Authenticity.* Chicago: University of Chicago Press, 2004.

Freeman, Roland. *A Communion of the Spirits: African-American Quilters, Preservers, and Their Stories.* Nashville: Rutledge Hill, 1996.

French, Sean. *Jane Fonda.* London: Pavilion Books, 1997.

Goldfarb Marquis, Alice. *Alfred H. Barr Jr.: Missionary for the Modern.* Chicago and New York: Contemporary Books, 1989.

Goldstein, Malcom. *Landscape with Figures: A History of Art Dealing in the United States.* Oxford and New York: Oxford University Press, 2000.

Haden-Guest, Anthony. *True Colors: The Real Life of the Art World.* New York: Atlantic Monthly Press, 1996.

Halle, David. *Inside Culture: Art and Class in the American Home.* Chicago: University of Chicago Press, 1993.

Helfenstein, Josef, and Roman Kurzmeyer. *Deep Blues: Bill Traylor 1854–1949.* New Haven, CT, and London: Yale University Press, 1999.

Hoban, Phoebe. *Basquiat: A Quick Killing in Art.* New York: Viking Penguin, 1998.

Holzer, Erika, and Henry Mark Holzer. *"Aid and Comfort": Jane Fonda in North Vietnam.* Jefferson, NC, and London: McFarland & Company, Inc., 2002.

Hurston, Zora Neale. *Dust Tracks on a Road.* Philadelphia: J. B. Lippincott, 1942.

James, A. Everette. *Essays in Folk Art.* Chapel Hill, NC: Professional Press, 2000.

Janis, Sidney. *They Taught Themselves: American Primitive Painters of the 20th Century.* New York: Dial, 1942.

Litwack, Leon. *Trouble in Mind: Black Southerners in the Age of Jim Crow.* New York: Vintage Books, 1999.

Lomax, Alan. *The Land Where the Blues Began.* New York: The New Press, 1993.

Lukaszewski, James. *Surviving 60 Minutes and the Other News Magazine Shows.* New York: The Lukaszewski Group, Inc., 1998.

Maizels, John. *Raw Creation: Outsider Art and Beyond.* London: Phaidon Press Limited, 1996.

Maresca, Frank, and Roger Ricco. *Bill Traylor: His Art and Life.* New York: Alfred A. Knopf, Inc., 1991.

McDowell, Deborah. *Leaving Pipe Shop: Memories of Kin.* New York: W. W. Norton & Company, 1996.

McWhorter, Diane. *Carry Me Home: Birmingham, Alabama—The Climactic Battle of the Civil Rights Revolution.* New York: Touchstone, 2001.

Mencken, H. L. "The Sahara of the Bozart." In *Prejudices: Second Series.* New York: Knopf, 1920.

Michels, Caroll. *How to Survive & Prosper as an Artist: Selling Yourself without Selling Your Soul.* New York: Henry Holt & Company, 1983.

Patton, Sharon. *African-American Art.* Oxford and New York: Oxford University Press, 1998.

Pomerantz, Gary. *Where Peachtree Meets Sweet Auburn: A Saga of Race and Family.* New York: Scribner/Simon & Schuster, 1996.

Rhodes, Colin. *Outsider Art: Spontaneous Alternatives.* London: Thames & Hudson, 2000.

Rosen, Robert. *The Jewish Confederates*. Columbia: University of South Carolina Press, 2000.

Rosenak, Chuck, and Jan Rosenak. *Contemporary American Folk Art: A Collectors Guide*. New York: Abbeville Press, 1996.

Shafton, Anthony. *Dream Singers: The African American Way with Dreams*. New York: John Wiley & Sons, 2002.

Shannon, Charles. *Bill Traylor 1854–1947*. New York: Hirschl & Adler Modern, 1985.

Thompson, Robert Farris. *Flash of the Spirit: African & Afro-American Art & Philosophy*. New York: Vintage Books, 1984.

Wahlman, Maude Southwall. *Signs & Symbols: African Images in African American Quilts*. Atlanta: Tinwood Books, 2001.

Walker, James. *Things . . . Remembered! Stories about Western Jefferson County, Alabama*. McCalla, AL: Instant Heirloom Books, 2001.

Wertheimer, Alan. *Exploitation*. Princeton, NJ: Princeton University Press, 1996.

Wolfe, Tom. *The Painted Word*. New York: Farrar, Strauss & Giroux, Inc., 1975.

MAGAZINES (PRINT AND ONLINE)

Adams, Susan. "Why Not a Sonnet? Poetry before Business," *Forbes*, May 17, 1999.

Bailey, Martin, and Jason Kaufman. "Revealed: US and UK Museum Director Salaries," *Art Newspaper*, www.artnewspaper.com.

Book, Jeff. "Return of a Giant," *Smithsonian Magazine*, March 2004.

Borum, Jenifer P. "Spirit from Head: Jenifer P. Borum Reconsiders the Art of Self-Taught Visionary Bessie Harvey (1928–1994)." *Raw Vision*, no. 37.

———. "Thornton Dial: Ricco/Maresca," *Artforum*, February 1995.

Chiu, Tony, and Denise Lynch. "United States of Amazing," *People* Magazine Extra: Amazing Americans, Fall 1991.

Cullum, Jerry. "Thornton Dial: Ladies in the United States," *ArtPapers*, May/June 1990.

———. "Vernacular Art in the Age of Globalization," *ArtPapers*, January/February 1998.

————. "'The Herod Paradigm': A Conversation with William Arnett," *ArtPapers*, January/February 1998.

————. "Commission Impossible?" *ARTnews*, Summer 2002.

D'Arcy, David. "Art in the Land of Newt Gingrich and Coca-Cola," *Art Newspaper*, July-August 1996.

Ebony, David. "Sculpture Garden Threatened," *Art in America*. May 1997.

Ennis, Michael. "Peter's Principals," *Texas Monthly Magazine*, February 1998.

Feinberg, Shaina. "You Too Can Be an Outsider Artist: Career Counseling for Losers," *ReadyMade*, May/June 2004.

Finch, Charlie. "Art and Stardom," *artnet*, April 12, 2002, http://www.artnet.com/magazine/features/finch/finch4-12-02.asp.

Fowler, Miriam. "Artists of Alabama, Unite!" *Alabama Magazine*, July 1990.

French, Christopher. "Seven Questions for Peter Marzio, Director of the Museum of Fine Arts, Houston." GlassTire: Texas Visual Arts Online. http://glasstire.com/features/marzio.html.

Gaver, Eleanor. "Inside the Outsiders," *Art & Antiques*, Summer 1990.

Goddard, Seth. "Keeping the Faith: Civil Rights and the Baby Boom. An Interview with Congressman John Lewis," *Life*, http://www.life.com/Life/boomers/lewis.html.

Golden, Thelma. "Top Ten," *Artforum*, December 2003

Goldman, Lea, and Luisa Kroll. "The World's Billionaires," *Forbes*, March 10, 2005.

Green, Joshua. "Karl Rove in a Corner," *The Atlantic Monthly*, November 2004.

Greppi, Michele. "CBS Inc. Moves Jeff Fager Back to 60 Minutes," *TelevisionWeek*, January 26, 2004.

Gull, Nicole. "Packaging's Folk Revival," *INC.*, June 2003.

Haggerty, Gerard, and Phyllis Joyner. "Folk Art at Fancy Prices," *Folk Art Messenger*, Spring 1990.

Hancock, Butler. "The Designation of Indifference," *New Art Examiner*, October 1992.

Hartigan, Lynda Roscoe. "Going Urban: American Folk Art and the Great Migration," *American Art*, Summer 2000.

"Insiders Seek Outsider Art," *Antique Monthly*, April 1993.

Jones, Malcolm, Jr. "The Arts Games," *Newsweek*, July 29, 1996.

Kotz, Mary Lynn. "The First Lady's Sculpture Garden," *Sculpture*, August 1998.

Lantos, Lauren. "Atlanta's Olympiad: Defining the Souls of a City," *Museum News*, July/August 1996.

Locke, Donald. "Other Rivers: Revisiting 'Souls Grown Deep,'" *ArtPapers*, May/June 2001.

"Lowry Says No to Morley," *artnet*, November 24, 1998, www.artnet.com.

Marsh, Dave. "Mr. Big Stuff: Alan Lomax: Great White Hunter or Thief, Plagiarist and Bigot?" *CounterPunch*, www.counterpunch.org/marsh0721.html.

———. "In a Pig's Eye. Alan Lomax: Dead, But Still Stealing." *CounterPunch*, http://www.counterpunch.org/marsh05082004.html.

May, Stephen. "Horace Pippin: World War I Veteran and Artist— World War I Veteran Horace Pippin Used Art to Purge Himself of the Horrors of the Trenches," *Military History* (February 1998).

McEvilley, Thomas. "Doctor Lawyer Indian Chief: '"Primitivism" in 20th-Century Art' at the Museum of Modern Art in 1984," *Artforum*, November 1984.

———. "The Missing Tradition—African American Art, Atlanta City Hall; Thornton Dial, Michael C. Carlos Museum, Atlanta, Georgia," *Art in America*, May 1997.

McEvilley, Virginia. "The State of Art: From Globalism to Globalization: Recent Changes in the Social Situation of Art," *artscene*, November 2004.

McGill, Lynn Burnett. "For Love or Money? Controversy Stalks Atlanta Art Collector and Dealer Bill Arnett. Some Say He Exploits Black Primitive Artists. Others Call Him Their Savior," *Atlanta Magazine*, February 1991.

McWillie, Judith. "Another Face of the Diamond: Black Traditional Art from the Deep South," *The Clarion: America's Folk Art Magazine* 12, no. 4 (Fall 1987).

————. "Lonnie Holley's Moves," *Artforum Inernational*, April 1992.

Meyers, Laura. "African American Art Moves beyond Black and White: Collectors, Curators and Galleries Are Embracing a Greater Diversity of Genres and Styles in African American Art While Other Artists Move toward a 'Post-Black' Art Which Cannot Be Defined in Terms of Race," *Art Business News*, January 2003.

Morrin, Peter. "Bill Traylor," *ArtPapers*, July/August 1990.

Myers, D. G. "Signifying Nothing," *New Criterion* 8 (February 1990).

O'Connor, Colleen. "You Call This Crazy? Outsider Art Moves inside the Mainstream," *Business 2.0*, May 2001.

Oppenheimer, William. "Charlie Lucas and Nall," *The Folk Art Messenger*, Fall 2000.

Patterson, Tom. "Dust Storms in the Parallel Art Universe," *ArtPapers*, November/December 2001.

————. "Reflections on Twenty-Five Years in the Self-Taught/Outsider Art Field," *Picklebird*, September 2004. (This article first appeared in *ArtPapers'* 25th Anniversary Edition.)

Patton, Phil. "He Drew the Blues," *Esquire*, September 1991.

Perfect Sound Forever. "A Man, a Mission, a Tape Recorder: Alan Lomax and His *Southern Journey*," http://www.furious.com/perfect/lomax.html.

Pollack, Barbara. "The New Visionaries: Contemporary Artists Are Picking Up Where Self-Taught Artists Left Off—With Rough-Hewn, Unguarded Styles Some Call Faux Naïve," *ARTnews*, December 2003.

Rankin, Allen. "He Lost 10,000 Years: When Uncle Bill Traylor Began to Paint, He Went Straight Back to His Ancestors of Prehistoric Times. The Critics Are Impressed," *Collier's*, June 1946.

Reuse, Ruth Beaumont. "Creator of Things: Is Thornton Dial the Art World's Next Genius?" *Birmingham*, August 1991.

Rowan, Victoria. "See Jane Publish," *ARTnews*, October 2001.

Rubinstein, Raphael. "Alabama Assemblage," *Art in America*, May 2004.

Russell, Charles. "Thornton Dial," *Raw Vision*, Summer 2003.

Rutherford, Megan. "Catching Their Second Wind: Late in the Game, Some Folks Find Life's Best Rewards," *Time*, January 31, 2000.

Sancton, Thomas, Victoria Foote-Greenwell, and Daniel Levy. "An American in Paris," *Time*, June 13, 1994.

Shannon, Charles. "Bill Traylor's Triumph," *Art & Antiques*, February 1988.

Sharpe, Patricia. "Peter Marzio: On the Money," *Texas Monthly*, September 1997.

Torres, Louis, and Michelle Marder Kamhi. "Yes . . . But Is It Art? Morley Safer and Murphy Brown Take on the Experts," *Aristos*, June 1994, www.aristos.org/backissu/yesbutis.htm.

Tully, Judd. "Outside, Inside, or Somewhere In-Between," *ARTNews*, May 1996.

Wallis, S. "An Artist Besieged," *Art & Antiques*, May 1997.

Watson, Tom. "Atlanta Goes for Gold," *Arts and Antiques*, Summer 1996.

Young Miller, Rennie. "Letter to Editor," *Artforum*, March 2004.

JOURNALS

Agnew, Lea, and David Hughes Duke. "A History of the Woodruff Arts Center." *atlantahistory: A Journal of Georgia and the South* 38, nos. 1–2 (Spring-Summer 1994): 7–43.

Cohen, Ron. "Alan Lomax: Citizen Activist." Institute for Studies in American Music Newsletter (Brooklyn College of the City University of New York) 32, no. 1 (Fall 2002).

Howett Smith, Catherine. "Letter from the Interim Director." *MCCM: Newsletter of the Michael C. Carlos Museum, Emory University* 7, no. 21 (Fall 1996): 2.

Metcalf, Eugene W. "Black Art, Folk Art, and Social Control." *Winterthur Portfolio* 18, no. 4 (1983): 271–89.

Scheper-Hughes, Nancy. "Through the Quilting Bee." *Anthropology Today* 19, no. 4 (August 2003): 15–21.

Trend, M. G. "Government Capital and Minority Enterprise: An Evaluation of a Depression Era Social Program." *American Anthropologist* 88, no. 3 (September 1986): 595–609.

Walker, Meredith. "Bill Traylor: Freed Slave and Folk Artist." *Alabama Heritage*, no. 14 (May 1980): 25.

Wilson, Bobby M. "America's Johannesburg and the Struggle for Civil Rights: A Critical Geography." *Southeastern Geographer* 42, no. 1 (May 2002): 81–93.

NEWSPAPERS AND ONLINE NEWS SOURCES

Adams, Lorraine. "Frame and Fortune: To Become the World's Best Contemporary-Art Museum, the Hirshhorn Needs More Money and More Forward-Looking Art. New Director Ned Rifkin Thinks He Knows How to Get Them," *Washington City Paper*, October 11–17, 2002.

Allen, Frederick. "Presidential Parkway Pokes Along in Slow Lane," *Atlanta Journal and Constitution*, April 23, 1987.

"Another Account of Fight," *Washington Post*, October 24, 1898.

Applebome, Peter. "At '96 Games, Culture Will Compete," *New York Times*, February 1, 1995.

"Artist Holley Out on Bail after Alabama Arrest," *Atlanta Journal and Constitution*, December 12, 1998.

Associated Press. "Airport Learns Value of Art," *Atlanta Journal and Constitution*, November 1, 1997.

———. "Shooter Injures Folk Artist at Home," *Atlanta Journal and Constitution*, July 2, 1998.

———. "Finster's Garden in Trouble," *Atlanta Journal and Constitution,* March 18, 2003.

———. "Big Changes Afoot at '60 Minutes': '60 Minutes II' to Be Enfolded into Original; Ed Bradley Takes Prime Spot," *MSNBC*, September 21, 2005, http://www.msnbc.msn.com/id/9429560.

Auchmutey, Jim. "Gudmund Vigtel's Career at High Tide," *Atlanta Journal and Constitution*, May 22, 1988.

———. "Inside the Outsider: A Collection without a Home," *Atlanta Journal and Constitution*, December 12, 1993.

————. "Inside the Outsider: Controversial Collector Bill Arnett Leads Pack in Promoting Folk Art," *Atlanta Journal and Constitution*, December 12, 1993.

————. "Sandman's Blues, Part 2: Art & Money, Lonnie Holley Has a Rich Imagination but a Thin Wallet," *Atlanta Journal and Constitution*, March 15, 1999.

————. "Sandman's Blues, Part 3, Family in the Fire: Artist Lonnie Holley Struggles with Crime and Consequences," *Atlanta Journal and Constitution*, March 16, 1999.

————. "Sandman's Blues, Epilogue: Father & Sons," *Atlanta Journal and Constitution*, March 17, 1999.

Beasley, David. "DOT, Road Foes Give Up on Talks," *Atlanta Journal and Constitution*, May 3, 1991.

Blackmon, Douglas. "From Alabama's Past, Capitalism Teamed with Racism to Create Cruel Partnership," *Wall Street Journal*, July 16, 2001.

"Blood Galore," *Los Angeles Times*, October 24, 1898.

Bowman-Littler, Wendy. "Games Have Boosted City's Arts into the Big Leagues," *Atlanta Business Chronicle*, July 19–25, 1996.

Brown, Patricia Leigh. "From the Bottomlands, Soulful Stitches," *New York Times*, November 21, 2002.

Campbell, Colin. "10 Best Atlanta Sights," *Atlanta Journal and Constitution*, December 21, 1994.

Cooper, Len. "The Damned: Slavery Did Not End with the Civil War. One Man's Odyssey into a Nation's Secret Shame," *Washington Post*, June 16, 1996.

Crenshaw, Holly. "Then & Now: A Feature Examining Atlanta's Development," *Atlanta Journal and Constitution*, May 21, 2001.

Cullum, Jerry. "REVIEW: 'Art of Nigeria from the William S. Arnett Collection,'" *Atlanta Journal and Constitution*, November 4, 1994.

————. "Visual Arts: REVIEW: 'The Art of Collecting: Recent Acquisitions by the Michael C. Carlos Museum,'" *Atlanta Journal and Constitution*, November 21, 1997.

Daniel, Jeff. "Southern Art Grows Deep," *St. Louis Post-Dispatch*, February 20, 2002.

Day, Jeffrey. "Atlanta Exhibits Dropped the Ball," *State* (Columbia, SC), July 21, 1996.

Diggs, Michael. "All It Took Was Time," *Birmingham Post Herald*, September 17, 1990.

Drennen, Eileen. "Bill Arnett: Collector Backs Self-Taught Artists," *Atlanta Journal and Constitution*, July 29, 1990.

———. "Self-Taught Passion: Dedicated to Sharing the Stories of Self-Taught Artists, High Museum's New Folk Art Curator Stages a Show about Four of the South's Best: The Exhibit: 'Dust Tracks on a Road,'" *Atlanta Journal and Constitution*, August 20, 1995.

Faulk, Kent. "County Water Near for Creswell: Residents May Turn on Tap as Soon as Halloween," *Birmingham News*, September 1993.

Feaster, Felicia. "Inside the World of Outsider Art: William Arnett Turns Folk Artists into Stars and Makes Enemies along the Way," *Creative Loafing*, January 6, 2001.

Forgey, Benjamin. "New South, True South: Art Remembers in a City That Longs to Forget Its Ghosts," *Washington Post*, July 14, 1996.

Foskett, Ken. "Justice Center Praised for Mediation in Parkway Case," *Atlanta Journal and Constitution*, September 12, 1991.

"Fourteen Negroes Killed," *Atlanta Constitution*, October 26, 1898.

Fox, Catherine. "ART: Emory Exhibition First in U.S. of African Asen Art," *Atlanta Journal and Constitution*, October 6, 1985.

———. "'Cameroon Art' a Dramatic Exhibition Show at Kennesaw State College Gallery Celebrates Visual Power, Craftsmanship of Objects from Atlantan's Collection," *Atlanta Journal and Constitution*, February 8, 1989.

———. "Self-Taught Artist Makes Compelling Case for Human Rights," *Atlanta Journal and Constitution*, March 13, 1990.

———. "Exhibit Preview: 'Seeing with New Eyes: Pre-Columbian Art from the Thibadeau Collection,'" *Atlanta Journal and Constitution*, March 1, 1992.

————. "Emory's New Treasure: All the Grandeur of an Expanded Michael C. Carlos Museum Carries Our Imaginations Deep into a World of Ancient Treasures," *Atlanta Journal and Constitution*, May 9, 1993.

————. "Visual Arts: Art Scene Goes Global with Olympiad's Help: Shows Offer Glimpse of Mexico, Asia, Africa," *Atlanta Journal and Constitution*, August 29, 1993.

————. "Thornton Dial's Rich Art Continues to Push Limits," *Atlanta Journal and Constitution*, December 5, 1993.

————. "Cultural Olympiad: Carlozzi's Way: She's Bringing Art Community Together to Find a Vision for '96," *Atlanta Journal and Constitution*, February 7, 1994.

————. "The '94-'95 Atlanta Arts Guide: Visual Art: Galleries Focus on the Art of Social Concerns: Season Offers the Beautiful and the Daring," *Atlanta Journal and Constitution*, August 28, 1994.

————. "Carlos Museum Chief to Take Toronto Post," *Atlanta Journal and Constitution*, May 27, 1995.

————. "Don't Bother Touching this Dial," *Atlanta Journal and Constitution*, July 9, 1996.

————. "Breaking Down More Barriers," *Atlanta Journal and Constitution*, July 29, 1996.

————. "A Generous Gift for the High, Folk Lift: Businessman's Donation of Self-Taught Art Puts Museum's Collection in Front Ranks," *Atlanta Journal and Constitution*, December 12, 1996.

————. "Atlanta's Endangered Arts: The First in an Occasional Series—Acquiring Taste: New Art Devotees Show That Atlanta Is No Longer a City Too Busy to Collect," *Atlanta Journal and Constitution*, March 29, 1998.

————. "Specializing in Schmoozing? Whitney Opts for Other Skills over Expertise," *Atlanta Journal and Constitution*, August 9, 1998.

————. "Volume Explores 'Souls' of Folk Art," *Atlanta Journal and Constitution*, March 19, 2000.

———. "Unfinished Homage: An Atlanta Group's Plan to Honor John Lewis, Civil Rights Leader and Bridge Builder, with an Outdoor Sculpture Hits Some Unexpected Bumps in the Road," *Atlanta Journal and Constitution*, April 8, 2002.

———. "Pieces of the Past from Gee's Bend," *Atlanta Journal and Constitution*, February 17, 2002.

———. "Tinwood Books, 'So Profound It's Subversive': Tiny Atlanta Publisher Champions Black Artists," *Atlanta Journal and Constitution*, February 17, 2002.

———. "Artist, Neighborhood Group Continue Fight over 'Bridge,'" *Atlanta Journal and Constitution*, August 18, 2002.

———. "Battle over 'The Bridge' Ends with Art in Atlanta," *Atlanta Journal and Constitution*, December 11, 2003.

———. "Gee's Bend Quilts Honored, African-American Work Gains Notice," *Atlanta Journal and Constitution*, February 13, 2004.

———. "Public Works: All Around Town, Installations Are Enlivening the Social Fabric," *Atlanta Journal and Constitution*, May 27, 2004.

———. "Gratitude Girds 'Bridge' for Lewis," *Atlanta Journal and Constitution*, September 10, 2005.

Graves, John Temple, "The Big World at Last Reaches Gee's Bend," *New York Times*, August 22, 1937.

Griffis, Kevin. "Freedom's Just Another Word: Freedom Park Seeks Identity," *Creative Loafing*, June 27, 2001.

Grisamore, Ed. "Georgia Woman's the Elvis Babe: Toenails, Warts and All," *Macon Telegraph*, August 15, 2004.

Hales, Linda. "From Museum to Housewares: Marketing Gee's Bend Quilts," *Washington Post*, February 28, 2004.

Henry, Derrick. "Obituaries: Atlanta: William Thibadeau, 83, Collector of Artifacts," *Atlanta Journal and Constitution*, December 1, 2002.

Hinckley, David. "Patronage—or Pillage? Folk Song Collectors Like Alan Lomax Greatly Enriched American Music—If Not Musicians," *N.Y. Daily News*, July 28, 2002.

Hudgens, Dallas. "Heritage, Piece by Piece," *Washington Post*, February 27, 2004.

Hughes, Tom. "Montgomery Artist Reaches Settlement with Traylor Family," *Montgomery Advertiser*, October 6, 1993.

Jackson, Derrick Z. "Strength in Every Stitch," *Boston Globe*, July 29, 2005.

Jinkner-Lloyd, Amy. "The Art of the Deal," *Creative Loafing*, November 26, 1994.

———. "Public Exposure," *Creative Loafing*, December 31, 1994.

Jones, Vanessa E. "Financial Success Isn't in Artist's Picture, Painting in Poverty: His Artworks Appear in the Smithsonian and Sell for Thousands, but Joe Light Can Hardly Pay His Bills," *Atlanta Journal and Constitution*, August 9, 1997.

Kaimann, Frederick. "Holley Holds on Tight—Artist Lonnie Holley Gets a Ride to the Top in Atlanta but a Bumpy One at Home in Birmingham," *Birmingham News*, April 21, 1996.

Kaplan, Melanie D. G. "Art for the Masses," *USA Today*, October 26, 2003.

———. "Art for the Masses: Director Peter C. Marzio Made Houston's Art Museum the Hottest Ticket in Town. Now His Innovations Are Imitated Nationwide," *USA Weekend*, October 26, 2003.

Kemp, Kathy. "Shooting Denies Lonnie Holley Piece of Mind," *Birmingham News*, August 1, 1998.

Kimmelman, Michael. "By Whatever Name, Easier to Like," *New York Times*, February 14, 1997.

———. "Jazz Geometry, Cool Quilters," *New York Times*, November 29, 2002.

Kinzer, Stephen. "Soul Searching at a Private Pantheon of Art; Menil Collection in Houston Grapples with Its Identity under New Leadership," *New York Times*, January 31, 2001.

Knight, Christopher. "Wins, Losses of Olympic Proportions," *Los Angeles Times*, July 4, 1996.

Lee, Thonnia. "Councilman Byron's Art to Be Up for Public 'Yea'," *Atlanta Journal and Constitution*, November 10, 1988.

THE LAST FOLK HERO

Leonard, Elizabeth. "Attendance Light, but Growing, at Museum Exhibitions," *Atlanta Journal and Constitution*, July 8, 1996.

Levitan Spaid, Elizabeth. "Arts Vault into the Games," *Christian Science Monitor*, July 11, 1996.

Locke, Donald. "In the Vernacular: Souls Grown Deep," *Creative Loafing*, July 13, 1996.

Lodge, Emily. "Why Did the American Center Die? Henry Pillsbury Tells What Happened," *Paris Voice,* April 1999.

Matchan, Linda. "With These Hands: A Group of Alabama Women, Descended from Slaves, Took the Scraps of Their Lives and Pieced Together American Treasures," *Boston Globe*, May 15, 2005.

Milloy, Marilyn. "Homegrown Artist Springs from South," *Newsday*, September 26, 1990.

Moehringer, J. R. "Crossing Over," *Los Angeles Times*, August 22, 1999.

———. "An Obsessive Quest to Make People See: After Antique Collector James Allen Discovered Scores of Lynching Photos, Black Americans Were Grateful—and Confused. Was His Motive Compassion—or Something Else?" *Los Angeles Times*, August 27, 2000.

Moses, Jonathan. "Heirs of Folk Artist Seek Rights to Work," *Wall Street Journal*, November 30, 1992.

Murphy, Melissa. "Carlos Museum Exhibit Offers Peek," *DeKalb* (Georgia) *Neighbor*, July 10, 1996.

Murray, Steve. "Film Unveils History amid Paris Tragedy," *Atlanta Journal and Constitution*, October 4, 2001.

"News Briefs," *Birmingham News*, February 20, 1996.

O'Brien, Tim. "Visionland on Time, under Budget," *Amusement Business*, June 1, 1998.

———. "Visionland's Food Vision: Low Suppliers Low Cost," *Amusement Business*, June 8, 1998.

Pareles, Jon. "Alan Lomax, Who Raised Voice of Folk Music in U.S., Dies at 87," *New York Times*, 20 July 2002.

Passy, Charles. "Few Spectators for Cultural Events," *Atlanta Journal and Constitution*, July 25, 1996.

Perez-Pena, Richard. "Decades Later, Family Finds Art, and a Possible Fortune," *New York Times*, December 8, 2003.

Pousner, Howard. "Olympic Watch: Countdown to the Atlanta Games: Cultural Olympiad: Picasso, Miro Works Likely at Emory in '96," *Atlanta Journal and Constitution*, December 18, 1993.

———. "Olympic Exhibits: Carlos, High Museums Welcoming Folk Art," *Atlanta Journal and Constitution*, November 21, 1994.

Raabe, Nancy. "Sandman Fights for Art: Sculptor Wrestles Airport Relocation, Theft," *Birmingham News*, November 29, 1996.

———. "William Arnett Says He Supports, Not Exploits, African-American Vernacular Art," *Birmingham News*, January 11, 1998.

———. "Ogun Meets Vulcan," *Birmingham News*, February 13, 2000.

"Race War," *Boston Daily Globe*, October 24, 1898.

Raines, Laura. "Walk through Art on the Web at Michael C. Carlos Museum," *Atlanta Journal and Constitution*, May 13, 1996.

Raynor, Vivien. "A Gentle Naif from Alabama," *New York Times*, February 14, 1982.

Rochelle, Anne. "Waiting for Takeoff," *Atlanta Journal and Constitution*, October 21, 1997.

Roughton, Bert, Jr. "DOT's Tom Moreland Plans to Retire," *Atlanta Journal and Constitution*, April 16, 1987.

———. "The Road: 27 Years of Controversy—Battle of the Parkway: A High-Stakes Saga Still in the Making," *Atlanta Journal and Constitution*, September 11, 1988.

Sabulis, Tom. "Remembering the Day Atlanta Stood Still: TV Documentary Recalls 1962 Air Disaster That Decimated City's Arts Community," *Atlanta Journal and Constitution*, September 30, 2001.

"Seven Killed in Race War," *Chicago Daily Tribune*, October 24, 1898.

Siskin, Diane. "The Cultural Olympiad," *Chattanooga Free Press*, June 17, 1996.

Sledge, Lynn. "Learning the Vernacular: New Enterprise Dedicated to Spreading Message of African-American Art Form," *Mobile Register*, June 24, 2001.

Smith, Dinitia. "Bits, Pieces and a Drive to Turn Them into Art," *New York Times*, February 5, 1997.

Smith, Roberta. "A Young Style for an Old Story," *New York Times*, December 19, 1993.

———. "'A Return to January 1982'—'The Corcoran Show Revisited," *New York Times*, March 8, 2002.

———. "Washington's Museums Traverse Miles and Eras," *New York Times*, August 22, 2003.

Solis-Cohen, Lita. "The Quilts of Gee's Bend," *Maine Antique Digest*, January 2003.

Spencer, Thomas. "In Joe Minter's Garden, God Is Watching . . . and Listening," *Birmingham Weekly*, November 20–27, 1997.

Tomberlin, Michael. "Mayor's Idea Creates Unity Where It Once Seemed Impossible," *Birmingham Business Journal*, July 24, 1995.

———. "State's First Amusement Park Captures 'Deal of the Year,'" *Birmingham Business Journal*, December 1, 1997.

Troncale, Terri. "Water under the Bridge Aids Flood Control," *Birmingham News*, April 4, 1985.

Twardy, Chuck. "Aesthetic Soul Food Volume Advances the Study of Black 'Outsider' Artists," *Atlanta Journal and Constitution*, October 1, 2000.

Vesey, Susannah. "Drawn into Controversy: Bill Traylor Drew from His Memory of Plantation Life. The Former Slave Made His Simple but Provocative Images While Living Five Decades Ago on the Streets of Montgomery, Ala. Now His Descendants Claim His Now-Popular Artwork Belongs to Them," *Atlanta Journal and Constitution*, January 3, 1993.

Vogel, Carol. "Who Will Run Frick and the Whitney?" *New York Times*, July 31, 2003.

Wallach, Amei. "The Eye of the Tiger," *Newsday*. November 21, 1993.

White, Gayle. "Art of Alabama Family Winning Praise after Decades of Obscurity," *Atlanta Journal and Constitution*, May 16, 1989.

Wibking, Angela. "Carving a Name: Nashville Sculptor William Edmondson's Work Finally Gets the Attention It Deserves," *Nashville Scene*, January 31, 2000.

Woodhead, Henry. "The Porcelain Affair: The Oriental Ceramics Drew Special Praise until the Smithsonian Turned Thumbs Down," *Atlanta Journal and Constitution Sunday Magazine*, 1977.

Zimmerman, David. "Joe Light's Inspired Art: He Delivers Messages from God through His Works," *USA Today*, November 18, 1997.

INTERVIEWS (BY AUTHOR)

Alexander, Judith. July 28, 2003, and September 16, 2004.

Allen, Jimmy. August 28, 2003.

Anderson, Max. August 14, 2003.

Ansehl, Jeanne. August 2, 2004.

Apfelbaum, Ben. January 23, 2003, and July 24, 2003.

Archer, Barbara. August 27, 2003.

Arnett, Harry. Multiple interviews during the period May 2003 through September 2005.

Arnett, Judy. July 18, 2003.

Arnett, Matt. May 27, 2003, July 28, 2003, and August 20, 2003.

Arnett, Paul. Multiple interviews during the period October 2002 through July 2005.

Arnett, William (Bill). Multiple interviews during the period October 2002 through October 2005.

Arnold, Genevieve. September 1, 2004.

Arrasmith, Anne. August 26, 2004.

Ausfeld, Margaret Lynne. August 23, 2004.

Babcock, Jeffrey. March 14, 2005.

Bass, Clayton. August 4, 2005.

Beardsley, John. August 20, 2003, August 16, 2004, and June 11, 2005.

Bendolph, Mary Lee. August 24, 2004.

Berry, Jenny Lind. June 19, 2003.

Blazar, Alan. May 16, 2005.

Bodine, Bill. March 2, 2005.

Bookman, Wayne. August 23, 2004.

Bowman, Russell. July 31, 2003.

Branch, Walter. June 4, 2004.

Broda, Donald. June 19, 2003.

Broun, Betsy. February 19, 2003.

Brown, Christopher. August 25, 2003.

Browne, Lynne. August 2003.

Bunnen, Lucinda. September 8, 2003, and October 29, 2003.

Caproni, Al. August 17, 2004.

Cargo, Robert. July 25, 2003.

Carlozzi, Annette. April 4, 2005.

Cassidy, Carol. June 27, 2003, July 17, 2003, August 28, 2003, and
 October 3, 2003.

Clarke, Georgine. August 24, 2004.

Crane, Susan. August 20, 2004.

Crawley, Susan. February 3, 2005.

Cubbs, Joanne. January 21, 2004.

Cullum, Jerry. August 2, 2004.

Dial, Dan. August 25, 2004.

Dial, Richard. August 25, 2004.

Dial, Thornton, Jr. ("Little Buck"). July 8, 2003.

Dial, Thornton, Sr. Multiple interviews during the period
 November 2002 through October 2005.

Dimon, Kelly. June 19, 2003.

Egan, Richard. September 8, 2003.

Fager, Jeff. August 2, 2004, and February 17, 2005.

Fine, Gary. August 27, 2003.

Fonda, Jane. May 15, 2003.

Gennilliat, Bill. August 26, 2003, and September 11, 2003.

Gordon, David. August 20, 2003.

Griffin, Roberta. August 9, 2004.

Harper, Glenn. September 17, 2004.

Hecht, Bobby, and Joanne Hecht. June 19, 2003.

Hobbs, Robert. August 27, 2004.

Holley, Lonnie. Multiple interviews during the period February
 2003 through October 2004, as well as additional discussions
 at Kentuck and other art exhibitions.

Hopps, Walter. August 2, 2004.

Jonas, Peggy. July 25, 2003.

Kennedy, Mark. August 24, 2004, and March 4, 2005.

Kerlin, Patricia. August 20, 2004.

King, George. June 6, 2003.

Land, Tere. September 22, 2005.

Livingston, Jane. August 20, 2003, November 18, 2003, and June 11, 2005.

Louis-Dreyfus, William. July 11, 2003, and July 24, 2003.

Lucas, Charlie. March 3, 2005, as well as several discussions at Folk Fest and Kentuck.

Maresca, Frank. July 28, 2003.

Marzio, Peter. May 6, 2003, August 20, 2003, and August 23, 2004.

McCarthy, Mary. August 20, 2003, and April 11, 2005.

McDowell, Deborah. July 16, 2003.

Mcintyre, Kipp. August 29, 2003.

McWillie, Judith. January 25, 2005.

Metcalf, Gene. August 31, 2004, and June 11, 2005.

Minter, Joe. February 6, 2003.

Moos, David. July 22, 2003.

Morrin, Peter. July 27, 2004.

Nasisse, Andy. January 19, 2004.

Nieporent, Amy. February 7, 2005.

O'Gorman, Therese. May 9, 2005.

Oppenheimer, Anne. February 14, 2003.

Pryzbylla, Carrie. January 22, 2003.

Raabe, Nancy. July 29, 2003.

Rabren, Lynn.. November 13, 2004.

Rifkin, Ned. August 18, 2003, September 2, 2003, and March 7, 2005.

Safer, Morley. August 4, 2004.

Santos, Dextor. January 12, 2005.

Schenk, Joe. August 7, 2003.

Sledge, Lynn. May 22, 2003, and August 7, 2003.

Slotin, Steve, and Amy Slotin. March 28, 2003, and May 3, 2003.

Smith, Becky. May 23, 2003.

Smith, Louis. January 3, 2005.

Spriggs, Lynn. July 16, 2003.

Sudduth, Seebow ("Osey"), and Jimmy Lee Sudduth. October 18, 2003.

Thomas, Jerry. July 21, 2003, July 25, 2003, and August 11, 2003.

Thomason, Bill. July 8, 2003.

Toner, Dominga. August 25, 2004.

Trechsel, Gail. July 9, 2003.

Vigtel, Gudmund. August 13, 2003.

Wall, Ruth. August 17, 2004, and August 13, 2005.

Wardlaw, Alvia. June 11, 2005.

Weber, Marcia. August 25, 2003, and August 24, 2004.

West, Ruth. September 14, 2004.

Winn, Billy. July 12, 2003.

Yelen, Alice Rae. September 12, 2003.

PERSONAL COMMUNICATIONS AND UNPUBLISHED PAPERS

Alexander, Henry Aaron. "Notes on the Alexander Family of South Carolina and Georgia and Connections: 1651–1954," 1954.

Arnett, William (Bill). "Notes for Attorney, Summarizing Arnett's View of Events with Emory's Carlos Museum." Unpublished papers, 1997.

———. "Re: Bill Arnett and the Souls Grown Deep Exhibition." Unpublished papers, circa 1997.

———. "Diagram of Suspected Conspiracy to Derail *Souls Grown Deep* Exhibition." Unpublished papers, circa 1998.

———. "Dial Interview," Unpublished notes, December 24, 1999.

———. Collection of Letters from Citizens of Gee's Bend, Alabama, Regarding the Impact of the Arnetts and the *Quilts of Gee's Bend* Project on the Gee's Bend Community. Circa 2003.

———. "Enemies List,*" Handwritten document provided to author, July 15, 2003.

Caproni, Al, III. Memorandum to Donna Howell re: Lewis Plaza/ Thornton Dial, December 6, 2001.

————. Memorandum to Donna Howell re: Lewis Plaza/Thornton Dial, January 2, 2002.

Caproni, Al, III, and Ruth Wall. Correspondence to Thornton Dial re: *Bridge* Sculpture Honoring John Lewis, February 15, 2002.

Dial, Clara Mae. "Complete Transcript from Clara Mae Dial," in reference to legal proceedings surrounding *The Bridge*, from unpublished papers of William Arnett, November 2003.

Dodson, Howard. "Letter to President William Chace of Emory University regarding *Souls Grown Deep* Book." Unpublished papers, December 7, 1995.

Emory University. "Draft: Agreement Regarding the Souls Grown Deep and Thornton Dial Exhibitions." Unpublished papers, circa 1995.

Evans, Lynda. Correspondence To Whom It May Concern "Out of Concern for the Misrepresentations made on *60 Minutes*' 'Tin Man' Episode," Unpublished papers. June 10, 1995.

Freedom Park Conservancy. Various invitations and promotional materials related to fund-raising event for *The Bridge* sculpture by Thornton Dial in honor of John Lewis. Event held on March 21, 1998.

Gottlieb, Paul. "Telefax Transmission to Howard Dodson regarding Souls Grown Deep book." Unpublished papers, November 30, 1995.

Howell, Donna. Fax Correspondence to Al Caproni and Ruth Wall re: Request for Freedom Park Conservancy to Refrain from Building and Installing Pedestal for *The Bridge* sculpture, December 11, 2001.

Kerlin, Patricia. Correspondence to Thornton Dial re: John Lewis Plaza, November 15, 2001.

Letter to Lucy Cullman Danziger, Trustee of American Folk Art Museum. Unpublished letter, December 5, 1990.

McIntyre, Kip. "Affidavit regarding Souls Grown Deep and Carlos Museum." Unpublished papers, 1997.

Trechsel, Gail Andrews. Unpublished Papers from Birmingham Museum of Art Files Related to Conversation with Charlie Lucas following Initial Airing of *60 Minutes'* "Tin Man" episode, November 29, 1993.

Wahlman, Maude. "Letter to Howard Dodson, Schomburg Center for Research in Black Culture." Unpublished papers, November 30, 1995.

Wall, Ruth. Unpublished papers entitled "The John Lewis Commemorative Plaza: Sequence of Events by Years." Summer 2002.

ONLINE SOURCES

Amiri Baraka: Biography and Historical Context. http://www.english.uiuc.edu/maps/blackarts/historical.htm.

Ancestry.com. www.ancestry.com.

Baraka, Amiri. www.amiribaraka.com.

The Barnes Foundation. www.barnesfoundation.org.

Bessemer Alabama Chamber of Commerce. http://www.bessemeral.org/Henry_DeBardeleben.html.

Birmingham Airport. www.bhamintlairport.com/.

Blair, Adam. "The Connections are too obvious to ignore!" Eat This (online) Zine. http://gladstone.uoregon.edu/~ablair2/eat_this/connections.htm.

———. "Freemason Black Magic: Folk Artist Bessie Harvey." Eat This (online) Zine. http://gladstone.uoregon.edu/~ablair2/eat_this/bessieharvey.htm.

Caribiana Sea Skiffs. www.caribiana.com.

"Christie's London Auction Records for Chivalry." Artprice, www.artprice.com.

Drabble, John. "The FBI, COINTELPRO-WHITE HATE and the Decline of Ku Klux Klan Organizations in Alabama, 1964–1971." http://home.ku.edu.tr/~jdrabble/.

Folk Art Society. www.folkart.org.

Georgia Institute of Technology, School of Architecture. "Getting the Games: The Winner . . . is . . . Ah-tlanta!" Atlanta & the Games. www.arch.gatech.edu/imagine/Atlanta96/documents/getting/getting.htm.

Haardt, Anton. "Bessie Harvey," Anton Haardt Gallery. http://antonart.com/bio-harv.htm.

————. "The ABC's of Mose Tolliver." Anton Haardt Gallery. www.antonart.com/writings/mose.htm.

Harry Abrams Publishing. www.harryabrams.com.

The High Museum of Art. www.high.org.

Kaufman, Jason Edward. "Director of The Whitney Quits: 'I Didn't Want to Preside over the Museum If It Was Not Going to Try Something Significant': Maxwell Anderson, Director of the Whitney Museum, New York, Resigns after the Trustees Shelve the Proposed Extension by Rem Koolhaas," Art Newspaper. http://www.theartnewspaper.com/news/article.asp?idart=11133.

Lomax, Alan. www.alan-lomax.com.

Louis Dreyfus Companies. www.louisdreyfus.com.

Lyons, Beauvais. "Issues Raised by Folk Art Parody." University of Tennessee, Knoxville School of Art. http://web.utk.edu/~blyons/spelvinissues.html.

Mabe, Joni. "Jonie Mabe the Elvis Babe." Joni Mabe. www.jonimabe.com.

McDowell, Deborah. "Leaving Pipe Shop." Deborah McDowell. http://xroads.virginia.edu/~public/pipeshop/excerpt5.html.

Musarium. http://www.musarium.com/withoutsanctuary/main.html.

The New Criterion. www.newcriterion.com.

Phillips, John. "Caribiana Island Cruises," Night Hawk Publications: John's Journal—Entry 98, Day 1. www.nighthawkpublications.com/journal/journal098-1.htm.

Po Folks. www.pofolks.com.

Sloss Furnaces. http://www.slossfurnaces.com/media/html/sloss_story/index.html.

University of Alabama Business Hall of Fame. http://v2.cba.ua.edu/giving/hall_of_fame/87HFD.html.

U.S. Census. www.census.gov.

U.S. Pipe. www.uspipe.com.

Vulcan Park Foundation. www.vulcanpark.org/history.html.

Wilson, Richard Guy. "Contemporary American Folk Art: Charming Junk or Art with a Capital A?" Richard Guy Wilson. http://xroads.virginia.edu/~DRBR2/folkartwilson.html.

THESES AND DISSERTATIONS

Umberger, Leslie. "The Art of Thornton Dial: Race, Class, and the Politics of 'Authenticity'." MA thesis, University of Colorado, 1998.

PAMPHLETS, CORPORATE REPORTS, BROCHURES, AND FREESTANDING PUBLICATIONS

Columbus High School. "For bold in heart and art," William Arenowitch's inscription in the 1957 Columbus High School Yearbook, taken from a Lord Alfred Tennyson poem, "Idylls of the King, The Coming of Arthur."

Emory University, Michael C. Carlos Museum. "Exhibition Brochure for Souls Grown Deep." 1996.

———. "Exhibition Notebook for Souls Grown Deep." 1996.

"Historic Millionth Freight Car: An Industry Record," *Perspective* (a publication of Pullman Incorporated) 13 (December 1979).

Smithsonian Institution, Office of Public Affairs. "Press Announcement: Ned Rifkin, Under Secretary for Art and Director of the Hirshhorn Museum and Sculpture Garden," January 2004.

MANUSCRIPT COLLECTIONS AND ARCHIVES

Thompson, Perry (Interview #48), President of Local 1466 of United Steel Workers of America. 1972. Hardy T. Frye Oral History Collection. Auburn University Special Collection and Archives.

Exhibition Catalogs

Abstraction in the Art of Thornton Dial. Kennesaw, GA: Kennesaw State College, Sturgis Library Gallery, 1995. Published in conjunction with the exhibition *Abstraction in the Art of Thornton Dial,* shown at the Kennesaw State College, Sturgis Library Gallery.

The Art of William Edmondson. Edited by Rusty Freeman. Nashville: The Cheekwood Museum of Art, in association with University Press of Mississippi, 2000. Published in conjunction with the exhibition *The Art of William Edmondson,* shown at The Cheekwood Museum of Art.

Artists of the Heath Gallery: 1965 to 1998. Edited by Annette Cone-Skelton. Atlanta: The Museum of Contemporary Art of Georgia, 2002. Published in conjunction with the exhibition *Artists of the Heath Gallery: 1965 to 1998,* shown at the Museum of Contemporary Art of Georgia.

Black Folk Art in America 1930–1980. Edited by John Beardsley and Jane Livingston. Washington, DC: Corcoran Gallery of Art, in association with University Press of Mississippi, Jackson, and the Center for the Study of Southern Culture, 1982. Published in conjunction with the exhibition *Black Folk Art in America 1930–1980,* shown at the Corcoran Gallery of Art.

Do We Think Too Much? I Don't Think We Can Ever Stop. Edited by Michael Stanley and David Moos. Birmingham, UK, and Birmingham, AL: Birmingham Museum of Art and Ikon Gallery, 2004. Published in conjunction with the exhibition *Do We Think Too Much? I Don't Think We Can Ever Stop: Lonnie Holley, A Twenty-Five-Year Survey,* shown at the Birmingham Museum of Art and Ikon Gallery.

Let It Shine: Self-Taught Art from the T. Marshall Hahn Collection. Edited by High Museum of Art publications staff. Atlanta: High Museum of Art, in association with University Press of Mississippi, 2001. Published in conjunction with the exhibition *Let It Shine: Self-Taught Art from the T. Marshall Hahn Collection,* shown at the High Museum of Art.

Lively Times and Exciting Events: The Drawings of Bill Traylor. Edited by Margaret Lynne Ausfeld and Eileen Knott. Montgomery, AL: Montgomery Museum of Fine Arts, 1993. Published in conjunction with the exhibition *Lively Times and Exciting Events: The Drawings of Bill Traylor*, shown at the Montgomery Museum of Fine Arts.

Passionate Visions of the American South: Self-Taught Artists from 1940 to the Present. Edited by Alice Rae Yelen. New Orleans: New Orleans Museum of Art, in association with University Press of Mississippi, 1993. Published in conjunction with the exhibition *Passionate Visions of the American South: Self-Taught Artists from 1940 to the Present*, shown at the New Orleans Museum of Art.

Pictured in My Mind: Contemporary American Self-Taught Art from the Collection of Dr. Kurt Gitter and Alice Rae Yelen. Edited by Gail Andrews Trechsel. Birmingham, AL: Birmingham Museum of Art, in association with University Press of Mississippi, 1995. Published in conjunction with the exhibition *Pictured in My Mind: Contemporary American Self-Taught Art from the Collection of Dr. Kurt Gitter and Alice Rae Yelen*, shown at Birmingham Museum of Art.

"Primitivism" in 20th Century Art: Affinity of the Tribal and the Modern. Volumes I and II. Edited by William Rubin. New York: The Museum of Modern Art, 1984. Published in conjunction with the exhibition *"Primitivism" in 20th Century Art: Affinity of the Tribal and the Modern*, shown at the Museum of Modern Art, New York; Detroit Institute of Arts; and Dallas Museum of Art.

The Quilts of Gee's Bend. Edited by Paul Arnett and William Arnett. Atlanta and Houston: The Museum of Fine Arts, Houston, in association with Tinwood Books, 2002. Published in conjunction with the exhibition *The Quilts of Gee's Bend*, shown at The Museum of Fine Arts, Houston.

Testimony: Vernacular Art of the African-American South. Edited by Elisa Urbanelli. New York: The Schomburg Center for

Research in Black Culture of the New York Public Library and Exhibitions International, in association with Harry N. Abrams, Inc., 2001. Published in conjunction with the exhibition *Testimony: Vernacular Art of the African-American South: The Ronald and June Shelp Collection*, shown at Kalamazoo Institute of Arts, Columbia Museum, the AXA Gallery, Tubman African-American Museum, and Terrace Gallery, City of Orlando.

Thornton Dial: His Spoken Dreams. Essay by Thomas McEvilley. New York: Ricco/Maresca Gallery, 1998.

Thornton Dial: Image of the Tiger. Edited by Harriet Whelchel and Margaret Donovan. New York: The Museum of American Folk Art and the New Museum of Contemporary Art, in association with Harry N. Abrams, Inc., 1993. Published in conjunction with the exhibition *Thornton Dial: Image of the Tiger*, shown at the Museum of American Folk Art and the New Museum of Contemporary Art, 1993.

Thornton Dial in the 21st Century. Edited by Paul Arnett and William Arnett. Atlanta and Houston: The Museum of Fine Arts, Houston, in association with Tinwood Books, 2005. Published in conjunction with the exhibition *Thornton Dial in the 21st Century*, shown at the Museum of Fine Arts, Houston.

Thornton Dial: Strategy of the World. Edited by Willa S. Rosenberg. Jamaica, NY: Southern Queens Park Association, 1990. Published in conjunction with the exhibition *Thornton Dial: Strategy of the World*, shown at Southern Queens Park Association, Jamaica, NY.

BROADCASTS, TRANSCRIPTS, AND RECORDINGS

Arnett, Matt, and Vanessa Vadim. *The Quilts of Gee's Bend*. Tinwood Media, Documentary video, 2002.

Carey, Celia. *The Quiltmakers of Gee's Bend*. Alabama Public Broadcasting, 2005.

———. *Thornton Dial*. Alabama Public Broadcasting, 2005.

Cassidy, Carol. Raw documentary footage of May 2001 trip through Alabama with Jane Fonda, Bill Arnett, and tour bus as well as additional footage of Thornton Dial at Fox Theater event.

"Closer Look: Runway Artist—Lonnie Holley." WAGA-TV, FOX5 Atlanta, March 3, 1997.

Dell Smith, Tommie, and Bob Richardson. *Thornton Dial: Image of the Tiger.* PBS/Museum of American Folk Art, New York, November 1993.

How We Got Over: The Sacred Songs of Gee's Bend. 2 CD Set, Tinwood Media, 2002.

King, George. *Lonnie (House Demolition) & New House. 6/23/98.* Raw documentary footage, 1998.

Kuerten, Bruce, and John DiJulio. *From Fields of Promise.* Auburn Television, 1993.

Moser, Chris. *The Day Atlanta Stood Still.* Georgia Public Television, 2001.

PBS NewsHour. "Quilts of Gee's Bend Exhibition: Interview with Quilter Arlonzia Pettway," Public Broadcasting System, 2003.

60 Minutes. "Yes, But Is It Art?" 1993 © CBS Broadcasting Inc. All Rights Reserved. Originally broadcast on *60 Minutes* on September 19, 1993, over the CBS Television Network.

———. "Tin Man." 1993 © CBS Broadcasting Inc. All Rights Reserved. Originally broadcast on *60 Minutes* on November 21, 1993, over the CBS Television Network.

———. "Andy Rooney." 2001 © CBS Broadcasting Inc. All Rights Reserved. Originally broadcast on *60 Minutes* on May 20, 2001, over the CBS Television Network.

OFFICIAL AND SEMIOFFICIAL PUBLICATIONS

Certificate of Death for Sidney Arthur Moses, Alabama Center for Health Statistics, May 9, 1932.

"Complaint for preliminary and permanent injunctive relief, breach of contract, specific performance and declaratory judgment." *In the Circuit Court for Jefferson County, Alabama Bessemer Division, Civil Action No. CV-02-1607. Freedom Park*

Conservancy, Inc., Plaintiff, v. Thornton Dial, Defendant. November 14, 2002. Filed by James Richey, counsel for Freedom Park Conservancy.

"Deposition of Al Caproni, III regarding events in Bessemer Courtroom on February 28, 2003." *In the Circuit Court for Jefferson County, Alabama Bessemer Division, Civil Action No. CV-02-1607. Freedom Park Conservancy, Inc., Plaintiff, v. Thornton Dial, Defendant.* May 18, 2003. Filed by Bill Thomason, counsel for Thornton Dial.

Kennedy, Mark. "Statement from Mark Kennedy," in response to *60 Minutes* "Tin Man" story. Birmingham Museum of Art, Charlie Lucas files, November 22, 1993.

"Motion for hearing." *In the Circuit Court for Jefferson County, Alabama Bessemer Division, Civil Action No. CV-02-1607. Freedom Park Conservancy, Inc., Plaintiff, v. Thornton Dial, Defendant.* March 25, 2003. Filed by Bill Thomason, counsel for Thornton Dial.

"Motion to set aside order." *In the Circuit Court for Jefferson County, Alabama Bessemer Division, Civil Action No. CV-02-1607. Freedom Park Conservancy, Inc., Plaintiff, v. Thornton Dial, Defendant.* March 25, 2003. Filed by Bill Thomason and Orin Ford counsel for Thornton Dial.

"Plaintiff Freedom Park Conservancy, Inc.'s motion to stay May 6, 2003, Order and for reconsideration of plaintiff's motion to enforce settlement agreement and opposition to defendant's motions." *In the Circuit Court for Jefferson County, Alabama Bessemer Division, Civil Action No. CV-02-1607. Freedom Park Conservancy, Inc., Plaintiff, v. Thornton Dial, Defendant.* April 29, 2003. Filed by Al Caproni III, counsel for Freedom Park Conservancy.

"Plaintiff's motion to enforce settlement agreement and opposition to defendant's motion for hearing, motion to set aside order, motion for extension of time to file evidence in support of motion to set aside, and motion to compel." *In the Circuit Court for Jefferson County, Alabama Bessemer Division, Civil*

Action No. CV-02-1607. Freedom Park Conservancy, Inc.,
 Plaintiff, v. Thornton Dial, Defendant. April 29, 2003. Filed by
 Al Caproni III, counsel for Freedom Park Conservancy.
"Recorded statement of Thornton Dial regarding events in
 Bessemer Courtroom on February 28, 2003." *In the Circuit*
 Court for Jefferson County, Alabama Bessemer Division, Civil
 Action No. CV-02-1607. Freedom Park Conservancy, Inc.,
 Plaintiff, v. Thornton Dial, Defendant. April 10, 2003. Filed by
 Bill Thomason, counsel for Thornton Dial.
Shannon, Charles, Eugenia Shannon, and Traylor Family.
 "Statement by the Parties Announcing Settlement of the
 Lawsuits Concerning the Art of Bill Traylor," October 1993.

ACKNOWLEDGMENTS

SPECIAL THANKS AND LOVE TO MY WIFE, JANICE, AND DAUGHTERS, Samantha and Jessie, who were incredibly patient and supportive during the three years it took to research and write this story. The same goes for my parents, Phil and Diane Dietz, who instilled in me a love of the arts that gave me the will to complete this project. And to my sister, Karen, who is also my wonderful, dear friend and spirited cheerleader. Also, thanks to my in-laws, Burton and Barbara Gold, who lent their encouragement and insight.

Especially, thanks to my late mother-in-law, Lenore Gold, without whom this book could not have been written. Lenore first exposed me to the art of Thornton Dial and Lonnie Holley; because of her I connected with Paul and Bill Arnett, and because of her so many great people agreed to spend time with me discussing this story. Lenore was friendly with many of the key characters in this book and she inspired many of them to embrace the arts with a new passion. Lonnie Holley and Ronald Lockett once visited Lenore and Burton's exquisite, gallery-like apartment on the fortieth floor of an Atlanta high-rise, and both artists' work accelerated because of what they saw and heard. After Lenore lost her life in a tragic car accident just prior to the 1996 Summer Olympics, Lonnie Holley created a sculpture that captured her essence entitled *Finally Getting Wings above the 41st Floor*. That piece captured my imagination and sent me down the no-turning-back path that became *The Last Folk Hero*.

Thanks, too, to the many friends who have been so kind through this process: John Helyar, Paul Hemphill, Howard Lalli, Michael Koziol, Jane Jackson, Marjorie Blum, Bob McDonald, Peggy Jonas, Joe Massey, Sheila Jordan, Michael Parker, Gaye and Henri Van der Eerden, Deborah Lauter, Cathy Caruth, Andrew Feiler, and many others. Special thanks to Caroline Amory for her friendship and for her faith in me. Also thanks to Lucinda Bunnen, the heart of Atlanta's art community, patron, champion, and exceptional artist in her own

right. Lucinda shared her memories, friendship, and also some of her photographs so that this book might come to fruition.

George King and Carol Cassidy were gracious in allowing me to view their unfinished documentary footage about Lonnie Holley and Thornton Dial. Mike Melia and Karly Young were masterful in their cover design efforts. Bob Land and Jill Dible were a stellar copyediting and layout team. Chuck Perry and Jim Levine both provided guidance and insight. Jonathon Keats is a spectacular editor and writer, and a brilliant artist with a piercing sense of humor; he was a catalyst for this project at a crucial stage. Curt Matthews, Mary Rowles, Sara Hoerdinger, and the entire team at Independent Publishers Group were critical to the successful creation of this book. Chris Graham and Jeff Leonard of Cohen Pollock Merlin LLP and Jim Rawls of Powell Goldstein LLP have also been important catalysts and wise, trusted advisors.

This book could not have been completed without Alita Anderson, my editor and collaborator. Alita is a genius, an artist, a poet, and a shining light.

Morley Safer, Jeff Fager, Ned Rifkin, Peter Marzio, Jane Livingston, John Beardsley, Jane Fonda, Susan Crawley, Mary McCarthy, William Louis-Dreyfus, Marcia Weber, Gail Trechsel, Ruth Wall, Ruth West, and a huge number of others were also incredibly generous with their time and insights.

Lonnie Holley, Joe Minter, Mary Lee Bendolph, Thornton Dial, and Mr. Dial's entire family were kind and patient as I probed the details of their lives, as were other artists chronicled here. More patient, still, were the Arnetts. Bill Arnett is not typically associated with the word "patient," except, as I imagine Bill might say, by his doctor. However, Bill and his family—Paul, Matt, Harry, Tom, Judy, and Robert—always treated me with a healthy dose of patience, kindness, and respect, and they were always available to talk as needed. The Arnetts provided all manner of documents and information, and they invited me into situations openly so that I could witness firsthand their encounters—for better or worse—with the various art, business, and community worlds that they traverse.

Andrew Dietz is a writer, entrepreneur, and art lover based in Atlanta, Georgia. He was born in Brooklyn, New York; raised in Stamford, Connecticut; and educated at the University of Michigan and Duke University. He has lived in the South for the past twenty years and currently resides in Atlanta with his wife and two daughters. The nonfiction novel *The Last Folk Hero* is his first book.